STOREY'S ILLUSTRATED BREED GUIDE TO

SHEEP, GOATS, CATTLE, and PIGS

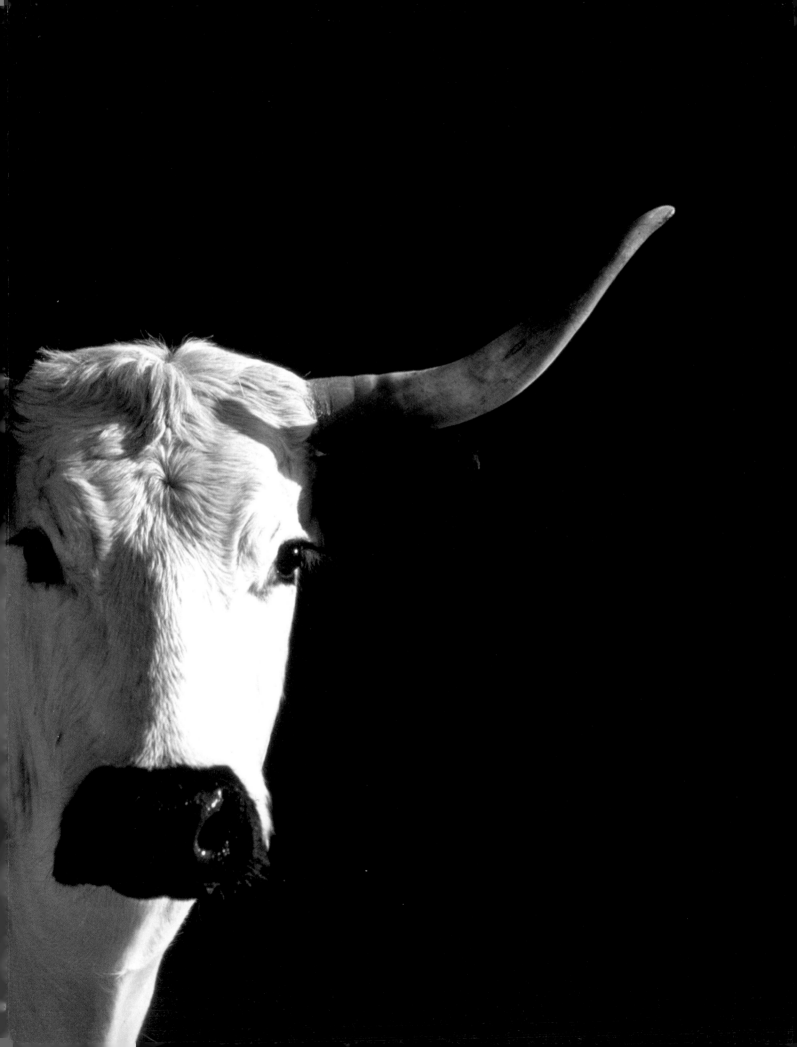

STOREY'S
ILLUSTRATED BREED GUIDE TO

SHEEP
GOATS
CATTLE
AND
PIGS

163 BREEDS FROM COMMON TO RARE

Carol Ekarius

 Storey Publishing

The mission of Storey Publishing is to serve our customers by
publishing practical information that encourages
personal independence in harmony with the environment.

Edited by Sarah Guare and Deborah Burns
Art direction and cover design by Dan O. Williams
Book design by Leslie Anne Charles/LAC Design

Front cover photographs by © Gabriella Fabbri/www.i-pix.it (top right); © Trudy Loosman
 (middle right); © Derek Dammann/iStockphoto (bottom left); © Robert Dowling
 (bottom right)
Back cover photographs by © Lynn Stone (top left and bottom right); © Dale Huhnke
 (top center); © John and Melody Anderson, Wayfarer International Ltd. (top right);
 © Robert Dowling (middle left and bottom left); © Ken Woodard Photography
 (author photo)
Interior photography credits begin on page 310

Photography management by Mars Vilaubi
Prepress by Kevin A. Metcalfe
Indexed by Andrea Chesman

Printed in the United States by Walsworth Publishing Company
10 9 8 7 6 5 4 3 2 1

Library of Congress Cataloging-in-Publication Data

Ekarius, Carol.
 Storey's illustrated breed guide to sheep, goats, cattle, and pigs / Carol Ekarius.
 p. cm.
 Includes bibliographical references and index.
 ISBN 978-1-60342-036-5 (pbk. : alk. paper)
 ISBN 978-1-60342-037-2 (hardcover with jacket : alk. paper)
 1. Cattle breeds. 2. Goat breeds. 3. Sheep breeds. 4. Swine breeds.
 I. Title. II. Title: Illustrated breed guide to sheep, goats, cattle, and pigs.
SF198.E33 2008
636—dc22
 2008026110

To Ken, who has made this possible.

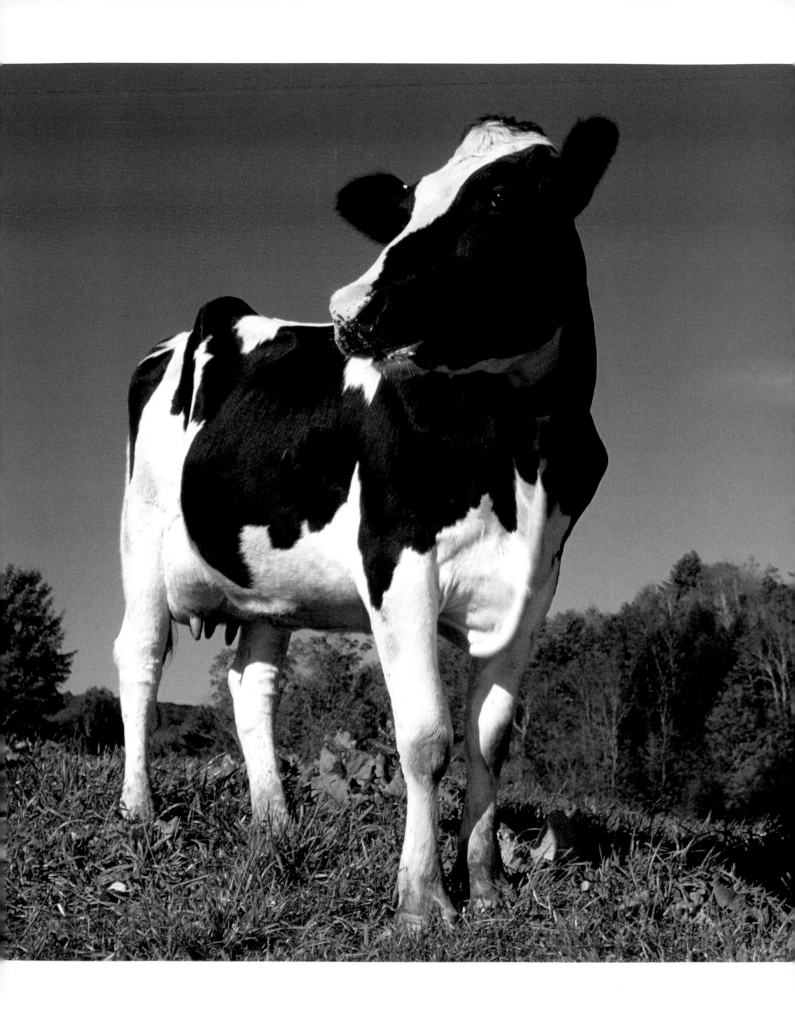

CONTENTS

Goats 142

Pigs 178

Sheep 208

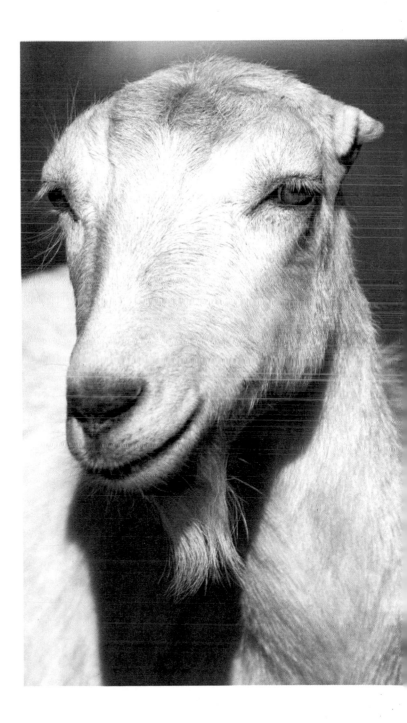

ACKNOWLEDGMENTS

Writing an encyclopedic book requires tapping in to the knowledge of many, many people.
I extend my heartfelt thanks to everyone who helped, including:

The staff and volunteers at the American Livestock Breeds Conservancy, in particular Don Schrider, Marjorie Bender, Dr. Don Bixby, and Dr. Phillip Sponenberg, for writing about the need to protect breeds and for reviewing text.

The staff and volunteers at Rare Breeds Canada, especially Jane Mullen, Bev Davis, Ted Lawrence, and Doug Law, for reviewing the descriptions of Canadian heritage breeds.

Dr. Sheila Schmutz of the University of Saskatchewan, for help with understanding the current state of genetic research and animal color, as well as sharing the story of Snowdrop.

Dr. Larry Cundiff of the USDA Meat Animal Research Center in Clay Center, Nebraska, and Dr. Roger Johnson of the University of Nebraska, for help with understanding genetic research as it relates to meat quality.

Dr. Steven Stoll of Yale and Dr. Alfred W. Crosby, emeritus professor at the University of Texas, for help in teasing out the historic threads of animal domestication, the spread of domestic animals, and the importation of animals to the New World.

Steve Johnson, archival librarian at the Bronx Zoo, Lisa Neely, the librarian at the King Ranch, and the research staff at the Toronto Public Library, for their invaluable assistance sorting out the World War II imports of White Park cattle.

Dr. A. H. J. Rajamannan of Agro-K Corporation, for tremendously interesting insights into the importation of Continental European breeds from the 1960s through the 1980s, the history of artificial insemination, and the history of the development of embryo transfer technology.

Carol Christiansen, curator and community museums officer of the Shetland Museum and Archives, for clarifying the Viking origins and influence on Shetland and other British sheep breeds.

Dr. John Winder at Washington State University, for helping clarify the nuanced differences between composite and synthetic breeds.

Dr. Tim Olson of the University of Florida, for clarifying the nuanced differences among Crackers, Pineywoods, and Criollo breeds in the Southeast.

Ninety-plus individual breeders and breed association staff, who graciously responded to questions, pointed me to other experts, or reviewed the description for the breed they work closely with. Without these dedicated individuals, our agricultural heritage would be a much poorer thing. Several breeders went above and beyond in responding to my questions, including Russ Bueling, Wes Henthorne, Robert Lynch, Betty Rowe, and Jim Schott.

All of the photographers (see credits on page 311) for supplying the beautiful photos that help bring the animals to life for us, and all the breeders who shared their animals with us. Special thanks to Debbie Jones and the rest of the folks at Jones Ranch in Tatum, New Mexico, for hosting a photo shoot during shearing.

Deborah Burns, Sarah Guare, and the rest of the Storey team, for helping make this project happen.

PREFACE

I CAN STILL REMEMBER our first livestock. We were young, having just moved to forty acres about forty miles out of the ski town where we worked, and we wanted to raise a calf for our own meat. As complete country neophytes, we had no idea how one goes about buying a calf. There were no sale barns nearby; truthfully, we didn't even know that such places existed. The local newspaper had a classified section for farm and ranch, but it mainly listed horses, tack, and tractors. We didn't know there were specialty newspapers dedicated to agriculture that advertise other types of stock, or that there were auctions with animals on the bill.

At the time we were naive but also enterprising. We decided to simply drive up to the nearest working ranch and ask if we could buy a calf. Mrs. Thompson came to the door when we knocked and asked, "Can I help you?"

We described our mission, and she looked at us like we were Martians who had just landed from outer space, with big green ears and antennae sticking out of our heads. I guess to an old-time rancher, a couple of ski-town kids were from another universe. But Mrs. Thompson was a gracious woman. She invited us in for coffee and explained that ranchers don't typically sell their calves in the spring, but just that morning her son had found an orphan calf out on the range. They thought the mother cow probably died from eating locoweed, though they couldn't be sure what killed her. "It is really young and shouldn't have been weaned yet," she said. "It probably won't live, but if you want to try and raise it, I'll let you have her for $50.00."

Little Fat Girl, a pretty little Hereford, rode home on my lap and survived our steep learning curve. She was the first of many farm animals we have shared our lives with.

INTRODUCTION

LIVESTOCK AND FARMS go hand in glove. Animals not only provide food, fiber, and income for farmers, but their manure can also be a beneficial fertilizer, they can consume otherwise unwanted crop residues, they can control weeds and shrubs, and many can be used for draft power. Farm animals offer enjoyment for owners and help children learn important life skills. In fact, farm animals are so important to the agricultural sector that 12 percent of the world's population depends solely on livestock for its livelihood. In the United States, animal agriculture accounts for more than 50 percent of the value of commercial agricultural products (exceeding $100 billion in 2006). These statistics don't include the value of farm animals kept primarily by hobby farmers for pleasure and personal food supply.

Unfortunately, as commercial agriculture has become industrialized, we have come to rely on a rather narrow gene pool. Just a handful of breeds now dominate agricultural production for each of the main species raised in the United States, often with only limited bloodlines being used within those breeds. The dairy industry provides an excellent example: of the approximately nine million cows in the U.S. dairy herd, more than 95 percent are registered or grade Holsteins, and more than one-third of the herd traces its lineage to just three bulls. Granted, Holsteins make large quantities of milk in an industrial-type dairy, but our growing dependence on a few animals that perform well in such a system is causing a dangerous erosion of genetic resources that took tens of thousands of years to develop, and those resources could be critical to our future survival (read about protecting the genetic diversity of livestock on page 21).

The good news is there are dozens of breeds in all the major classes of livestock still hanging on, and this book will serve as your introduction to all of them.

The Randall Lineback is a dairy breed that was once common in New England.

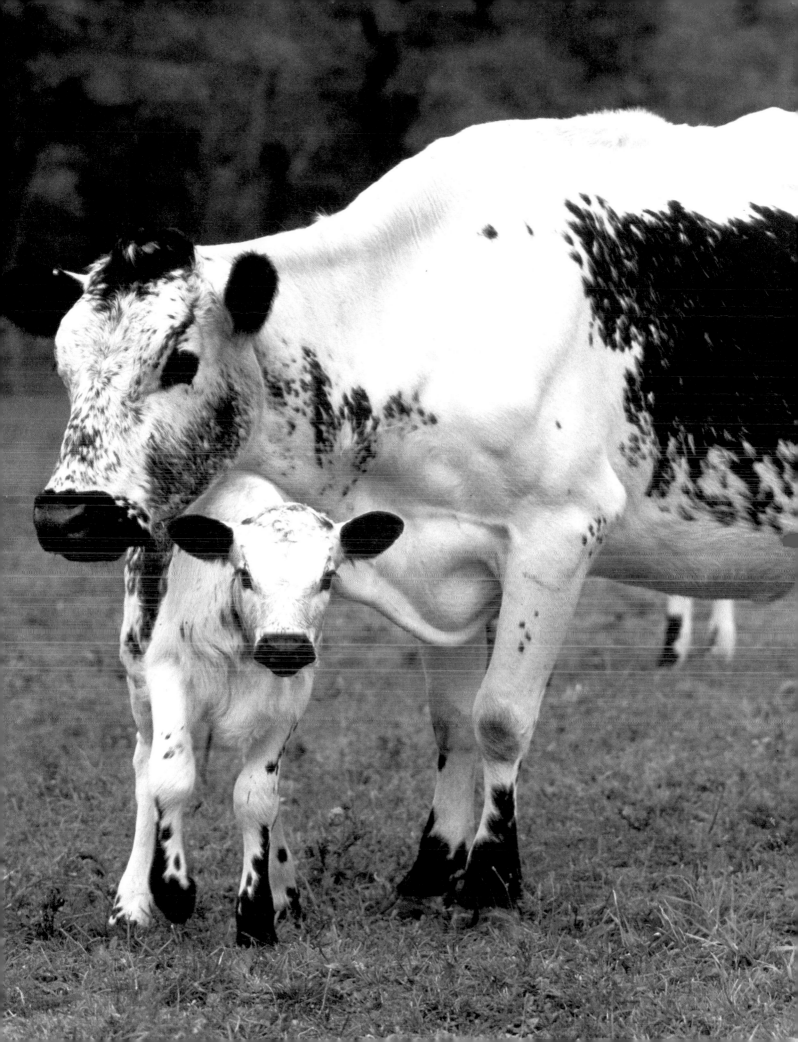

Defining and Evaluating Breeds

THERE IS NO UNIVERSALLY SANCTIONED definition of a breed, and no certifying agency that says this group of animals is recognized as a legitimate breed, or that group of animals isn't. A generally accepted definition of a breed is: a group of domestic animals with definable and identifiable characteristics (visual, performance, geographical, and/or cultural) that allow it to be distinguished from other groups within the same species. In reality, a breed is whatever a group of breeders recognizes as such, with one important caveat, breeders and scientists agree that breeds *breed true;* in other words, those traits that make a particular breed unique will pass down in a consistent manner to the offspring of purebred breed members.

Breeds come and go as human interests change. New ones are formed when breeders begin selecting for specific traits over a period of time. Older breeds languish when only a few breeders maintain interest in them, or

The Florida Cracker cattle breed was derived from the cattle brought to the New World by early Spanish explorers. It is well suited for hot, humid areas.

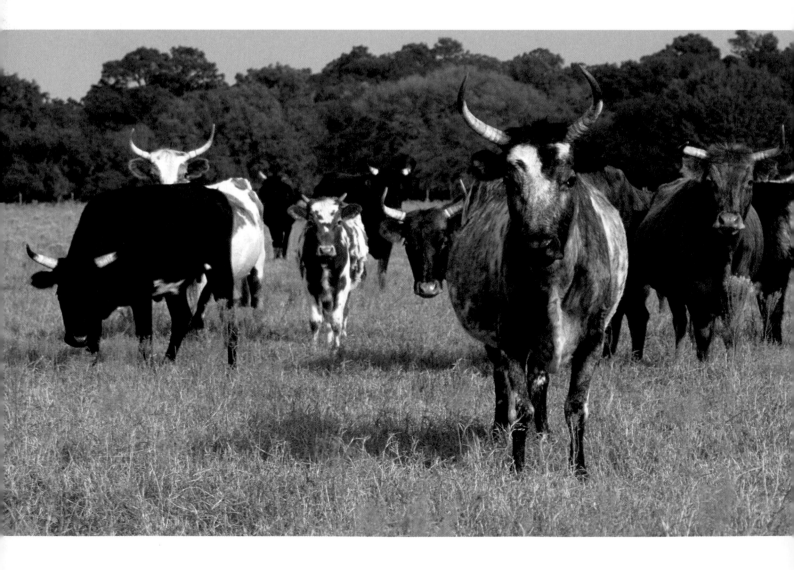

become extinct when those few breeders that have kept the breed viable die themselves or are forced to sell their remaining stock.

No single breed excels in all traits, in spite of what breeders and breed associations may tell you. If you are looking to acquire animals, remember that while the breeders you talk to truly believe their breed has value and offers something important to the marketplace, they depend on sales. Their claims should be viewed as a sales pitch that is best taken with a grain of salt unless backed up by scientific data or credible documentation.

For example, when we first started looking for cattle we were interested in the Highland breed. We had done our research and really liked the breed, but to hear some of the Highland breeders talk, you would think their animals could live off twigs and dirt and still produce well. We did eventually buy some Highlands and didn't regret our decision. They are hardy thanks to those long, curly tresses; they can eat rougher forage than many other breeds of cattle that have been "bred up" for higher production; and they can produce a nice calf on that rougher forage. However, their nutritional requirements aren't *significantly lower* than other breeds, and they won't perform well if they are offered nothing to eat but brush and dirt.

At the same time, all breeds of livestock do have traits that have proved to be of value at some point in time, and they may prove more valuable again in the future. Breeds that aren't popular with mainstream agriculture today (because they aren't quite as big at birth, are slower growing, or don't produce as much milk or as many eggs) often have characteristics that work well for small-scale family farmers and hobby farmers. They may have greater resistance to diseases or parasites, be more acclimated to a particular climate (and with climate change, heat tolerance may become a very important trait), perform well in an alternative production system such as grass-based farming, or have superior taste and better nutritional benefits. Some breeds also have special aesthetic values, such as beautiful and unique coats, that make them interesting and worth maintaining.

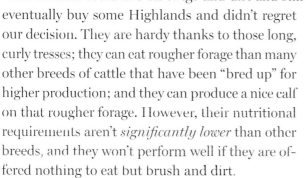

Like Florida Cracker cattle, Gulf Coast sheep have adapted to the hot and humid areas of the United States. They boast excellent parasite resistance.

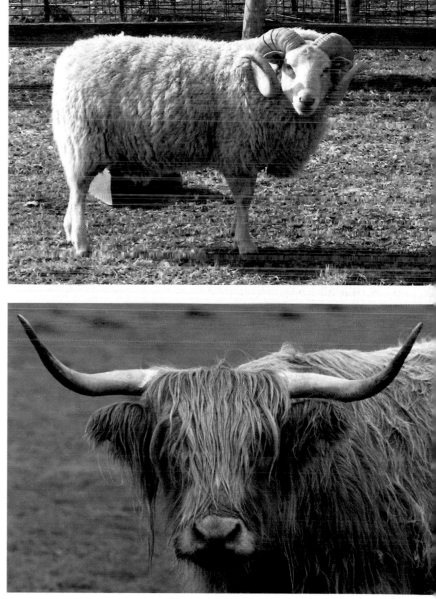

Highland cattle can handle the cold well, thanks to their long locks.

DEFINITION OF BREED TERMS

Adaptability. Some breeds can conform to a wide variety of ecosystems or climatic zones (meaning they are highly *adaptable*), while others perform poorly outside the type of area in which they were developed. For example, the "fine-wool" breeds of sheep, such as Merinos, do well in cold climates, as well as in hot and arid places, but not so well in hot and humid parts of the country. On the other hand, Katahdin hair sheep perform admirably well in both of those areas, as well as in cold climate zones.

Composite. This is a breed that is formed from breeding two or more established breeds together. Most composites have a standardized percentage of blood from the foundation breeds (for example, the American breed of cattle has a mix of ½ Brahman, ¼ Charolais, ⅛ bison, ¹⁄₁₆ Hereford, and ¹⁄₁₆ Shorthorn). This percentage varies among composites, depending on the goals of the breeders who developed the breed. Composite breeding is one of the primary ways that new breeds have been developed in recent years.

Domesticated species. A species that has been brought into a codependant and relatively "tame" relationship with humans, resulting in unique biological changes. Many individual wild animals can be tamed, but of the thousands of species that share the earth with us, fewer than 50 species have been truly domesticated.

Feral. A domesticated animal that has returned to an actively reproductive state in the wild, though still maintaining at least some of the biological characteristics of the domesticated species from which it sprang. Some species, such as pigs and cats, go feral very easily, quickly developing self-sustaining wild populations. Others, like cattle, rarely go completely feral. San Clemente goats and Hog Island sheep are examples of once-feral populations.

Genotype. The complete genetic makeup of an individual as described by the arrangement of its genes. The genotype of individuals within the same breed will be close, with the exact same combination of genes, yet unique in which alleles (halves of the gene, one supplied by mom, the other by dad) are actually present.

Grade. An animal of uncertain ancestry that generally shows the traits for which a particular breed is known, or a purebred animal that has not been registered with a breed association or society. For example, of the millions of Holstein cattle born in the United States each year, the majority are not registered and are therefore considered grade animals. Farmers did register 305,143 Holsteins in 2006, but these animals represent their best stock and may be used for developing promising breeding and show lines.

Hybrid. The offspring of two different species that interbreed, such as the Beefalo, whose parents are a cow and a bison. The term is sometimes also used interchangeably with the term *crossbred*, which refers to an offspring of two different breeds within the same species but isn't used when referring to a cross that has been standardized to yield a recognizable composite breed.

Landrace. An older type of breed that was developed by farmers with little emphasis on modern breeding techniques, which emphasize high production. Historically, natural selection played as large or larger a role in development than human selection based on written standards established by a breed organization. Because it has not undergone intensive selection, a landrace generally has greater genetic variability, as evidenced by more variation in coat color or other discernible traits, than standard breeds. A landrace breed usually lacks documentation through a registry, but it is always well adapted to the unique environmental conditions in which it was developed. The Gulf Coast Native (sheep) and the Florida Cracker (cattle) are examples of landraces still found in North America.

Phenotype. The physical characteristics or behaviors of an animal that can be observed or tested for, such as coat color, aggressiveness, and blood type.

Registered. A purebred animal whose lineage is documented through a registration process with a breed association or society. The association has issued it a certificate of registry.

Scrub. An animal of unknown breeding, or an animal that does not show traits clearly associated with a specific breed.

Standard breed. This is what we usually have in mind when we think of modern breeds. Members of these breeds are selected based on a breed standard, are supported by a breed association, and have pedigrees documented by a breed registry.

Strain. Although sometimes used synonymously with *breed*, most breeders use *strain* to describe a unique bloodline that concentrates on the genetics of a particular animal or group of animals within a breed. You might hear someone say, "John Smith's strain of Angus has always performed well in the heat."

Terminal sire. A breeding male (usually purebred) that is used in a crossbreeding program for the production of offspring that are intended to go directly to the butcher market. A terminal sire typically has a high growth rate and desirable carcass characteristics.

Type. When you talk to breeders, you will often hear them refer to type, which relates to how close an animal is to the ideal for a particular breed. It is basically a more casual term for phenotype. A breeder might say, "She is true to type."

Livestock through the Ages

NO ONE IS QUITE SURE when humans and animals began the co-dependent relationships that gave way to today's domesticated species. Archaeobiologists are scientists who study the archaeological record to better understand the relationship between early humans and the plants and animals that occupied their world. They confirm that our forefathers and foremothers had domestic dogs living in their camps more than 14,000 years ago, but molecular biologists now point to genetic evidence that the first "dogs" may have been domesticated from wolves by hunter-gatherers more than 100,000 years ago.

Today, scientists debate not only when the first dogs were domesticated but also which species first became domesticated for food. Until recently, the consensus was that goats held that distinction, with sheep following closely behind, but now some scientists think that the pig may have beaten out both goats and sheep. According to archaeobiologists, humans were husbanding goats, sheep, and pigs at least 9,000 years ago; horses and cattle were domesticated 6,000 to 7,000 years ago; and chickens were domesticated about 4,000 years ago. But again, molecular biologists are

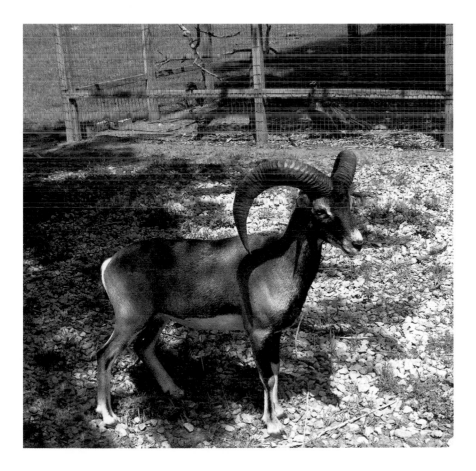

The mouflon (as seen here in Toronto's public High Park Zoo), progenitor of our domestic sheep, is threatened with extinction in the wild.

using the analysis of DNA data to push those dates further into the past. They think the first domestications of cattle probably took place more than 10,000 years ago and that goats, sheep, and pigs were domesticated even earlier. Regardless of when domestication first happened, or which species was domesticated first, the result is the same: the relationships between humans and domestic animals changed the course of history, socially and biologically, forever.

Many of the wild animals that gave way to our current domesticated livestock are now either extinct or extremely vulnerable to extinction. Cattle evolved from the aurochs (*Bos primigenius*), an animal that ranged over much of the globe at the time when our ancestors first began domesticating cattle. The last aurochs was killed in Poland in 1627. Domestic sheep are thought to have descended from the Asiatic mouflon (*Ovis orientalis*), although there is some evidence that the Urial (*Ovis vignei*) may also have contributed to some European breeds. Both species are now in danger of becoming extinct. The loss of the wild progenitors of our important domesticated species means we can't "reinvent the wheel" in the future. For example, if domestic cows were wiped out by a disease, there is no wild pool from which to redomesticate them.

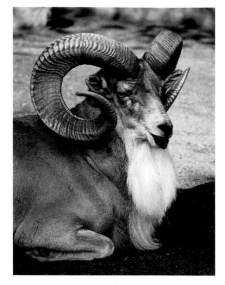

The Urial sheep is another wild sheep that may have contributed to the development of some European sheep breeds. Like the mouflon, it is endangered in the wild.

THE HISTORICAL DEVELOPMENT OF BREEDS

Once species became domesticated, breeds began to evolve. At first, the development of breeds was largely the result of environmental and geographic influences, such as climate or the proximity to other groups of animals, and not necessarily a result of conscious decision making by the humans involved. Yet, archaeobiologists can point to period art from the Babylonians and ancient Egyptians showing that those cultures had distinct breeds of dogs, cattle, and sheep almost four thousand years ago. Pictographs in Egyptian tombs show some cattle with horns and others that are polled (naturally hornless), as well as distinct solid-color types versus spotted types.

The first written reference to purposeful, selective breeding comes from the Bible. In the book of Genesis, the story of Jacob illustrates selective breeding for color. Jacob worked for his father-in-law, Laban, but he wanted to go out on his own. He asked Laban if he could keep the spotted sheep as part of his wage, and Laban agreed. In a dream, God told Jacob to use only spotted rams, and soon the flock consisted of only spotted sheep. When Jacob left, he took all the sheep, and today we have a breed, Jacob sheep, named after this enterprising breeder (see page 245 for breed description).

This Jacob ram shows multiple horns, a trait known as polycerate that is also seen in Navajo-Churro sheep.

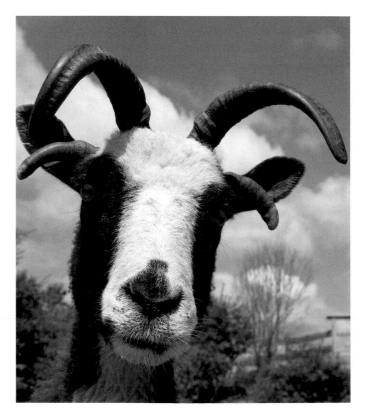

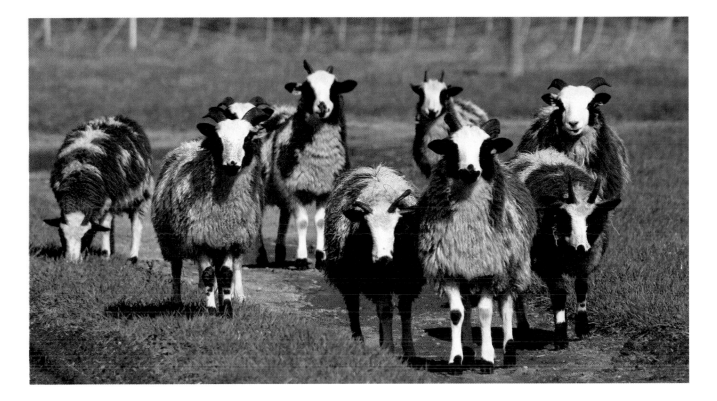

THE MODERN DEVELOPMENT OF BREEDS

In spite of these early successes with domestic breeding, things continued in a fairly random fashion until Englishman Robert Bakewell took over his father's Dishley Grange farm in 1760. While still quite young, Bakewell traveled throughout Europe studying farming practices of the time. Once the family's farm became his, he began applying and documenting new ideas for irrigation, fertilization, crop rotation, and livestock breeding.

Bakewell began his breeding program with the native breed of sheep in his region of Leicestershire. At the time, both sexes were kept together in the fields, but the first thing Bakewell did was separate the rams from the flock. By controlling which rams were allowed to enter the flock for breeding, and when, he found he could breed for specific traits. The rams he selected for breeding were big yet delicately boned and had good-quality fleece and fatty forequarters to respond to the market of the day (which favored fatty mutton). Soon Bakewell's flock showed distinctive changes, and he named his new breed of sheep the New Leicesters, or Dishley Leicesters.

Bakewell also developed the breed society or association. In 1793, he established the Dishley Society for breeders who would breed New Leicesters. Its members were required to follow a list of rules that maintained the purity of the breed. The New Leicester breed died out soon after Bakewell's death, as popular taste changed and leaner meat became more fashionable. But many of the advances that Bakewell made still influence breeders today, and the modern Leicester Longwool breed of sheep retains a lineage that goes back to Bakewell's animals.

These Jacob ewes show the spotted coloring that Jacob selected for in the biblical story, which is the first written account of breeding selection.

Bakewell's breeding work was not limited to sheep; it extended to cattle and horses as well. He noticed that the long-horned cattle of his day appeared to be the most efficient meat producers; they ate less and put on more weight than any other breed. As with the sheep, he began controlling the bulls' access to the herd and chose bulls that had good meat characteristics. His cattle were fat and meaty, but in 1810 his English Longhorns (which are not related to the modern Texas Longhorn) went out of fashion when one of his apprentices, Charles Colling, created the earliest strains of today's Shorthorn breed, which were said to be "equally profitable for the dairyman and the butcher." Both the Clydesdale and the Shire breeds of draft horses also benefited from work Bakewell did on breeding up his workhorses.

The heyday for breed development was the nineteenth century. With the pioneering practices developed by Bakewell, Colling, and others, farmers quickly began making major strides in improving production, and new breeds proliferated throughout the world.

The Leicester Longwool retains traits that date back to Robert Bakewell's New Leicester breed, the first improved breed, developed beginning in the 1760s.

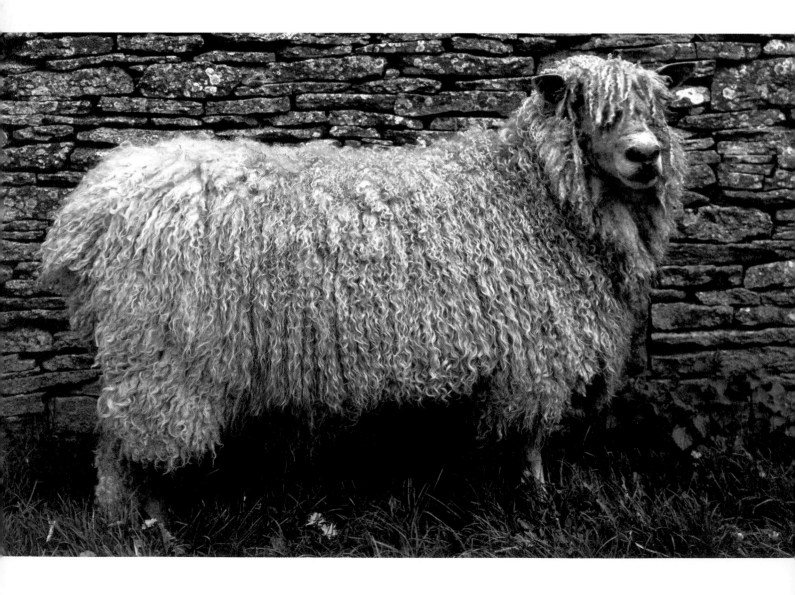

RARE BREEDS AND HEALTHY BIODIVERSITY

Text courtesy of The American Livestock Breeds Conservancy.

Since the earliest days of agriculture, countless individuals have dedicated themselves to the care and breeding of livestock. These animals have filled a wide array of human needs for food, fiber, creative and spiritual expression, sport, and companionship. Both human and natural selection have worked together in the evolution of breeds, each reflecting the characteristics valued in the interplay among the people, the animals, and the environment. Breed diversity existing within each species today is a legacy from our ancestors and reflects the multitude of environments in which the animals have lived and the ways that they have been kept. Taken together, the breeds represent their species' adaptability and utility, providing the genetic diversity the species needs to survive and prosper.

The importance of genetic diversity is widely recognized as it relates to the wild realm of rain forests, wetlands, tidal marshes, and prairies. Similarly, agriculture is a biological system with humans as a major source of selection pressure, and it is dependent on the options genetic diversity provides to be both dynamic and stable.

Genetic diversity *within* a species is represented by the presence of a large number of genetic variants for each of its characteristics. As an example, variation in coat texture of cattle could allow for the selection of individuals with dense, short coats, as found on the Florida Cracker cattle breed, which are perfect to deter insects and for a hot, humid environment, or for thicker, darker coats that trap insulating air in breeds such as the Galloway or Highland cattle, which are perfect for a cold, wet climate. These differences show how genetic diversity within a species can allow it to adapt to variations in environment and other selection pressures.

The opposite of genetic diversity is genetic uniformity. An intensely selected population, such as the Holstein cow, may be well adapted to a specialized habitat or production system, but such specialization results in uniform, predictable animals

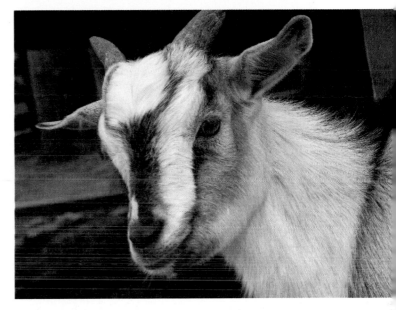

The Arapawa Island Goat was developed on a New Zealand island and is critically endangered.

reflecting a homogeneous genetic package in which genetic variability has been dramatically reduced. This can result in inbreeding depression and an overall drop in breed health and productivity. If this genetic narrowing affects the entire species, as it has with turkeys and hogs, the species' ability to adapt to changing production or environmental conditions is greatly compromised. A truly uniform population has a limited reserve of genetic options for change, making it vulnerable, for example, to being wiped out by a disease outbreak or by climatic change.

The industrialization of agriculture has consolidated and specialized the once decentralized production of animal agriculture into standardized systems of specialized production. The use of climate-controlled confinement housing, sophisticated husbandry and veterinary support, chemical additives, and heavy grain feeding has allowed breeders to ignore adaptation and other survival characteristics in favor of maximized production. While industrial stocks are highly productive in these exquisitely designed and supported environments,

(continued)

they are unlikely to be able to adapt to a changed system with restricted energy and other inputs, such as medicines and specialized rations. Breeds with more variability, such as the Gulf Coast sheep, are highly capable of surviving significant environmental changes. Genetic uniformity and genetic diversity are mutually exclusive.

Genetic conservation requires us to actively pursue the conservation of breed diversity to include varied breeds and types, especially those that have traits no longer found in industrial stocks. The conservation of rare breeds of livestock protects the broad genetic base found in each of the species of cattle, pigs, sheep, and goats, as well as in horses, asses, poultry, and rabbits.

Genetic diversity, as represented by a wide variety of genetically distinct breeds, must be conserved to meet six societal needs: food security, economic opportunity, environmental stewardship, scientific knowledge, cultural and historical preservation, and ethical responsibility.

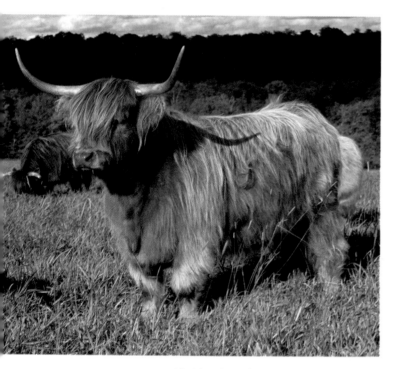

Highland cattle are a breed preservation success story: once critically endangered, the American Livestock Breeds Conservancy lists them as Recovering.

Food Security

Civilization is dependent on a stable food supply. Genetic diversity is the basis for responses to future environmental challenges, such as global warming, evolving pests and diseases, bioterrorism, energy availability, and changing production systems. The Irish potato famine, foot-and-mouth disease, and avian influenza are examples of the vulnerability of genetic uniformity and industrial consolidation. Diversity is essential for long-term food security.

Economic Opportunity

Rare breeds can offer a potential for economic opportunity by providing specialty products (such as healthful, flavorful meat and dairy products, and colored fiber for crafts, decoration, and fashion) that can be marketed into specialty niches, and specialty services. Services might include pest control, recreational opportunities, on-farm labor (such as draft power), or, in the case of pigs and goats, tilling and brush control. Rare breeds can also be used for product association, such as Clydesdale horses with Anheuser-Busch Brewing Company, or Highland cattle with Dewar's Scotch.

Genetic diversity can be used to develop new breeds to meet new needs. Breeds that are rare today were important contributors to human welfare in the past and may possess characteristics that will be needed again to meet new or reemerging needs, such as possibly using Dutch Belted cattle to increase longevity in today's Holstein herd. What a tragedy it would be if these survival traits were lost through negligence.

Environmental Stewardship

Agriculture is the chief interaction of humans with the environment. Genetic resources are essential to allow for agriculture's adaptation to environmental changes, to improve the sustainability of agricultural production, and to substitute services and products for environmentally and economically costly use of chemicals, energy, and other inputs. These sustainable practices are increasingly recognized for their economic and environmental value.

Scientific Knowledge

To fully understand the animal kingdom, to which we belong, requires the protection of genetic diversity. Many rare breeds are biologically unusual because of the selection pressures applied in their evolution. Climate adaptation, disease and parasite resistance, reproduction differences, and feed utilizations could be useful sources of information for improved agricultural production and human health.

Cultural and Historical Preservation

The root of agriculture is culture. Like artwork, architecture, language, and other complex artifacts, rare breeds enlighten us about the interests, skills, and values of the people who preceded us. Solutions to contemporary problems are often found in records of the past. Many traditional livestock husbandry techniques retain their usefulness today, but that once-common wisdom is slipping away. These living creatures also reflect our evolving relationship with the natural world. Rare breeds of domestic poultry and livestock, as well as rare varieties of agricultural plants, represent the biodiversity that is closest to us and upon which we are most dependent.

Ethical Responsibility

Stewardship of the planet includes the many species of wild animals, plants, and habitats as well as the domestic animals and plants that are part of the biological web of life. Those who appreciate the role of domesticated animals in providing services, food, and other products believe that domestic animals have a right to continued existence, as do the wild species. Domestic animals are often the first animals we learn about as chil-

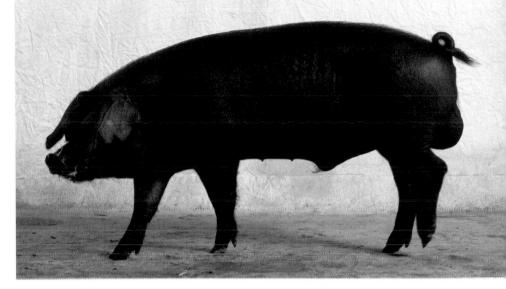

The large-scale industrialization of the pork industry has really hurt breeds like the Large Black that don't perform well in confinement operations, but these breeds may be well suited to small-scale producers.

dren and are the subject of most nursery rhymes and children's stories. Human beings have a special obligation to protect the domestic species that have been our partners for so many centuries of coevolution and interdependence.

Rare breed conservation also keeps livestock genetic resources in the hands of individual farmers and breeders. Livestock can be freely owned, used, and bred by farmers and breeders without the barriers of patents and other corporate restrictions. In contrast, concentration of genetic ownership and patenting of hybrid and genetically modified seeds by the seed industry has resulted in the lack of access to diversity and loss of many heirloom varieties. The adaptability and biological health of each domesticated species must be maintained to ensure that domestic animals continue to thrive in a wide range of environments and production systems without elaborate and expensive support systems.

The American Livestock Breeds Conservancy is the pioneer conservation organization in North America. The mission of the organization is the protection and promotion of more than 150 breeds of cattle, goats, horses, asses, sheep, pigs, rabbits, chickens, ducks, geese, and turkeys. Founded in 1977, the American Livestock Breeds Conservancy is a nonprofit membership organization working to conserve genetic diversity in livestock and poultry and save heritage breeds from extinction. For more information about participating in breed conservation efforts, contact the American Livestock Breeds Conservancy (see page 306 for contact information).

Livestock in North America

MOST SCHOOLCHILDREN can recite the tale of Christopher Columbus's first voyage in 1492 on the *Niña*, the *Pinta*, and the *Santa Maria*. Few people, however, realize that most of the modern livestock species typically associated with farming in North America came to the Americas with Columbus on his second voyage in 1493 and with later European explorers and immigrants. The Indian was as advanced a farmer as any in the world, but he did not domesticate many animals. According to Dr. Alfred Crosby, a historian and professor emeritus at the University of Texas, in his book *The Columbian Exchange: Biological and Cultural Consequences of 1492*, "In 1492 he [the Indian] had only a few animal servants: the dog, two kinds of South American camel (the llama and the alpaca), the guinea pig, and several kinds of fowl (the turkey, Muscovy duck, and possibly a kind of chicken). He had no animal that he rode. Most of his meat and leather came from wild game. He had no beast of burden to be compared to the horse, ass, or ox."

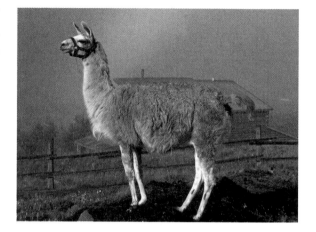

When Europeans arrived in the New World, they used the llama — a member of the camel family — as their only beast of burden.

When he set forth with 17 ships on his return voyage to the New World, Columbus changed the face of the American continents. The Spaniards unloaded horses, cattle, pigs, sheep, goats, chickens, and European dogs, which were notably larger than their American counterparts of the time. The animals reproduced quickly in their new land and followed the Spanish wherever they went.

For example, in 1539, Hernando de Soto brought 13 pigs to Florida with him, and in just three years there were more than 700. In 1540, Francisco Vásquez de Coronado led an expedition that went north into Arkansas, Kansas, Texas, Oklahoma, New Mexico, and Arizona. Along the way, horses and cattle were released, lost, or taken by Native Americans, fueling dramatic changes in both population distribution and lifestyle of the Plains Indians. Soon, horses spread through North America. Tribes as far north as Washington, Idaho, Montana, and Canada had horses by the mid-1700s.

In 1539, Hernando de Soto brought 13 pigs to Florida (shown here is a Tamworth). By 1542 there were more than 700 pigs in Florida, according to Spanish tax records.

Although most of our livestock heritage comes from the time after Columbus, the Vikings had brought sheep, and perhaps cattle, to the Canadian island of Newfoundland as early as the thirteenth century. Those animals didn't seem to spread the way livestock did

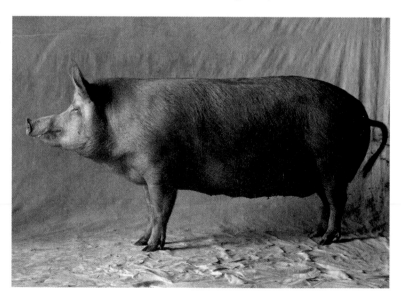

following Columbus's introductions, however. After Columbus's second voyage, livestock became regular passengers on almost all ships coming to the New World. George Percy, president of the Jamestown Council (the governing body of Britain's first permanent settlement in Virginia), reported back to London in 1607 that there was good pasture for cattle. Pigs were bred in a quasi-feral system in the forests of the New World. Later, when the Pilgrims landed at Plymouth, they brought goats and cheese-making tools. Chickens were so common on ships that they weren't even listed on the ships' manifests.

Importations continued to the New World for centuries. By the beginning of the twentieth century, there were approximately 1,500 breeds of domestic livestock and fowl in North America.

Today, few live animals are brought into the United States due to both the cost of transport and quarantine issues. Though live importations from other continents are still theoretically possible, imported sperm and embryos have become the more common way to introduce new blood and new breeds to the United States. Since the late 1960s, Canada has become the leader in the introduction of new breeds of livestock to North America. The Canadian government has invested in quarantine facilities to assure that foreign livestock diseases, such as foot-and-mouth disease, won't come to North America, thus allowing more imports to come via Canada rather than directly into the United States.

IMPORTATION AND EXPORTATION

For additional information about importing or exporting live animals, semen, eggs, or embryos, contact the United States Department of Agriculture, National Center for Import and Export, or the Canadian Food Inspection Agency (see page 306 for contact information for these organizations).

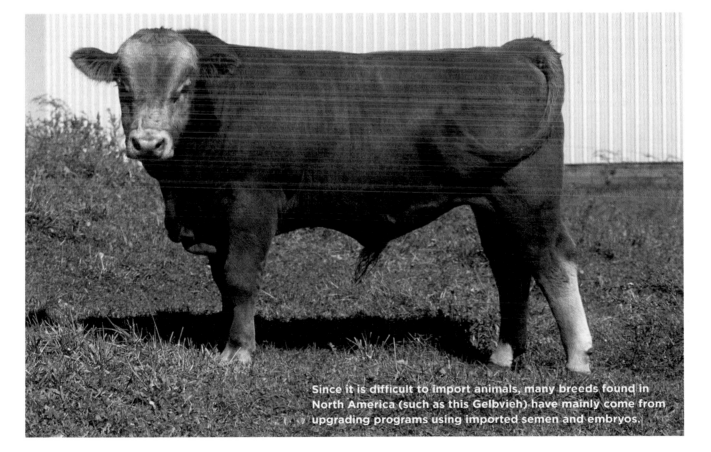

Since it is difficult to import animals, many breeds found in North America (such as this Gelbvieh) have mainly come from upgrading programs using imported semen and embryos.

Understanding Genetics

GENETICS MAY have been a new concept when Bakewell began his breeding program, but today we hear about new genetic breakthroughs on a seemingly daily basis. From Dolly the sheep (the first cloned mammal) to stories of genetically engineered cows that will not be susceptible to mad cow disease, and the successes of the Human Genome Project, there is a continuing buzz about genetics.

BREAKING CELLS INTO PARTS

If you are thinking of breeding livestock, you may find the following quick review of some of the principles of genetics and breeding to be helpful. All living things are made up of cells. In mammals, all cells contain a nucleus, within which is stored a genetic code that defines the creature, be it a newborn pig or the prize bull strutting his stuff in the pasture. This code is carried on chromosomes, the number of which varies depending on the species. Chromosomes typically come in pairs, except within the egg and sperm cells, which each has only one chromosome. When the egg and sperm combine to create a *zygote*, or fertilized egg, *it* has a complete pair of chromosomes.

All chromosomes are made up of a single molecule of DNA (deoxyribonucleic acid), and with the exception of the chromosomes in the egg and the sperm, they are all identical in shape and proportion, though they do vary in size. For example, a cow, which has a total of 30 chromosome pairs, would have 29 pairs of chromosomes that are the same shape and share the same proportion, and these pairs are called autosomes. The one pair that looks different from the rest is a pair of sex chromosomes. The letters X and Y designate the sex chromosomes, with the female having two X chromosomes (written XX), and the male having an X and a Y chromosome (written XY).

NUMBER OF CHROMOSOMES BY SPECIES

SPECIES	NUMBER OF CHROMOSOME PAIRS	TOTAL NUMBER OF CHROMOSOMES
Human	23	46
Cow	30	60
Goat	30	60
Sheep	27	54
Chicken	39	78
Pig	19	38
Horse	32	64

The DNA molecule is structured as a double helix (a twisting ladder) made up of four compounds: adenine (A), thymine (T), guanine (G), and cytosine (C), which join together to form the rungs of the ladder. Two compounds form each ladder rung, and, like a lock and key, the A always fits with the T, and the G always joins the C. The sides of the helix are made up of a sugar (deoxyribose) molecule and a phosphoric acid molecule. About six hundred of these "base pairs" combine to form an individual gene. During cell division and multiplication, the ladder splits apart, with each new cell getting half of the helix. Since the A always has to fit with a T, and the G with a C, the helix quickly rebuilds from materials inside the new cells.

DNA molecules are made up of still smaller units called genes, and a single DNA molecule has hundreds, even thousands, of genes on it. Genes have two halves (remember, one half is delivered by the dam and the other half by the sire). These are called *alleles*, and every gene has at least two potential alleles. Some alleles act like an on-off button, while others behave more like a dimmer switch, altering the intensity of a trait. Alleles are designated by a letter, or by letters and symbols.

Most mammals have 25,000 to 35,000 genes, and this total package of genetic code is called the genome. Since the 1990s, geneticists have been mapping the genome for humans, pigs, cattle, chickens, mice, fruit flies, and other species that have economic or scientific value. The data they are providing helps us to better understand many facets of the biological world, such as the relationships between species, how and where domestications took place, and why some animals get sick in a certain set of circumstances while others don't.

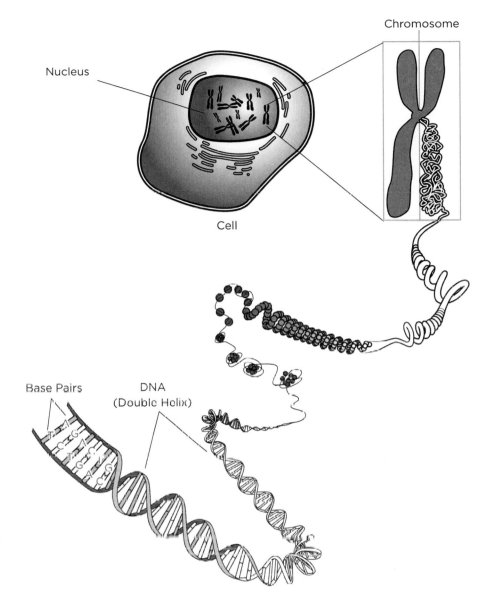

This graphic shows the ladder of DNA at the bottom, which is the building block of chromosomes (upper right). Chromosomes are found in the nucleus, or dark gray area, of the cell (upper left).

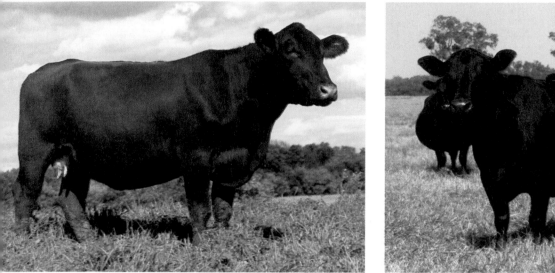

HOW GENES WORK

Let's examine cattle coat color to understand how genes work. Red and black are the two most common coat colors in cattle. The gene that controls red or black in breeds such as Angus and Holstein cattle is the Melanocortin 1 Receptor (MC1R) gene (this may be referred to in older texts as the Melanocyte Stimulating Hormone Receptor, or MSHR). The MC1R has two common alleles, the E^D and the e, and one less common allele, the E^+.

Letters (or letters and symbols) are written in pairs, such as $E^D E^D$, ee, $E^+ E^+$, $E^D e$, $E^D E^+$, or $E^+ e$. When the alleles are identical, such as $E^D E^D$, the gene is said to be *homozygous;* when the alleles differ, as in $E^D e$, the gene is *heterozygous.* In heterozygous pairs, one allele is typically dominant over the other. On the MC1R gene, the E^D is dominant, and when it is present, the animal's coat is black. An animal that has a red coat can't have an $E^D E^D$, nor an $E^D e$ pair on the MC1R gene, but must have a homozygous pair of the recessive e alleles (ee).

Scientists think that E^+ generally acts as a neutral allele, though they still aren't certain what role it plays in all color schemes. In other words, the E^D is dominant over it, and the e also seems to be dominant over it, meaning that an $E^D E^+$ animal is black and an $E^+ e$ animal is usually red, though there may be some exceptions for this combination. When the allele combination is $E^+ E^+$, the cattle can be almost any color, since in this case other genes seem to play a greater role than normal in determining which pigments are produced.

Animals that aren't solid black or solid red have other genes coming into play. For example, the dun color in the Dexter breed is the result of two different genes coming together. In this case, the Dexter has at least one E^D allele at the MC1R gene, but it also has a bb combination on the TYRP1 (tryptophan 1), or brown, gene. Thus, dun is a recessive trait that requires a homozygous allele at the TYRP1 gene, which is programmed to interact with the MC1R gene.

Red and black are two of the most common colors in cattle (shown at left is a red Angus and at right is a black Angus). The MC1R gene controls these colors. Black is the dominant color, so red animals are homozygous for the recessive e allele.

The Dexter's dun color is the result of a homozygous allele pair on the TYRP1, or brown, gene.

When multiple genes affect one trait, one gene may be *epistatic*, or act as though it is fully dominant over all of the other genes that typically have an impact on that trait. True epistasis is fairly rare in nature, because most of the time genes tend to act in an additive fashion, each one tweaking the resulting trait based on its code. The white gene, as found in the Charolais cattle breed, is an example of an epistatic gene. Charolais may have black or red coloring on their MC1R gene, but their white gene is homozygous and epistatic, so it masks the MC1R gene's behavior. In heterozygous form, which occurs when a purebred Charolais is crossed with another breed, the offspring will have a smoky color because the white gene has an additive, instead of a masking, effect on the MC1R.

Albinos (those that have a complete lack of pigment in skin, hair, and even eyes) can be found in many species, but they are quite rare. Mutations, or changes, in the gene's structure are responsible for albinism. I like to use the story of Snowdrop to illustrate albinism. Snowdrop is an albino cow from purebred Braunvieh breeding. She was born on a North Dakota ranch in 2002 and donated shortly after birth (along with her dam) by owner Darrell Workman to Dr. Sheila Schmutz's genetics lab at the University of Saskatchewan, which is known for its genetics of color research.

Snowdrop has a mutation on the tyrosinase gene. This gene (which uses the letter C for its alleles) influences color in several types of white cattle, including the White Park breeds. When this gene has a mutation on a single rung of the DNA ladder (substituting an A for a G on the 312th rung), enzymes and amino acids send improper messages, which results in a complete, and epistatic, lack of melanin pigment formation.

Most albinos have other health problems and can't be out in the sun, so they usually don't live long. However, due to the care Snowdrop receives at the university, she has not only survived, but has had calves of her own that are helping Dr. Schmutz understand more about how genes work together and influence each other.

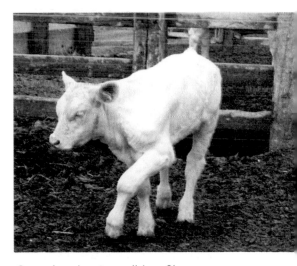

Snowdrop is a true albino. She was donated to Dr. Sheila Schmutz's genetic lab at the University of Saskatchewan to help further our understanding of cattle genetics.

Scientists have identified a variety of genes that play a role in cattle color, and they suspect there are still more to be found. Genes account for differences in pattern, such as spotting, roaning (a pattern created by white hairs interspersed with the dominant base color, such as black, red, or yellow), points (such as the colored nose and ears of White Park), and belting (such as the midbody stripe on Belted Galloway cattle), as well as different shades within a particular color. Similarly, other species' colors are determined by a variety of genes.

GENETIC MUTATIONS

Genetic code usually passes correctly from mom and dad to their offspring, but sometimes, as was the case in Snowdrop's story, the code is corrupted and a mutation occurs. Mutations are most often due to the loss or re-arrangement of chromosomal material (one of the As, Ts, Cs, or Gs is lost or placed in the wrong spot) and usually result in either resorption of the developing embryo or miscarriage later in the pregnancy. The odd animal that is born with such a mutation often dies shortly after birth or suffers from problems such as slow and abnormal growth or infertility. That said, some mutations are beneficial (such as the mutation on the myostatin gene that causes double muscling — an increase in muscle-cell size), and over centuries breeders may begin selecting for these genetic anomalies.

The majority of chromosomal problems are not directly genetic but are simply a mistake in code replication. That said, there are a relatively small number of chromosomal problems that are inherited, or truly genetic, problems associated with certain gene pairs in certain species or breeds. Almost every breed has some known genetic defects that pop up occa-sionally, though a few breeds have historically had more problems than others. The good news is that with our rapidly expanding understanding of genetics, many of these problems can now be tested for, and breeders (usually through their breed associations) are actively working to identify the genes and the carriers to eliminate these problems.

For example, Brown Swiss cattle can suffer from a disease known as Weaver syndrome, which ultimately results in complete loss of control of the hindquarters by 18 to 24 months of age. The Brown Swiss Association and scientists at the University of California at Davis have worked together to develop DNA marker testing that allows Brown Swiss breeders to test the DNA of their breeding stock to discover whether the animal is a carrier of the disease-causing gene. They have also traced the pedigrees of those Brown Swiss in which the disease is found. Thanks to these two strategies, the breeders have pretty well eliminated the problem by prohibiting carrier animals from breeding with each other.

NATURE VERSUS NURTURE

We often hear the nature versus nurture argument, but the truth is that the vast majority of traits, ranging from color to size and hardiness to per-sonality, depend on both nature and nurture, and more often than not, more than one gene is involved in how a trait manifests itself. For ex-ample, people used to think that color in animals was a genetically simple matter, controlled by only one or two genes, but as research on gene sequences has pro-gressed, we are now coming to understand that color is really quite complex and many genes can affect it.

Breeding Approaches

FARMERS AND RANCHERS use a variety of approaches when making breeding decisions. Some of the approaches that are commonly used include the following.

Breeding Up

Breeding up refers to the intensive selection of certain traits or of certain breed lines. Modern Holsteins, for example, have been bred up for extraordinary milk production. Breeds such as the Gelbvieh and the Tarentaise were introduced to North America by breeding-up programs. Breeders used semen from purebred bulls on cows from another breed and continued to breed offspring with purebred semen until the animals essentially represented the desired breed. (Throughout this text, you'll see the term *breeding up* used interchangeably with the terms *upgrading* and *up breeding*).

Crossbreeding

Crossbreeding is the mating of two purebred animals of different breeds. The term *F1* ("F" for filial, which means "pertaining to a son or daughter," and "1" for first generation) is usually applied to such a cross.

There are two major benefits of crossbreeding over straight breeding within a single breed. The first benefit is that of *heterosis*, or hybrid

Holsteins have been "bred up," or selected, for milk production over the past half century.

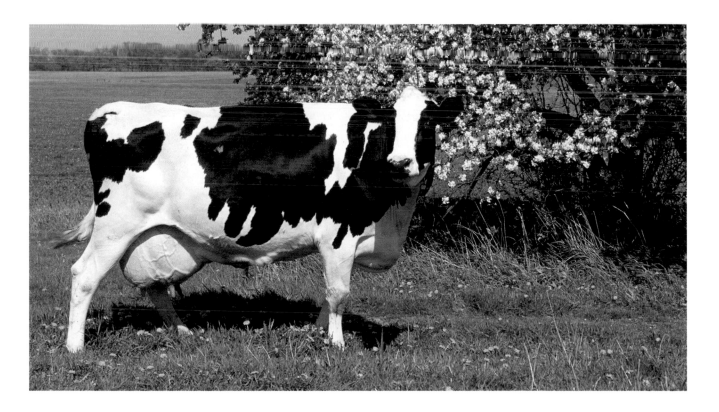

vigor, which is measured as the average performance of crossbred offspring compared to the average performance of offspring from purebred parents. Heterosis is usually positive, so that the F1 offspring of two purebred parents of different breeds often outperform comparable offspring from two purebred parents of the same breed. Heterosis is highest in fitness traits such as fertility and disease resistance, so these are the areas where you will see the most benefit from crossbreeding. Heterosis is intermediate for milk production, weight gain, feed efficiency, and body size, and is lowest in carcass traits such as meat grade and cutability.

The Senepol breed was developed by crossbreeding Red Poll bulls with native cattle of African descent on the island of St. Croix.

The second benefit comes from combining breeds with different characteristics to produce a superior product. For example, females with genetics for high carcass quality but small body size and slower growth could be mated to sires with genetics for large size and fast weight gain but low carcass quality, resulting in offspring that are average for both traits. For farmers, these favorable trait combinations are often the most important benefit of crossbreeding.

Breeders use the term *terminal cross* when crossbred offspring are intended for the slaughter market and are not kept for breeding. Terminal crosses can be made between two purebred parents of different breeds (also called a two-way terminal cross), between one purebred parent and one crossbred parent (a three-way terminal cross), or between two crossbred parents (a four-way terminal cross). Crossbred lines are specifically used as terminal crosses, rather than for breeding purposes, because the F2 generation (offspring of F1 parents) tends to show extreme variability and doesn't reflect the traits and characteristics of its grandparents, which breeders were selecting for in the first place.

Linebreeding

Linebreeding is a practice that involves the inbreeding of closely related family members, such as fathers to daughters, for the purpose of concentrating bloodlines to fix particularly valuable traits. Most breeds have been established through the use of at least some linebreeding, but linebreeding should not be indiscriminately practiced, as it can bring out less than desirable traits. *Inbreeding depression* is the term used to describe the effect of reduced vigor and performance that may result from linebreeding. Inbreeding depression is most likely seen in reproductive and growth traits.

Line Crossing

Used within a breed to provide a genetic boost similar to the boost provided by crossbreeding, line crossing uses distinct and unrelated bloodlines within the same breed. For example, when farmers use imported semen from a breed that hasn't been imported in decades, they are using line crossing to reduce the effects of linebreeding within the American herd and to add renewed genetic vigor to the American lines of the breed.

Pedigree Breeding

Farmers who use the pedigree system pay close attention to genetic lines, selecting sires and dams based on those lines. They strictly control which sire has access to a given dam, and they may base these choices on things like fame of a particular line within the breeding community, or on assumptions about how the pedigrees may complement each other. Pedigree systems often involve linebreeding.

Phenotype Breeding

The word *phenotype* means "the displayed characteristics of an organism," so farmers who breed using this approach base their breeding decisions on their animal's performance characteristics or visual appearance. Coat color and fattiness are phenotype characteristics. Geneticists refer to breeding based on phenotype as *assortative breeding*. There are two forms, positive assortative breeding and negative assortative breeding. Examples of positive assortative breeding would be mating the heaviest males to the heaviest females, or mating black males to black females. Examples of negative assortative breeding would be mating the heaviest males to the lightest females, or mating black males to white females. Positive assortative breeding results in more extreme variation among the offspring than random mating and is used with the hope of producing animals that change quickly for some particular trait, while negative assortative breeding results in more average offspring.

Random Breeding

Random mating is probably the most common approach practiced on small farms. In a random mating system, access to females is not controlled, so in theory each mature male has an equal opportunity of mating with each female. Although random breeding may work out fine for animals intended for terminal offspring, it won't result in improvements of specific desirable traits for breeding animals. Also, as it is the most aggressive male that mates the largest number of females in a random mating system, random breeding can result in increased aggressive behavior in the herd, or, if the most aggressive male has sterility problems, it may result in depressed fertility and fewer offspring.

Breed Registries

BREED ASSOCIATIONS AND REGISTRIES fulfill two primary functions: establishing eligibility rules for registration of purebred stock and handling the registration process, which includes an application procedure and issuance of a registration certificate. Other functions depend on the size of the association but may include publishing a herd, stud, or flock book; adopting standards of perfection or scoring systems for breeders who show animals; sanctioning and organizing shows; promoting the breed to potential breeders and sometimes promoting products derived from the breed (think of the great job the Angus beef people have done promoting Angus meat to consumers and you can see what a benefit breed-based marketing can be for members of the association); and working with researchers and veterinarians to develop testing procedures for genetic problems.

The breed association secretary is typically the person who is responsible for the registration process. He or she accepts applications, ensures that the applicant's animals qualify for registration, issues the registration paperwork to the applicant, and enters pedigree data into the association's books. Though some associations still strictly record and approve registration based on pedigree information, many are also requiring breeders to submit production and performance information for animals that they register. A handful of associations strictly record and register animals based on actual production performance data, meaning an animal cannot be fully registered until after it has been used for breeding and its offspring are analyzed for performance using criteria such as birth weight and weight gain at a certain age. A few associations have also begun requiring blood typing and/or DNA testing in their registration process.

Breed associations maintain records on registered animals and may issue a breed certificate, like this one from the American Lowline Registry. Certificates typically document lineage.

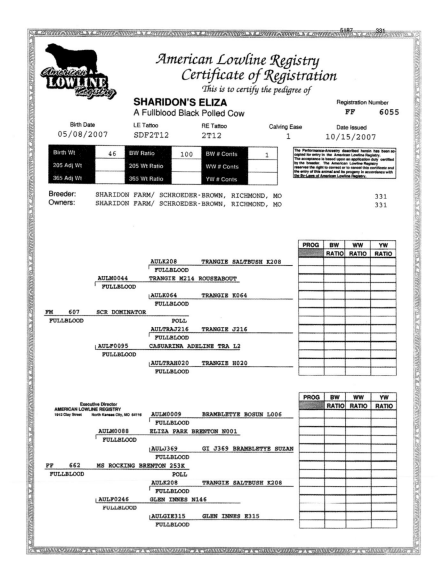

Notes on the Breed Descriptions

THE OLD SAYING GOES "The devil is in the details," and when it comes to writing about the almost two hundred breeds of livestock that are covered in the pages to come, it is so true. I have tried to dig up the details and share them with you, but at times details lose out to generalities because that is the best information that's available.

Before you begin looking at the breed descriptions that follow in the next four chapters, please take the time to read the following short discussions, which will help you understand some of the details, as well as the generalities, that I use in the write-ups. I think you will find this brief section worth your while.

ANIMAL DISPOSITION

If you are new to livestock farming and are using this book to help you evaluate breeds you might want to purchase, please remember that my breed descriptions are general. When I describe a breed as docile or gentle, these are general descriptions for the breed as a whole; temperament can vary greatly between individual animals. In fact, there is often a greater difference in temperament between individual animals within any breed than between breeds.

Most animals can also have different dispositions, depending on the situation or the circumstances. I can still remember a day when Libby, a large and totally lovable Holstein, kicked my husband in the face as he bent down to place the milker on her. He went flying across the milking parlor — glasses broken, a knot on his head, and a headache to go along

GENETIC IMPROVEMENT PROGRAMS

Beginning late in the nineteenth century, scientists working for government agencies and academic institutions began developing genetic improvement programs that used statistical analysis for aiding in the selection of breeding stock. These analyses produced EPDs, or "expected progeny differences," a measure of the expected outcomes of using a particular sire or dam in a breeding operation. As artificial insemination became more widely used, the system of analyzing sires, in particular, took off.

The first active use of these genetic improvement programs, which can predict characteristics such as ease of birth, weaning weight, and milk production, was probably the U.S. Dairy Herd Improvement Program. The USDA began collecting milk data from farmers in 1895. In 1908 it hired a scientist, Harold Rabild, to work out of Michigan State to coordinate the first Dairy Herd Improvement Association, which organized the breeding and milk-production records of dairy cows across the country, so that farmers could use the data to better select their breeding stock. Today there are improvement programs for many breeds of livestock, with data collected, analyzed, and reported by breed associations, government agencies, and nonprofit organizations.

Animal sizes vary fairly dramatically between breeds, as seen here. The Dexter at top is a fully grown, mature bull, while the Chianina at the bottom is a young cow who still has some growing to do.

with it. He startled Libby, who reacted because she didn't know he was there but did know that other cows were moving behind her.

Males during breeding season, females defending their young, or animals that are startled can be especially dangerous, even if in normal circumstances they are sweet and docile. If you are getting into livestock, learn proper and quiet handling techniques and have handling systems (such as catch pens and chutes). These will make the experience better for you and your critters.

ANIMAL SIZES AND FUNCTIONAL TYPES

Just as in the dog world, where we have teacup poodles, Great Danes, Chihuahuas, and Saint Bernards, there are amazing differences in the size of livestock breeds within a single species. Although no one officially classifies dogs as large, medium, or small, we can easily mentally classify them that way: A friend of mine's Chihuahua is very small. My German shepherd cross is medium to large. When I see another friend's Bernese mountain dog, I always think, "That is a large dog!" We make these mental corollaries without really giving it much thought.

Producers in commodity meat markets are familiar with *frame size* as a tool for evaluating and describing animals. Frame size is reported in terms of small, medium, or large, so I have used those terms to describe the relative sizes of the breeds in the chapters that follow. I think most of us can see, through comparison, that a Chianina bull, which averages 3,000 pounds (1,360 kg) and stands 6 feet (1.8 m) tall at the withers, is a very large breed, while a Dexter bull, which averages around 950 pounds (430 kg) and 3.5 feet (1.1 m) at the withers, represents a small breed. When assigning these size descriptors, I decided to describe the weight of mature males. The chart below shows the weight ranges of the mature males in each size category and species. But if you are familiar with even one or two breeds, you can then use these comparisons to begin sorting animals by size in your head.

As with sizes, the functional types I have noted in the following chapters are not established by any organization. It is a designation that I have assigned based on the type of use for which a breed is best known. For example, a breed may be characterized as a meat breed or as a dairy breed. Obviously, meat breeds do produce milk and dairy breeds do produce meat, but today most standard breeds have been bred up to concentrate on a specific functional trait. Historically, all breeds were dual- or even triple-purpose, but today most breeds are more specialized. Each species' chapter contains a discussion of the functional types associated with that species.

SIZE ESTIMATES

Species	Very Small	Small	Medium	Large
Cattle (mature bull)	<1,000 lb. (454 kg)	1,000–1,200 lb. (454–544 kg)	1,200–1,500 lb. (544–680 kg)	>1,500 lb. (680 kg)
Goat (mature buck)	NA	<100 lb. (45 kg)	100–150 lb. (45–68 kg)	>150 lb. (68 kg)
Sheep (mature ram)	NA	<140 lb. (64 kg)	140–170 lb. (64–77 kg)	>170 lb. (77 kg)
Pig (mature boar)	NA	<400 lb. (181 kg)	400–800 lb. (181–363 kg)	>800 lb. (363 kg)

BREED CONSERVATION

As you read the breed descriptions, you will see a category called "Conservation Status." This category refers specifically to designations for breed diversity and conservation needs as established by the American Livestock Breeds Conservancy (ALBC) or by Rare Breeds Canada, in the case of breeds primarily found in Canada. The box on the facing page describes the categories and criteria used by ALBC for classifying breeds, and though there are some differences for Rare Breeds Canada, the criteria for the two organizations are fairly similar. These breeds may not be popular with large-scale commodity and production agriculture, but for family farmers involved in direct marketing, or homesteaders interested in raising their own food, they can truly be perfect choices. I hope you will consider them if you are getting into animal agriculture, or if you are expanding an existing operation to take advantage of new marketing and production approaches.

Slow Food, an international nonprofit organization dedicated to "improving gastronomic experience and educating people about how food choices affect the world," has launched an exciting initiative to help breed conservation efforts. They sponsor the Ark of Taste, a program designed to "preserve endangered tastes and to celebrate them by introducing them to the membership and then to the world, through media, public relations, and Slow Food events." A number of threatened and endangered livestock breeds have been added to the Ark of Taste, and these are mentioned in the appropriate breed descriptions. This program does a good job of raising consumer awareness, and breeds that have been adopted on the Ark are already seeing some benefit.

Starting in 2005, the breed conservation movement also jumped to a higher level with the development of a cooperative effort known as RAFT (Renewing America's Food Traditions). This effort involves ALBC, Slow Food's Ark of Taste, the Center for Sustainable Environments at Northern Arizona University, Chefs Collaborative, Cultural Conservancy, Native Seed/SEARCH, and Seed Savers Exchange. These groups are working together to save rare breeds of livestock, as well as rare plant species and heritage varieties, by creating a national list of endangered foods and promoting those foods to consumers. Whether you are a consumer or a producer, you can help protect this cornucopia of critters that has evolved with us over so many generations and that has traits worth protecting. Just by buying this book, you have already helped, as I make a donation to ALBC for each copy that is sold.

AMERICAN LIVESTOCK BREEDS CONSERVANCY CRITERIA

1. The breed is from one of the seven traditional U.S. livestock species: asses, cattle, goats, horses, pigs, rabbits, and sheep. (Rabbit parameters are defined separately.)

2. The breed census satisfies numerical guidelines:

 Critical. Fewer than 200 annual registrations in the United States and estimated global population less than 2,000.

 Threatened. Fewer than 1,000 annual registrations in the United States and estimated global population less than 5,000.

 Watch. Fewer than 2,500 annual registrations in the United States and estimated global population less than 10,000. Also included are breeds that present genetic or numerical concerns or have a limited geographic distribution.

 Recovering. Breeds that were once listed in another category and have exceeded Watch category numbers but are still in need of monitoring.

 Study. Breeds that are of genetic interest but either lack definition or lack genetic or historical documentation.

3. The breed is a true genetic breed (when mated together, it reproduces the breed type).

4. The breed has an established and continuously breeding population in the United States since 1925. Or, if imported or developed since 1925, it meets one of the following criteria:

 - The foundation stock is no longer available.

 - The breed's numbers are below global guidelines (see #2).

 - It has at least three breeding lines in the United States.

 - There are at least 20 breeding females in the United States.

 - There are at least five breeders in different locations in the United States.

 - It has an association of breeders in the United States.

 - It is contributing to the breed's survival internationally. In general, this means that the United States population is reciprocal to other international populations (meaning it is an important and numerous population when compared to that in other countries, or the non–United States populations of the breed are at risk geographically or politically). Registry must be sanctioned by the mother organization so as not to be a dead end for the breed, and breeding stock must be licensed according to the rules of the mother organization.

5. Breeds not meeting all of these criteria may be placed in the "Study" category and monitored.

CATTLE

THE UNITED STATES is the world's largest producer of cattle. According to the U. S. Department of Agriculture (USDA), there are close to 96 million bulls, cows, and calves residing here, and Canada has more than 15 million. As a commodity, cattle generate more money than any other agricultural commodity, annually producing more than $50 billion in revenue.

At the mention of cattle, the first things that pop into most people's minds are beef and dairy products, but cattle provide so much more. By-products, such as hides and tallow, account for more than 10 percent of the value of a typical steer sold in North America. These are used in products ranging from cosmetics and pharmaceuticals to sporting goods and textiles.

Until the 1950s, there were only about 20 breeds found extensively throughout North America, and British breeds, such as Angus, Ayrshire, Hereford, Guernsey, Shorthorn, and Jersey, dominated cattle production. Starting in the years after World War II, more Continental cattle, such as the Charolais and the Simmental, and more breeds with the blood of Indian cattle (also called Zebu), such as the Brahman and the Santa Gertrudis, started gaining ground. The quickly expanding number of breeds changed the agricultural picture dramatically by offering farmers a wider array of breeds from which to choose. Some breeds were better suited for certain environmental or climatic conditions; others were better suited for increasing functional production. As interest in these breeds grew it also spurred breeders to develop dozens of new composite breeds, such as the Chiangus (a cross of Chianina and Angus) and the Brangus (a cross of Brahman and Angus).

Cattle are the most valuable agricultural commodity in the world. Seen here is a Brown Swiss in her home country, Switzerland. Notice the cowbell under her chin. Farmers historically used cowbells to locate their cows while they were out on pasture in mountains.

A Brief History

BREEDS OF CATTLE are classified into two genetic subspecies: *Bos taurus taurus* (*Bos taurus*, from here on) and *Bos taurus indicus* (*Bos indicus*, henceforth). *Bos taurus* cattle include those of European ancestry and are still the most common genetic type in North America, but *Bos indicus*, or the humped Zebu cattle, have found favor as the progenitors of new heat-tolerant breeds that perform well in hot climate areas of the United States.

Cows were domesticated from the now-extinct aurochs (*Bos primigenius*). The aurochs (aurochsen for plural), which survived in Poland until the last one was killed by hunters in 1627, was a slow-growing creature that reached five to six feet (1.83 m) tall at its withers and up to 10 feet

European cattle (here a Simmental) are members of the *Bos taurus* subspecies.

(3.05 m) in length. It looked somewhat like a really large Highland with long, curly hair and impressive horns. Thought to have evolved in India about two million years ago, the aurochs was found throughout much of the Old World by 250,000 years ago. It preferred areas where grass was abundant but with forests and swamps close by, not the open plains of steppes and savannas. The aurochs was hunted by humans long before it was domesticated, and it was memorialized by hunter-gatherers in cave paintings in widely divergent sites, including the most famous "Chamber of the Bulls" at the caves at Lascaux, France, which was painted 170,000 years ago.

Historically, archaeologists believed that all domestication of cattle took place in the Fertile Crescent, an area of the Middle East that includes parts of Egypt, Israel, Jordan, Syria, Iraq, Iran, and Turkey. But scientists using DNA analysis are now quite sure that there were at least two distinct

Cattle breeds that developed in India and Asia are members of the *Bos indicus* subspecies, which is known for its drooping ears and humpy back, as seen in this Brahman cow.

ZEBU BREEDS

Although there are around 30 known Zebu breeds, the three most common and important in their native land are the Gir, the Nelore, and the Guzerat. These, and the less common Krishna Valley breed, are also the primary breeds that have been imported to North America.

The first import of Zebu to the United States took place in 1849, when Dr. J. B. Davis of South Carolina, who also imported the first Angora goats, bought a bull and a cow from London's Royal Gardens. Through the remainder of the nineteenth century, and during the early years of the twentieth, there were a number of additional importations. Most of these importations involved small numbers of animals, but one in

There are more than 30 breeds of *Bos indicus* cattle in India and dozens more in Africa. All pure *Bos indicus* are generally classified as Zebu.

1906 added 30 Zebu bulls and 3 cows to the U.S. herd. The crossbred progeny of these early imports multiplied, and by the 1920s there were large numbers of animals throughout the South with Zebu bloodlines. Additional imports arrived in the 1940s, 1970s, and 1980s.

The only African breed to have any significant influence in North America is the Afrikander, which was imported to the famous King Ranch of Texas in 1931 and was used in the development of the Barzona breed.

The sweat glands of the Zebu are larger and more numerous than those of their nonhumped counterparts, particularly in the hump area, which allows them to sweat more efficiently, a very advantageous adaptation for very hot climates. In general, Zebu reach reproductive maturity more slowly than the *Bos taurus* cattle, but they also tend to remain productive for several years longer.

The humps come in two basic types, the thoracic hump, which is located directly over the withers, and the cervico-thoracic hump, which is located on the back of the neck and is less prominent and less fatty than the thoracic hump. The thoracic hump is common in the Indian cattle of *Bos Indicus,* while the cervico-thoracic hump, which is considered a genetic intermediary that results from the breeding of nonhumped *Bos taurus* breeds with thoracic-humped breeds, is common in the African Sanga.

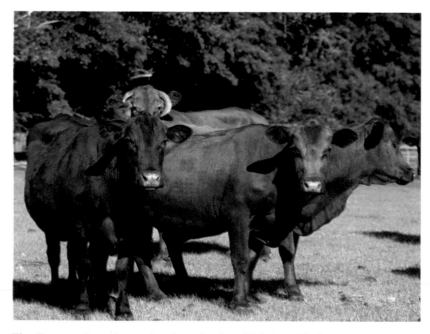

The Barzona breed was developed using Afrikander bulls on Hereford cows, with additions of Angus and Shorthorn bloodlines.

domestications, one in the Fertile Crescent and one farther to the east in modern Pakistan and India. The *Bos taurus* originated from *Bos primigenius primigenius* in the Fertile Crescent, while the *Bos indicus* emanated from a separate subspecies, *Bos primigenius nomadicus*, in modern Pakistan and India. There is also evidence, though not as strong as that for the other two centers of domestication, that a third domestication center existed in Africa, and that the African domestication gave way to a similar-yet-unique strain of *Bos taurus*–type cattle from yet a third subspecies of aurochsen, *Bos primigenius opisthonomus*.

Zebu is a general term applied to the *Bos indicus* breeds of cattle that originated in India. Some people speculate that the word *zebu* came from the Portuguese word for hump, *gebu*, while others think it originated with a Tibetan word, *zeba*, which means "hump of the camel." Either way, it is a widely used term to indicate any of the 30-plus humped breeds originating in India and Pakistan. The Zebus have a fairly pendulous dewlap under their throat and floppy ears. They also have sebaceous glands under the skin, from which they secrete an oily substance that smells unpleasant but is thought to offer them some protection against insects.

As well as being known as Zebus, some of the humped cattle that developed in Africa are also known by the name Sanga, though that name is less common in North America. These cattle may have developed from a cross of the Fertile Crescent *Bos taurus* with the Pakistani/Indian *Bos indicus*, or if a domestication did take place in Africa, as a cross between the African *Bos taurus* and the Pakistani/Indian *Bos indicus*.

THE KING RANCH

In the world of cattle, few ranches enjoy the recognition of the King Ranch. For well over a century, it has been one of the most prominent ranches in North America.

As a boy in the mid-1830s, 11-year-old Richard King was indentured to a New York City jeweler. Times were hard, and the jeweler was a cruel man, so King escaped his servitude by stowing away on a ship. He took to shipping and became a riverboat captain plying southern rivers.

By the middle of the nineteenth century, King's river boating had made him a reasonably wealthy man, so he decided to acquire land along the Texas coast for a ranch. In a turbulent, violent time of transition, King and a partner, Texas Ranger Gideon K. Lewis, acquired a Spanish land grant known as Rincon de Santa Gertrudis in the Wild Horse Desert, a 15,500-acre parcel located about 35 miles southwest of Corpus Christi. King took breeding seriously and began using the best scientific knowledge of the day to breed up animals on the ranch. The King Ranch is still operating today on more than 800,000 acres and has influenced many of the breeds that follow.

New Breeds from Old

NEW BREEDS can be developed by breeding different existing breeds together. There are two terms used to describe these new breeds: composite and synthetic. Although these terms are sometimes used interchangeably, some sources note a distinction between the two. In the nuanced version, composites are developed by crossing two known breeds in order to fill an environmental or market niche while maintaining hybrid vigor (through the frequent addition of bloodlines from members of the parent breeds). Synthetics are developed to fill an environmental or market niche, but without the intention of retaining hybrid vigor (once the breed is established, infusions of new bloodlines from parent breeds are rare or nonexistent). There are dozens of well-established composite and synthetic breeds, and many new ones have been developed just since the 1980s. Some are fairly common and readily available, such as the Brahman-Angus cross, the Brangus, while others are uncommon or found in limited geographic areas.

"Probably the two greatest benefits that we talk about relative to composite or synthetic breeds of cattle are, first, that it's possible to make something that is optimal for a certain environmental or marketing situation, and the second advantage, and this is a very significant one, is that you gain hybrid vigor, which is so important for commercially vital characteristics for beef cattle," says John Winder, associate dean and associate director of the Washington State Extension. "This is particularly true for reproductive characteristics and other traits that are hard to improve through traditional selection."

In other words, on average, composites and synthetics outperform their parent-breed peers, thanks to the combination of valuable traits for a given situation and hybrid vigor. For example, Brahman synthetics generally perform far better in hot and humid climates than their Continental and English counterparts, while finishing with a better carcass and better meat quality than purebred Brahmans.

The benefits can last for generations. "As you increase the number of breeds in a composite you increase the amount of hybrid vigor that's retained, and in theory it is retained forever, as long as there isn't another force that negates those benefits, such as

Top: A Brangus is a composite breed, thus additions of new blood from registered Brahman and Angus cattle may be infused from time to time.

Bottom: The Santa Gertrudis is a synthetic breed, so all animals registered today as full-blood Santa Gertrudis come from the original foundation stock bred at the King Ranch in Texas.

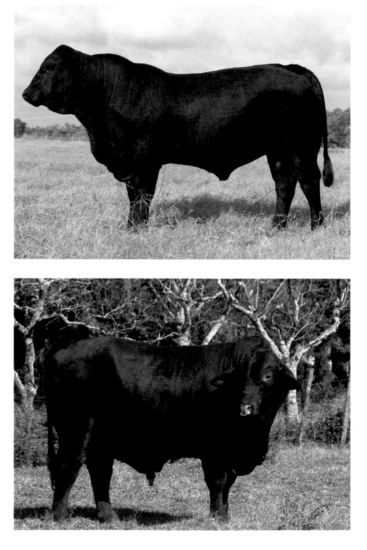

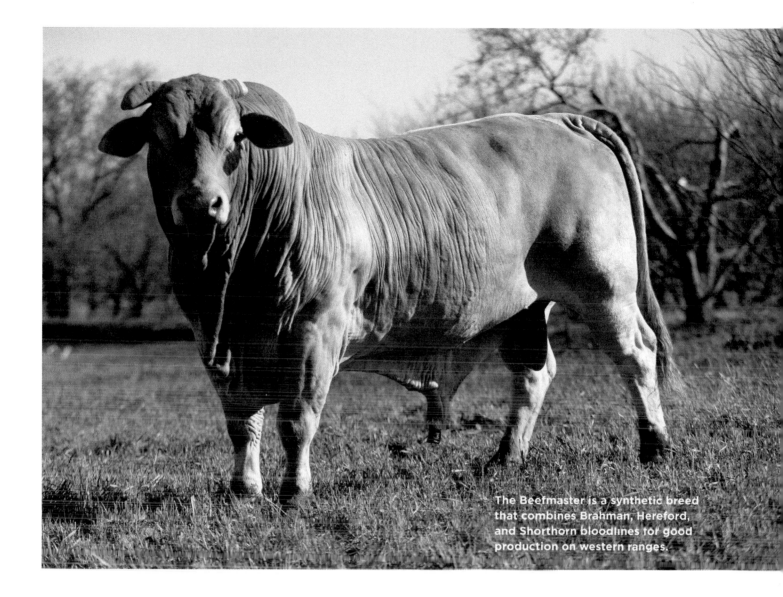

The Beefmaster is a synthetic breed that combines Brahman, Hereford, and Shorthorn bloodlines for good production on western ranges.

COMPOSITE AND SYNTHETIC BREEDS ROUNDUP

AMERICAN
Brahman/bison/
Charolais/Hereford/
Shorthorn

BRAHMAINE
Brahman/Maine-Anjou

BRAHMANSTEIN
Brahman/Holstein

BRAHMOUSIN
Brahman/Limousin

BRALERS
Brahman/Salers

BRANGUS
Brahman/Angus

CANADIAN SPECKLE
PARK
Angus/Shorthorn/
White Park

CHARBRAY
Charolais/Brahman

CHIANGUS
Chianina/Angus

CHIFORD
Chianina/Hereford

CHIMAINE
Chianina/Maine-Anjou

DROUGHTMASTER
Angus/Shorthorn

GELBRAY
Gelbvieh/Red Angus/
Brahman

LUING
Shorthorn/Highland

PINZBRAH
Pinzgauer/Brahman

RX3
Hereford/Red and White
Holstein/Red Angus

SALORN
Salers/Texas Longhorn

SANTA CRUZ
Santa Gertrudis/Red
Angus/Gelbvieh

SANTA GERTRUDIS
Shorthorn/Brahman

SENEPOL
African N'Dama/Red Poll

SIMBRAHS
Simmental/Brahman

TEXON
Texas Longhorn/Devon

BISON

About 2.4 million years ago, an ice bridge formed between Alaska and Russia, providing a path for many Eurasian animals (and humans) to migrate to North America. Some of the immigrants that passed over the ice bridge about 400,000 years ago were the ancestors of the American Bison.

Although bison are the largest native land mammal in North America (bulls stand 6 feet [1.83 m] tall at the shoulders and weigh up to a ton), ancestral bison were more than twice as large as those we know today and had considerably larger and straighter horns. Over the millennia they evolved into the two distinct subspecies found in North America today, the Wood Bison (*Bison bison athabascae*), which traditionally inhabited parts of Canada, and the Plains Bison (*Bison bison bison,* also incorrectly referred to as the buffalo) that populated most of North America when Europeans first arrived.

Like birds, bison herds migrated northward in the spring and southward in the fall. Their migration and feeding patterns were integrally entwined with the formation and maintenance of the great grasslands of the North American plains.

The stories of bison on the plains of North America are famous: Estimates of the plains' herd size in the mid-1800s range from 30 million head to as high as 80 million head. For Native Americans, the bison played both a utilitarian role (they were hunted and their meat, bones, hides, and horns used to support the tribes) and a cultural role in tribal members' religious and spiritual lives.

When Euro-Americans began their westward expansion in the middle of the nineteenth century they encountered these vast herds of bison, but then they nearly wiped out the species. As the nineteenth century gave way to the twentieth, there were fewer than 1,500 animals left in North America. A herd of about 50 was living in Yellowstone National Park; some were held in five private herds around the United States; and some were in small groups of free-roaming animals in the United States and Canada.

A handful of individuals helped keep the animals from extinction, including President Grover Cleveland, who signed into law the 1894 Yellowstone Wildlife Protection Act, which made it illegal to shoot wildlife within the park, and William Hornaday, who was the chief taxidermist of the Smithsonian Institution in the late 1800s and the first director of the National Zoo. Hornaday included bison as some of the first residents of the National Zoo, and in 1889 he wrote the book *The Extermination of the American Bison,* which helped sway public opinion.

The head, shoulder, shoulder hump, and forelegs of bison are covered with brownish black, woolly hair. The rest of the body is covered with brown, short hair. They have massive heads, sport a shaggy mane and beard that is more prominent on bulls, and both sexes have horns. The cows are considerably smaller than bulls, with a large cow reaching 5 feet (1.5 m) at the withers and weighing less than 1,000 pounds (454 kg).

A symbol of the American West, bison have made a comeback from the brink of extinction and are once again routinely seen on western ranges.

Bison are herd animals. In natural settings the bulls will separate out into bachelor groups during the fall, then return to the herd during the rut, or mating season, which typically starts in July and runs through September. During the rut, fighting among bulls is intense.

Calves are cinnamon-brown colored when born, usually in May and June after a 270- to 285-day gestation. They are less than 50 pounds (23 kg) at birth, but within three hours of birth they can travel with their mothers and outrun a coyote. Bison paw and roll to make depressions in the grasslands. These depressions, known as wallows, are used by bison for dusting to alleviate the irritations of biting insects. Other than humans, the only predators of bison are grizzly bears and wolves.

Bison are phenomenal athletes. They can run 35 miles per hour and jump six-foot-tall fences without much trouble. They are known for brutish strength that enables them to easily take down fences made to control other livestock. They can be dangerous for those trying to handle them, though some owners of small bison herds have tamed them down like cattle.

In spite of the potential drawbacks of dealing with an animal that is still close to being wild, there are now more than 4,000 ranchers raising bison. They are marketing bison meat as a heart-healthy red meat that's low in cholesterol and fat (though this could change as more producers use corn-fattening and feedlot-type approaches to raising bison) and tastes similar to beef but with a slightly richer flavor. Bison have also been used in crossbreeding with cattle. The American and Beefalo breeds both have bison bloodlines.

inbreeding," Winder says. "In fact, inbreeding causes the exact opposite of hybrid vigor, reducing the vigor of offspring."

So, some of the older and more common composites and synthetics may have lost the extra boost that hybrid vigor yields due to linebreeding within the bloodlines of the breed. Yet those breeds still benefit from the combination of traits that suit a specific environmental or market niche.

One downside for newer composites and synthetics is that all but the oldest and best-established composites and synthetics (which were developed in the first half of the twentieth century) have a hard time getting a toehold in the marketplace. "Some of these will become part of the fabric of the cattle industry, but most others will have limited impact, and some may simply disappear," Winder says. "It's a tough market for someone to break in to with a new breed. When Brangus, Santa Gertrudis, and Beefmaster synthetics were developed, there weren't as many options available for cattlemen. Today, there are numerous breeds, so the market is much more competitive. However, there may be some real potential for breeds that are developed for specific situations that need something else, such as the ability to navigate tough terrain or function in hot/humid or hot/arid climates. In order for a new composite to be sustainable you need to either have a lot of breeders involved, or at the very least, a single large herd, and that is missing for many of these newer composites."

Form and Function

THE FUNCTIONAL TYPES for cattle are beef, dairy, and dual-purpose (beef/dairy, beef/draft, or dairy/draft). However, most dual-purpose animals have been used for beef production in the past few decades and are therefore losing some of their dual-purpose traits.

BEEF CATTLE

Beef animals can be characterized by frame size as large-, medium-, or small-framed animals. Large-frame steers and heifers would be expected to reach U.S. choice carcass grade (about 0.5 inches [1.25 cm] of fat at the 12th rib) at a weight heavier than 1,250 pounds (565 kg) for steers and 1,150 pounds (520 kg) for heifers. Medium-frame animals would be expected to meet choice grade at 1,100 to 1,250 pounds (500 to 565 kg) for steers and 1,000 to 1,150 pounds (455 to 520 kg) for heifers. Small-frame cattle would do so at weights of less than 1,100 pounds (500 kg) for steers and 1,000 pounds (455 kg) for heifers.

Some beef breeds show a genetic trait known as double muscling, or muscular hypertrophy. Double-muscled animals look like a bodybuilder who overdosed on steroids. The double-muscling phenomenon is essentially caused by a naturally occurring mutation on the myostatin gene sequence, which controls the release of myostatin, a growth factor that regulates the size of muscles in most vertebrates. Typically the more myostatin, the less well developed the muscles. In double-muscled cattle, part of the gene sequence that controls myostatin is missing or changed, so the body produces little or no myostatin. As an inherited condition, double muscling occasionally can be found in many breeds of cattle, but the highest frequency of it is found in the Belgian Blue and Piedmontese breeds. Breeders of these breeds have selected for the condition for several decades.

Double muscling has both benefits and challenges. The benefits include higher meat yield, a higher proportion of expensive cuts of meat, and lean yet very tender meat. These superior meat and carcass traits were responsible for widespread selection for double muscling in some of the European breeds, where premium prices are paid for double-muscled carcasses. Some of the problems include lower fertility, dystocia (difficult births), and reduced calf survival.

The Belgian Blue is a beef breed known for double muscling, a trait that is associated with a mutation on the myostatin gene.

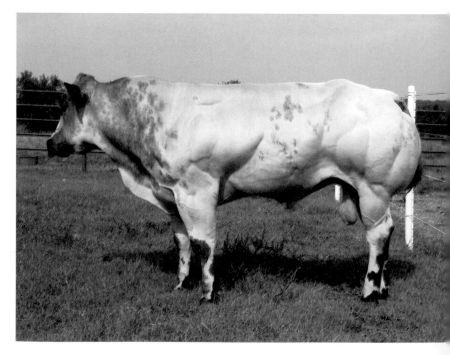

DAIRY CATTLE

Modern dairy cows have been bred to do one thing exceptionally well, and that's make milk. A top-producing Holstein can give more than 60,000 pounds (27,200 kg) of milk in a year, or well over 25 gallons of milk per day during her lactation. A lactation typically runs 10 months, with a two-month break before the cow calves again. Her udder is a remarkable organ to behold, often at the size of a large washtub. Even the average Holstein is producing more than 26,000 pounds (11,800 kg) of milk per lactation.

Generally, when a dairy farmer sells milk to a processor he is paid for volume as well as for the amount of fat and protein in the milk. A farmer who is strictly going for pounds of production milks only Holsteins, which produce the most milk by a wide margin, and that has led to the breed's absolute dominance in the dairy industry. But some of the other dairy breeds, such as Brown Swiss, Guernseys, Jerseys, and Milking Shorthorns, produce more butterfat and protein and tend to perform better on pasture. Thanks to recent developments like the artisan cheese movement, where butterfat and protein content are more important than quantity, and the consumer demand for milk and meat produced on grass, some small farmers are starting to renew their interest in these breeds.

Dairy cows today have a very different body type than their beef counterparts, and dairymen typically refer to it as the "feminine type." A dairy cow's body is longer, leaner, and more angular than a beef cow's body, with a more fine-boned appearance and a slight slope from the withers to the rump. The rump is wide between the pins (hip bones) and the udder is well attached to the frame at the base of the rump. The udder (also known as "the bag") is also very large yet well proportioned (almost boxy), with the four teats (each about 2 inches long) evenly spaced and centered on either side of the center line of the bag.

DRAFT CATTLE

Most Americans gave up on draft animals when tractors became readily available, but cattle have served humans for thousands of years as working oxen, and they still do in many less developed areas of the world. Although oxen aren't used in North America out of necessity, there are still folks who love training and working with oxen for hobby purposes, or for educational purposes at historic parks.

Oxen are most often castrated males (steers) that have reached the age of four; younger animals are called "working steers." In developing countries, cows and bulls are sometimes used for draft, but almost never in North America. The most common breeds of choice for oxen are among the small- to medium-size animals, such as Ayrshire, Brown Swiss, Devon, Dutch Belted, Hereford, Jersey, and Shorthorn, though some drovers (the people who work with oxen) prefer larger breeds, such as Charolais and Holstein.

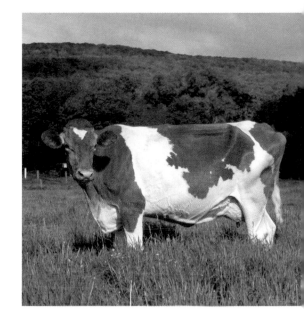

Dairy cattle, like this lovely Guernsey, have more feminine lines than their beef counterparts.

Shorthorn cattle have a long tradition of being used as draft animals.

American

NEW MEXICO RANCHER Art Jones developed this breed beginning in the 1950s after an extended drought in an already arid region seriously reduced his purebred Hereford herd. The first bloodlines he crossed in were British and Continental breeds (Shorthorn and Charolais), but they lacked the hardiness and heat tolerance he was looking for, so he added Brahman and bison (page 48), which he noticed had weathered the drought well on scrub and poor feed. The breed he developed ended up with a mix of ½ Brahman, ⅛ bison, ¼ Charolais, ⅟₁₆ Hereford, and ⅟₁₆ Shorthorn. In the early 1970s, Jones began working with Dr. Jerry Caldwell, then of Texas A&M University. Caldwell tested the blood of the entire foundation herd to confirm that the genetic marker for bison was present, and to this day, all American cattle must show their bison heritage when tested for the genetic marker. The breed association formed in 1971.

The American is known as a gentle and easy-calving breed that yields low-cholesterol, low-fat meat. As Norm Burcham, an extension livestock specialist at New Mexico State University, says, "These were really bred to be a desert-type breed." They are primarily found on ranches in New Mexico, Arizona, Texas, and Oklahoma, though there are also a few breeders in Illinois and Idaho, as well as in the countries of Poland and New Zealand.

AMERICAN

FUNCTIONAL TYPE Beef.

APPEARANCE Color varies; often shows spots or patches of color. Floppy ears and humpiness in the shoulder area.

SIZE Medium to large.

HORNS Naturally horned.

CONSERVATION STATUS Not applicable.

PLACE OF ORIGIN New Mexico.

BEST KNOWN FOR Drought tolerance.

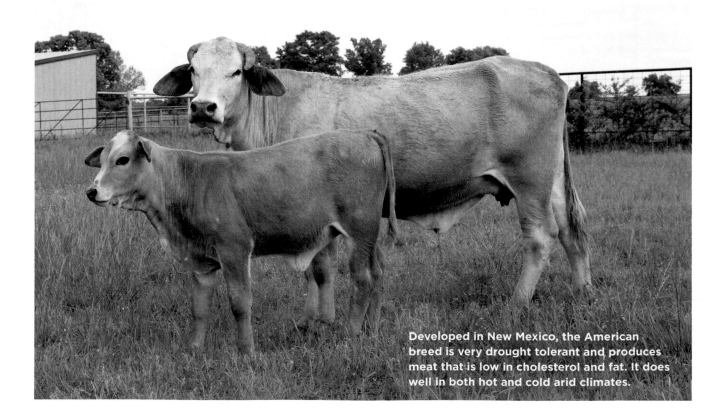

Developed in New Mexico, the American breed is very drought tolerant and produces meat that is low in cholesterol and fat. It does well in both hot and cold arid climates.

American-British White Park

THERE ARE TWO distinct breeds with White Park in their name: the American-British White Park and the Ancient White Park. Both are of British origin and are thought to have developed from primitive genetic lines of cattle that have been documented in Great Britain since the Romans invaded the British Isles centuries before the birth of Christ.

Both breeds share similar coloring of white with black or red points, though the American is naturally polled and the Ancient has impressive horns. British aristocracy historically kept both breeds within their large, enclosed estates, which are also known as parks. When, in 1918, the British first formed a breed society to help preserve park cattle, it registered both the polled and the horned types. The two are distinct breeds, however, as was recently confirmed by DNA testing, and since 1946 the breed registries have been split. The polled variety was given the name British White, which is the breed's name in Britain. On this side of the Atlantic, it is now called the American-British White Park. Exactly when the British White made its way to North America is not certain. Most sources refer to an importation made during the years leading up to World War II, but after doing extensive research with archivists in Toronto, at the Bronx Zoo, and at the King Ranch, I was able to determine that those

(continued)

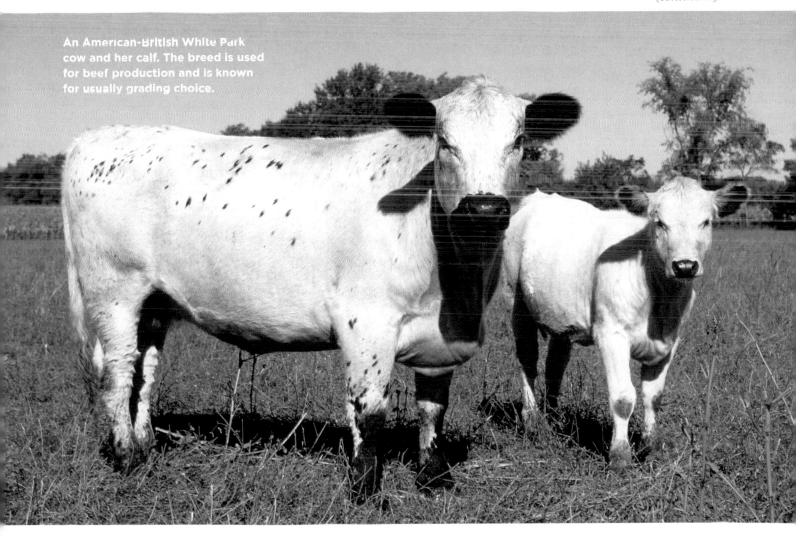

An American-British White Park cow and her calf. The breed is used for beef production and is known for usually grading choice.

American-British White Park (continued)

animals were the horned Ancient White Parks. Somewhere along the line, however, someone did import some British Whites and crossbred them with breeds such as Angus and Shorthorn to give us the American-British White Park (thus the American-British White Park in the United States and the British White in the UK are not quite the same breed today). The foundation for the American-British White Park comes from the genetics of a small herd of British Whites that the U. S. Department of Agriculture sold off in 1960.

The breed was traditionally maintained as a dual-purpose animal in Britain for both meat and milk, and it was known to be quite docile. Today the breed is recognized for producing carcasses that grade out at USDA Choice.

AMERICAN-BRITISH WHITE PARK

FUNCTIONAL TYPE Beef.

APPEARANCE Muscular. White with colored (mainly black, occasionally red) points on the ears, nose, and eyes.

SIZE Medium to large.

HORNS Predominantly polled; about 3 percent are born with horns.

CONSERVATION STATUS Not applicable.

PLACE OF ORIGIN Britain.

BEST KNOWN FOR Colored points. Production of choice cuts.

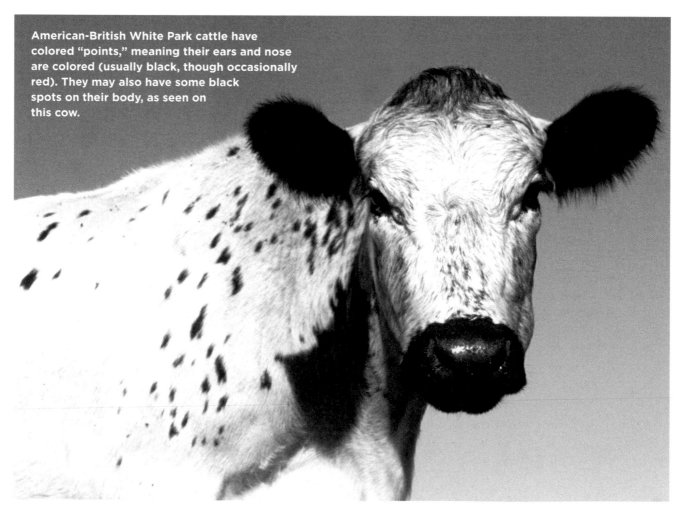

American-British White Park cattle have colored "points," meaning their ears and nose are colored (usually black, though occasionally red). They may also have some black spots on their body, as seen on this cow.

Amerifax

THE AMERIFAX ORIGINATED in the United States in the 1970s when a group of cattlemen in several states began experimenting with breeding Beef Friesian bulls to their Angus cows. These producers found that a genetic combination with ⅝ Angus and ⅜ Beef Friesian blood seemed to work well for their needs. They formed a breed society in 1977.

Although primarily black, animals are occasionally red due to a recessive gene, and those animals are eligible for registration. Breeders say that the Amerifax retains the best traits of the Angus, but thanks to the infusion of Friesian blood, the breed has even stronger milk production. Calves are lightweight at birth but grow quickly, so they still have competitive weaning weights. In fact, in a study performed at California Polytechnic State University's Animal Science Department, Amerifax-sired heifers had a 41 pound (18.6 kg) weight advantage at weaning. The Amerifax is popular with Argentina's grass-based producers, who are among world leaders in grassfed beef production, making them a breed worth considering by farmers interested in producing grassfed beef.

AMERIFAX

FUNCTIONAL TYPE Beef.
APPEARANCE Angus-type color (black or red) and conformation.
SIZE Medium to large.
HORNS Naturally polled.
CONSERVATION STATUS Not applicable.
PLACE OF ORIGIN United States.
BEST KNOWN FOR Quick growth.

BEEF FRIESIAN

The "Beef Friesian" bloodlines used for developing the Amerifax were imported from Ireland in 1971. The Friesian is a Dutch breed that provided the foundation for the Holstein breed, but the strain imported in 1971 had been selected from the original dual-purpose Friesians for beef traits. As a beef breed, the Friesian didn't really take off on this side of the Atlantic and was apparently lost to crossbreeding, but its legacy is retained in the Amerifax.

Amerifax cattle resemble the Angus breed, from which they were bred, and thanks to the infusion of Friesen blood, calves grow a bit more quickly. The Amerifax is a gentle breed with good maternal traits.

Ancient White Park

FOR CENTURIES after the Romans left Britain, the forebears of the Ancient White Park cattle were feral beasts that were used sacrificially as offerings to the gods by the Celtic priests of Ireland. Beginning in the thirteenth century, British royalty and the wealthiest members of society began gathering these animals in enclosures, or "parks," yet these great-horned cattle remained more feral than domesticated well into the 1800s.

In fact, during the eighteenth and early nineteenth centuries, owners of the Ancient White Park kept them not for milk, beef production, or draft but for hunting, and they claimed that their animals were wild — the

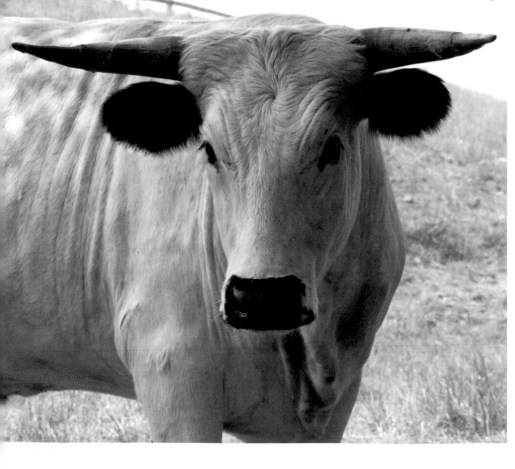

direct descendants of aurochs that once roamed the British Isles. Modern science has proved them wrong: the Ancient White Park is not a direct descendant of the small subspecies of aurochs found in Britain but is a descendant of the *Bos taurus* cattle first domesticated in the Fertile Crescent thousands of years earlier.

Although there may have been a few imports in the early twentieth century, the first confirmed import came on the cusp of World War II. The British feared they would lose the bloodlines of these historic beasts, so they sent one bull and one cow from the herd at Chillinham and one bull and one cow from the herd at Cadzow to the zoo in Toronto to assure their survival. In 1941, the Toronto Zoo sold them to the Bronx Zoo, which was having a special exhibition of farm animals. At the end of the exhibition, the Bronx Zoo sold these four animals to the King Ranch in Texas.

The King Ranch maintained a small herd of purebred Ancient White Park cattle until the early 1980s, when they were sold to the Moeckly family of Polk City, Iowa. The Moecklys imported a bull, Cadzow Ernest, from Scotland in 1985, and possibly semen from the Dynevor herd in southwest England. In the late 1980s, the Moeckly family sold their herd to the Seed Savers Exchange in Decorah, Iowa, and the B-Bar Ranch in Big Timber, Montana.

The Ancient White Park has a phenomenally interesting history dating back to before the birth of Christ, when the Romans invaded Britain.

Seed Savers, the B-Bar, and the American Livestock Breeds Conservancy are working on increasing numbers of Ancient White Park cattle. The B-Bar has found that the breed, which is critically rare, does very well as a grass-finished animal, producing choice carcasses with very fine-grained meat, similar to Hereford beef. The Ancient White Park does not marble like more modern breeds, even when grain finished, but it develops a richer flavor than most of the beef available in supermarkets.

ANCIENT WHITE PARK

FUNCTIONAL TYPE Beef.
APPEARANCE White with black or red points on ears, eyes, nose, teats, and feet.
SIZE Large.
HORNS Large, lyre-shaped horns.
CONSERVATION STATUS Critical.
PLACE OF ORIGIN Britain.
BEST KNOWN FOR Unique looks. High-quality meat. Hardiness.

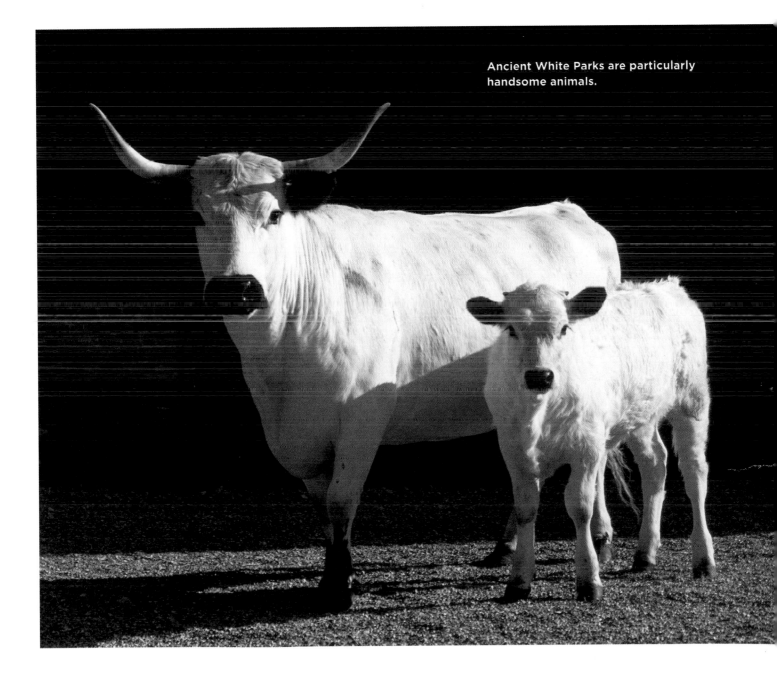

Ancient White Parks are particularly handsome animals.

Angus

THE FIRST ANGUS are thought to have been imported to North America from their native Scotland in 1873, and since that time they have come to dominate beef production. The American Angus Association records more cattle each year than any other registry in the world, and some experts estimate that 60 percent of the beef cattle raised in North America have Angus blood.

In Scotland, the breed was developed in the latter half of the eighteenth century from the naturally polled cattle that had been found in the Aberdeen and Angus regions for centuries. Originally, Angus were a very short-legged, stocky breed, but in the past 40 to 50 years breeders have selected for more height and somewhat leaner lines than the old Angus.

Most Angus are black, but they do have a recessive red gene. Blacks are registered with the American Angus Association, while reds have been registered in a separate herdbook managed by the Red Angus Association of America since 1954 (so they are treated as a separate breed for registration). Both share many of the same traits, including a docile disposition.

We used Angus bulls for crossbreeding our dairy heifers and can attest that they deserve their reputation for easy calving. Although the calves are relatively small at birth, they make up for this with quick growth. For example, in research conducted at the Meat Animal Research Center, a cooperative effort between the USDA and the University of Nebraska, Angus and Red Angus calves had the lowest birth weights but had the highest number of calves to survive to weaning and the highest 400-day weights. They are also known for producing a high percentage of prime meat.

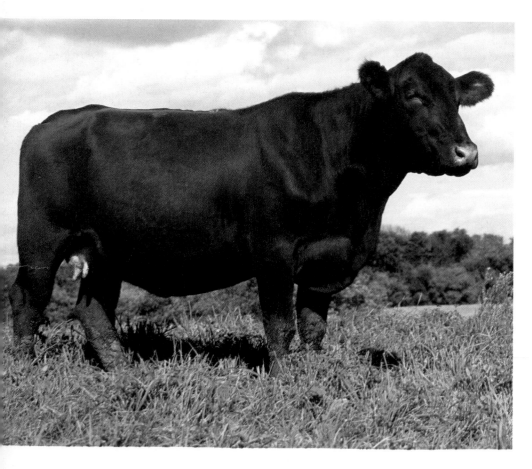

ANGUS

FUNCTIONAL TYPE Beef.
APPEARANCE Black or red.
SIZE Medium to large.
HORNS Naturally polled.
CONSERVATION STATUS
Not applicable.
PLACE OF ORIGIN Scotland.
BEST KNOWN FOR Easy calving, quick growth. High-quality, well-marbled meat.

Although less common than their black counterparts, Red Angus have the traits that the breed is known for, including easy calving, fast-growing calves, and a docile temperament.

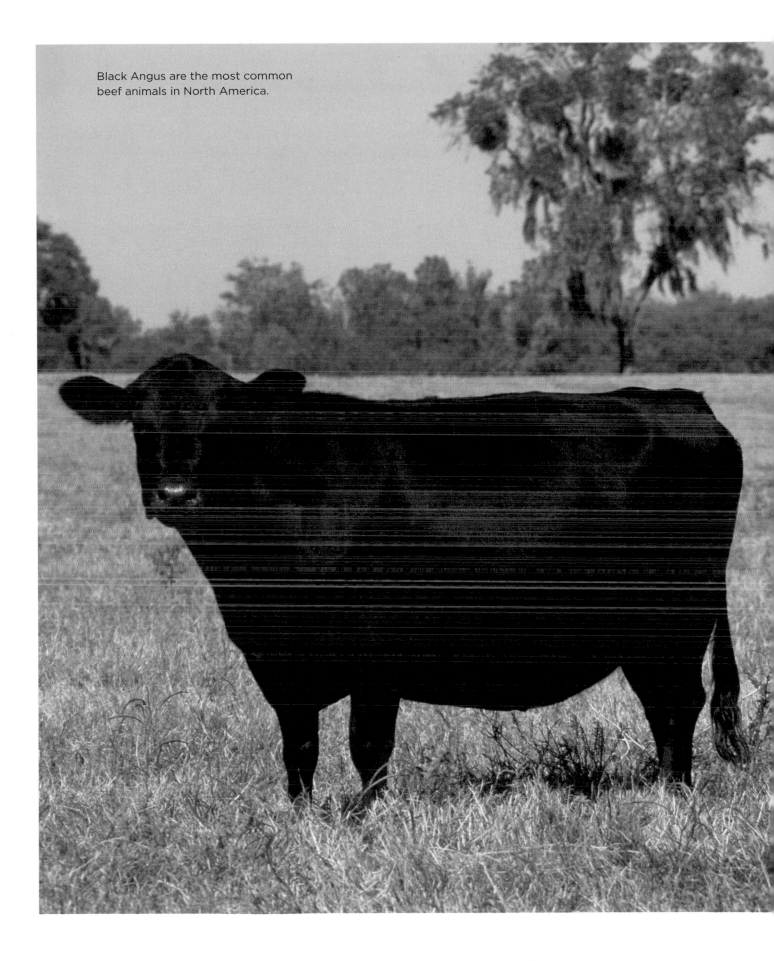

Black Angus are the most common beef animals in North America.

Ankole-Watusi

IF YOU ARE LOOKING for a really impressive set of horns, the Ankole-Watusi is definitely for you! The first time I saw the breed was at the Colorado State Fair, and I remember wondering how this medium-size animal could hold up its very long, large-diameter horns. But the horns didn't seem to cause it any problems.

The breed, which originated about six thousand years ago in the Nile Valley of Africa, was known as the Egyptian Longhorn, and its likeness appears in pictographs in the pyramids of Egypt. It can be a solid color or spotted. Horns are symmetrical, with a large base diameter and proportional length. Lyre (U-shaped) and circular shapes are preferable to flat. At birth, calves weigh just 30 to 50 pounds (14 to 23 kg), so calving problems are rare. The cows' milk has a high concentration of fat (about 10 percent), so some dairy farmers are using the breed for crossbreeding to boost butterfat levels. Because the breed was developed in a climate where daily temperatures may range from 20 to 120°F (-6.5 to 49°C), the Ankole-Watusi tolerates temperature and weather extremes well.

In January 1983, North Americans interested in the breed formed the Ankole-Watusi International Registry. Some producers wanted to concentrate solely on helping to preserve the breed from extinction; others raised them for meat, recognizing the market potential for their low-fat and low-cholesterol meat; still others focused on their use in raising crossbred "roping" stock for the rodeo circuit. DNA analysis is required for registration.

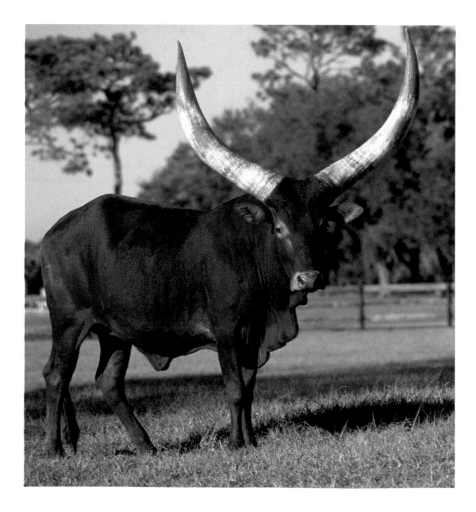

ANKOLE-WATUSI

FUNCTIONAL TYPE Beef.
APPEARANCE Varied colors and patterns.
SIZE Medium to large.
HORNS Large, symmetrical.
CONSERVATION STATUS Recovering.
PLACE OF ORIGIN Africa.
BEST KNOWN FOR Giant horns. Easy calving, quick growth. High-quality, low-fat meat.

The Watusi is highly adaptable to a variety of climates. It has very rich milk and lean meat.

The Ankole-Watusi, sometimes simply called the Watusi, is easily distinguished by its giant horns.

Aubrac

THE AUBRAC (pronounced oh-brock) breed was developed by Benedictine monks in the Massif Central, an area of mountains and high plateaus in south-central France, during the seventeenth century. It is named after the town of Aubrac. Traditionally the cattle were kept at the lower elevations of the Massif (desertlike plateaus) during the winter and taken to the high mountains in the summer for grazing on the grasses that grow in the rich, peaty soil.

Each year, the trip to summer pasture was (and still is) treated as a community holiday, called the Fête de la Transhumance. The cows are decorated with ribbons, flowers, bells, and giant flags and are paraded through the town before their journey to the mountains. In 1975, the breed was close to extinction because farmers had begun using higher-producing animals that depended on high inputs, but the French government supported efforts to bring it back from the brink. Today its numbers in France have rocketed back to more than 68,000 head. The Aubrac's milk, still produced from the grass of the mountain meadows, is used in cheese. Artisans use its horns to make Laguiole (pronounced la-yoll) knives.

Aubracs are a recent import to North America, brought here in 1995 by Eric Grant, Wayne Bollum, Scott Fredrickson, and Dennis and Jane Svoma, who considered them ideal for grass-based production. Breed importer Grant sees their foraging capability as a real advantage for the breed as we shift our sources of energy. "Since worldwide energy prices increased sharply, much of the world's grain production has been shifted away from livestock feed to ethanol manufacturing," he explains. "This has driven increased interest in Aubracs around the world as cattle producers have begun demanding bovine genetics that are forage efficient and not grain dependent."

Aubracs are adaptable to a variety of climates. The cows are long-lived and are known for easy calving. They produce lean but high-quality carcasses.

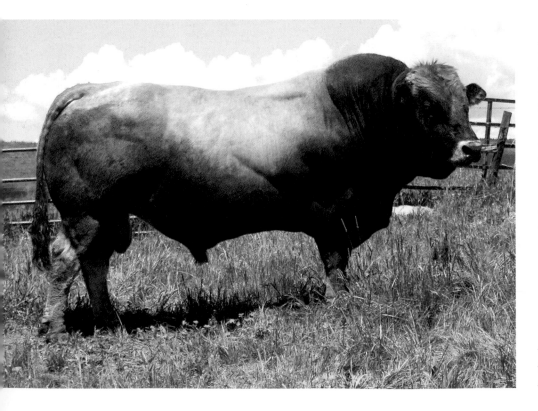

AUBRAC

FUNCTIONAL TYPE Beef.
APPEARANCE Light brown.
SIZE Medium to large.
HORNS Medium.
CONSERVATION STATUS
Not applicable.
PLACE OF ORIGIN France.
BEST KNOWN FOR
Good production of meat
on pasture.

The Aubrac has excellent genetics
for grass-based production of meat
and milk.

Ayrshire

AN OLD BREED of dairy cattle, the Ayrshire's lineage can be traced to the eighteenth century and to the County of Ayr, Scotland. The Highland Agricultural Society sponsored the first Ayrshire show in 1786. The breed is thought to have been imported to North America in 1822. It was well received by New England farmers because the breed performed admirably in the wet and cold climate and on the famously rocky New England pastures.

Although the breed's numbers have fallen dramatically in the past 50 years as most dairy farmers moved to using Holsteins, the trend seems to be stabilizing, or even turning around. The breed is again finding interest with dairy farmers who are moving to grass-based production systems, as it is still an excellent grazer. According to the USDA, the Ayrshires are producing 19,320 pounds (8,760 kg) of milk with 745 pounds (340 kg) of butterfat and 611 pounds (275 kg) of protein on average.

(continued)

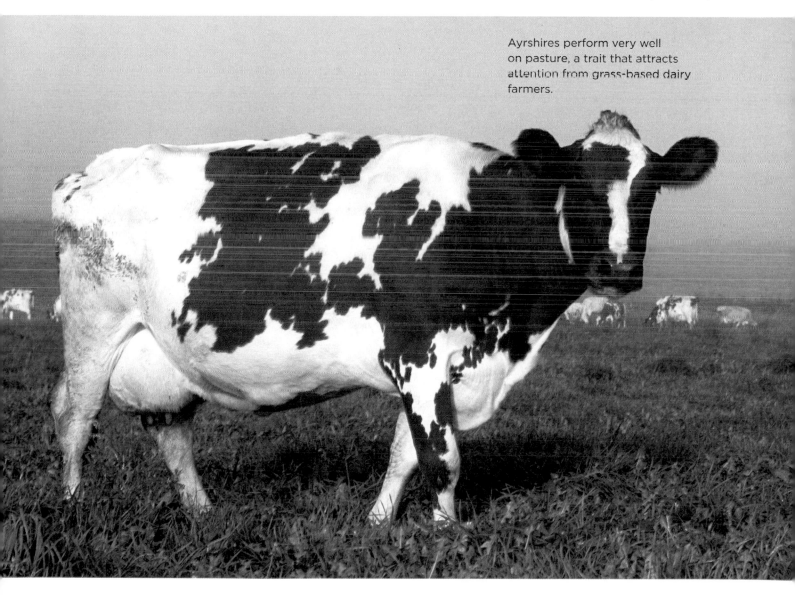

Ayrshires perform very well on pasture, a trait that attracts attention from grass-based dairy farmers.

Ayrshire (continued)

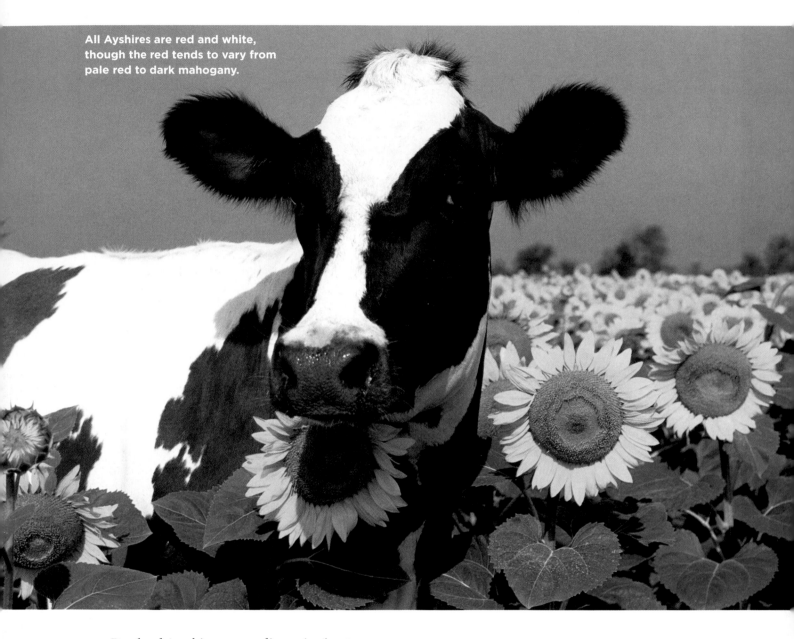

All Ayrshires are red and white, though the red tends to vary from pale red to dark mahogany.

Purebred Ayrshires are medium-size (mature cows weigh about 1,200 pounds [550 kg]. They only produce offspring with a mahogany-red and white coat, with markings varying from primarily red to primarily white (any combination in between is acceptable). The spotting is usually quite distinct, though an occasional brindle or roan-type pattern is possible. The breed is horned, though most producers dehorn calves shortly after birth.

AYRSHIRE

FUNCTIONAL TYPE Dairy.

APPEARANCE White with fawn to reddish brown spots. Feminine, pretty cows with a good dairy frame.

SIZE Medium.

HORNS Medium, lyre-shaped.

CONSERVATION STATUS Watch.

PLACE OF ORIGIN Scotland.

BEST KNOWN FOR Good milk production on grass.

Barzona

A COMPOSITE BREED, the Barzona was developed at the impetus of Arizona rancher Francis Norwood Bard in the 1940s. Bard hired Jack Humphrey to help him develop a new breed that would produce more pounds of beef in the extremely tough environment of the arid Southwest.

Humphrey wasn't just a hired hand, he was a self-taught geneticist and animal trainer of note. In the 1920s he had done pioneering breeding and training research with German shepherd seeing eye dogs at Fortunate Fields, a farm and research center in Switzerland, and the offspring of one of his shepherds went to Antarctica with Admiral Byrd. In the 1930s, he helped to establish one of the top lines of Arabian horses in the United States, and in 1972, he was awarded a Seedstock Producer of the Year award from the Beef Improvement Federation for his work in helping to develop the Barzona.

The Barzona was developed with bloodlines from the Afrikander, Angus, Hereford, and Shorthorn breeds. Although the Afrikander, an African breed, is not found in North America, it is well known for having very good feet and legs, excellent heat and tick resistance, a quiet temperament, and reasonably good fertility under some of the harshest conditions imaginable for raising cattle.

The Barzona is a medium-size beef animal with a somewhat longish head. It may be either horned or polled and is generally medium red, but color may vary from dark to light red, with occasional white on the underline or switch.

BARZONA

FUNCTIONAL TYPE Beef.

APPEARANCE Primarily shades of red; occasionally animals are white.

SIZE Medium.

HORNS Either horned or polled.

CONSERVATION STATUS Not applicable.

PLACE OF ORIGIN Arizona.

BEST KNOWN FOR Excellent heat and drought tolerance.

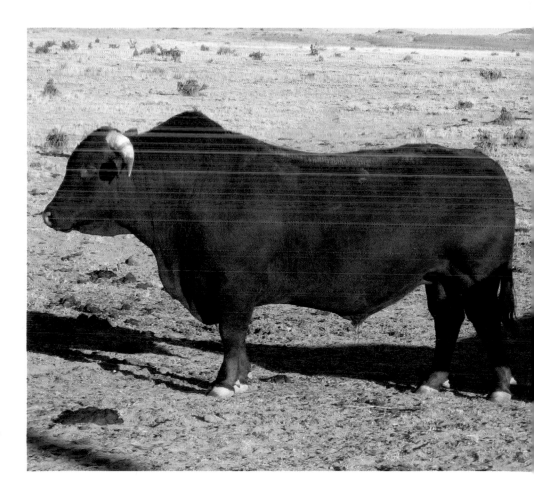

The Barzona is a synthetic breed that performs extremely well in very arid climates.

Beefalo

THE BEEFALO BREED is a hybrid cross between bison (see more about bison on page 48) and any breed of domestic cattle. The idea of crossing these two species isn't new. In 1866, famous Texas rancher Charles Goodnight gathered a herd of about 250 bison at the urging of his wife, Mary Ann, who wanted to help keep the species alive following the rampant killing of the great herds of bison that once roamed the plains. He experimented with crossbreeding them to his cattle, hoping to improve hardiness, heat tolerance, and other traits in his cattle herd.

Goodnight encountered problems. Calves were often stillborn in the first cross, cows would die during pregnancy or while trying to give birth to first-cross calves, and the few male calves that were born were sterile. Despite the challenges, farmers and ranchers kept trying the cross. In 1962, a Montana rancher named James Burnett had a fertile bull born to a Hereford/bison cross heifer. The bull, known as "Bur-nett #903," was ¼ Hereford, ¾ bison and became the foundation sire of the Beefalo breed.

Beefalo breeders can now be found throughout North America. Purebred Beefalo have ⅜ bison blood and ⅝ beef blood. They have many of the traits that Goodnight was interested in, but they are also known for extra-lean meat that is lower in cholesterol than beef, pork, or chicken.

BEEFALO

FUNCTIONAL TYPE Beef.
APPEARANCE Varies greatly depending on cattle used in cross program.
SIZE Medium to large.
HORNS Either horned or polled.
CONSERVATION STATUS Not applicable.
PLACE OF ORIGIN United States.
BEST KNOWN FOR Efficiency, hardiness. Extra-lean meat.

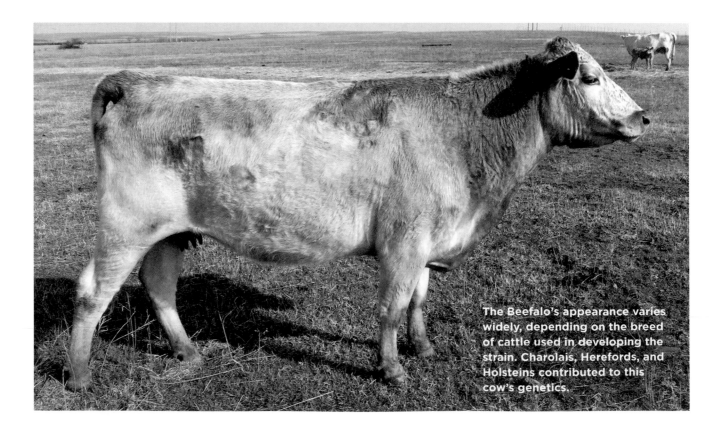

The Beefalo's appearance varies widely, depending on the breed of cattle used in developing the strain. Charolais, Herefords, and Holsteins contributed to this cow's genetics.

Beefmaster

A COMPOSITE BREED (approximately ¼ Hereford, ¼ Shorthorn, and ½ Brahman), the Beefmaster was developed in Texas, beginning in the early years of the twentieth century. In 1908, Ed Lasater acquired Brahman bulls to breed with his Hereford and Shorthorn herds of cattle on the Texas ranch he homesteaded with his father. These crosses would lead to the breed's formation.

When Lasater passed away in 1930, his son Tom took over the ranch. In 1931, Tom Lasater began crossing the Brahman/Hereford herd with the Brahman/Shorthorn herd to get a three-way cross that performed extremely well under the adverse conditions of the Texas range. The Lasater family moved to the plains of Colorado in 1949, bringing their foundation Beefmaster herd with them. Lasater's grandson, Dale, now runs the ranch and is a leader in the grass-fed beef movement, something for which the Beefmasters are well suited.

Beefmasters are usually brownish red, but other colors are acceptable, as the breed has no standards for traits that don't affect beef quality and productivity. Beefmaster breeders select for traits such as weight, conformation, disposition, fertility, hardiness, and milk production. Thanks to the infusion of Brahman blood, they tolerate extremes of heat and humidity and have good resistance to insects and parasites.

BEEFMASTER

FUNCTIONAL TYPE Beef.
APPEARANCE Generally red, though other colors are acceptable.
SIZE Medium.
HORNS Either horned or polled.
CONSERVATION STATUS Not applicable.
PLACE OF ORIGIN Texas.
BEST KNOWN FOR Good production on pasture. Hardiness. Gentleness.

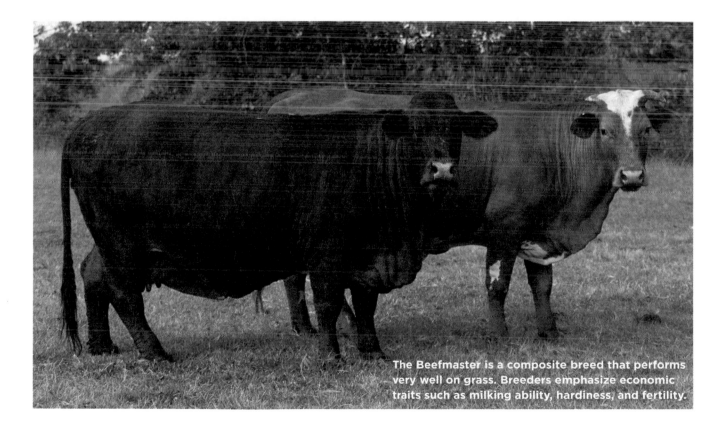

The **Beefmaster** is a composite breed that performs very well on grass. Breeders emphasize economic traits such as milking ability, hardiness, and fertility.

Belgian Blue

AS THE NAME IMPLIES, the Belgian Blue originated in Belgium, where it still accounts for almost half of that nation's cattle herd. It was developed during the second half of the nineteenth century by breeding the local red-pied and black-pied cattle with Shorthorns (some sources say Charolais were also crossed in during this period). The genetic combination resulted in interesting coloring. Animals can be solid white, solid black, or bluish roan, with many animals showing pied or spotted patterns.

The breed began as a dual-purpose dairy and meat breed, but during the 1960s breeders in Belgium began selecting for meat production, concentrating on muscle development and size. By 1974, the resulting beef animals were large and predominantly showed double muscling, a genetic mutation that brought benefits to farmers. Belgian Blue cattle yield 20 percent more meat per animal than most other breeds of cattle, and yet, thanks to their small-size muscle fibers, the meat remains tender and lean.

In tests performed by the USDA's Meat Animal Research Center in Clay Center, Nebraska, Belgian Blue crossbred cattle were tested for tenderness. They had a lower shear value than other breeds, comparable tenderness and flavor on taste tests, less than half the fat cover, 16 percent less marbling, and 14.2 percent more rib-eye area than the average carcass. These production stats are raising interest among commercial cattlemen who are thinking of using Belgian Blue bulls as terminal sires. Double muscling in purebred Belgian Blues does have one disadvantage. It results in a higher number of calving problems, so many breeders routinely use cesarean techniques for delivering calves. The breed has a relatively short gestation period of about 282 days, and calves are around 95 pounds (43 kg) at birth.

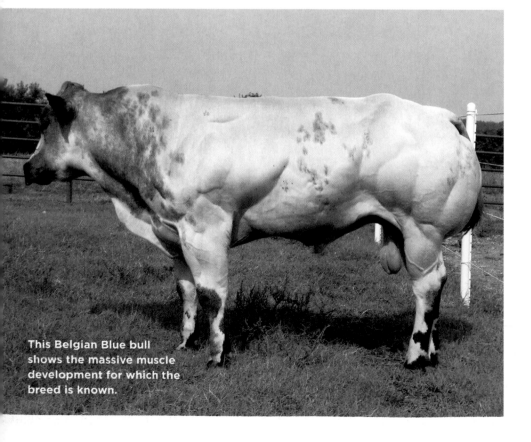

This Belgian Blue bull shows the massive muscle development for which the breed is known.

BELGIAN BLUE

FUNCTIONAL TYPE Beef.

APPEARANCE Stocky animals, like bodybuilders on steroids. In white, bluish roan, or black, with varied patterns.

SIZE Large.

HORNS Naturally horned.

CONSERVATION STATUS Not applicable.

PLACE OF ORIGIN Belgium.

BEST KNOWN FOR Very heavy double muscling for high meat production. Good disposition.

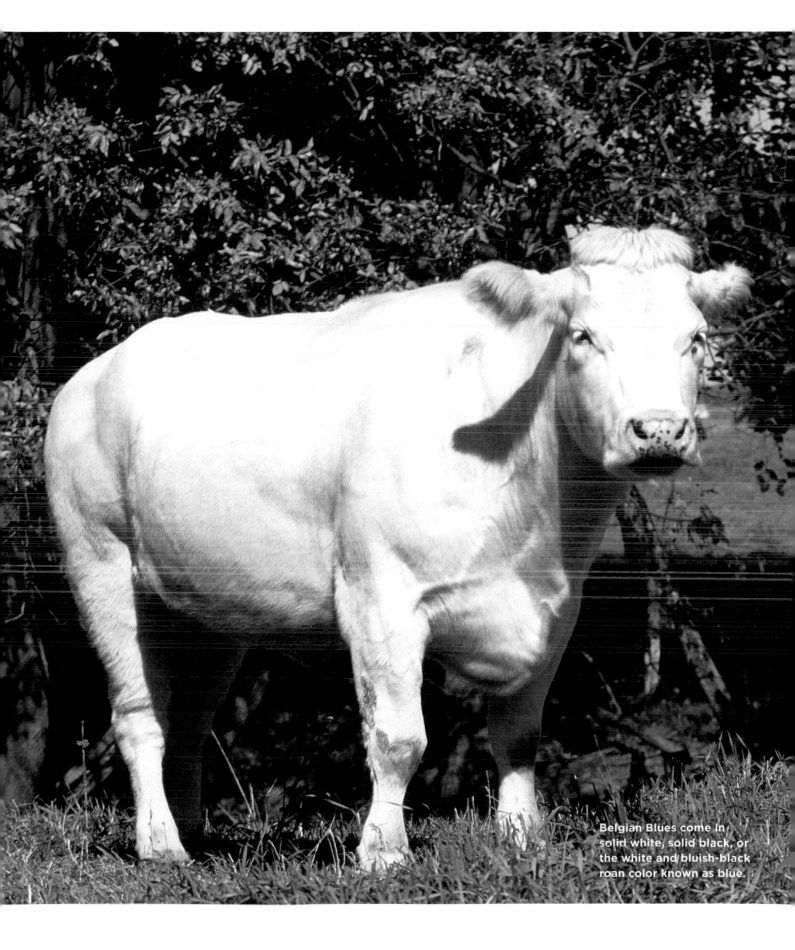

Belgian Blues come in solid white, solid black, or the white and bluish-black roan color known as blue.

Blonde d'Aquitaine

A MODERATELY LARGE, well-muscled breed of cattle, the Blonde d'Aquitaine's forebears (the Garonnais breed of southwestern France) were known as early as the sixth century. For centuries Garonnais were raised as dual-purpose animals for both meat production and draft purposes, which helps to explain both their mass and their gentle dispositions. Around the 1940s, breeders began selecting for beef traits, and the resulting strain was officially recognized as the Blonde d'Aquitaine breed in 1963.

The cattle can be naturally polled or have horns. They are quite heat tolerant, and many people think that their skin, which is thicker than the skin of other breeds, contributes to their heat tolerance. Their color ranges from whitish tan to bright golden yellow to light brown.

During the 1960s, the French government established a breed registration system based on performance criteria, and cattle were tested at government research stations. Modern Blondes also had some small infusions of Charolais, Limousin, and Shorthorn blood and were then bred back to maintain their historic body type. A splash of new blood combined with performance-based selection resulted in quick improvement of the breed for characteristics such as conformation, calving ease, growth rate, and disposition. The breed produces well-marbled, fine-grained meat that has minimal external fat. The breed was first imported into Canada in 1971, and into the United States in 1972.

BLONDE D'AQUITAINE

FUNCTIONAL TYPE Beef.

APPEARANCE Varying shades of golden color.

SIZE Medium to large.

HORNS Either horned or polled.

CONSERVATION STATUS Not applicable.

PLACE OF ORIGIN France.

BEST KNOWN FOR Hardiness in both hot and cold climates. Easy calving. Good production traits.

Today the Blonde d'Aquitaine must meet performance criteria to be registered. Its forebears were used as draft animals during the Middle Ages.

Braford

BRAFORDS WERE DEVELOPED in 1947, on the Florida ranch of Alto Adams Jr., from initial crosses of Brahman cows with Hereford bulls (though the breed has also been developed independently in other parts of the world). Though the calves produced from the cross performed well, the Hereford sires that Adams was using didn't stand up very well to the hot, muggy, swampy climate of Florida. Adams soon decided to do away with purebred Hereford bulls, identifying some of the top bull calves from his Brahman/Hereford crosses to use as sires. These bulls were the foundation for the breed's development.

By 1969, Adams's animals, and those that he had sold to other southern ranchers, were distinguished enough to form a breed association. Today, breeders recognize a ⅜ Brahman, ⅝ Hereford cross as the purebred Braford, and the United Braford Breeders do allow up breeding from registered Brahman and Hereford stock.

Brafords perform very well in the Southeast but have also found favor with breeders as far away as central Canada. Brafords have always been recognized for superior maternal abilities such as good milk production and being attentive mothers when cattle are on range. They are long-lived and are also known for early puberty, high fertility, and easy calving.

BRAFORD

FUNCTIONAL TYPE Beef.

APPEARANCE Commonly red to reddish brown with white facial markings, but other colors are seen as the breed has no color standard. Many show somewhat pendulous ears and some bulls may show humpiness around the shoulders.

SIZE Medium to large.

HORNS Either horned or polled.

CONSERVATION STATUS Not applicable.

PLACE OF ORIGIN Florida.

BEST KNOWN FOR Excellent heat tolerance. Early puberty, high fertility, and easy calving.

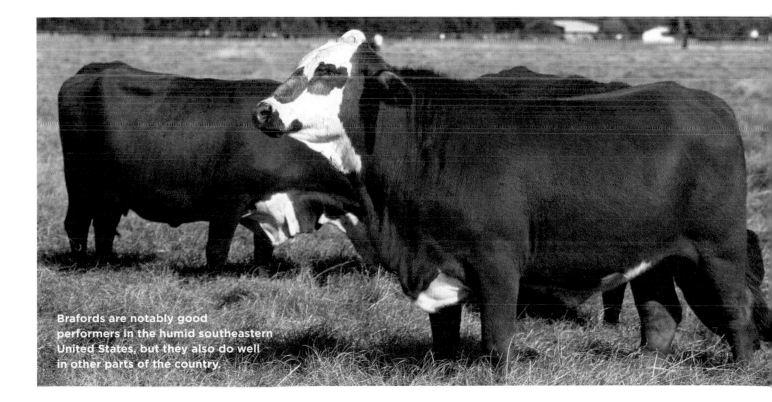

Brafords are notably good performers in the humid southeastern United States, but they also do well in other parts of the country.

Brahman

A PUREBRED *Bos indicus* breed, the Brahman was developed in the United States from four breeds of Zebu cattle (Gir, Guzerat, Nelore, and Krishna Valley) that were imported from India. Although some sources indicate that there may have been an import of Zebu bulls as early as 1835, the first documented imports were made in 1849 by Dr. James Bolton of South Carolina.

Small numbers of Zebu continued to trickle in to the country. Their influence was readily seen in many crossbred animals across wide areas of the Deep South, but it wasn't until the 1920s that larger importations were made. In a three-year period, between 1923 and 1925, 210 bulls and around 20 cows of Gir, Guzerat, and Nelore breeding were imported from Brazil to Texas. These provided the true foundation for development of the modern Brahman. In 1924, the breeders joined together to form a breed association.

Through attentive selection, the Texas and Louisiana breeders of the 1920s and 1930s made marked improvements in the Brahman over their Indian fore-bears, increasing the size and muscling of the animal, as well as boosting its milk production. Today, the Brahman is a favored breed in any hot climate, where it performs well on marginal feed. Animals are long-lived and are known for their stamina. Calves are small at birth but grow quickly; by the time they are ready to butcher, they have a nice, lean carcass. Brahman and Brahman-cross bulls are commonly used for rodeo bull riding.

The breed has also become very important in the development of dozens of composite breeds, thus widening its sphere of influence. Some of the most well-known Brahman composites are the **Braford** (⅜ Brahman, ⅝ Hereford); the **Brahmousin** (⅜ Brahman, ⅝ Limousin); the **Bralers** (⅜ Brahman, ⅝ Salers); the **Brangus** (⅜ Brahman, ⅝ Angus); the **Charbray** (⅜ Brahman, ⅝ Charolais); the **Gelbray** (flexible within these ranges: ¾ to ¼ Gelbvieh, ½ to 0 Red Angus, and ⅜ to ⅛ Brahman); and the **Santa Gertrudis** (⅜ Brahman, ⅝ Shorthorn).

BRAHMAN

FUNCTIONAL TYPE Beef.

APPEARANCE Colors vary from light grayish white to shades of brown, gray, and black, though medium gray is common. Recognized by their prominent hump, dewlap, and floppy ears.

SIZE Medium to large.

HORNS Small to medium.

CONSERVATION STATUS Not applicable.

PLACE OF ORIGIN United States.

BEST KNOWN FOR Heat tolerance. Ability to perform well on marginal feed.

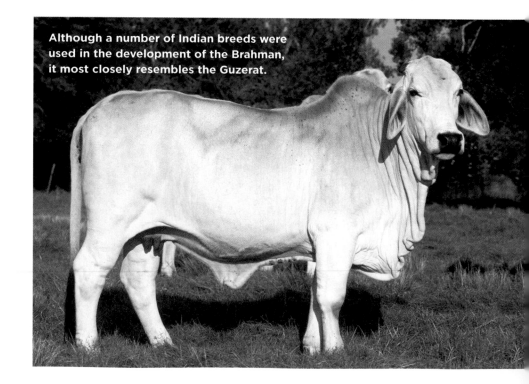

Although a number of Indian breeds were used in the development of the Brahman, it most closely resembles the Guzerat.

BRAHMANS AND HINDUISM

In India, Hinduism is the major religion, practiced by more than three-quarters of the country's population. Hindus don't pray to a single god, but to many. Although different Hindu sects may revere different gods (and goddesses), all sects recognize three gods: Brahma, the creator; Vishnu, the preserver; and Shiva, the destroyer. Among all the gods of Hinduism, Brahma, a four-headed god whose heads point to the four directions of the compass, is the highest god. The highest order of priests is also called Brahman.

Within the Hindu religion, all creatures are to be shown care and respect, but the cow, particularly any cow giving milk, is considered an almost sacred being in its own right, the embodiment of motherhood and fruitfulness. The cow is to be shown respect as if she were a godly gift, and she is a sign of health and prosperity. Anyone who kills a cow is outcast, and in some cases, may be prosecuted for murder.

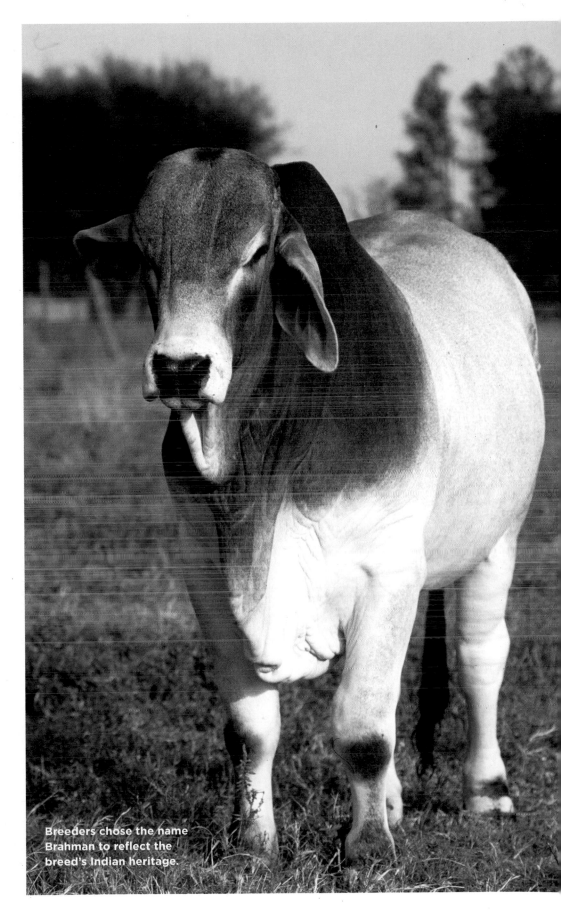

Breeders chose the name Brahman to reflect the breed's Indian heritage.

Braunvieh/Brown Swiss

SWITZERLAND IS NOT ONLY the land of many mountains and lakes, it is also the land of many brown cows. Historically, different cantons (similar to a state or province) of Switzerland had at least 12 different strains of brown cows. The strains were fairly similar, and the animals were triple-purpose beasts used for draft, meat, and milk production. The forebears of Switzerland's brown cows were kept in the valleys of the Alps as early as the Bronze Age, four thousand years ago, and changed little for centuries. In the mid-1800s, in the canton of Schwyz, Austrian Pinzgauers were imported to increase the size of the brown cows. The Pinzgauers contributed a little extra size and a dorsal stripe.

The name Braunvieh means brown cow in German (one of four official languages in Switzerland). The first importation of Braunvieh cattle to North America (one bull and seven cows all known to come from particularly good milking lines) was brought to Massachusetts in 1869. The descendants of those eight animals provided the foundation for the development of the American Brown Swiss breed. During the late 1800s

and early 1900s there were several more importations, 155 animals in all. Brown Swiss breeders continually selected for milk production. Back in Switzerland, the Braunvieh continued to serve multiple purposes.

In 1906, the U.S. government banned the importation of livestock from countries where foot-and-mouth disease was known, severely curtailing additional imports of the original Braunvieh (and many other breeds) directly to the United States. In the 1960s,

BRAUNVIEH

FUNCTIONAL TYPE Beef.

APPEARANCE Coat is brown, ranging from light to dark, and grayish brown to almost blackish brown.

SIZE Medium.

HORNS Either horned or polled.

CONSERVATION STATUS Not applicable.

PLACE OF ORIGIN Switzerland.

BEST KNOWN FOR Exceptional carcass quality. Easy calving. Docility.

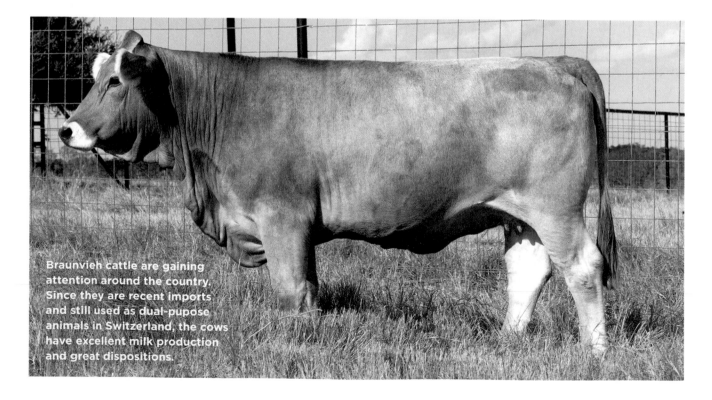

Braunvieh cattle are gaining attention around the country. Since they are recent imports and still used as dual-pupose animals in Switzerland, the cows have excellent milk production and great dispositions.

Most dairy historians consider the Brown Swiss the oldest recognizable dairy breed in the world. They have excellent feet and legs, which contributes to longevity in the milk herd.

Canada developed a new quarantine facility, allowing a Canadian beef producer to import Aron, a beefy Braunvieh bull, from Switzerland. The beef producer began selecting and breeding Brown Swiss for a beef strain, which was initially called "beef Brown Swiss," but he later differentiated the cattle from the dairy strain by using the German name Braunvieh. Through the mid-1980s the Canadians imported more bulls and some cows with better beef traits, and the Braunviehs gained widespread popularity in Canada.

In 1983, Harland Doeschot, a Nebraskan rancher, again imported traditional Braunviehs to the United States from Switzerland via a rather meandering route that took the cattle first to France, then to the Azores and Bermuda, and finally to Florida. Doeschot saw the animals in their native home while on a trip looking for new Simmental bloodlines and decided he needed some. In the mid-1980s several groups of beef Braunvieh were also imported from Canada.

Obviously cold-hardy animals, with their mountain heritage, the Braunvieh and Brown Swiss also do surprisingly well in hotter climates. Both types are docile and have good feet and legs. Calves are born creamy white to fawn-colored and darken to brown as they age.

The Brown Swiss is the third most common dairy breed in North America, behind Holsteins and Jerseys.

Its milk production is considerably lower than that of the Holstein, but its butterfat and protein are higher, and it performs really well on pasture, so it is finding favor among grass-based dairymen. The Brown Swiss cows are averaging 22,395 pounds (10,158 kg) of milk, with 899 pounds (408 kg) of butterfat and 742 pounds (337 kg) of protein, according to USDA's most recent data.

For the beef producer, Braunvieh calves are born quite small, which makes for easy calving, but with their abundant milk supply, Braunvieh cows wean calves that are quite large compared to their birth size. Braunvieh crosses have won a number of the country's most prestigious awards for carcass quality.

BROWN SWISS

FUNCTIONAL TYPE Dairy.

APPEARANCE Good feminine type. Coat is brown, ranging from light to dark, and grayish brown to brownish black.

SIZE Medium to large.

HORNS Either horned or polled.

CONSERVATION STATUS Not applicable.

PLACE OF ORIGIN Switzerland.

BEST KNOWN FOR High butterfat and protein content of milk. Good milk production on pasture.

BueLingo

AROUND 1978, Russ Bueling, a North Dakota cattle and grain rancher, was looking toward partial retirement and turning over the day-to-day operation of his ranch to his kids. "I didn't like golf, didn't like fishing, but wanted something to challenge me in my old age," he told me on a cold winter day in 2007, with his ninetieth birthday looming large. Bueling worked with Russ Danielson, a friend and animal scientist at North Dakota State University, who acted as an advisor and advocate. Together they developed the BueLingo.

Bueling and Danielson realized that in order to direct attention to a new breed, the breed would need a distinctive look. They decided this new breed would have a belt. They studied information on belted breeds and chose the Dutch Belted as one of the foundation breeds, but there were no Dutch Belted cattle in North Dakota. Locating some in Indiana, Bueling arranged to buy a bull named Freightrain. "Freightrain lived in a box stall on a dairy farm, and I was disappointed. He looked kind of scrawny, but he had a wonderful disposition, and I'd driven that far, so I took him home," said Bueling.

Freightrain filled out on pasture, and Beuling bred him to some of his commercial cows that had a lot of Angus and Shorthorn blood. Freightrain's contribution turned out to be far greater than Bueling could have hoped for: his offspring had his consistent belting pattern, good growth, and docile disposition. The progeny were like "little pets."

In the early to mid-1980s, 88 calves were born from breedings with Freightrain. Bueling decided to breed these with another breed to develop a little more muscling and to breed out the dominant horns. He purchased a Chianina bull, Yuma, and his genetic contribution finally yielded the type of animal Bueling was looking for.

Today, BueLingo cattle are found throughout the United States, in Canada, and overseas. Cows reach puberty early. Birth weights are light (around 75 pounds [34 kg]), for easy calving, but the 205-day weaning weight (around 300 pounds [136 kg]) averages half the dam's weight. The cattle are easily adaptable to a wide range of climates, and they are still known for their docile dispositions.

BUELINGO

FUNCTIONAL TYPE Beef.

APPEARANCE Similar coloring and conformation to Black Angus but with a white belt around the middle.

SIZE Medium.

HORNS Normally polled, though 2 to 3 percent of calves may have horns.

CONSERVATION STATUS
Not applicable.

PLACE OF ORIGIN
North Dakota.

BEST KNOWN FOR
Easy calving, excellent weaning weights. Docile dispositions.

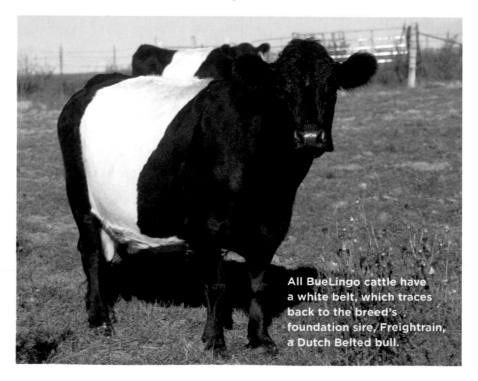

All BueLingo cattle have a white belt, which traces back to the breed's foundation sire, Freightrain, a Dutch Belted bull.

Canadian Speckle Park

THE SPECKLE PARK (which is not directly related to the American-British White Park, nor the Ancient White Park) is a fairly new breed of cattle developed in the Canadian province of Saskatchewan beginning in the late 1950s, when Mary Lindsey of Lloydminster noticed an unusually colored heifer in her father's herd. She kept the heifer, a spotted roan of Shorthorn/White Park breeding, and bred it to an Angus bull. The unusual spotting passed to all of the heifer's offspring. Soon Lindsey was selling some of her spotted cattle to other breeders.

Bill and Eileen Lamont were among the buyers, acquiring their first heifer from Lindsey in 1959. They liked the offspring that came from the spotted heifer and their Black Angus cattle and decided to begin a concerted breeding program aimed at developing a new breed. The Lamonts chose the name Speckle Park and, along with eight other Speckle Park breeders, formed the first breed association in 1985. The breed was recognized as a distinct breed by the Canadian government in 2006.

With a significant portion of Angus and Shorthorn bloodlines in the breed, Speckle Parks show many of the traits associated with those two breeds, such as easy calving, high feed efficiency, and hardiness. And, they all display the unusual coloring of Lindsey's first heifer.

CANADIAN SPECKLE PARK

FUNCTIONAL TYPE Beef.

APPEARANCE Black and white spotted, black and white leopard patterned, or white with black points (females only).

SIZE Medium.

HORNS Naturally polled.

CONSERVATION STATUS Not applicable.

PLACE OF ORIGIN Saskatchewan, Canada.

BEST KNOWN FOR Status as one of the newest breeds (officially recognized in Canada in 2006).

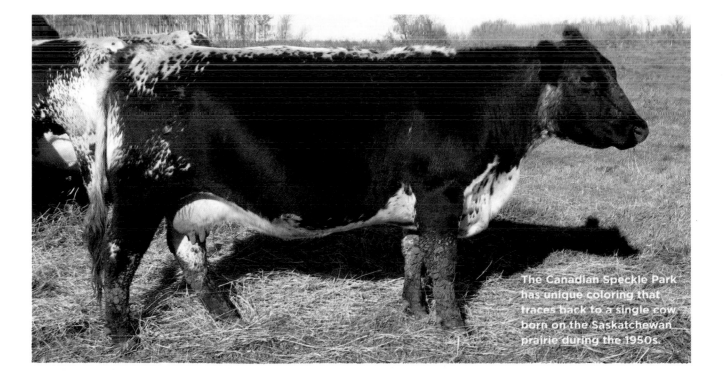

The Canadian Speckle Park has unique coloring that traces back to a single cow born on the Saskatchewan prairie during the 1950s.

Canadienne

THE CANADIENNE BREED was developed in Quebec, Canada, from the cattle that French immigrants brought with them during the sixteenth and seventeenth centuries. By 1883, three-quarters of the cattle found in Quebec were Canadienne, and they had also spread to other Canadian provinces and across the border into adjacent states in the United States. The Canadienne was once the primary breed used for milk production in Canada. But, like other dairy cattle, their numbers have fallen precipitously since 1950, when government and industry priorities reduced interest in all but the highest producing Holsteins. Rare Breeds Canada has declared the once-abundant Canadienne a rare breed, with fewer than 100 purebred females registered in Canada. Registration numbers have been increasing in recent years, as grass-based dairy farmers find the Canadienne to be a good addition to their herds.

Canadiennes look similar to Jersey cattle and are sometimes referred to as Black Jerseys, though recent DNA testing shows that they are not related to Jerseys. They are well adapted to the extraordinarily harsh climate of Canada but do quite well in warmer areas. They have a heavy, almost oily, winter coat and shed out to a very slick summer coat that helps them withstand hotter weather. Though they don't break records for volume of milk, they do produce a high quantity relative to their body size and feed requirements.

The Canadienne is another dairy breed that is doing well under intensively managed pasture production. The meat of Canadiennes tends to be lean, yet tender, and they have light bones, which means greater yield of usable cuts. Cows have good fertility, and calves, which are born a pale fawn color but darken with age to dark brown or black, are born without assistance.

CANADIENNE

FUNCTIONAL TYPE Dairy.

APPEARANCE Dark brown to brownish black coat. Feminine lines due to light bone structure, with a well-proportioned udder.

SIZE Small.

HORNS Naturally polled.

CONSERVATION STATUS Critical.

PLACE OF ORIGIN Quebec.

BEST KNOWN FOR Hardiness. Good production on pasture.

This Canadienne heifer represents a historic genetic package that is critically endangered. The Quebec provincial government has invested in programs to help save the breed, which is extremely hardy.

Charolais

AN ANCIENT FRENCH BREED, the Charolais hails from Charolles County in the Burgundy region of east-central France. During the early eighteenth century, the Burgundy region became an important area for draft and beef production improvements of the native cattle. The area was home to many small landholders who concentrated on producing animals that were strong for draft purposes and yielded high-quality meat for the Paris markets.

The breed is thought to have had little outside influence, though in the 1830s the Count of Bouille, who was raising Charolais on his estate, did seek to increase the breed's daily weight gain by crossing some British Durhams into his herd. In 1864, Bouille established the first herdbook for Charolais cattle. By then the breed's key traits — heavy muscling, a broad chest and pelvis, and short limbs — were well established.

(continued)

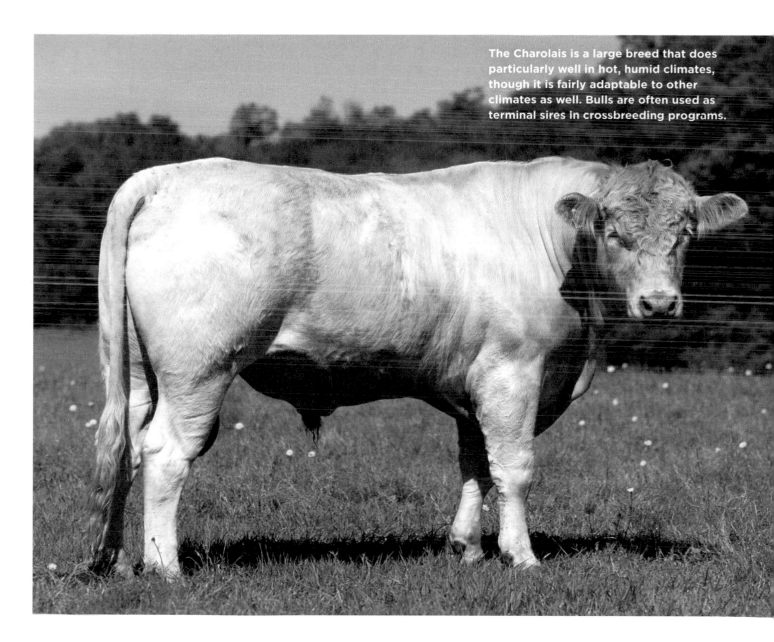

The Charolais is a large breed that does particularly well in hot, humid climates, though it is fairly adaptable to other climates as well. Bulls are often used as terminal sires in crossbreeding programs.

Charolais (continued)

In the 1930s, Jean Pugibet, a French expatriate living in Mexico, imported 37 head of Charolais to that country. The King Ranch of Texas purchased several bulls from these Mexican imports in 1936. Other southern ranchers also imported small numbers of bulls, which proved extremely valuable in crossbreeding, particularly with Brahman stock. In order to control what it saw as a valuable asset, the Mexican government forbade the sale of purebred Charolais cows to the United States. This cut off the only legal road to obtaining the cattle since U.S. ranchers couldn't import cattle directly from France due to foot-and-mouth disease restrictions.

Alphe Broussard, a Louisiana cattle rancher, was determined to acquire Charolais breeding animals, so in 1952 he purchased a Mexican herd from Henri Gilly, another French expatriate living in Mexico, for $500,000. Under the agreement, it was up to Gilly to get the animals to Broussard. Gilly paid bribes to Mexican officials and smuggled the herd across the Rio Grande and into Texas by foot. But due to the political storm that followed once the Mexican government realized what had happened, the U.S. Customs Bureau arrested Broussard, who spent a year in a federal prison before being pardoned by President Eisenhower. Through convoluted maneuvers that included a Mexican court battle, the Broussard family did end up with the first Charolais herd in the United States.

The Charolais performs better than most Continental or British breeds in the Southeast and Gulf Coast regions but can also do well farther north. It is a fast-growing breed with good carcass characteristics.

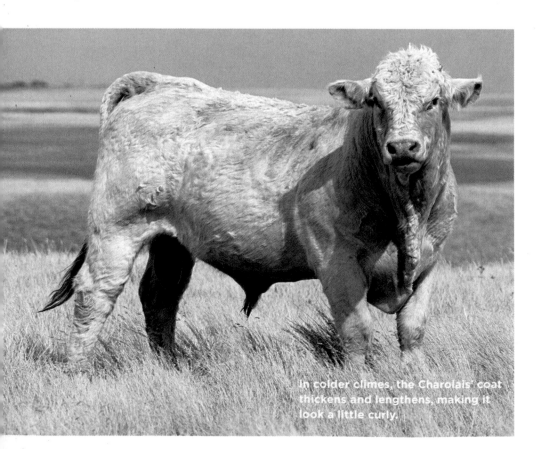

In colder climes, the Charolais' coat thickens and lengthens, making it look a little curly.

CHAROLAIS

FUNCTIONAL TYPE Beef.

APPEARANCE Heavily muscled. Mostly white; some have a reddish tint.

SIZE Large.

HORNS Mainly horned, though there are polled lines.

CONSERVATION STATUS Not applicable.

PLACE OF ORIGIN France.

BEST KNOWN FOR Fast growth. Good carcass characteristics.

Chianina

THE ROMAN POET VIRGIL wrote about the Chianina (pronounced kee-a-nee-na) breed, which traces its lineage as far back as two thousand years in the Chiana Valley of Tuscany, Italy. During the Roman Empire, large white bulls were used for sacrifice to the gods and to pull chariots in official processions. The breed was also used as a draft animal for the farmers of the region, so size and disposition were critical.

The Chianina is one of the largest breeds of cattle. Bulls can weigh as much as 4,000 pounds (1,815 kg) and reach up to six feet (1.83 m) tall at the back. At birth, the calves are fawn colored, but by about three months of age their coat lightens, and by adulthood, they have porcelain-white hair and black skin. They adapt extremely well to hot climates but easily tolerate colder ones. The breed is known for its rapid growth rate, leanness, high carcass yield, and easy calving relative to its size. The first importation into Canada occurred in 1971. The first U.S. importation was in 1975.

Like the Brahman, the Chianina is being used in the development of composite breeds. The Chiangus (Chianina/Angus), also known as the Ankina; the Chiford (Chianina/Hereford); and the Chimaine (Chianina/Maine-Anjou) are the three most common.

CHIANINA

FUNCTIONAL TYPE Beef.

APPEARANCE Tall, muscular. Pure white to steel-gray with black points (eyes, nose, tip of tail) and black skin.

SIZE Large.

HORNS Small.

CONSERVATION STATUS Not applicable.

PLACE OF ORIGIN Italy.

BEST KNOWN FOR Large size (the biggest breed of cattle). Excellent carcass quality.

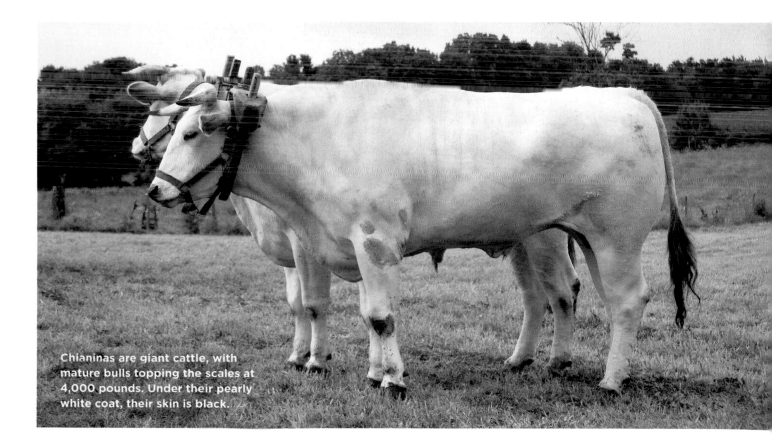

Chianinas are giant cattle, with mature bulls topping the scales at 4,000 pounds. Under their pearly white coat, their skin is black.

Corriente

THE CORRIENTE was developed from the very first cattle imported to the New World by Spanish explorers. In the Spanish-American colonies, the word *criollo,* which originally meant "native of Spain," was used to refer to people, animals, and things of Spanish and Portuguese descent. The Corriente is a criollo breed, as are any other breeds that evolved from those earliest Spanish imports, including the Florida Cracker, the Pineywood, the Texas Longhorn, and the Chinampo (a breed mainly found in northern Mexico), as well as a number of breeds found in Central and South America.

The cattle that the Spaniards brought to the New World primarily originated in the Iberian Peninsula and were relatively small and quite rugged to withstand the grueling ocean journey. Once in the New World, they spread quickly, becoming semiferal throughout much of Latin America and the southern tier of North America. Beef producers would occasionally round up herds, and though this extensive production system provided inexpensive meat, the quality wasn't good because the meat of the self-reliant animals tended to be tough and of small quantity. By the early twentieth century, consumers demanded high-quality beef and were willing to pay more for it, which drove ranchers to fence their lands and introduce improved breeds that produced better-quality carcasses. Criollo breed numbers plummeted throughout their range.

During the late nineteenth and early twentieth centuries, cowboys often rounded up the wild criollo cattle that remained in remote areas of northern Mexico and the southwestern United States for use as rodeo stock, or to be driven to distant markets in the famous cattle drives of the Old West. These animals were fast out of the shoot, making them a favorite for roping and bulldogging (steer wrestling) competitions. Because of their speed, they were known as Corriente, which means "running" in Spanish. The North American Corriente Association formed in 1982 to help preserve the breed. Slow Food USA has adopted the Corriente, which produces lean meat, on its Ark of Taste (see page 38).

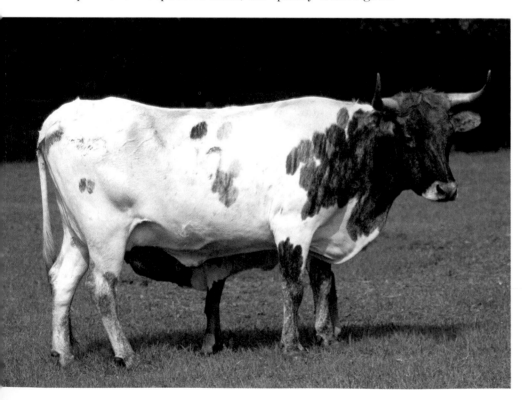

CORRIENTE

FUNCTIONAL TYPE Beef.

APPEARANCE Athletic-looking with a lean yet muscular build. Variety of colors.

SIZE Small.

HORNS Medium to large.

CONSERVATION STATUS Not applicable.

PLACE OF ORIGIN Mexico and United States, from Spanish stock.

BEST KNOWN FOR Speed as rodeo roping stock.

Corrientes use larger areas and more diverse habitats when they graze in desert conditions, making them an ideal breed for the arid southwestern United States.

Devon and Milking Devon

THE DEVON has a long history in North America. In fact, the first British cattle of any type to make the voyage to the New World were a Devon bull and three Devon heifers that arrived in the Massachusetts Plymouth Colony in 1623. The Devon was a common, triple-purpose breed used for meat, milk, and draft in the northern part of Devon County, England (located in the southwest corner of the country). It has been considered a separate breed from the South Devon (see page 134) since the seventeenth century.

The Devon was small but agile and intelligent, making it an excellent breed for drovers in New England, where it accounted for 30 percent of the region's oxen herd in the 1890s. Farmers in the mid-Atlantic region, including President George Washington, who kept Devons on his Mount Vernon farm, also favored the breed. In recognition of its importance to the settling of the New England colonies, it was recognized on the first official state seal of Vermont.

A breed association for Devon cattle formed in 1881, and the breed continued to be a popular multipurpose breed into the 1940s. After World War II, dairy farmers began seeking milk animals with higher production rates, dropping the old dual-purpose type of animals from their milking herds. At the same time, beef farmers began selecting breeds that had a beefier carcass. In 1952, the American Devon Cattle Club opted to begin developing a beef animal. The farmers who were raising Devon for beef began selecting away from dual-purpose traits for a beefier animal, but they never were effective at promoting their animals, so the new animals' numbers fell. A small number of breeders kept the beef Devon from completely disappearing, and today they are making a comeback as their ability to perform well on pasture is appreciated by farmers and consumers interested in grass-fed beef.

At about the same time as the American Devon Cattle Club moved to beef, the small number of breeders who were maintaining the multipurpose strains formed the American Milking Devon Association, but their numbers dwindled and the association went dormant. In 1978, with assistance from the American Livestock Breeds Conservancy (see page 21), a few breeders revived the association with the goal of conserving the then-critical bloodlines of the original multipurpose Devons. These Milking Devons are still quite rare and represent a genetic package that isn't found anywhere outside the United States, as the

(continued)

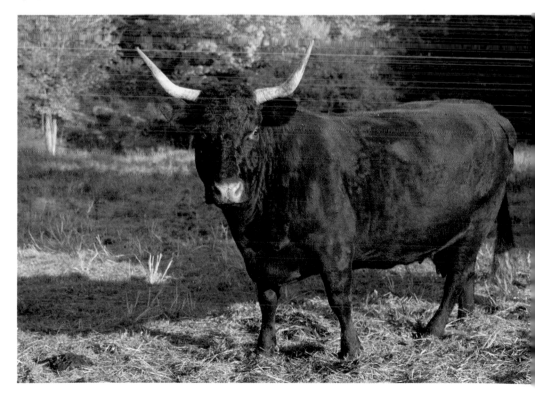

Today, there are two types of Devon cattle: a beef Devon and a Milking Devon (shown here). Milking Devons are a perfect homestead dairy animal.

Devon and Milking Devon (continued)

original Devons in England have disappeared due to crossbreeding and selection for beef.

Today, Milking Devons are maintained by a number of living history museums, as well as homesteaders and hobby drovers who enjoy working with them. They are also finding renewed interest among dairy graziers and some beef producers looking to increase milk production and improve grazing traits in their beef herds. Their milk production is considerably lower than that of other dairy breeds (around 12,000 pounds [5,450 kg] per year), but they are valuable for other traits, such as hardiness and the ability to produce a decent quantity of milk from a forage-based diet.

Both beef Devon and Milking Devon are known for good fertility and easy calving. They produce tender meat that is well marbled but with little fat between the muscles. Devons are very tolerant to widely varying climates, from the heat of Louisiana and New Mexico to the cold of Canada, and have long, productive lives. The American Livestock Breeds Conservancy has successfully nominated the Milking Devon to the Slow Food USA's Ark of Taste (see page 38).

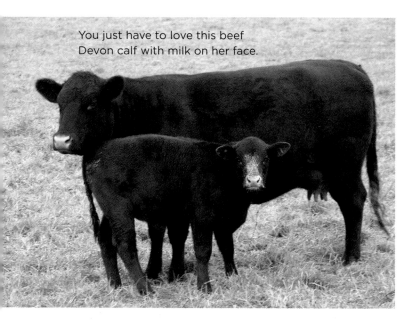

You just have to love this beef Devon calf with milk on her face.

Both beef and Milking Devons are still popular with drovers as draft animals.

DEVON

FUNCTIONAL TYPE Beef.

APPEARANCE Stout with relatively short limbs. Deep mahogany to ruby-red coloring.

SIZE Medium.

HORNS Horned (medium-size) or polled, depending on the strain.

CONSERVATION STATUS Recovering.

PLACE OF ORIGIN England.

BEST KNOWN FOR Excellent production traits for grass-fed beef market.

MILKING DEVON

FUNCTIONAL TYPE Dairy/multipurpose.

APPEARANCE Fine-boned. Deep mahogany to ruby-red color.

SIZE Small to medium.

HORNS Medium to moderately long.

CONSERVATION STATUS Critical.

PLACE OF ORIGIN England.

BEST KNOWN FOR Traditional multipurpose traits with good production on grass.

Dexter

HAILING FROM IRELAND, Dexter cattle look as though they could be a creation of the fairies that are common in Irish mythology. Standing just 3 to 3.5 feet (91 to 107 cm) tall at the withers when they reach maturity, Dexters are very small (and cute and productive). Archaeologists have found bones of small Dexter-like cattle in Ireland dating back to the Iron Age, around 800 BC.

Many sources believe that Dexter cattle were developed from Ireland's Kerry cattle, another small breed that was one of the earliest recognized dairy breeds in the world, but DNA analysis from one study indicates that the two breeds might not be that closely related, and that the Dexter developed separately from the Kerry cattle. The assumption that they are connected stems, at least in part, from the fact that both breeds were represented by the same herd society, and the same herdbook, for a period beginning in 1890, when Ireland's first herdbook was created. But as more DNA studies are completed, our understanding of the Dexter's heritage should increase.

Although the Dexter breed's origins are uncertain, we know that it is named for a Mr. Dexter, who acted as an agent to Lord Hawarden, one of Ireland's landed gentry in the mid-1800s. Dexter acted as a promoter, not a developer, of the breed that was found on small-holdings in the hilly area of south-central Ireland.

Dexters were brought to England from Ireland in 1882, where they were mainly viewed as a novelty. The first known importation of Dexters to North America came in 1905, though others may have been brought over earlier in shipments of Kerry cattle. The first Dexter registry in North America was formed in 1911.

Dexters are quite hardy and perform really well on pasture, producing lean but tender meat. The cows also produce a reasonable amount of milk relative to their size, making them of interest to homesteaders looking for a milk cow for family use. The cows are good mothers and they have good fertility, but some strains have a lethal recessive gene for "bulldog" dwarfism, a condition in which calves are stillborn or die shortly after birth. Bulldog calves are recognized by extremely short limbs and prominent craniofacial defects. Dexter breeders are using genetic testing to avoid this problem

DEXTER

FUNCTIONAL TYPE Dual-purpose, beef and dairy.

APPEARANCE Compact animals. Black or occasionally red or dun.

SIZE Very small.

HORNS Naturally horned, though a polled strain exists.

CONSERVATION STATUS Recovering.

PLACE OF ORIGIN Ireland.

BEST KNOWN FOR Tiny size. Production of home-stead-scale milk.

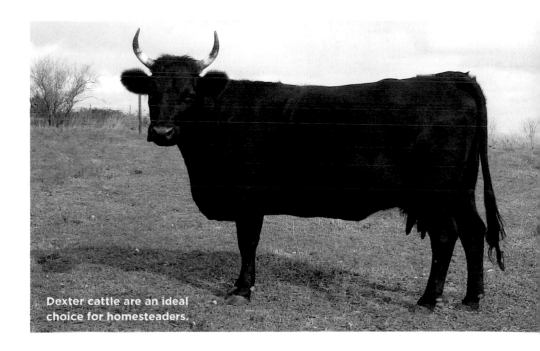
Dexter cattle are an ideal choice for homesteaders.

Dutch Belted

THE EARLIEST DOCUMENTED cases of belted coloring come from cattle in the Austrian and Swiss Alps. Noblemen from Holland imported some of these cattle in the 1600s and called them Lakenvelder, which means "sheeted field," in reference to the white sheet around their middle. The Dutch nobility became somewhat obsessed with this pattern, breeding rabbits, pigs, goats, and chickens in addition to the Dutch Belted cattle.

D. H. Haight, who served as the United States' official consul to Holland, first imported Lakenvelders to the United States in 1838. Two years later, P. T. Barnum imported several to travel the country as an oddity with the circus. Ultimately, Barnum sent his Lakenvelders to his farm in New York, where the farm's staff was pleasantly surprised by their milking capabilities. There were several additional importations until 1906, when the government prohibited additional imports of cattle from countries where foot-and-mouth disease occurred. The American strain of the Lakenvelder, named the Dutch Belted, developed from these early importations and won many dairy production prizes in the early part of the twentieth century.

The Dutch Belted is not just a novelty animal. High-producing cows make up to 65 pounds (29.5 kg) of milk, and it is especially high in butterfat and protein, raising interest among artisan cheese makers. At one time many of the Dutch Belted cattle produced milk with very small fat globules, making the milk almost naturally homogenized. Sadly, with the drastic reduction in the Dutch Belted national herd in the mid-twentieth century, that characteristic seems to have been lost. The Dutch Belted is critically endangered, yet there is a resurgence of interest in the breed among farmers producing milk on pasture. These farmers say that the Dutch Belteds perform almost as well as Holsteins on pasture, yet have few of the health and fertility problems that plague modern dairy cattle, and they look nice in the field.

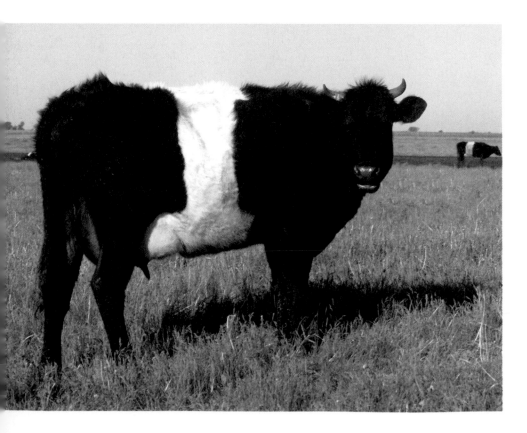

DUTCH BELTED

FUNCTIONAL TYPE Dairy.

APPEARANCE Belted in white on black, or sometimes white on red.

SIZE Medium.

HORNS Small.

CONSERVATION STATUS Critical.

PLACE OF ORIGIN Netherlands.

BEST KNOWN FOR Belted coloring. Good dairy production on pasture with high butterfat and protein.

Dutch Belted cows are excellent milkers in grass-based production systems, and they have a gentle disposition.

Florida Cracker

ANOTHER OF THE CRIOLLO cattle breeds (see also Corriente, Pineywoods, and Texas Longhorn) that evolved from early Spanish importations in the sixteenth century, the Florida Cracker, also known as the Florida Scrub, developed as an open-range animal in the vast pinewood-dotted grasslands and swamps of Florida. In fact, when Spanish conquistador Ponce de León landed in Florida in 1521, the cattle (and horses) he off-loaded were the first to ever set foot in North America. In 1700, Spanish tax collectors reported more than 20,000 head of cattle in Florida.

The cattle from those early Spanish importations that survived in the tropical South developed resistance to the diseases that were associated with parasites that thrived in those sultry climes. The cattle were found not only in Florida but also in the hottest and most humid parts of the country, from Georgia to Louisiana, where English and Continental cows could barely survive. They thrived until 1949, when the Florida leg-

islature passed a law requiring cattle to be fenced in on land the farmer owned. As with the Corriente of New Mexico, the combination of new fencing laws and dramatic improvements in agricultural practices and veterinary medicine following World War II allowed northern European breeds to finally survive and be productive in the Deep South, and the Crackers almost died out.

By the late 1960s there were only a handful of pure Cracker cattle left, held by just a few families. Members of the Florida Cattlemen's Association and the Florida Commissioner of Agriculture joined forces to preserve some Cracker cattle, acquiring five heifers and a bull from Zona Bass and Zetta Hunt, the daughters of Florida pioneer cattleman James Durrance. Durrance's Cracker cattle were regarded as some of the purest specimens remaining in the state. Other breeders also donated stock over the ensuing years, and by the late 1970s the Florida Department of Agriculture had built

(continued)

FLORIDA CRACKER

FUNCTIONAL TYPE Beef.

APPEARANCE Compact, athletic-looking cattle with lean yet muscular builds in a variety of colors.

SIZE Small.

HORNS Medium to large, in various shapes.

CONSERVATION STATUS Critical.

PLACE OF ORIGIN Florida, from Spanish stock.

BEST KNOWN FOR Heat tolerance and disease resistance.

Descended from the original cattle imported by Spanish explorers, the Florida Cracker is found in a variety of colors and patterns. Crackers reach puberty early.

Florida Cracker (continued)

herds that were kept at the Withlacoochee State Forest, the Lake Kissimmee State Park, and the Paynes Prairie State Preserve.

In the 1980s, encouraged by the American Livestock Breeds Conservancy, the Florida Department of Agriculture joined together with the handful of remaining private owners of Crackers to ramp up conservation efforts. They wanted to go beyond simply keeping the animals as a historical novelty at parks and preserves, so they formed the Florida Cracker Cattle Association. Today, the breed association holds an annual auction at which it sells Cracker cattle, and though the breed's numbers are still quite limited, the actual number of animals and number of herds have increased.

Crackers are disease and parasite resistant, have excellent fertility and longevity, and are able to survive on the poor-quality forage that is native to Florida.

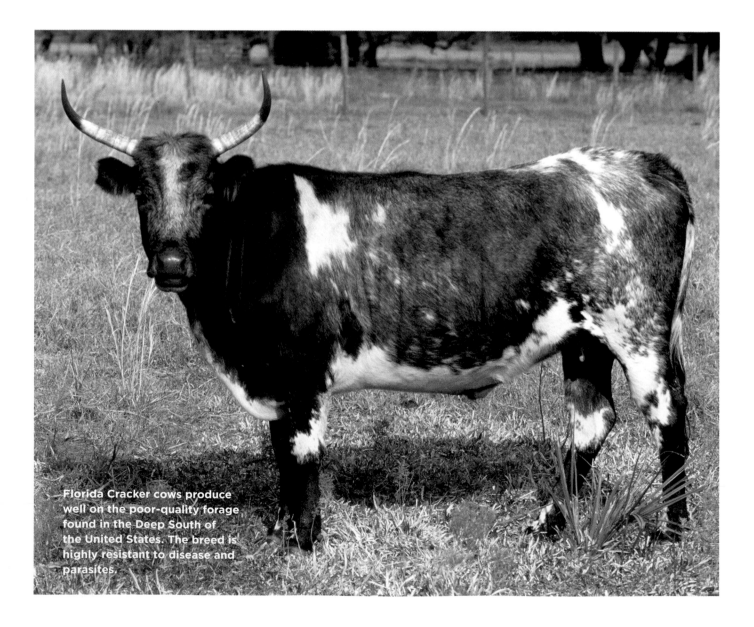

Florida Cracker cows produce well on the poor-quality forage found in the Deep South of the United States. The breed is highly resistant to disease and parasites.

Galloway

A SHAGGY-HAIRED, hornless breed, the Galloway came out of the hilly seacoast region of southwestern Scotland. It was documented there in writing by the sixteenth century, though its roots are even older. The earliest Galloways were horned, but during the late 1700s breeders began selecting for the polled trait, which was seen occasionally. Today all Galloways are polled. The first Galloway cattle imported to North America arrived in Toronto in 1853. Ten years later, Galloways were imported to the United States.

Galloways grow to be about the same size as traditional Angus cattle of the 1950s, but they have lower birth weights (which contributes to easy calving) and slightly lower weaning weights. Breeders like their mild-mannered disposition, and the fact that they do well in a managed grazing system (they do better on rougher-quality forage than many bred-up breeds) is gaining the breed new fans, particularly among small producers who appreciate their aesthetic value as much as their production value.

(continued)

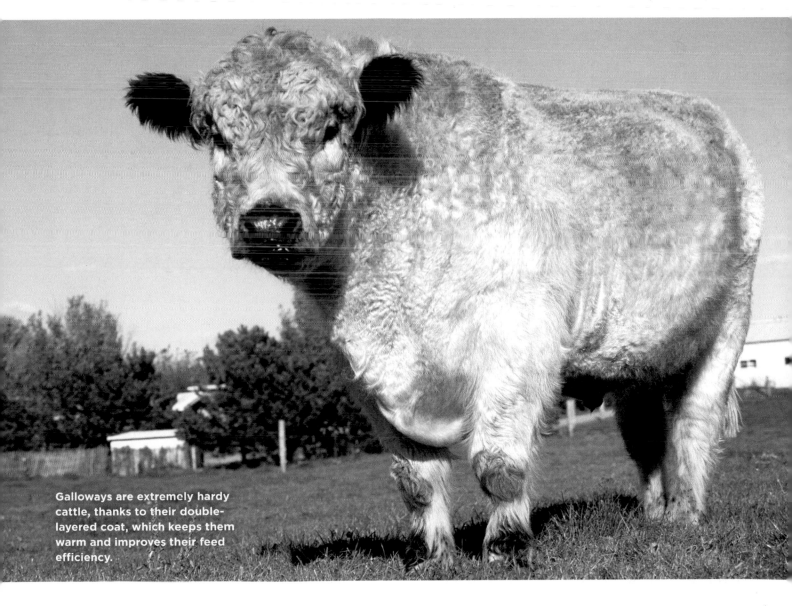

Galloways are extremely hardy cattle, thanks to their double-layered coat, which keeps them warm and improves their feed efficiency.

Galloway (continued)

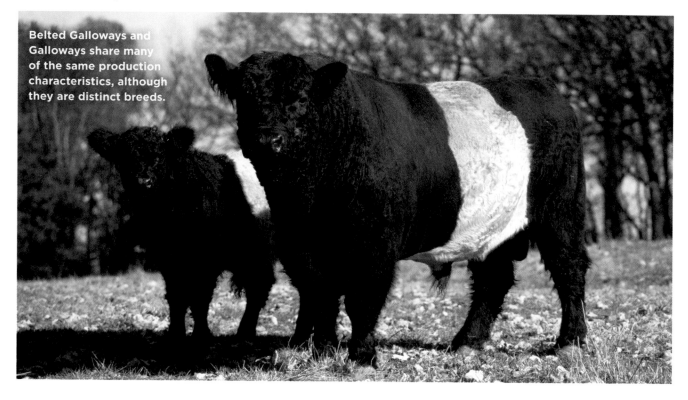

Belted Galloways and Galloways share many of the same production characteristics, although they are distinct breeds.

Their meat is tender and juicy (and this has been officially confirmed in taste tests at the U.S. Department of Agriculture's Meat Animal Research Center). Thanks to a double-layered coat of long, coarse hair over a furry inner layer, they are hardy in the most extreme winter conditions and handle dampness better than most breeds. Researchers at Montana State University have shown that the Galloway's coat reduces their winter-feed needs by about 25 percent.

GALLOWAY

FUNCTIONAL TYPE Beef.
APPEARANCE Black, red, dun, or white with colored points, or belted (front and rear quarters in black, red, or dun, with distinctive white band around middle).
SIZE Medium.
HORNS Naturally polled.
CONSERVATION STATUS Galloway—Watch. Belted Galloway—Recovering.
PLACE OF ORIGIN Scotland.
BEST KNOWN FOR Shaggy hair, hardiness, and thriftiness.

BELTED GALLOWAY

Simply known as Belties among breeders, the Belted Galloway is easily discernible by the white belt that is sandwiched between solid black, dun, or red hair. Though it shares many traits with nonbelted Galloway cattle, the Belted Galloway is registered with a separate registry and has been genetically distinct from nonbelted Galloways for more than a century.

No one is quite sure where this pattern comes from, though some speculate that Dutch Belted cattle were crossbred with Galloways centuries ago. Geneticists are studying the belting pattern (which also appears in Dutch Belted and Belted Swiss cattle, Hampshire hogs, Dutch Belted rabbits, and some mice) and know that it is the result of a genetically dominant allele. This belted pattern also supplies Belties with another nickname: Oreo-cookie cows.

Gelbvieh

IN ITS NATIVE GERMANY, the Gelbvieh (pronounced gelp-fee), or "yellow cow," was developed during the second half of the 1800s by careful selection and some crossing of the native landrace (unimproved red cattle in the Bavarian region) with improved breeds such as the Oberland Bernese (an ancestor of the Simmental; Braunviehs; Grey Alpine; Shorthorns; and Charolais). The native cattle were fairly small and slow-growing animals that came in a variety of colors, but the crossbred offspring were moderately large animals with consistent color (solid yellowish red) and enhanced performance in draft, milk, and meat production. In 1897, farmers in Germany formed the first breed society for the Gelbvieh.

After World War II, Germany moved into a new phase of its cattle breeding program and began widely using artificial insemination with bull selection based on progeny testing. In 1960, German breeders added some Red Danish blood to the Gelbvieh lines to improve milk production. At about the same time, in the United States, the food company Carnation developed a cattle genetics division focused on improving production in dairy cattle, making the company one of the early entrants into the field of genetic testing in large livestock. By the late 1960s, Gelbvieh cattle caught the eye of Carnation staff, and they imported 43,000 "straws" (units) of Gelbvieh semen. North American Gelbvieh come from animals upgraded using this semen. Cows that are at least ⅞ Gelbvieh, and bulls that are at least ¹⁵⁄₁₆ Gelbvieh, can be registered with the American Gelbvieh Association.

Gelbvieh and Gelbvieh-cross cows have excellent maternal characteristics, including good fertility and milk production. The breed tends to be docile and calm. Gelbvieh provide a heavily muscled carcass that yields well.

GELBVIEH

FUNCTIONAL TYPE Beef.

APPEARANCE No color restrictions for registration, but black, red, yellowish red, or cream are common; straight lines and good muscle.

SIZE Medium to large.

HORNS Either horned or polled.

CONSERVATION STATUS Not applicable.

PLACE OF ORIGIN Germany.

BEST KNOWN FOR Being used in crossbred beef production.

In its native Germany, the Gelbvieh is always a yellowish red color, but in North America there are no color restrictions, as the Gelbvieh has been developed through up-breeding programs.

Guernsey

GUERNSEY IS ONE of the Channel Islands off the coast of France in the English Channel. No one is sure exactly how, or when, cattle arrived on the island, but by the late 1700s the breed was quite distinguishable, and a law precluding importations of other cattle to the island prevented the Guernsey's bloodlines from being diluted. The first Guernseys arrived in New York in the fall of 1840. From this, and a few subsequent importations, the Guernsey spread fairly quickly throughout New England, and the American Guernsey Cattle Club was formed in 1877.

Guernseys are gorgeous dairy cattle known for their golden-colored milk that is very high in butterfat and protein. Guernseys' milk also has higher concentrations of calcium, vitamin D, and vitamin A than milk from other dairy breeds, as well as very high beta-carotene content, which contributes to its lovely golden color. Artisan cheese makers like using the milk, in part thanks to the Guernseys' kappa casein B gene, which accounts for the Guernseys' firmer curd, increased volume, and better cheese-making charac-

teristics. According to USDA figures, Guernsey cows typically produce 18,162 pounds (8,238 kg) of milk, with 795 pounds (360 kg) of butterfat and 594 pounds (270 kg) of protein.

The cows mature early and readily breed back two months after giving birth. The breed also has the best calving ease of any of the major dairy breeds. They are also very docile and perform very well on grass-based dairy operations.

GUERNSEY

FUNCTIONAL TYPE Dairy.
APPEARANCE Golden brown with white patches.
SIZE Large.
HORNS Medium.
CONSERVATION STATUS Watch.
PLACE OF ORIGIN Channel Island of Guernsey.
BEST KNOWN FOR Golden Guernsey milk, which is richer than other milk.

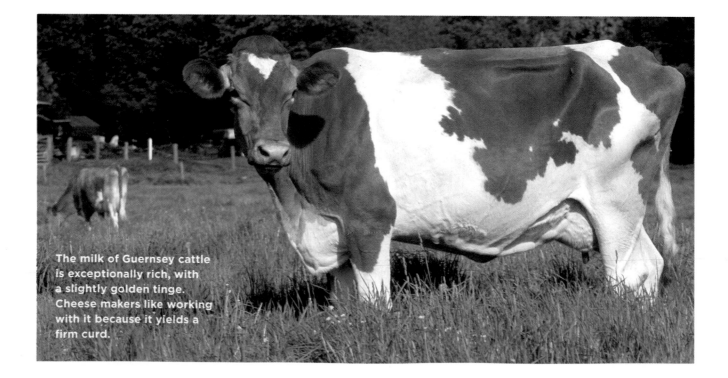

The milk of Guernsey cattle is exceptionally rich, with a slightly golden tinge. Cheese makers like working with it because it yields a firm curd.

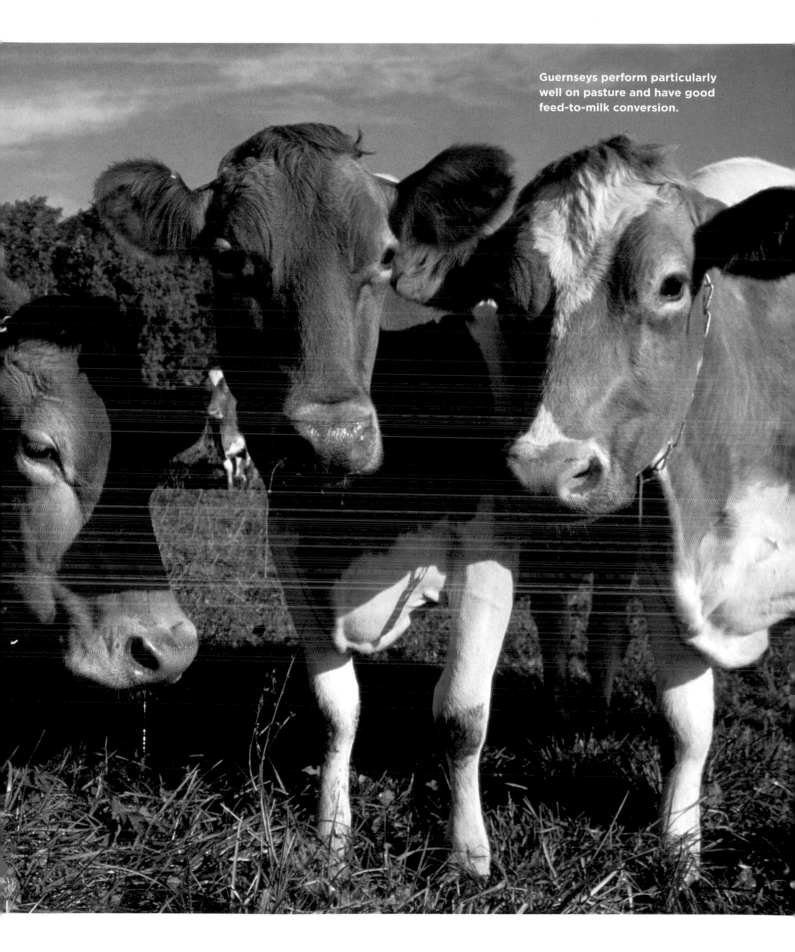

Guernseys perform particularly well on pasture and have good feed-to-milk conversion.

Hays Converter

CANADA'S FIRST RECOGNIZED BREED of beef cattle, the Hays Converter was developed beginning in 1959 and was acknowledged as a breed by the Canadian Department of Agriculture in 1975. The breed is named after Harry Hays, an Alberta-born farmer who started out as a successful Holstein dairyman (also raising pork and poultry) in the first half of the twentieth century and went on to become Minister of Agriculture for Canada and a senator.

Hays set out to develop a new breed of beef cattle that would be measured only on its performance "as a converter of feed to saleable meat." He also put tremendous emphasis on developing a breed whose hardiness was suitable for the winters of the Canadian west.

Hays started by breeding eight sons of an outstanding Holstein bull to a herd of Hereford cows. The top granddaughters from those crosses were then bred to a top-performing Hereford bull. In turn, granddaughters from the crosses were finally bred to the grandsons of a top-producing Brown Swiss cow, Jane of Vernon, who also had excellent feet and legs and a superior udder. From those offspring Hays made selections of breeding stock that excelled in such traits as productive life, calving ease, milk production, healthy udders, high fertility, good feet and legs, fast rate of growth, and excellent carcass quality of offspring.

Hays continued to tweak his breeding program, selecting and rejecting cattle based on these productive traits, and by 1969, he had cemented the traits he wanted. He began breeding the selected cows from these lines to bulls of the same breeding.

Primarily found on the prairies of western Canada, the Hays Converter is an exceptionally hardy, productive breed of beef cattle.

HAYS CONVERTER

FUNCTIONAL TYPE Beef.

APPEARANCE Black or red with white face and underbelly.

SIZE Medium to large.

HORNS Medium.

CONSERVATION STATUS Not applicable.

PLACE OF ORIGIN Canada.

BEST KNOWN FOR Strong beef production in harsh-winter zones.

Hereford

A READILY RECOGNIZED breed thanks to its red body and white face, the Hereford is found throughout North America. In 1742, Benjamin Tompkins inherited his father's estate in Herefordshire County in western England, a grassy area with a long history of cattle farming. It was here where he, and later his son Benjamin, bred and promoted the red and white animals that had triple-purpose value for draft, milk, and meat.

By the 1780s, the breed was primarily raised for beef production, and its easily distinguished color pattern of red with white face, abdomen, tail switch, and feet was fixed. The white face is a dominant trait, so when Herefords are bred with other breeds, all offspring have the white face pattern. Crosses between Herefords and Angus are often called black baldies, referring to their white face.

Henry Clay, the famous Kentuckian who served as secretary of state and a United States senator, was the first to import Herefords, a bull and two heifers, to North America in 1817. Many more importations followed Clay's, and by the 1870s more than 3,700 Herefords had been brought to North America from England. The breed spread westward with the country's expansion, and its influence on western rangeland grazing can still be seen today. In the 1890s, Hereford breeders developed a polled strain. Polled Herefords are supported by their own breed association and breed registry, which maintains the herdbook for the Polled Herefords.

Herefords are generally short, stocky animals that are finely boned. They fatten easily and are even-tempered and relatively docile. Cows mature early, though they produce less milk than some other breeds, resulting in calves that tend to be a little lighter than some other breeds at weaning. They are hardy in cold climates but can stand a fair amount of heat.

The Hereford's distinctive white face is a dominant trait that passes down when Herefords are crossbred with other breeds.

HEREFORD

FUNCTIONAL TYPE Beef.

APPEARANCE Red with white markings on face, abdomen, feet, and tail switch.

SIZE Medium.

HORNS Either horned (widespread) or naturally polled.

CONSERVATION STATUS Not applicable.

PLACE OF ORIGIN England.

BEST KNOWN FOR Gentleness. Hardiness. Good performance in grass-based production as well as the feedlot.

Highland

PEOPLE WHO DON'T KNOW or care about cows are captivated when they see a Highland's big horns and shaggy coat, and it seems that many city slickers know a Highland when they see one. The Highland is a very old breed of cattle. In fact, some historians consider it to be the oldest and purest British breed. The first Highland herdbook was established in 1884 in Scotland, and around the same time the first Highland cattle made their way to Canada and the United States.

The breed developed largely through natural selection in the remote Highlands of Scotland. This area, which covers much of the northern half of Scotland, is extremely rugged and rocky. The Highlands is largely comprised of treeless mountains and scanty, rough forage. Its location, at a northern latitude comparable to Juneau, Alaska, results in a harsh climate. Bright sunshine is a rare treat, it snows frequently in the winter and rains frequently the rest of the year, with the western Highlands receiving up to 120 inches (305 cm) of precipitation per year, and the wind is strong, especially during the winter. This tough environment yielded an equally tough breed of cattle that copes well with exceedingly harsh weather. Highland cattle have a heavy, long hair coat that helps protect them from the elements. Their lean yet tasty meat is considered a side benefit of the long coat, which allows them to put on less fat than other breeds to stay warm. They have sturdy feet and legs, which helps account for their longevity.

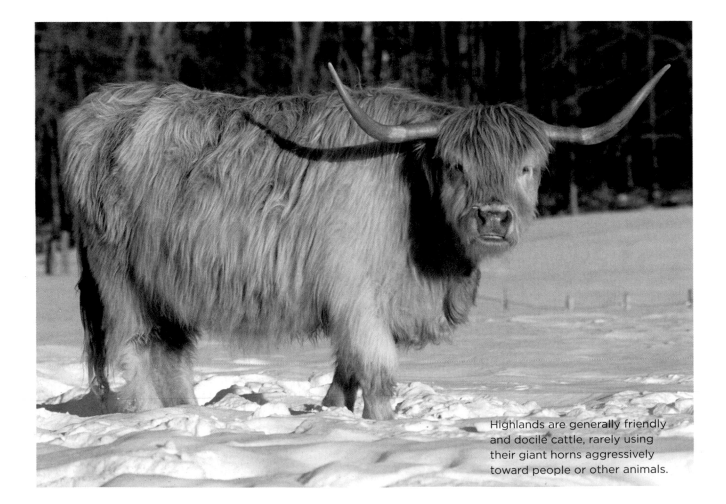

Highlands are generally friendly and docile cattle, rarely using their giant horns aggressively toward people or other animals.

Highland cattle have acclimated over centuries to the rugged terrain and climate of western Scotland (as seen here). One of the adaptations passed down through the generations is their long curly locks, which provide benefits such as insulation and insect resistance.

HIGHLAND

FUNCTIONAL TYPE Beef.
APPEARANCE Blocky build on stout legs with long, curly hair in various colors.
SIZE Medium.
HORNS Large.
CONSERVATION STATUS Recovering.
PLACE OF ORIGIN Scotland.
BEST KNOWN FOR Curly locks. Hardiness. Thriftiness.

Holstein (Friesian)

WITH ITS LARGE PATCHES of black against white (though red and white are also seen), the Holstein is one of the most readily recognized breeds of cattle in North America. Interestingly, this popular breed was misnamed. Holstein cows were developed in the northernmost areas of the Netherlands, particularly the provinces of North Holland and Friesland, where they were known as Dutch Black Pied. But the first representatives of the breed shipped to North America in the mid-1800s were sent from a port in the Holstein province of Germany. People on this side of the Atlantic began naming it after this port.

In the Netherlands, the Black Pied was a high milk-producing, dual-purpose animal. Upon arrival in North America, farmers quickly began selecting for dairy traits, and by the late 1800s the Holstein was indisputably a dairy breed.

The Holstein dominates the North American dairy herd because it is the most productive breed based on pounds of milk per cow. There is little doubt that its dominance will continue in the foreseeable future, yet recent data shows that its numbers are slipping a bit in relation to the other dairy breeds. Although Holsteins out produce other breeds on a volume basis,

their milk has a lower percentage of butterfat and protein. As more milk is used to make cheese and other dairy products, and less is sold as liquid milk, farmers are looking favorably at the other dairy breeds that produce milk with higher percentages of butterfat and protein.

The Holstein's popularity has also declined due to increased health problems associated with inbreeding purebred Holsteins. Thirty percent of the U.S. Holstein herd traces its bloodlines to just two bulls from the 1960s, and for decades the small number of bulls used as artificial insemination sires have been chosen primarily for high milk production over other traits. Their sons were then chosen as the next generation of A1 bulls, and their sons after them. As almost all Holstein cows are bred by artificial insemination, this narrowing of male lines has resulted in dramatically constricted genetics, and subsequent health and fertility problems ranging from increased calving difficulty and lower fertility to much lower longevity among Holstein cows than other dairy breeds.

Holstein producers are beginning to use crossbreeding to try to improve these traits. They are also selecting bulls based on a wider array of traits than just their production potential. The USDA's most recent data shows that Holsteins average 26,134 pounds (11,854 kg) of milk, with 965 pounds (438 kg) of butterfat and 802 pounds (364 kg) of protein.

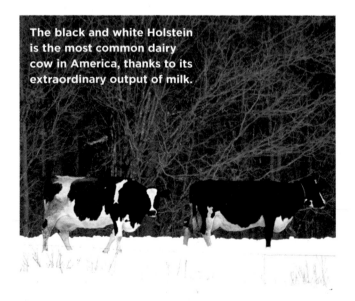

The black and white Holstein is the most common dairy cow in America, thanks to its extraordinary output of milk.

HOLSTEIN (FRIESIAN)

FUNCTIONAL TYPE Dairy.

APPEARANCE Tall. Patches of black and white or red and white.

SIZE Large.

HORNS Medium.

CONSERVATION STATUS Not applicable.

PLACE OF ORIGIN Netherlands.

BEST KNOWN FOR Production of highest volume of milk of all dairy breeds.

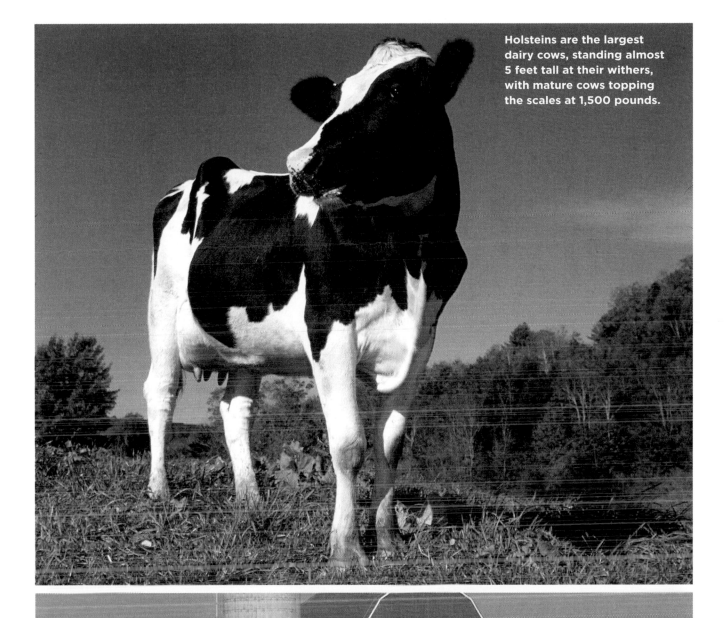

Holsteins are the largest dairy cows, standing almost 5 feet tall at their withers, with mature cows topping the scales at 1,500 pounds.

Although the black and white Holstein is by far the most common strain, there are also strains of red and white Holsteins. They are registered with the Red and White Dairy Cattle Association.

Jersey

AN OLD BREED, the Jersey takes its name from the Isle of Jersey, one of the British-ruled Channel Islands located off the coast of France in the English Channel. In 1789, importations of cattle to the Isle of Jersey were blocked by government decree, so the breed developed in isolation after that time.

The first Jersey cow was brought to North America in 1657 by George Poingdestre, an immigrant to Williamsburg, Virginia. Small numbers of Jerseys continued to cross the Atlantic with early colonists, but serious importation of the breed began in the 1850s and continued into the early twentieth century, with thousands of animals arriving in the United States and Canada.

The Jersey is the smallest of the major dairy breeds and is lovely looking with a very feminine, dished face dominated by large doelike black eyes. But its stature belies its nature. Jersey cows can be quite rowdy and playful, kicking up their heels when given half a chance, and Jersey bulls are considered to be among the most dangerous bulls. (Like Holsteins, almost all Jersey cows are bred artificially.) The breed is quite adaptable, performing well in both very hot and very cold climates.

Jersey cows are the second most common breed in the North American dairy herd, and thanks in part to their small size, they are also a favored milk cow for homesteaders. Jerseys average 19,680 pounds (8,927 kg) of milk, with 887 pounds (402 kg) of butterfat and 710 pounds (322 kg) of protein, according to USDA data. That data also indicates they have the longest productive life of any of the dairy breeds on official test with the Dairy Herd Improvement Program.

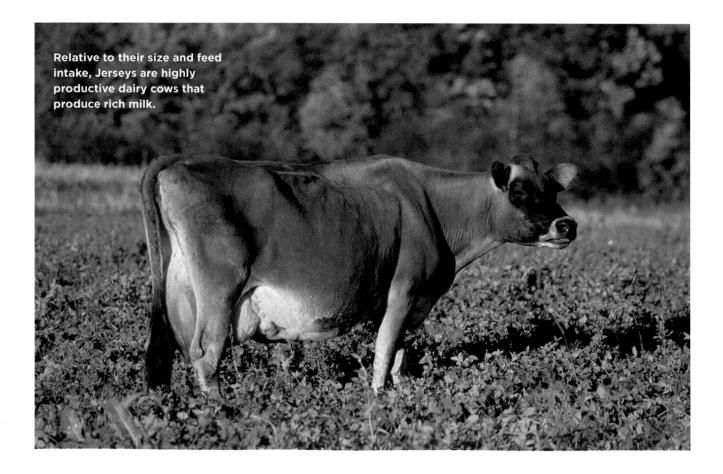

Relative to their size and feed intake, Jerseys are highly productive dairy cows that produce rich milk.

Jerseys have a distinctive dished face with large doelike eyes.

JERSEY

FUNCTIONAL TYPE Dairy.

APPEARANCE Feminine bone structure, doelike eyes, and long eyelashes. Brown color, ranging from light to quite dark, with occasional white markings.

SIZE Small to medium.

HORNS Naturally horned.

CONSERVATION STATUS Not applicable.

PLACE OF ORIGIN British-ruled Channel Island of Jersey.

BEST KNOWN FOR Production of good amounts of rich, creamy milk for body weight and feed.

Kerry

IRELAND IS THE HOME of the Kerry, a rugged little breed whose forebears were around since the early Celts took up farming hundreds of years before the birth of Christ. It is considered by many agricultural historians to be one of the oldest breeds in Europe. For centuries, the Kerry was the most common breed of cattle in Ireland. At least one Kerry could be found in most backyards providing milk and meat for the family; in fact, the breed was considered the "poor man's cow."

In 1844, Kerrys were shown at the Royal Dublin Show and from that exposure became a rich man's pet cow in England. The first herdbook (shared with the Dexter) was started in 1887. The first North American importation was made to the United States in 1818. As in Ireland, the breed enjoyed success as a backyard milk cow, but by the 1930s, few people kept a family cow, and the breed's numbers dropped off quickly. At about the same time, herd numbers began dropping in Ireland and England as well.

By the 1980s, the Kerry breed was critically endangered worldwide, with only around 200 animals left. Efforts by the Irish government, as well as groups such as the Rare Breeds Survival Trust, the American Livestock Breeds Conservancy, and Rare Breeds Canada, have helped increase numbers somewhat. Though still critically endangered, its chance for survival is improving.

Kerrys are slow growing but long-lived, with cows still easily producing calves into their teens. They are quite hardy and nimble, doing well in rough country. The cows produce a surprisingly good amount of milk off nothing but forage (between 7,000 and 10,000 pounds [3,176 and 4,536 kg] per year), and the milk is quite high in butterfat and protein. The butterfat globules are smaller than those found in other cows' milk, meaning it, like goat's milk, is more easily digested by individuals who generally have trouble with cow's milk.

The Kerry makes great sense for anyone who's thinking of getting just a couple of cows for hobby farm or homestead use.

KERRY

FUNCTIONAL TYPE Dairy.

APPEARANCE Petite. Dairy-type body. Usually black, though red is a recessive color; may have some white markings.

SIZE Small to medium.

HORNS Medium, upright horns that are white with a black tip.

CONSERVATION STATUS Critical.

PLACE OF ORIGIN Ireland.

BEST KNOWN FOR Good production of milk with a high percentage of butterfat and protein relative to size and feed, including on poorer-quality pastures.

Limousin

LIMOUSIN, A PROVINCE in central France, is known for two exports: the fine china of Limoges, and its namesake cattle, the chestnut-colored Limousin breed. A beautiful but rugged region of hills, high plateaus, and forests, Limousin has abundant moisture and rather poor, granitelike soil. These harsh conditions contributed to the hardiness and thriftiness of the Limousin cattle. In spite of rough conditions, the cattle of Limousin, which had been raised in isolation for many centuries, produced high-yielding, tender beef with little excess fat between the muscles. These traits earned it the nickname "the butcher's animal" in midnineteenth-century France after Limousin cattle regularly won top honors at major agricultural shows of the time.

During the 1960s, a number of cattlemen from Canada and the United States were interested in the breed after seeing them in France, but due to a foot-and-mouth disease outbreak in France, imports were difficult. In 1968, fifteen cattlemen formed the North American Limousin Foundation (NALF) and worked to get Limousin cattle on this side of the Atlantic. The first import to Canada was made in late 1968. The first semen imports came to the United States from the Canadian Limousin herd in 1969, with the first live animals (born in Canada) arriving in 1971. Since the arrival of those first imports, NALF has registered nearly two million animals, and during the 1990s, the breed had the third highest number of registrations in the U.S. beef herd, behind the Angus and Hereford registries.

LIMOUSIN

FUNCTIONAL TYPE Beef.

APPEARANCE Golden red is the original color, but some animals are dark brownish red to almost black.

SIZE Medium.

HORNS Either horned or naturally polled.

CONSERVATION STATUS Not applicable.

PLACE OF ORIGIN France.

BEST KNOWN FOR Feed efficiency with good carcass yield and quality. Hardiness. Mothering abilities.

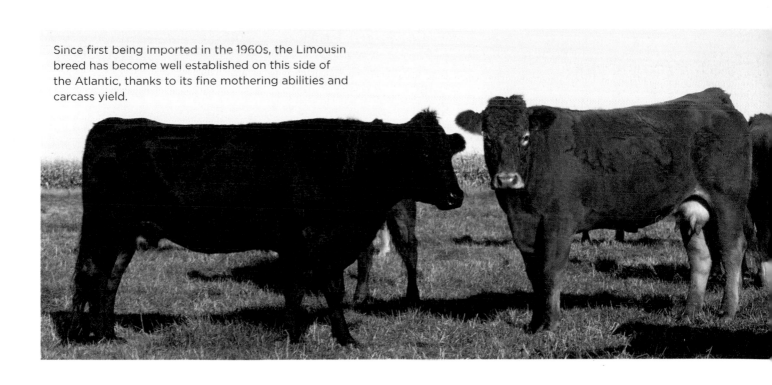

Since first being imported in the 1960s, the Limousin breed has become well established on this side of the Atlantic, thanks to its fine mothering abilities and carcass yield.

Lincoln Red

THE LINCOLN RED was developed in the late 1700s by crossing Shorthorn bulls with the old native cattle of Lincolnshire, England. These Lincolnshire natives were large draft cows that adapted well to the cold weather and stiff North Sea winds of northeastern Britain. The improved Lincolnshire was a red or red and white cow that could still work as a draft animal but made better beef and produced more milk than the old Lincolnshires.

In 1822 the breed was recognized in the Shorthorn herdbook, but in 1896 a separate herdbook for the Lincoln Red was formed. The breed thrived first as a multipurpose breed. In 1926 the Lincoln Red had the second highest number of registrations, right behind Shorthorns, of any breed in Britain. By the 1950s, it became identified as a beef breed and remained popular in Britain into the 1970s. However, it didn't convert feed on concentrated rations as efficiently as other beef breeds, and by the 1980s its numbers began dropping sharply.

Lincoln Reds were first imported to Canada in 1825. They were well adapted to Canada's harsh climate, but their lower feedlot performance resulted in the same downward slide as had occurred in Britain. A small following of producers who appreciate their hardiness, longevity, easy calving, and good production on rough forage has continued to keep the breed. The breed still requires no pampering and performs extremely well in grass-fed production systems. Lincoln Reds are early maturing and have excellent feet and legs.

LINCOLN RED

FUNCTIONAL TYPE Beef.

APPEARANCE Stocky. Cherry-red coat.

SIZE Medium.

HORNS Either horned or polled.

CONSERVATION STATUS Endangered (Rare Breeds Canada and Rare Breeds Survival Trust).

PLACE OF ORIGIN England.

BEST KNOWN FOR Good production in grass-based systems. Easy calving. Longevity.

Some historians believe that the Lincoln Red's ancestry dates back to Viking cattle introduced to Britain over 1,200 years ago. All Lincoln Reds have a deep cherry-red coat.

Lineback

THE TERM *LINEBACK* generally refers to a color pattern that is a strong recessive trait and can be found occasionally in any number of cattle breeds. A lineback animal has a prominent white stripe down its back, while its black, blue-black, or red sides may be solid, spotty, patched, or roan (colored hairs and white hairs mixed). The underbelly is usually white, and the area around the eyes, the ears, and the muzzle is usually colored.

The roots of lineback cattle in North America go deep. At least one lineback cow was documented at the Plymouth colony in 1627, and herds of lineback cattle were quite prevalent in some geographic areas of North America in the 1800s. Most were dual-purpose animals with strong dairy traits, but most disappeared in the twentieth century as dairy farmers moved toward higher production from Holsteins. A few farmers held on to their lineback herds, and from these, two *landraces* (locally developed and adapted breeds) of lineback cattle have been recognized: the Canadian Lynch Lineback and the Randall Lineback. These are old-type cows that are more dual-purpose than specialized, but both have fairly strong dairy characteristics. There is also a registry that accepts all lineback dairy cattle, regardless of breed origination.

(continued)

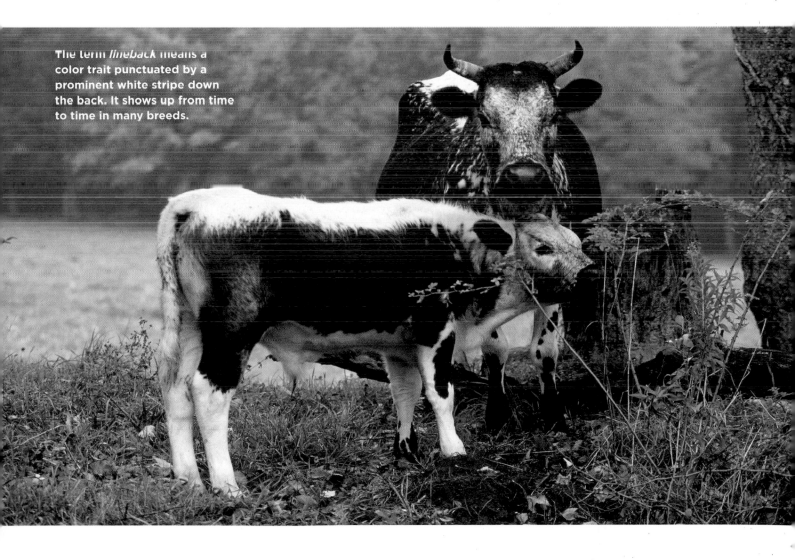

The term *lineback* means a color trait punctuated by a prominent white stripe down the back. It shows up from time to time in many breeds.

Lineback (continued)

CANADIAN LYNCH LINEBACK

Robert Lynch's family maintained the Canadian Lynch Linebacks in Mallorytown, Ontario. Lynch tells me that his grandfather kept a record book, in which he writes of receiving lineback cows from his father-in-law, Lynch's great-grandfather, around 1892. The family has kept linebacks as part of their ranching operations ever since.

Canadian Lynch Linebacks are a dual-purpose breed with good milking qualities. They are very hardy, and they do well on pasture. They are also very long-living cattle; Lynch tells of milking "Lois" until she was 23, and of milking other cows into their late teens.

Rare Breeds Canada recognized the value of the Lynch family's lineback cattle and has been supporting efforts to maintain the breed, including making available semen from one of Lynch's bulls. Lynch isn't sure of the lineage of his lineback cattle, and to date no DNA testing has been performed on the animals. He says, "There is little or no documentation about these lineback cattle, though they were very popular around here at one time."

RANDALL LINEBACK

The Randall Lineback cattle have the distinction of being recognized by the State of Vermont as a State Heritage Breed. They are fairly representative of the linebacks that were common throughout New England, the mid-Atlantic states, and southeastern Canada in the 1800s.

In 1985, Everett Randall of Sunderland, Vermont, passed away and his widow could not keep the family's unique herd, which had been closed to the introduction of outside blood for 80 years. There was no one left in the family to take them, and after the USDA implemented a dairy-herd buyout and culling program in 1985, there were no local farmers interested in acquiring the herd.

The cows changed owners a couple of times, with much of the herd lost. Ultimately Tennessee hobby farm owner Cynthia Creech bought 15 head (5 cows, 4 heifers, a herd bull, 2 yearling bulls, a weanling bull, and 2 calves). Creech had read an article about the herd. She didn't have much experience, but she had plenty of heart and wanted to save them from certain extinction. She worked with Dr. Phil Sponenberg, a technical advisor with the American Livestock Breeds Conservancy, to develop a breeding strategy that would maintain as much diversity within the breed as possible from such a small pool of bloodlines.

Today there are about 200 Randalls nationwide, and the number is growing, with herds in several states, and even a few in Canada with Robert Lynch. They don't produce as much milk as other dairy breeds, but those milking the Randalls are very impressed with the cheese-yield quantity and quality. Their milk is favored by several artisan cheese makers. Like other heritage breeds, they are hardy, long-lived, and do well on grass. Their main color is blue-black, but they are also known to throw red calves from time to time.

AMERICAN DAIRY LINEBACK

There is also a third type of lineback, the American Dairy Lineback. A registry, started in 1985, accepts registrations for dairy animals with the lineback color pattern. This registry includes some animals of historic breeding as well as many cattle that have Holstein, Milking Shorthorn, or the bloodlines of other breeds that have been added within the past half century or so. Thus, the American Livestock Breeds Conservancy says, "This population falls short of the genetic definition of a breed." With time, the breeders may stabilize these lines to the point that animals registered by the American Dairy Lineback Association are clearly recognized as a distinct breed. With the infusion of Holstein blood, breeders say their animals produce similar quantities of milk to Holsteins but with higher solids. They also indicate that their animals have better feet and legs.

AMERICAN DAIRY LINEBACK

FUNCTIONAL TYPE Dairy.

APPEARANCE Varied lineback coloring.

SIZE Medium to large.

HORNS Either horned or naturally polled.

CONSERVATION STATUS Not applicable.

PLACE OF ORIGIN Not applicable.

BEST KNOWN FOR Not genetically distinct as a breed, but a registry for lineback-colored dairy animals.

Any dairy cow with lineback coloring is eligible for registration with the American Dairy Lineback Association.

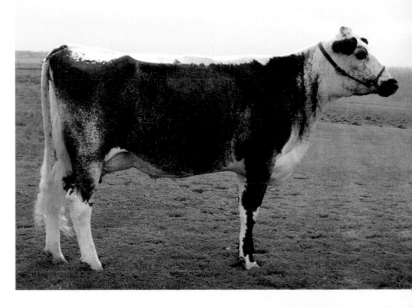

CANADIAN LYNCH LINEBACK

FUNCTIONAL TYPE Dual-purpose, milk and meat.

APPEARANCE Black sides with white dorsal stripe and white underbelly.

SIZE Medium.

HORNS Either horned or naturally polled.

CONSERVATION STATUS Critical.

PLACE OF ORIGIN Ontario.

BEST KNOWN FOR Coloring. Longevity. Good production on pasture.

The Canadian Lynch Lineback represents a unique strain of cattle.

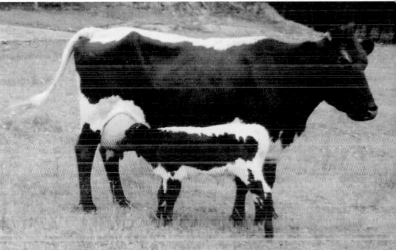

RANDALL LINEBACK

FUNCTIONAL TYPE Dairy.

APPEARANCE Dairy-type frame. Primarily blue-black (sometimes red) sides with white dorsal stripe and underbelly.

SIZE Medium.

HORNS Medium, lyre-shaped.

CONSERVATION STATUS Critical.

PLACE OF ORIGIN Vermont.

BEST KNOWN FOR Status as the State Heritage Breed of Vermont. Excellent cheese yield and quality.

The Randall Lineback is a good choice for small-scale dairy producers working with artisan cheese makers.

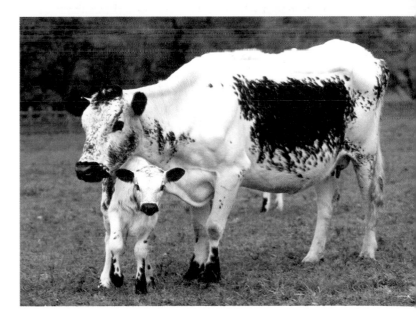

Lowline

THE LOWLINES WERE first developed at an agricultural research center in Trangie, a small valley town about 300 miles northwest of Sydney. In 1914, the government of New South Wales, Australia, charged the center with improving Australian cattle genetics. To accomplish that, they began importing and breeding top-quality Angus bulls and cows from Scotland, Canada, and the United States to some of the best Angus lines that were already in the country.

In 1974, researchers at Trangie began a new project designed to evaluate selection and production criteria to better understand how growth rate impacted herd profitability. They grouped their herd into three subgroups: one made up of the largest- and fastest-growing members of their herd, one of the smallest and slowest-growing, and a mixed group to serve as a control group. They continued breeding these three closed-herd subgroups over the next 19 years to determine whether the larger and faster-growing or the smaller and slower-growing animals were more efficient converters of grass into meat, and subsequently, meat into profits. The high yearling growth rate cattle were named the High lines and the low yearling growth rate cattle were named the Low lines. The researchers found that the Low line cattle, which were roughly 30 percent smaller than the High line cattle, were at least as profitable as the High lines on grass, and due to their size, they were easier to care for.

By the early 1990s, the New South Wales Department of Agriculture was ready to pull the plug on the experiment. They planned to send the animals to slaughter, but a handful of Australian cattle breeders intervened and purchased the Low line animals, which they dubbed Lowline. They saw value in the small, docile, and very well conformed herd and believed that they offered smaller landowners in particular a viable option for producing cattle.

A consortium of Canadian ranchers first imported the cattle to Canada in 1996. Two days after the cattle arrived, North Dakota rancher Neil Effertz went to see them at the ranch of Henry BeGrand. He immediately made arrangements to buy and import one of the heifers to the United States and to buy embryo-implanted cows. Both ranchers recognized the smaller animals' potential to increase ranchers' profits, thanks to their higher carrying capacity and other production traits.

The Lowlines are quite small compared to most modern cattle, which were being bred for increased size during the same period as the Trangie researchers were breeding these down, but they are excellent meat producers. They have a very high proportion of meat to bone, and their rib eye is 30 percent larger per hundredweight of body than the rib eye of the modern Angus. They produce high-quality, tender meat off grass, but when used in crossbreeding, their offspring perform very well in confinement, according to research from North Dakota State University. Cows are excellent mothers known for breeding back quickly after giving birth, and calves are very hardy in spite of their small size.

There is some debate as to whether Lowline cattle should be considered a unique breed or strictly a strain of Angus that more closely reflects traditional Angus size and conformation. I've chosen to see them as a breed in part because of the cohesiveness and focus of the Lowline breeders and in part because the American Lowline Registry requires DNA analysis for registration of full-blown animals that shows animals can be traced back to the original Trangie herd.

LOWLINE

FUNCTIONAL TYPE Beef.

APPEARANCE Black.

SIZE Small.

HORNS Naturally polled.

CONSERVATION STATUS Not applicable.

PLACE OF ORIGIN Australia.

BEST KNOWN FOR Low maintenance, easy calving, good growth, good meat-to-bone ratio, and high-quality, well-marbled meat. Produce well on grass.

Lowline cattle are highly productive relative to their size.

Maine-Anjou

IN THEIR NATIVE FRANCE, Maine-Anjou are still often bred for dual-purpose traits, but since their importation to Canada in 1969, North American Maine-Anjou cattle have been selected for beef production and used in crossbreeding. The breed was developed in northwestern France beginning in 1839, when the Count de Falloux imported English Durham cattle (the breed that was refined to produce the Shorthorn) and crossed them with the region's native breed, the Mancelle.

The Count de Falloux's cross became popular in the region and won awards at agricultural shows in France. Breeders formed the Society of Durham-Mancelle Breeders in 1908, but they changed the name to the Society of Maine-Anjou Breeders in 1980. The Maine and the Anjou are important rivers in northwestern France. The Maine-Anjou spread to the United States by importations of semen from live cattle that had been imported to Canada. The North American version of the breed was developed through an up-grading program.

In France, the Maine-Anjou is always dark red with white markings and horns, but the North American breed also shows solid black or red, and polled or scurred (stubby horns) as a result of the crossbreeding used in developing the breed here. It is fast growing and yields a high percentage of prime and choice cuts at the butcher. The breed does have two genetic defects, but the American Maine-Anjou Association has worked with scientists at AgriGenomics in Mansfield, Illinois, to identify carriers, so that breeders can select stock that will not pass the defects to their offspring.

The Maine-Anjou is an excellent breed for commercial beef production. Animals finish well in the feedlot, yielding choice and prime cuts.

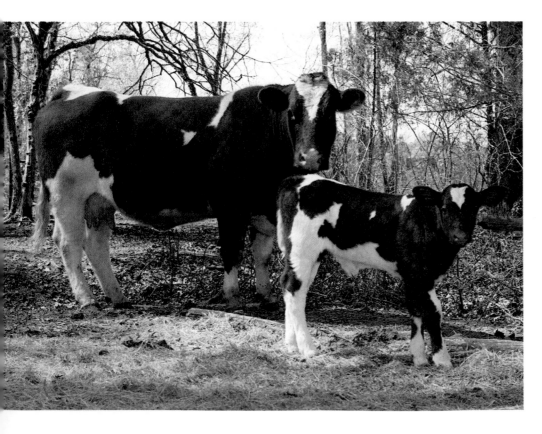

MAINE-ANJOU

FUNCTIONAL TYPE Beef.

APPEARANCE Dark red to black with some white markings, particularly on belly, rear legs, and tail.

SIZE Large.

HORNS Horns curled forward or polled.

CONSERVATION STATUS Not applicable.

PLACE OF ORIGIN France.

BEST KNOWN FOR Fast growth. High-quality meat production.

Marchigiana

LIKE THE CHIANINA, the Marchigiana (pronounced mar-kee-jah-nah) hails from Italy. Its name refers to the province northeast of Rome, Marche, where it was developed. In the late nineteenth and early twentieth centuries, farmers crossed the native Podolian cattle (a draft breed that has been documented in Italy since the fourth century and was once widespread throughout the Mediterranean, Eastern Europe, and into the Asiatic steppes) with Chianina and Romagnola bloodlines. The goal was to obtain a breed that did well on the poor-quality mountain forage of east-central Italy and coped with weather that varied from very hot and dry in summer to very cold and wet in winter.

The Marchigiana has been recognized as a breed in Italy since 1932, and the first herdbook was organized in 1957. Originally it was a dual-purpose breed, but since the 1950s it has been bred primarily for beef production. The Marchigiana represents about 45 percent of the cattle herd in Italy today.

Like a number of other Continental breeds, the "Markies" came to North America during the early 1970s. Most animals registered in North America today are from an up-breeding program.

The Marchigiana is smaller than the Chianina, but it is still a large animal by North American standards. Double muscling is seen in the Marchigiana breed, which is known for lean but tender beef. Markies are also known for maturing early, and the cows are good mothers.

The Marchigiana is a particularly good commercial breed, performing well in the feedlot and grading out largely at choice and prime.

MARCHIGIANA

FUNCTIONAL TYPE Beef.

APPEARANCE White to steely gray coat, with dark snout. Dark ring around eyes and dark tail switch.

SIZE Large

HORNS Either horned (short and white with black tip) or naturally polled.

CONSERVATION STATUS Not applicable.

PLACE OF ORIGIN Italy.

BEST KNOWN FOR High-quality beef. Early maturity.

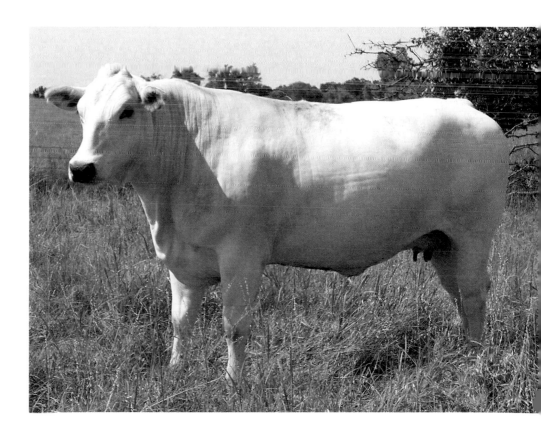

Murray Grey

NAMED FOR THE MURRAY RIVER in southeastern Australia, as well as for its gray color, the Murray Grey is the result of a genetic oddity. In 1905, a rancher in New South Wales discovered that one of his cows, a roan-colored Shorthorn, had gray calves whenever she was bred to an Angus bull. The rancher, Peter Sutherland, kept the animals in his herd.

Family members and neighboring ranchers began breeding some of the offspring and found the gray color to be dominant. They also found that the cattle performed well, and that butchers paid a premium for the cattle, which yielded excellent meat (tender, with good marbling but not an excess of intermuscular fat) when butchered straight off grass with no grain. The breed's influence grew in Australia and New Zealand, and the breed became an important export for Aussie producers selling to Japan and other high-end international meat buyers.

The Murray Grey was imported to North America beginning in 1969, and most of today's North American herd is the result of crossbreeding with other cattle. Grass-fed beef producers are attracted to the outstanding quality of meat that a Murray Grey can produce when raised only on pasture. The breed is also known for a docile temperament, easy calving, and good mothering abilities.

MURRAY GREY

FUNCTIONAL TYPE Beef.
APPEARANCE Dark gray skin and silvery gray to dun hair.
SIZE Medium.
HORNS Naturally polled.
CONSERVATION STATUS Not applicable.
PLACE OF ORIGIN Australia.
BEST KNOWN FOR Consistently finishing at choice directly off grass. Easy calving.

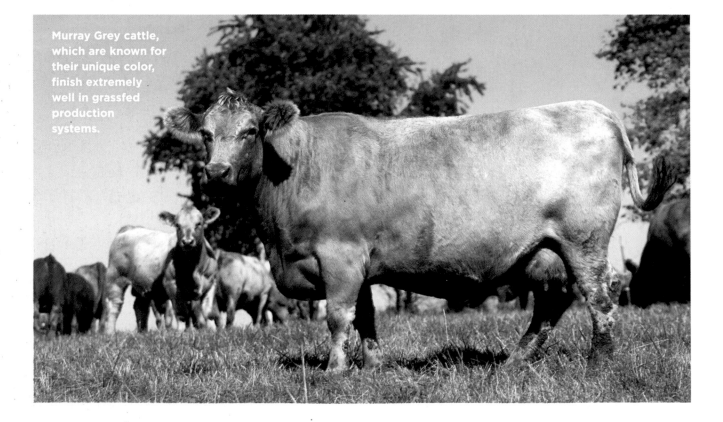

Murray Grey cattle, which are known for their unique color, finish extremely well in grassfed production systems.

Normande

AN OLD DUAL-PURPOSE breed, the Normande was developed from a number of ancient French breeds, including some that were possibly brought to the Normandy region by Viking sailors during the ninth and tenth centuries. Some Durham bloodlines were also added during the 1800s. In 1883, the French began a herdbook for the Normande and the breed prospered, producing rich milk and excellent meat. Many Normande cattle were killed during World War II, when Allied forces invaded Normandy, but today the breed has made a comeback. There are more than three million head in France (and at least that many in South America).

(continued)

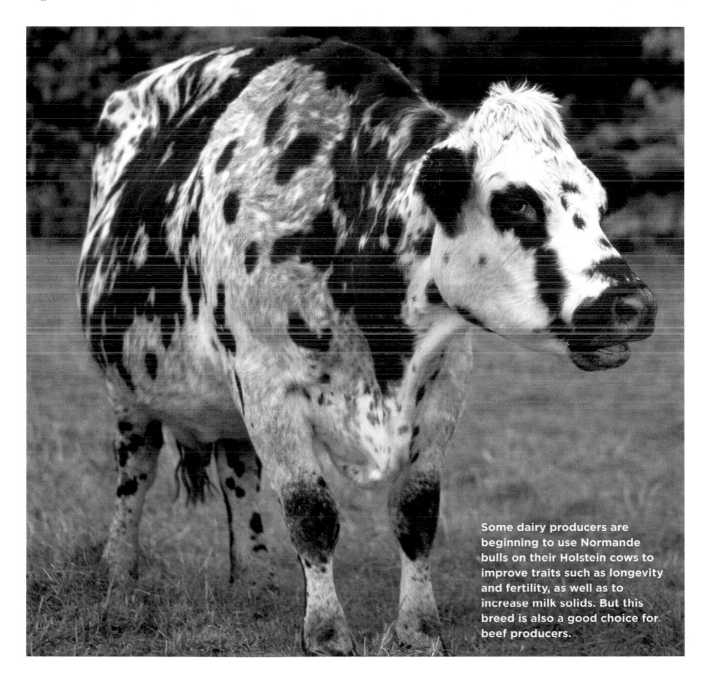

Some dairy producers are beginning to use Normande bulls on their Holstein cows to improve traits such as longevity and fertility, as well as to increase milk solids. But this breed is also a good choice for beef producers.

Normande (continued)

The Normande got its start in North America in the mid-1970s, when several U.S. beef producers imported 23 heifers, 6 bulls, and semen from 9 other bulls. A small cadre of these producers formed the first breed association, but internal strife held back the breed association, and the breed, for many years. During the late 1980s and early 1990s, the breeders reorganized with new leadership and began promoting the breed both for beef and dairy (particularly for crossbreeding). They also arranged for the importation of additional semen from some of France's top dairy-character bulls.

Normande cows give a very high amount of milk solids, making their milk particularly valuable for cheese making. They produce about 12,000 to 14,000 pounds (5,443 to 6,350 kg) per year. Their meat is very tender and well marbled. Interestingly, geneticists have found an allele unique to the breed that contributes to their unusual color but that also seems to be associated with their high-quality milk and meat production.

They have many of the other traits dual-purpose cattle are known for, such as high fertility, easy calving, and great hardiness. They do well in very hot climates (they are common throughout South America), as well as in very cold climates.

NORMANDE

FUNCTIONAL TYPE Dual-purpose, meat and dairy.

APPEARANCE Spotted cattle in black or red against a white background, with "black eyes" or spots around the eye; can also have brindled spots (black hairs among the red).

SIZE Medium to large.

HORNS Originally all Normande cattle had short horns, but today there is a polled strain in North America.

CONSERVATION STATUS Not applicable.

PLACE OF ORIGIN France.

BEST KNOWN FOR High-quality meat and milk from a highly adaptive breed.

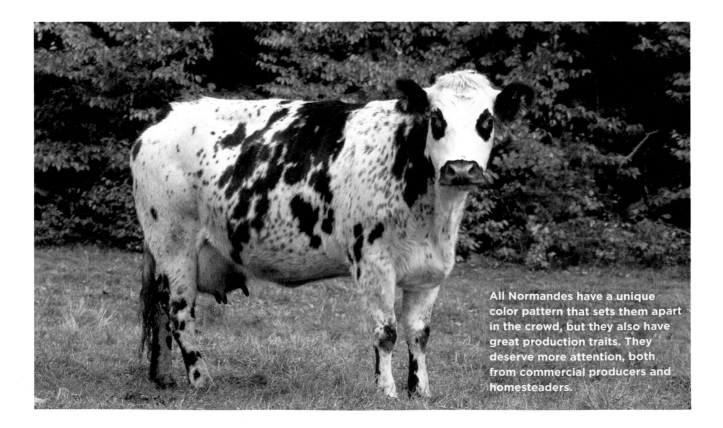

All Normandes have a unique color pattern that sets them apart in the crowd, but they also have great production traits. They deserve more attention, both from commercial producers and homesteaders.

Norwegian Red

ALSO KNOWN AS the Scandinavian Red, the Norwegian Red is an amalgamation of a number of breeds. Beginning in the early years of the 1960s, Norwegian breeders began registering the traditional Norwegian Red-and-White cattle, the Red Trondheim, the Red Polled Østland, and the Døle all in one registry. During the late 1960s and the early 1970s, other breeds, including South and West Norwegians, Ayrshires, Swedish Red-and-Whites, Friesians, and Holsteins, contributed genes to animals under the designation of Norwegian Red. By 1975, 98 percent of the Norwegian national herd was listed under the name Norwegian Red, and Norway's farmers selected heavily based on production traits for milk production, fertility, and growth rate in offspring.

The first Norwegian Reds were imported to North America in 1973. They didn't become very popular on this side of the Atlantic, but, in recent years, there has been renewed interest in the breed, particularly among Holstein dairy farmers looking to improve health-related traits while maintaining high production. Thanks to favorable research from the University of Minnesota's Dairy Science Department that showed Norwegian Red–Holstein crosses produce milk volumes comparable to straight Holsteins with higher fat and protein and greatly improved fertility and overall health, U.S. dairy farmers imported 70,000 straws of Norwegian Red semen in 2004 alone.

NORWEGIAN RED

FUNCTIONAL TYPE Dairy.

APPEARANCE Red and white.

SIZE Medium to large.

HORNS Either horned or polled.

CONSERVATION STATUS Not applicable.

PLACE OF ORIGIN Norway.

BEST KNOWN FOR Crossbreeding with Holsteins to improve health traits.

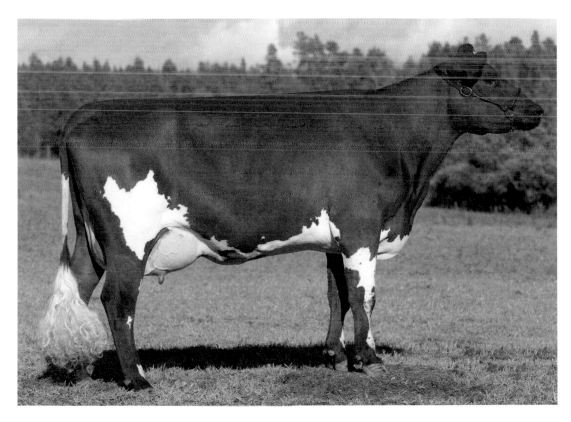

The Norwegian Red has definitely found a niche for crossbreeding with Holsteins. I know of no herds of purebred Norwegian Reds on this side of the Atlantic, but semen is readily available.

Parthenais

ANOTHER OLD FRENCH BREED (its herdbook dates back to 1893), the Parthenais (pronounced par-ten-ay) comes from the midwestern region of France. Although it was originally a triple-purpose breed raised for draft, meat, and milk, French breeders have been selecting for beef traits and using progeny testing since the 1970s. Today, it is clearly a beef animal, with double muscling common among breed members. They were imported to Canada in the early 1990s, and from there to the United States. Breeders from the United States and Canada formed a breed association in 1995.

Parthenais cattle are known for producing excellent carcasses, yielding a large amount of meat that is tender and lean. Although double-muscled animals often have lower fertility or trouble calving, the Parthenais is supposed to do better than other double-muscled breeds on these counts, in part because the muscle is an intermediate between regular muscling and full double muscling. Bulls and cows are highly fertile, and the majority of calves are born without assistance. At birth, the calves are dark brown, but they lighten with age to a golden-hued brown accentuated by light coloring around the large, dark eyes and the muzzle, which is set off by a dark snout.

The Parthenais is a generally docile breed. The cattle are rugged animals that have very strong feet and legs, meaning they do well in rough terrain.

PARTHENAIS

FUNCTIONAL TYPE Beef.

APPEARANCE Reddish brown with dished face.

SIZE Medium to large.

HORNS Small.

CONSERVATION STATUS Not applicable.

PLACE OF ORIGIN France.

BEST KNOWN FOR High yield. Fewer calving difficulties than other double-muscled breeds.

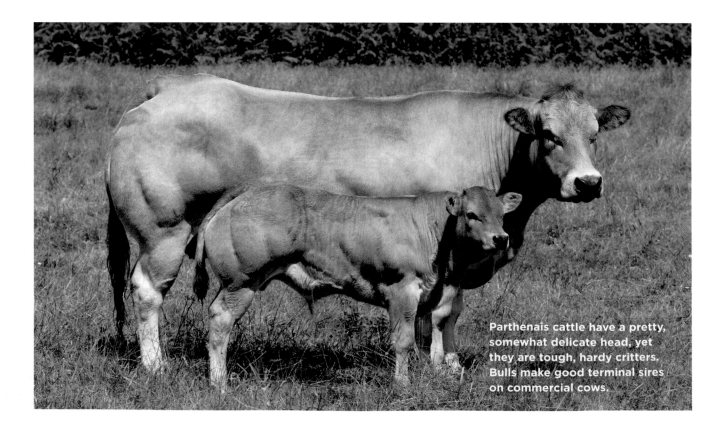

Parthenais cattle have a pretty, somewhat delicate head, yet they are tough, hardy critters. Bulls make good terminal sires on commercial cows.

Piedmontese

KNOWN AS ITALY'S BREADBASKET, the Piedmont is a large, agriculturally rich lowland valley bordered by the Alps on three sides. It is home to the Piedmontese, a breed that Italian scientists consider to be the most ancient breed in Italy. The breed shows both *Bos taurus* and *Bos indicus* influence, and the *Bos indicus* heritage has been documented in fossils and cave drawings within the Piedmont region that date back 25,000 years.

Piedmonteses were first imported to Canada in 1979, and several additional importations to both Canada and the United States occurred over the next several years. From these original importations of roughly a dozen animals and some semen, the breed has been developed through up breeding with North American cattle. The first North American Piedmontese breed association formed in 1984.

Winters in the Piedmont area are long, cold, and foggy, while summers are hot and sultry in the flat areas, and cooler in the hills and mountains. The region is known for high-quality pastures. Thanks to the climate and Italy's still-pastoral agricultural practices, the breed developed good adaptability to a variety of weather conditions, as well as excellent foraging capacity. And due to its long relationship with the farmers of the region, it is quite docile. The Piedmontese is a double-muscled breed with excellent-quality meat that is both lean and tender. The calves grow fast and mature quickly and have a fine-bone structure, so meat yields are high. *(continued)*

PIEDMONTESE

FUNCTIONAL TYPE Beef.

APPEARANCE Grayish brown to light gray to white, with black, around eyes, nose, tail switch, and possibly other points.

SIZE Medium.

HORNS All are horned in Italy (black in immature animals; yellow at the base, black at the top for mature animals), but both horned and polled are found in North America.

CONSERVATION STATUS Not applicable.

PLACE OF ORIGIN Italy.

BEST KNOWN FOR High-yielding carcass with lean but tender meat.

Piedmonteses have long, productive lives and excellent feed-conversion ratios. The bulls are good terminal sires.

Piedmontese (continued)

Farmers and ranchers are often concerned about sunburn and its complications with light-colored animals, but Piedmontese have black skin, so they do not suffer from sunburn.

Pineywoods

LIKE THE FLORIDA CRACKER, the Pineywoods developed in the southeastern United States (northern Florida, Georgia, Alabama, and Mississippi) from cattle brought there by early Spanish explorers. But, according to Tim Olson of the University of Florida's Department of Animal Science, the Pineywoods differ from the Florida Cracker in that some northern European bloodlines, such as Shorthorn, Devon, Angus, and Charolais (and perhaps some French breeds brought to Louisiana by early settlers), were added early in its development.

The southeastern United States is known for its pine forests and sandy soils that yield lots of low-quality forage, abundant parasites, and disease-causing organisms. During the early phases of the breed's development, it was also an area where predators could easily dine on cattle that weren't wily. The Pineywoods cattle evolved to cope with these conditions. They are naturally resistant to most diseases, they are able to forage on the rough, native vegetation of the South that would starve commercial cattle, and they are "dryland" cattle that have evolved to avoid predators by spending only a minimum amount of time at their water holes. Because they spend little time getting water, they don't tend to cause excessive bank erosion or fouling of water sources, making them very low-impact cattle. They are also known for high fertility, good mothering, and longevity.

The Pineywoods breed has been successfully nominated by the American Livestock Breeds Conservancy to Slow Food USA's Ark of Taste (see page 38). It has also been identified by the Renewing America's Food Traditions, or RAFT, partnership (which includes Slow Food, the American Livestock Breeds Conservancy, Seed Saver's Exchange, Chef's Collaborative, and other nonprofit organizations) as one of the Ten Most Endangered Foods in the United States.

PINEYWOODS

FUNCTIONAL TYPE Beef.
APPEARANCE A variety of colors and patterns.
SIZE Small to medium.
HORNS Most are horned.
CONSERVATION STATUS Critical.
PLACE OF ORIGIN Southeast United States.
BEST KNOWN FOR Adaptability to the humid Southeast. Excellent parasite and disease resistance.

The Pineywoods' excellent combination of traits should make it a good choice for anyone considering small-scale, grass-fed, direct-market beef production in the Southeast.

Pinzgauer

DEVELOPED IN THE ALPS (Austria, Germany, and to a lesser extent, Italy), the Pinzgauer was traditionally a triple-purpose breed used for meat, milk, and draft. Its ancestral stock was found in the mountains for many centuries (some sources say it dates back to the Roman Empire), but selective breeding began in earnest in the eighteenth century. The breed, which takes its name from the Pinzgau region of Austria, became a dominant breed throughout a large swath of Europe during the nineteenth century, but today it is endangered there.

Pinzgauers were imported to Canada in 1972, and to the United States in 1976. Most animals in North America are from up-breeding programs. Although the Pinzgauer was a dual-purpose breed in Europe, today's North American herd is purely a beef-type animal. It is among the earliest to mature of all beef breeds and produces very tender beef, as documented by the USDA Meat Animal Research Center in Nebraska. In spite of coming from the Alps, the breed does surprisingly well in hot climates and has fairly high resistance to ticks and other insects. Cows show good maternal traits, and the breed is quite docile.

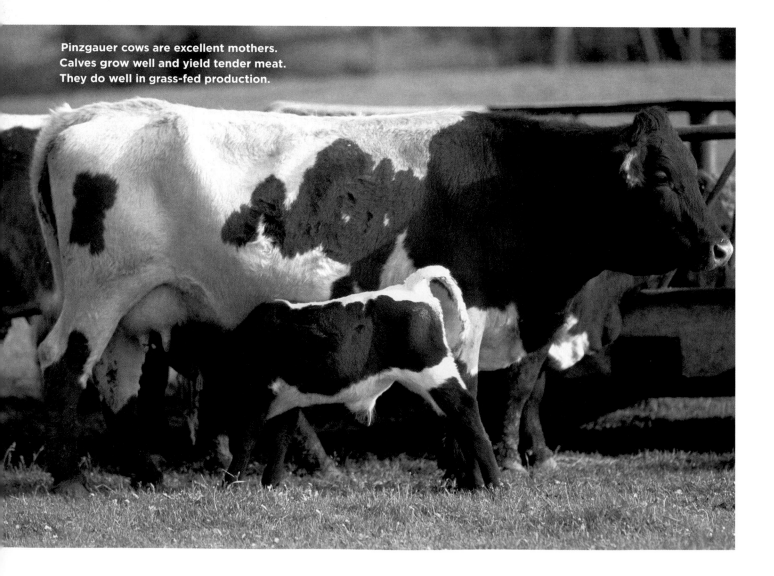

Pinzgauer cows are excellent mothers. Calves grow well and yield tender meat. They do well in grass-fed production.

PINZGAUER

FUNCTIONAL TYPE Beef.

APPEARANCE Dark red and white in a lineback pattern.

SIZE Large.

HORNS Either horned or polled.

CONSERVATION STATUS Not applicable.

PLACE OF ORIGIN Germany, Austria, Italy.

BEST KNOWN FOR Tender beef.

Red Poll

DURING THE NINETEENTH CENTURY, the Red Poll evolved as a dual-purpose breed in Norfolk and Suffolk counties (in eastern England) from two now-extinct native breeds, the Norfolk, a red and white horned animal with good beef traits that probably came to England with Vikings around the time of Christ, and the Suffolk Dun, a polled cow that was known for exceptional milk production relative to its size and feed intake. By the mid-1800s, the two counties had merged their agricultural societies, and in 1874 they established a herdbook.

The Red Poll remained a popular breed in eastern England until the middle of the twentieth century, when farmers began moving to the Friesian (Holstein) for dairy production and Red Poll numbers plummeted. In the 1980s, England's Rare Breeds Survival Trust recognized the breed as endangered and worked with the remaining breeders to revitalize the breed association and stave off the Red Poll's extinction in Britain.

The first Red Polls reached North America in the late 1800s, and hundreds more followed. The breed was very well received in North America, so its numbers increased quickly, and a breed association was formed in the United States in 1883, and in Canada in 1906. The breed remained popular until the mid-twentieth century, when the concept of dual-purpose cattle was completely abandoned. In the 1970s some beef producers began selecting for beef traits.

Today, the breed's numbers are increasing on both sides of the Atlantic as breeders recognize some of the Red Poll's strengths. Red Polls are very fertile and make good mothers. They are primarily raised as beef cattle, but they can still be used as dairy animals, especially

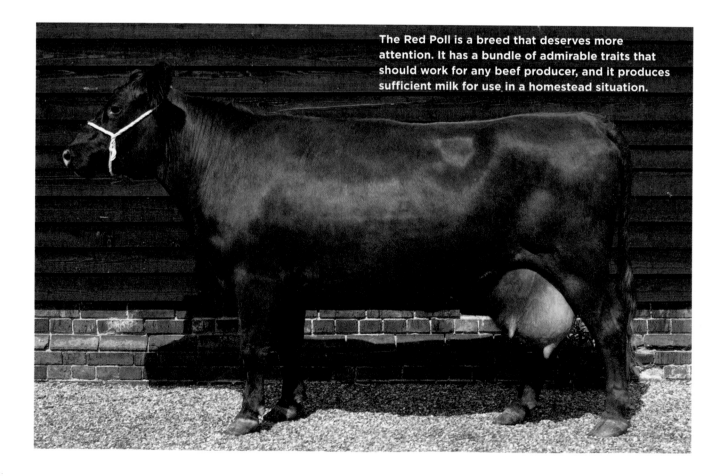

The Red Poll is a breed that deserves more attention. It has a bundle of admirable traits that should work for any beef producer, and it produces sufficient milk for use in a homestead situation.

on a homestead or a small-scale artisanal operation, producing 6,000 to 8,000 pounds (2,722 to 3,629 kg) of milk per year. Their milk is very rich with small fat globules, so people who normally have trouble drinking milk may find it easier to digest. Calves mature early and flesh out really well to yield a good-quality carcass.

They can yield excellent-tasting meat when raised on a pasture-based operation. I attended a taste testing of three kinds of steaks: commercial steaks purchased at a major grocery store, Red Poll steaks from animals finished in a commercial feedlot, and Red Poll steaks from animals that were grass-fed. The grass-fed Red Poll steak won hands down with a crowd of about 90 people. USDA research shows this wasn't a fluke. Red Polls excel in productivity on several measurements over other breeds tested.

RED POLL

FUNCTIONAL TYPE Beef (though they still have dual-purpose traits and may be used for milking).
APPEARANCE Deep, dark red (may have white tail switch or white on flanks of udder).
SIZE Medium.
HORNS Naturally polled.
CONSERVATION STATUS Threatened.
PLACE OF ORIGIN England.
BEST KNOWN FOR Good-quality meat, especially for grass-fed production. Excellent milk supply for homestead dairying. Successful use of bulls as terminal sires.

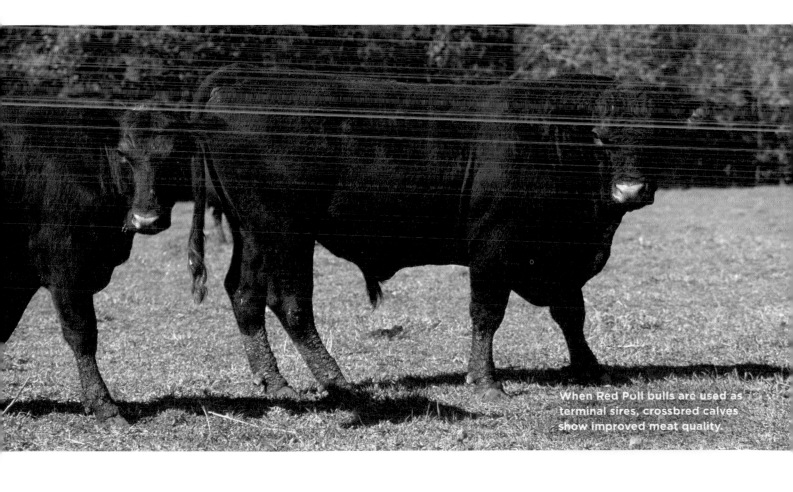

When Red Poll bulls are used as terminal sires, crossbred calves show improved meat quality.

Romagnola

THOUGH THE SMALLEST of the three white cattle breeds of Italy (see also Chianina and Marchigiana), the Romagnola is a fine, medium-size beef animal. Like the other Italian breeds imported to North America, the Romagnolas are silver-colored animals with a dark hide. They were imported to North America in the 1970s, and most animals are from an up-grading program.

The Romagnola does have some *Bos indicus* influence in its heritage. The theory put forth by breed historians is that early cattle brought to the region by the Goths (Germanic tribes that controlled much of Europe and Asia Minor in the third and fourth centuries) during their reign probably included some *Bos indicus* animals. The distant contribution of *Bos indicus* bloodlines makes the Romagnola particularly well suited to hot climates. The breed finishes with a high-yielding carcass. Cows mature early and are good mothers; the calves are small at birth but grow relatively fast. In Italy, the cattle live in mountainous country, so they have been bred for good feet and legs that stand up to rugged terrain.

ROMAGNOLA

FUNCTIONAL TYPE Beef.
APPEARANCE White to gray with black points and skin.
SIZE Medium.
HORNS Black horns, yellow at the base.
CONSERVATION STATUS Not applicable.
PLACE OF ORIGIN Italy.
BEST KNOWN FOR High-yielding, lean carcass.

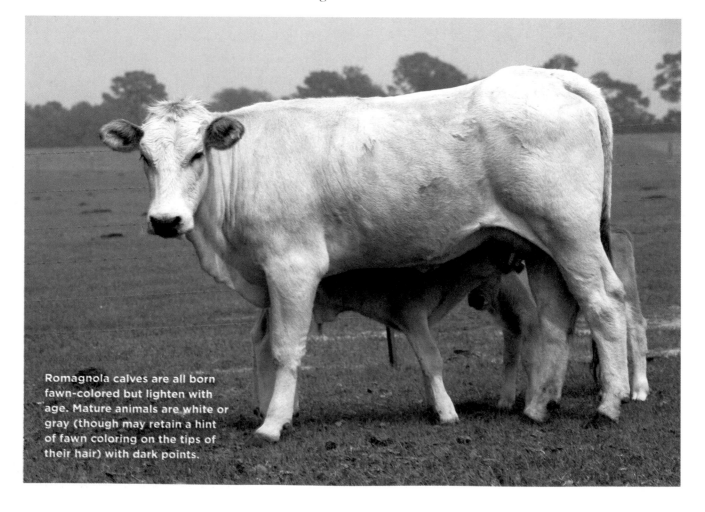

Romagnola calves are all born fawn-colored but lighten with age. Mature animals are white or gray (though may retain a hint of fawn coloring on the tips of their hair) with dark points.

Salers

THE BREED IS NAMED for the medieval town of Salers (pronounced say-lair) in mountainous south-central France. It is thought to be an ancient breed in that area, but it was greatly improved in the nineteenth century by Tyssandier d'Escou, a noted agronomist of the time who is memorialized by a statue in the town square of Salers for his contribution to the town's namesake cattle. Historically, Salers were a triple-purpose breed, expected to produce meat and milk from the relatively poor forage grown in the region, as well as to function as draft animals. It's still used as a dual-purpose breed in some areas of France, and its milk is still used in the region's famous Bleu d'Auvergne (a blue cheese that's renowned among cheese enthusiasts), though even in France more breeders are moving toward using the breed exclusively for beef production.

The Salers was imported to North America in the mid-1970s for beef production. From a couple of hundred head, the breed has grown in popularity and now has a fairly strong following in North America. Salers are known for having relatively small, yet very vigorous calves, making calving easy for the cow and the rancher. The calves grow quickly, so they have high weaning weights. The breed has a rare but lethal gene combination known as β-mannosidosis. Calves that are born with the condition die within 6 to 12 months from liver and kidney failure. Blood testing is available to check for carriers.

Salers from France are a bit excitable, but North American breeders have been consciously selecting for docility, so they are now fairly mellow. The breed is also known for excellent maternal traits, and according to research from the Meat Animal Research Center, Salers cows excel in pounds of calf weaned per cow exposed to the bull, and they yield a lean but heavy carcass with an exceptionally large rib-eye area.

SALERS

FUNCTIONAL TYPE Beef.

APPEARANCE Uniformly mahogany red in France, though the North American herd has uniform black as well.

SIZE Medium.

HORNS Either naturally horned or polled.

CONSERVATION STATUS Not applicable.

PLACE OF ORIGIN France.

BEST KNOWN FOR Easy calving, yet high weaning weights.

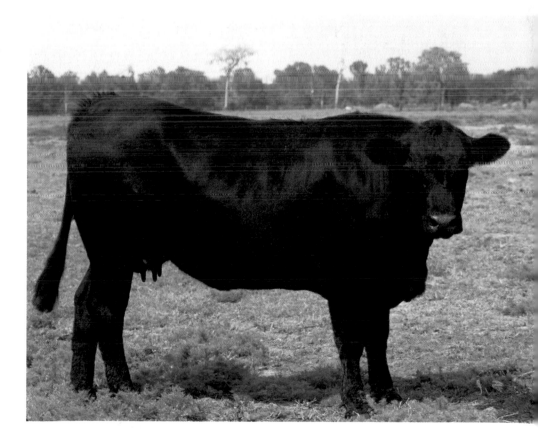

Salers are adaptable to a wide range of climates. Bulls have become popular as terminal sires, particularly in western range operations, where calving ease is an important attribute.

Santa Gertrudis

OFTEN REFERRED TO as "America's original beef breed," many historians consider the Santa Gertrudis to be the first breed that was developed on this side of the Atlantic solely for beef production. The breed is named after the Rincon de Santa Gertrudis, the Spanish land grant located southwest of Corpus Christi, Texas, that Richard King developed into the King Ranch (see page 45 for more information about the King Ranch).

The King Ranch began experimenting with crosses between Shorthorns and Brahman or Brahman-cross bulls in the early years of the twentieth century. In 1920, a bull calf with outstanding conformation and fast growth was produced from one of these crosses. The King Ranch began extensively breeding the bull, named Monkey, to a herd of Brahman/Shorthorn-cross cows, and the offspring of those breedings became the foundation for the Santa Gertrudis.

The breed is known for its hardiness in hot climates. The cattle have a thick hide, which helps protect them from insects, and good legs and feet, allowing them to travel over large areas for forage and water. The cows are quite fertile and make good mothers.

SANTA GERTRUDIS

FUNCTIONAL TYPE Beef.

APPEARANCE Honey to deep red coat. Bulls may show the humps found on their Brahman ancestors.

SIZE Medium.

HORNS Small.

CONSERVATION STATUS Not applicable.

PLACE OF ORIGIN Texas.

BEST KNOWN FOR Extreme hardiness in subtropical areas, with good hardiness in hot and arid climates.

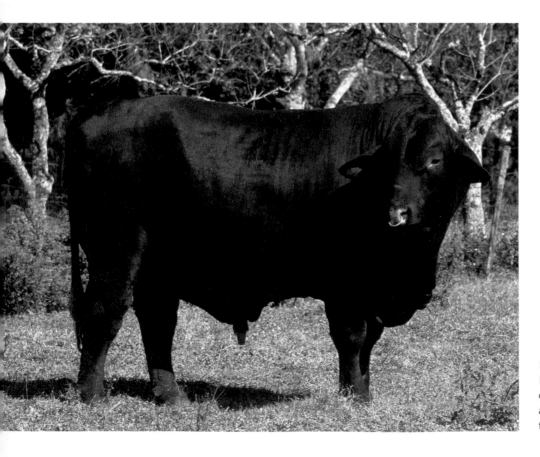

Santa Gertrudis cattle are quite handsome with their cherry-red coats. Although they thrive in any hot, humid climate, they also tolerate colder winter weather.

Senepol

THE ISLAND OF ST. CROIX, located 1,200 miles southeast of Miami in the U.S. Virgin Islands, is the home of the Senepol. Christopher Columbus made a stop at the island during his 1493 visit to the New World, but Europeans didn't settle the island permanently until 1733, when it was sold to the Dutch West India and Guinea Company. The company encouraged settlers, regardless of nationality, to settle on the island. Around 1785, the founders of the Senepol breed, an English family by the last name of Nelthropp, started a plantation on the island.

Some of the earliest cattle on the island were African breeds that were dropped on the island by slave traders. One such breed, the N'Dama, a long-horned *Bos taurus* breed from Senegal, performed fairly well on St. Croix in spite of the island's extreme climate and poor vegetation, but it didn't produce much milk. In 1918, in an effort to improve milk production and breed out the horns, Bromley Nelthropp bred a Red Poll bull from the island of Trinidad to his cattle herd. After years of breeding to this and other imported Red Poll bulls, Bromley had set the traits of his new breed.

(continued)

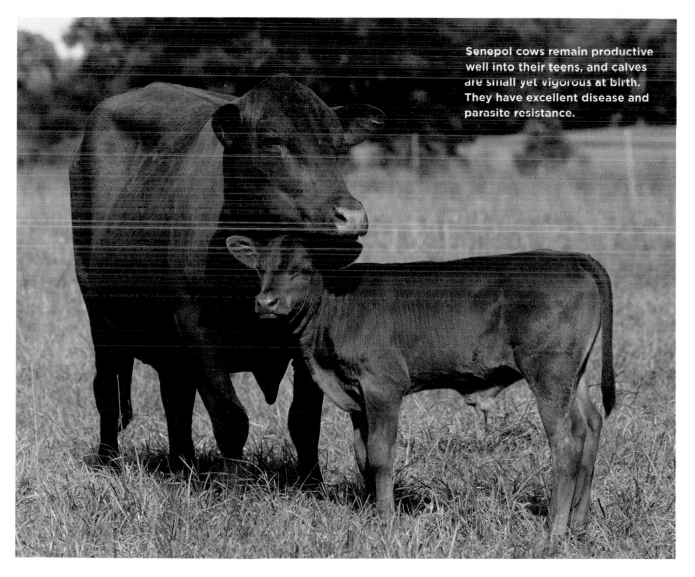

Senepol cows remain productive well into their teens, and calves are small yet vigorous at birth. They have excellent disease and parasite resistance.

Senepol (continued)

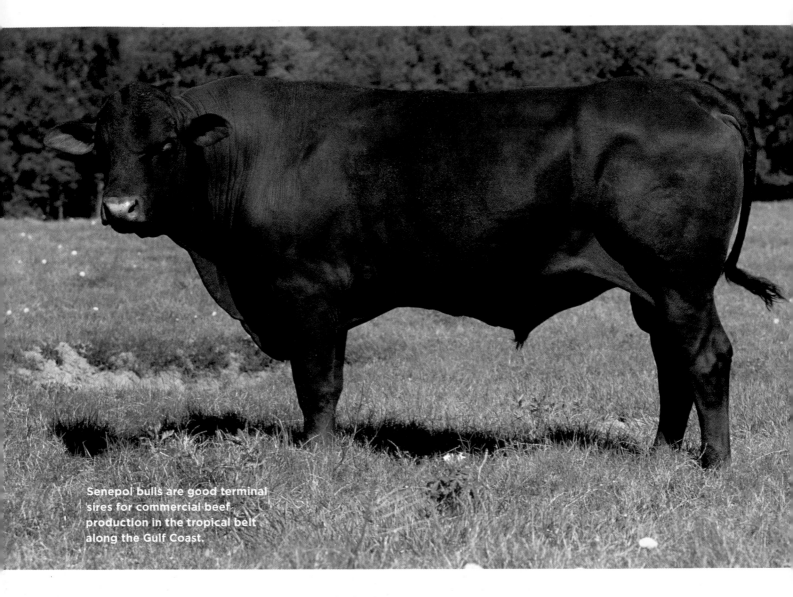

Senepol bulls are good terminal sires for commercial beef production in the tropical belt along the Gulf Coast.

Other farmers on the island began breeding the new cattle, which they initially called the Nelthropp breed. When, during the early 1950s, breeders began looking for recognition of the breed outside of St. Croix, they renamed it Senepol, a combination of Senegal and Red Poll. In 1977, the first shipment (22 head) was imported to the United States.

The Senepols were bred to make beef on marginal grass in a hot and humid climate. This capability was reinforced by decades of closing off the herd to outside blood, yet carefully selecting based on performance criteria.

SENEPOL

FUNCTIONAL TYPE Beef.

APPEARANCE Shades of red.

SIZE Medium.

HORNS Naturally polled.

CONSERVATION STATUS Not applicable.

PLACE OF ORIGIN St. Croix, Virgin Islands.

BEST KNOWN FOR Adaptation to tropical and subtropical climates and poor forage.

Shorthorn and Milking Shorthorn

A SHORT-HORNED TYPE of native cattle was common in northern England and Scotland since the Iron Age (around the sixth century BC). Starting in the sixteenth century, these native short-horned cattle were improved through crossbreeding with German and Dutch short-horned cattle, but the development of the modern Shorthorn breed is credited to Charles and Robert Colling. In 1783, after visiting and studying under the famous agriculturalist Robert Bakewell, the brothers began intensively selecting cattle from the local animals in the Tees River valley of northeast England.

The Colling brothers turned out to be not only astute students of Bakewell's selective breeding techniques but also astute marketers. They exhibited their massive cattle throughout the country and sold one bull calf for $5,000 in 1804, a princely sum at that time. One can trace the ancestry of most of today's Shorthorns to their animals. Although they were multipurpose animals, the Shorthorns had two types early in their development, the beef type tended to be more associated with animals of Scottish origin, while the dairy type was associated with the English lines.

The Shorthorn was the first international breed. It was exported by the British to all corners of the Empire and held the distinction of being the only widely dispersed cattle breed for well over a century and a half until it was eclipsed by the Holstein.

The first Shorthorns were imported to North America in the 1780s and were frequently imported through the first half of the 1800s. Breeders started a U.S. registry in 1846, and the American Shorthorn

(continued)

SHORTHORN

FUNCTIONAL TYPE Beef.

APPEARANCE Red and white, ranging from almost solid to spotted, roan, or brindled.

SIZE Medium.

HORNS Small.

CONSERVATION STATUS
Not applicable.

PLACE OF ORIGIN Britain.

BEST KNOWN FOR Good beef production on grass. Easy calving and good mothering ability with high milk production for heavy weaning calves.

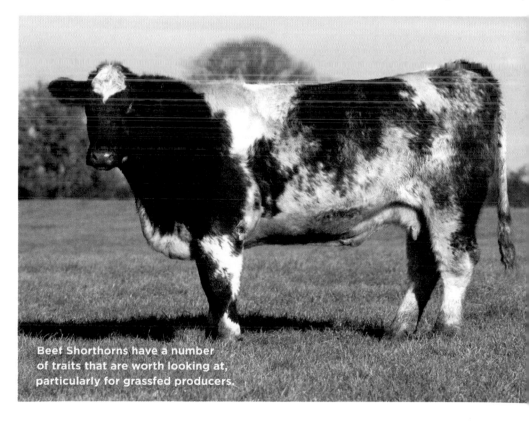

Beef Shorthorns have a number of traits that are worth looking at, particularly for grassfed producers.

Shorthorn and Milking Shorthorn (continued)

Breeders Association, which registered and promoted both beef and dairy types, formed in 1882. The association thrived for a couple of decades, but by the early decades of the twentieth century, farmers began using animals with more defined beef or dairy character, instead of dual-purpose animals. The Shorthorn's popularity slipped dramatically as a result, and by 1912, breeders of the dairy type began working with the association to keep milk records and promote dairy improvement.

In 1948, the dairy breeders split and formed their own association. Today Shorthorns (the beef type) and Milking Shorthorns (the dairy type) are each represented by their own breeders' organization, though animals in both registries trace their roots to the same foundation animals.

In spite of breeders' efforts to promote Milking Shorthorns, their numbers were slipping again in the 1950s and 1960s because they couldn't compete with the Holstein's high rate of production. To keep their animals as a viable choice for dairy farmers, members of the American Milking Shorthorn Society began allowing "genetic expansion" through the introduction of Red and White Holstein, Illwarra (an Australian Shorthorn), and Norwegian Red bloodlines. These cattle gave the Milking Shorthorn more angular dairy lines and increased its milk production. As a result, the breed has maintained a toehold in the dairy industry, and in fact, there has been a 50 percent increase in registrations since the turn of the century. According to the USDA, Milking Shorthorns average 18,017 pounds (8,172 kg) of milk, with 656 pounds (298 kg) of butterfat and 567 pounds (257 kg) of protein. The most recent record for a Milking Shorthorn is 46,666 pounds (21,167 kg) of milk, 2,098 pounds (952 kg) of fat, and 1,085 pounds (492 kg) of protein.

Unfortunately, the upgrading that kept Milking Shorthorns viable in modern dairy terms has had devastating effects on the original Milking Shorthorn lines, so in 2008 the American Livestock Breeds Conservancy and the American Milking Shorthorn Association (AMSA) worked to track bloodlines back to the original lines. Their findings: only 250 animals registered in 2006, and fewer than 700 animals total, traced their lines to pure original Shorthorn bloodlines. As ALBC says, "This is very troubling indeed, since the Milking Shorthorn played a vital role in international breed development." Considering that the original purebred population on this side of the Atlantic exceeds the numbers remaining in the United Kingdom, ALBC moved the breed to critical on its conservation priority list, and the AMSA has begun categorizing these animals with the designation "Native." Although these may not be the highest producing animals for commercial dairying, they should make exceptionally good homestead milkers, producing excellent calves and enough milk for the family. Sires with this dual-purpose heritage (and AMSA is working to market their semen) should also make excellent terminal sires for crossbreeding programs.

Both beef and dairy types do very well in grass-based production systems, and both still retain many of their best historic traits, including excellent dispositions, good mothering ability, easy calving, and good feed conversion. Shorthorns have a genetic lethal recessive associated with the TH (tibial hemimelia) gene, which causes multiple congenital defects, but breeders have worked with geneticists to identify carriers. A newer lethal, PHA (pulmonary hypoplasia with anasarca) has been observed in about a dozen Shorthorn calves, but at this time the gene associated with it is unknown, though breeders are working with the University of Nebraska to identify the gene and a test for it.

Milking Shorthorns have a wonderful disposition, and the calves are far beefier than those of other dairy breeds, so the extra value in the calves offsets the breed's slightly lower milk production.

MILKING SHORTHORN

FUNCTIONAL TYPE Dairy.

APPEARANCE Same red and white coloring as beef-type Shorthorn, but dairy-type body.

SIZE Medium to large.

HORNS Small.

CONSERVATION STATUS Critical.

PLACE OF ORIGIN Britain.

BEST KNOWN FOR Good milk production on grass. Excellent disposition.

Simmental

THE SIMMENTAL is named after the Simme Valley in the Alps of western Switzerland (*tal* means "valley" in German). It is considered to be one of the oldest breeds in Europe, with documentation of its existence in the canton (or state) of Berne dating back to at least the fifteenth century. The first herdbook for the breed was started in 1806, and the first breed association began promoting the breed in 1890.

In Switzerland, the Simmental was a triple-purpose breed with notably high milk production. In fact, it is considered to be the highest milk producer of any of the Continental breeds that were imported to North America for beef production in the 1960s and 1970s. Although all of the Simmentals found in North America today trace their roots to these importations (to Canada in 1967 and to the United States in 1968), there is evidence of earlier importations dating back to

the 1890s and the early years of the twentieth century. Apparently, the Simmentals from these earlier importations were crossbred out of existence by the 1960s.

In their native land, Simmental cattle are spotted, either in red and white or a yellowish dun and white, but since the North American herd was upgraded from limited imports, black has become a common color. Thanks to the breed's high milk production, its adaptability to various climatic conditions, and the North American breeders' dedication to selection based on performance criteria, Simmentals have become very popular with beef producers. The American Simmental Association is one of the top ten breed associations, based on registration numbers. The breed has a lethal allele, the TH gene (read more about TH under the Shorthorn entry, page 129), but the breed association has used DNA analysis to identify carriers.

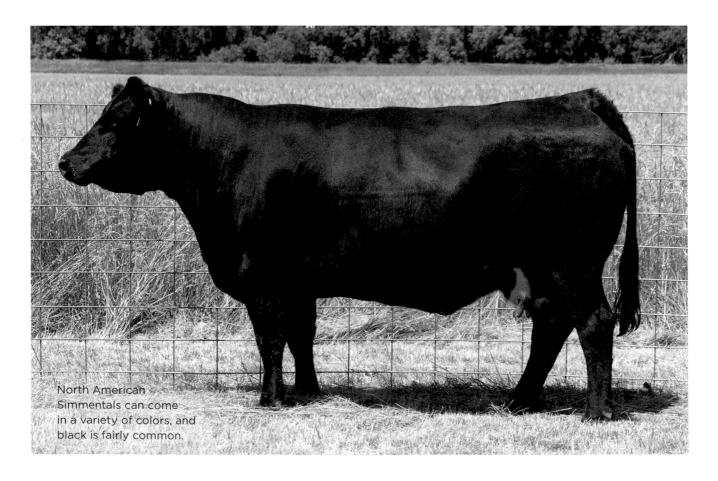

North American Simmentals can come in a variety of colors, and black is fairly common.

SIMMENTAL

FUNCTIONAL TYPE Beef.

APPEARANCE Originally red or yellow, spotted with white; black is now common in North America from up-breeding programs.

SIZE Large.

HORNS Fither horned or polled.

CONSERVATION STATUS Not applicable.

PLACE OF ORIGIN Switzerland.

BEST KNOWN FOR Excellent milk production for a beef animal. Good adaptability to various climates.

In their Swiss homeland, all Simmental cattle are colored like these girls.

South Devon

LIKE THE DEVON, the South Devon comes from Devon County in southwest England. Though of common ancestry, the Devon and the South Devon have been recognized as separate breeds since at least the seventeenth century.

The southern area of Devon County, from which the breed hails, is known as South Hams, and the breed was historically referred to as Hams. The South Hams district is a valley bordered by water on three sides (the sea and two river estuaries), and the Dartmoor hills on the other, making the district fairly isolated. That geography also made the district warm, by English standards, and quite fertile, thus producing abundant and high-quality forage, which allowed the district's cattle to fatten easily and helps explain the South Devon's stature as the largest English breed.

Although some South Devons were probably brought to North America by early British settlers, the South Devons in North America today come from importations made in 1969. The breed is still relatively rare in North America, but a report prepared by the USDA Agricultural Research Service showed that their registration numbers increased 63 percent from 1990 to 2000. Breeders appreciate their excellent mothering characteristics and very gentle disposition. They have a high potential for marbling on forage, making them a good choice for pasture production.

SOUTH DEVON

FUNCTIONAL TYPE Beef.

APPEARANCE Stocky. Orangey-red.

SIZE Large.

HORNS Either horned or naturally polled.

CONSERVATION STATUS Not applicable.

PLACE OF ORIGIN England.

BEST KNOWN FOR Good marbling off pasture. Docility and gentleness.

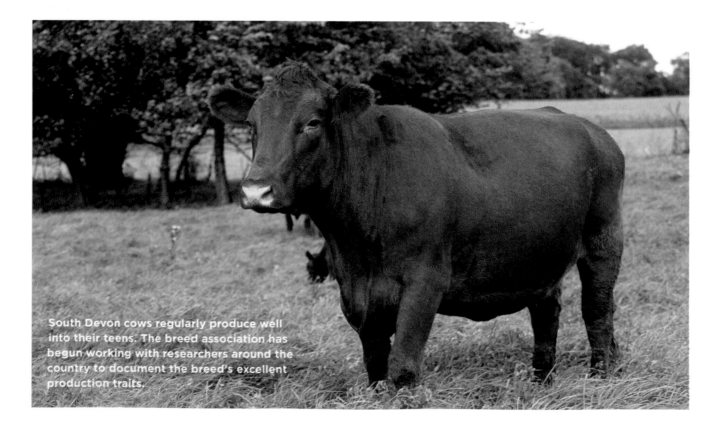

South Devon cows regularly produce well into their teens. The breed association has begun working with researchers around the country to document the breed's excellent production traits.

Tarentaise

NAMED FOR A VALLEY IN THE ALPS of southeastern France, the Tarentaise is an old, isolated breed that dates back to at least the eighteenth century. Like the Aubrac, it winters at lower altitudes, but it grazes in the high mountains during the summer. In fact, it grazes at a higher elevation and in rougher terrain than any other breed in France. Today in France it is used primarily as a dairy breed, with its milk going into either the region's Beaufort cheese (a Gruyère-type cheese that is loved by serious cheese connoisseurs for its sharp yet smooth flavor) or the Reblochon, a soft, creamy cheese.

In spite of its role as a dairy breed in France, the Tarentaise is used as a beef breed in North America. Cattle were first imported to Canada in 1972, and to the United States in 1973. Tarentaise cattle have excellent feet and legs, allowing them to travel over great distances and uneven terrain. Cows are excellent mothers known for high fertility rates, good milk production, and long lives. They are generally quite docile.

(continued)

TARENTAISE

FUNCTIONAL TYPE Beef.
APPEARANCE Mainly deep brown to reddish brown with black points, though occasionally black from up breeding.
SIZE Medium.
HORNS Medium; some are naturally polled.
CONSERVATION STATUS Not applicable.
PLACE OF ORIGIN France.
BEST KNOWN FOR Excellent feet and legs (they travel great distances in a grazing situation). Good maternal traits.

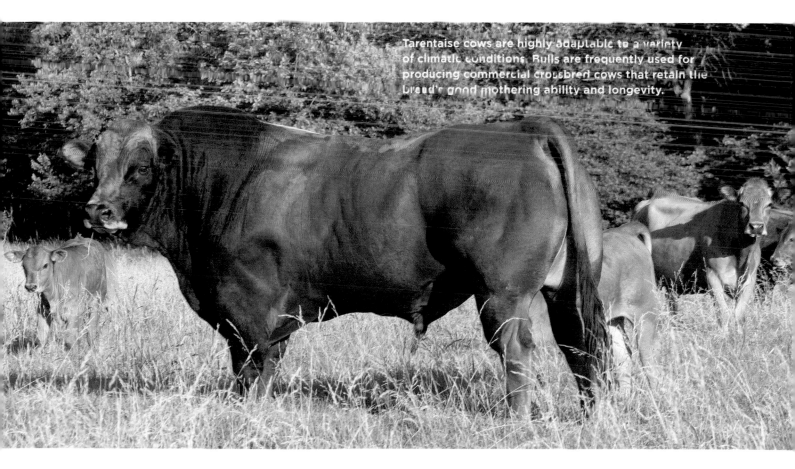

Tarentaise cows are highly adaptable to a variety of climatic conditions. Bulls are frequently used for producing commercial crossbred cows that retain the breed's good mothering ability and longevity.

Tarentaise (continued)

Thanks to their moms' good milk production, these Tarentaise calves will grow quickly.

Texas Longhorn

THE TEXAS LONGHORN IS AN ICON of the American West. One of its foundations is pure Spanish criollo, cows that had often gone wild and adapted to the harsh climate of the American Southwest, from Texas to California. When the first serious movement of Anglo-American settlers arrived in Texas in the 1820s, they came mainly to farm cotton, but they brought along some cows of northern European descent. These cows didn't perform well by themselves, but when blended with the criollo, they did exceptionally well. By the 1840s, the blend of criollo and northern European cattle resulted in a discernible population, called Texas Longhorns.

Historians estimate that by the time of the American Civil War, there were more than five million Texas Longhorns populating the Southwest. By the 1930s, the open range was divided and fenced, and ranchers began introducing more British and Brahman cattle into the Southwest, and Longhorn numbers began a free fall. By the early 1960s, there were only a few hundred Longhorns left. In 1964, the 30 breeders who were still maintaining Texas Longhorns banded together to form a breed association to bring the Longhorn back from the precipice of extinction. The breeders formed a registry and began actively promoting their breed. The result of their efforts is amazing: there are more than 100,000 Longhorns in the United States today.

The Longhorn is very well adapted to the Southwest, but it has adapted well to all North American climates. It has great disease and parasite resistance, as well as hard bones and feet that allow it to perform well in rugged areas and to travel long distances for feed and water. Cows are docile, make good mothers, and produce calves into their teens.

(continued)

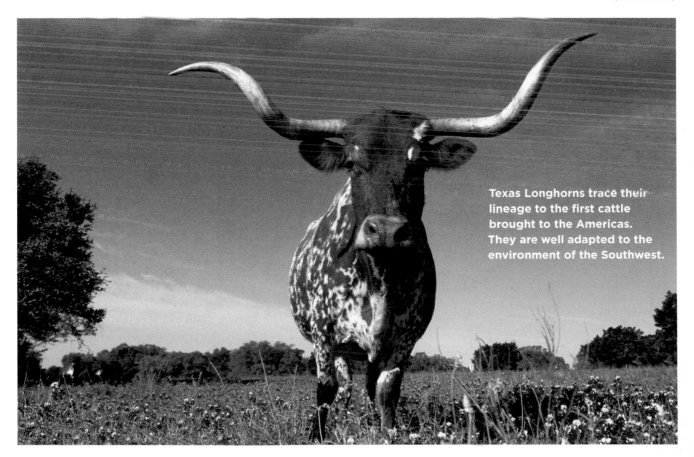

Texas Longhorns trace their lineage to the first cattle brought to the Americas. They are well adapted to the environment of the Southwest.

Texas Longhorn (continued)

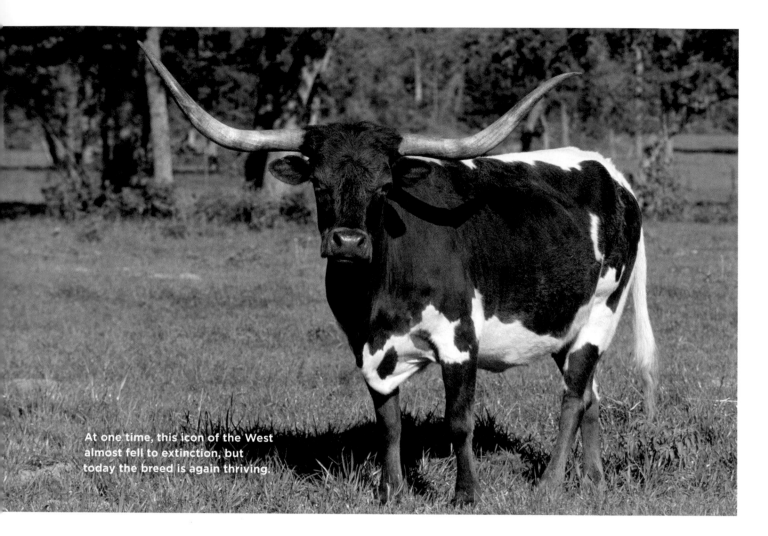

At one time, this icon of the West almost fell to extinction, but today the breed is again thriving.

TEXAS LONGHORN

FUNCTIONAL TYPE Beef.

APPEARANCE Long and lean bodies. Different colors and patterns, though black and white or red and white are the most common.

SIZE Medium.

HORNS Vary, but they are always long and impressive.

CONSERVATION STATUS Not applicable.

PLACE OF ORIGIN Texas.

BEST KNOWN FOR Being an icon of the West. Highly adaptable. Excellent disease and parasite resistance.

WICHITA MOUNTAINS WILDLIFE REFUGE

The **Texas Longhorn** is the only breed supported by federal legislation. In 1901, Congress established the Wichita Mountains Wildlife Refuge in Oklahoma as a sanctuary for the cattle. The refuge provides habitat for large native grazing animals such as American bison, Rocky Mountain elk, and white-tailed deer. Texas Longhorn cattle also share the refuge rangelands as a cultural and historical legacy species. More than 50 mammal, 240 bird, 64 reptile and amphibian, 36 fish, and 806 plant species thrive in this important refuge.

Tuli

AN IMPROVED SANGA type, the Tuli was developed during the 1940s and 1950s in Rhodesia (now the country of Zimbabwe) through selection by an agricultural researcher at the Tuli Research Station, then owned by the government. Zimbabwe is in south-central Africa, a place that is hot and prone to severe drought cycles. The Tuli was selected from the best cattle that had adapted to this extremely harsh climate over thousands of years.

Bill Bucek, a Texas rancher, imported the first Tuli bull from Australia in 1995, after seeing the breed on a trip there. Bucek was impressed that a breed with such strong *Bos taurus* traits could produce as well as a *Bos indicus* animal under extreme heat and poor forage, yielding a large carcass with exceptional meat quality. The breed is also highly adaptable, performing well in Canada as well as in the Southwest. Research done at Texas A&M University supports Bucek's observations. For example, in research of terminal calves raised under Texas conditions, Dr. Bill Holloway found that cows weaned 75 percent more pounds of calf per cow exposed when a Tuli bull was used as a terminal sire than Brahman-crossed calves, 53 percent more than Angus-crossed calves, and 21 percent more than Senepol-crossed calves.

TULI

FUNCTIONAL TYPE Beef.

APPEARANCE Muscular. Light silver to golden or reddish brown coat.

SIZE Medium.

HORNS Most are naturally polled; up to 30 percent may have horns.

CONSERVATION STATUS Not applicable.

PLACE OF ORIGIN Zimbabwe.

BEST KNOWN FOR Ability to yield an excellent carcass in hot climates with marginal feed quality. High fertility.

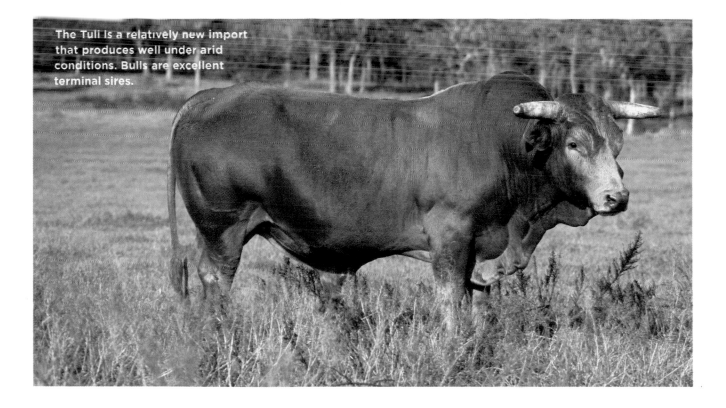

The Tuli is a relatively new import that produces well under arid conditions. Bulls are excellent terminal sires.

Wagyu

WAGYU MEANS JAPANESE (WA) CATTLE (GYU). In Japan there are actually several breeds of Wagyu, which were developed in the late 1800s and early 1900s as melting-pot breeds. These include native Japanese cattle, Brown Swiss, Shorthorn, Devon, Simmental, Ayrshire, Korean, Holstein, and Angus. In 1910, the Japanese ceased crossbreeding with these outside cattle breeds and began improving four primary breeds of the Wagyu strictly through selection. Most Japanese cattle were dual-purpose for meat and draft, but in selecting for beef production, the Japanese emphasized marbling. All of the Wagyu breeds have far more intense marbling than any other breed of cattle.

Two Wagyu bulls of the black Tottori breed and two Wagyu bulls of the red Kumamoto breed were imported to the United States in 1976, but there was limited interest in the breeds at that time. Then in 1993 and 1994 some U.S. producers became interested in supplying beef for Japan's famous Kobe beef, a product that sells for up to $100 per pound in Japanese markets. They imported an additional 40 head from Japan, and these have provided the foundation for exporting the cattle back to Japan for Kobe production.

Kobe beef is highly regulated in Japan. To be called "Kobe," the beef must not only come from purebred Wagyu cattle but must also be prepared in butcher shops in the city of Kobe. Today, North American producers ship Wagyu carcasses to Kobe for cutting, and they also sell Kobe-style beef in U.S. markets.

WAGYU

FUNCTIONAL TYPE Beef.

APPEARANCE Black or red.

SIZE Large.

HORNS Either horned or naturally polled, depending on original Japanese breed.

CONSERVATION STATUS Not applicable.

PLACE OF ORIGIN Japan.

BEST KNOWN FOR Highly marbled meat, exceeding prime.

Wagyu cattle are the most highly marbled cattle in the world, used for the production of Kobe and Kobe-style beef. It brings premium prices, both here and in Japan.

Welsh Black

WELSH BLACK CATTLE have a long history in Wales. There is some evidence that their forebears lived in Wales during the Roman occupation of Britain (AD 43 to 410). In 1799, their likeness appeared on one of the first paper notes issued as currency in Wales.

Like the Highland of Scotland, the Welsh Black is a shaggy-coated animal that adapted to and thrived on the rough forage of the hills and mountains of Wales. Until the 1970s it was a dual-purpose breed used for beef and milk production, though there were two distinct strains, a northern strain that was more beefy and a southern strain that had better dairy character. Today, the breed is raised primarily as beef in Wales.

The first breed association was formed in Wales in 1904. Black Welshes were imported to North America in 1970. Some breeders are keeping them in the United States, though they are more common in Canada, where there is an active breed association.

The breed is known for longevity, high fertility, and good mothering traits. It does well in pasture-production systems. The breed efficiently converts feed to meat, and in several studies has a comparable feed efficiency and carcass quality to Angus cattle.

WELSH BLACK

FUNCTIONAL TYPE Beef.

APPEARANCE Mainly black (occasionally red); may have some white on underbelly, behind naval. Shaggy-haired with blocky build. Historically, there were Belted Black Welsh cattle, but that characteristic has been lost.

SIZE Medium.

HORNS Either horned or naturally polled.

CONSERVATION STATUS Not applicable.

PLACE OF ORIGIN Wales.

BEST KNOWN FOR Longevity. Good feed conversion and carcass traits.

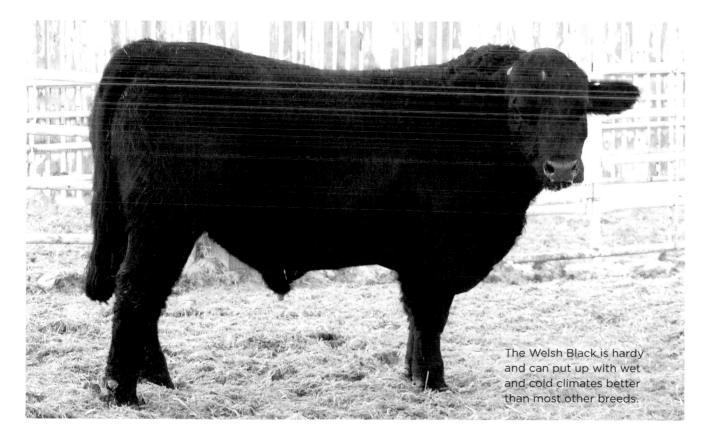

The Welsh Black is hardy and can put up with wet and cold climates better than most other breeds.

GOATS

GOATS HAVE ALWAYS played a critical role in agriculture, with a current worldwide population ranging from 500 to 700 million, depending on what source you check with. In most areas of the world, goats are raised as multipurpose animals, providing meat, milk, fiber, and skins. In some places goats are also used as pack animals. Their global success can be attributed to a number of unique characteristics, including:

- Their small size. This makes goats an appropriate choice for smaller plots of land, and an ideal choice for meat and milk production in areas of the world that lack refrigeration.

- A preference for a wider variety of feeds than other ruminants, such as cattle and sheep. They thus spread their grazing pressure more evenly over the landscape, which makes them an ideal choice in areas where brush is heavy.

- Their browsing nature. They are used to clear brush and weeds for improving pastures, to clear land under power lines, or to reduce vegetative fuel loads in fire-vulnerable ecosystems.

- Their reduced parasite problems. When they are able to browse on brush and trees, they tend to have fewer parasite problems than cattle and sheep.

- A reasonably high feed-conversion efficiency. They can outproduce cattle and sheep pound per pound, particularly in rugged and marginal settings.

Although they are raised throughout most of the world, goats are the least common animal raised for production in North American agriculture. They are, however, gaining in popularity, in part because significant numbers of people from goat-eating cultures have immigrated to Canada and the United States over the past several decades, and in part because growing niche markets for products like goat cheese and mohair (from Angora goats) are providing opportunities for entrepreneurs. There seems to be a particularly strong interest in goat production among smaller, part-time farmers getting into the business from nonagricultural backgrounds. And, for some people, goats make ideal pets.

Goats are practical and personable animals. Angora goats, as seen here, are raised for their fine mohair fiber.

A Brief History

THERE ARE EIGHT WILD GOAT SPECIES throughout the world. Domestic goats (*Capra hircus*) come from the bezoar ibex (*Capra aegagrus*). The latest archaeological evidence suggests that goats were first domesticated about 10,000 years ago. From their first domestication site, currently thought to be in the Zagros Mountains of western Iran, they quickly spread around the region. Scientists analyzing DNA speculate that was the first of three domestication events, with the subsequent domestications occurring in western Pakistan and Mongolia.

The bezoars, which are considered vulnerable to extinction by the World Conservation Union, are still found in the wild on the island of Crete, on several Greek Islands, in Turkey, in Pakistan, and in Turkmenistan. They are fairly large goats, with big males weighing as much as 300 pounds (136 kg) and standing four feet tall (1.22 m) at the withers. They are usually tan with black trim and pale bellies, but other colors and patterns do appear naturally. Both males and females have a beard, and, unlike most domestic goats, they have tall, scimitar-shaped horns that curl slightly to the back. Polling occurs from time to time in goats but is often associated with hermaphroditism (an animal having both male and female sexual organs). Dehorning is a common practice among domestic goat owners.

Like their domestic progeny, bezoars are gregarious, with females and young animals living in herds of 50 or more, and males living in small herds that disperse during the breeding season. Interestingly, next to cats, goats are the quickest critters to go feral if given a chance, and there are now bezoar-type wild goats in some areas of Europe where bezoars didn't traditionally exist: these are thought to be feral goats that reverted back to wild form and conformation.

In the wild, goats, like many other species, go through a seasonal anestrus period during which females do not ovulate or have heats. The season of estrus is timed so that babies are born in the spring when the grass flushes in its lushness. Biologically, this makes sense; babies born in winter in the wild have a slim chance of survival. Many domestic goat species still have a relatively long anestrus period during which they cannot breed and a shorter period of estrus during the fall and winter, when they can breed. These periods are controlled by the photoperiod (the hours of daylight their area receives each day). Breeds that were developed near the equator typically no longer show seasonality of their estrus cycles and are able to breed year-round. Animals with this trait are included in the breed descriptions that follow.

The wild bezoar is the ancestor of our domestic goats.

Form and Function

CASHMERE IS A LUXURIOUS FIBER spun from the fine down layer under the hair of goats. The name comes from the state of Kashmir in India. The British became enamoured of the fine fabrics woven from the down during their control of the Indian subcontinent during the 1800s.

With the exception of Angoras, all goat breeds have such down fibers. Cashmere is very soft, warm, and long-wearing, and while not quite as strong as wool, it usually outlasts wool. Since most goats produce the down, when you hear someone talk about cashmere goats, they are talking about strains that have been developed for cashmere, not a particular breed. New Zealand and Australia have been producing cashmere for years, and breeders there have been using selection practices among domestic and captured feral goats, which may ultimately yield a distinguishable breed. Some Americans have imported some of these down-under cashmere producers.

Goats, such as this Boer kid, are extraordinarily versatile animals: you can find goats for meat, milk, or fiber production; they make great pets; they are used for packing; and they are good for controlling brush and weeds.

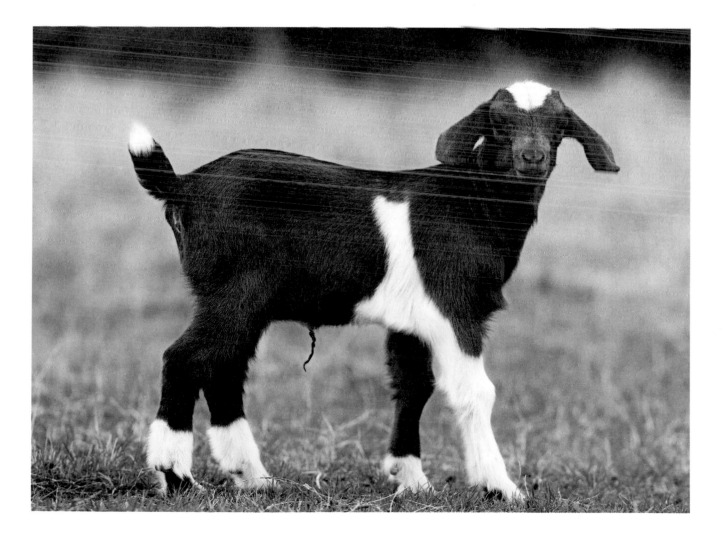

Mohair also comes from goats, but it is derived from just one breed: the Angora. It is a lustrous and durable luxury fiber that has been in use at least since the days of Moses (1571 and 1451 BC), though some textile historians believe that its use dates back hundreds of years before that. The Angora's fiber is unique to that breed: unlike the fiber of other goats (and sheep), it does not have microscopic scales along its surface, and the fibers from both primary hair follicles and secondary hair follicles are the same diameter. The Angora does not shed, and its fibers grow continuously throughout the year.

Although goat's meat has never been a staple in our diet in the United States and Canada, there is a growing demand for meat goats among ethnic communities, including immigrants from Mexico, Africa, and Asia. Although all goats produce edible meat, those raised as meat goats are more heavily muscled. The Boer goat is the dominant meat goat in North America today, but the Kiko and the Spanish goat are also being used for meat production.

As with goat's meat, goat's milk represents just a minor portion of North American agricultural production, but dairy goats are highly efficient for their size, and many people find it easier to digest goat's milk than cow's milk because the fat globules in the milk are smaller. The goat cheese industry has grown in recent years. Chèvre, a creamy, semisoft goat cheese of French origin, is probably the most common, but producers are also marketing feta and a variety of semihard cheeses.

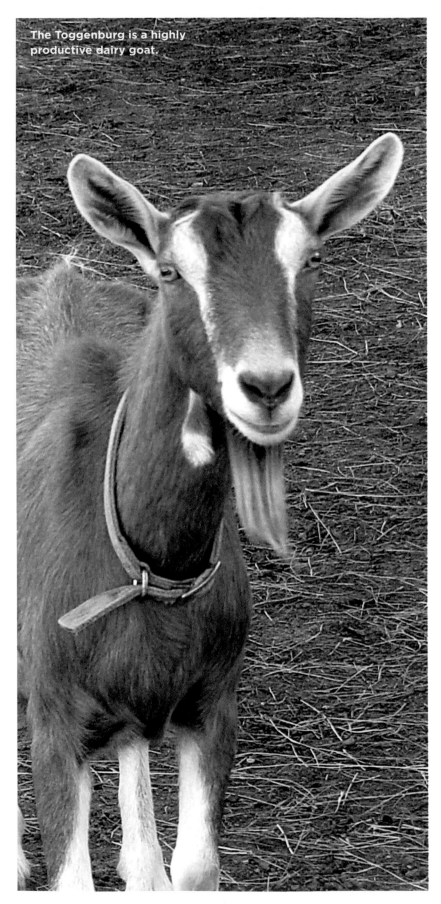

The Toggenburg is a highly productive dairy goat.

Angora goats are raised primarily for their mohair fiber, but young goats also make excellent chevon (goat meat), with a more delicate flavor than some meat goat breeds.

Alpine

DOMESTIC GOATS have long been found in the Alps of Switzerland, Germany, France, and Italy. These goats were mostly multipurpose animals with good dairy traits. But during the late years of the nineteenth century, breeders in France and Switzerland began concentrating on selecting for milk production, as well as standardizing color and conformation. By the early years of the twentieth century, a number of distinct breeds were recognized across the Alps region.

The French Alpine was the primary breed developed in France, and like the cattle of the French Alps, French Alpine goats have also been called Tarentaise. The Swiss Alpine goats include the Oberhasli, Saanen, and Toggenburg breeds. Later in the twentieth century, two more "Alpine" breeds were developed outside their home countries. The British Alpine, which is not found on this side of the Atlantic, was developed in the early 1900s in Britain by crossing Oberhasli with local goats, and the Rock Alpine was developed in the United States by crossing French Alpines with local goats, but this breed is now believed to be extinct.

The Alpine goats in North America today are primarily from the French Alpine. Nineteen does and three bucks, imported to California in 1922, provided the foundation for the breed in the United States. The breed is still more common on the West Coast and in the Rocky Mountain states than in the East.

Alpines are very heavy milkers, with top producers outperforming all other goats in the USDA's Dairy Herd Improvement Program. Their production for 2005 (the most recent data as I write this) was 2,085 pounds (946 kg) of milk, with 3.3 percent fat and 3.0 percent protein. The Alpines mature early, are hardy, and adapt to a variety of climates. They have a longer breeding season than many breeds.

Alpine goats are not only great milk producers but also highly adaptable to a wide range of climatic conditions.

ALPINE

FUNCTIONAL TYPE Dairy.

APPEARANCE Upright ears. Long neck. Rangy build. Male beards are prominent. "Wattles," or small clumps of hair-covered skin, may appear on either side at the base of the throat. Variety of colors, including:

Cou blanc White front quarters and black hindquarters with black or gray markings on the head.

Cou clair Front quarters are tan, saffron, off-white, or shading to gray with black hindquarters.

Cou noir Black front quarters and white hindquarters.

Sundgau Black with white markings, such as white underbody and white facial stripes.

Pied Spotted or mottled.

Chamoisee Mainly brown or bay with black markings on face, dorsal stripe, feet, and legs and sometimes a martingale running over the withers and down to the chest.

Two-tone chamoisee Light front quarters with brown or gray hindquarters.

Broken Any variation in the above patterns. For example, broken with white should be described as "broken cou blanc."

SIZE Medium to large.

HORNS Upright, scimitar-shaped.

CONSERVATION STATUS Not applicable.

PLACE OF ORIGIN France.

BEST KNOWN FOR Excellent milk production. Well-shaped udders.

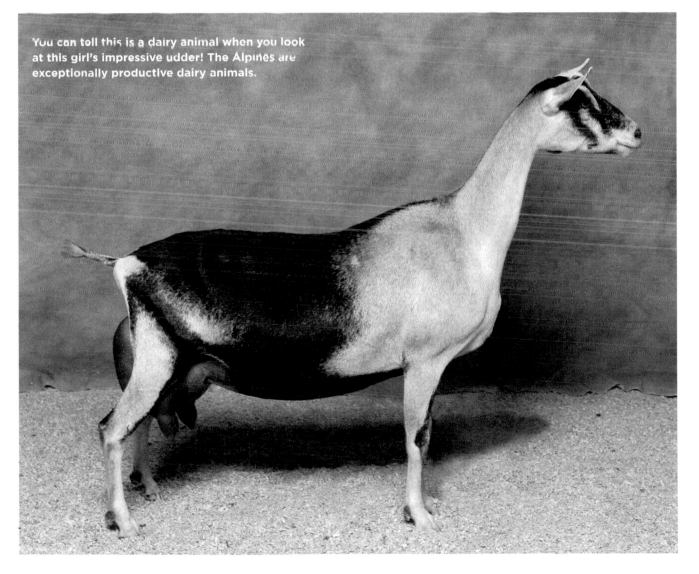

You can tell this is a dairy animal when you look at this girl's impressive udder! The Alpines are exceptionally productive dairy animals.

Angora

ANGORA GOATS are also sometimes called "mohair goats," in recognition of their fiber. The name Angora is derived from the name of the capital of Turkey: Ankara. Located in the west-central area of Turkey, Ankara is famous for Angora goats, Angora cats, Angora rabbits, and the wool products made from the goats' mohair fleece. Angora goats have been documented in the area since around 1500 BC.

Dr. James Davis of South Carolina imported the first Angora goats (as well as the first Brahman cattle) to the United States in 1849. The goats were a gift to Davis from the sultan of Turkey for work he did on the country's cotton production. Several additional importations followed until 1881, when a new sultan came to power and outlawed their export, under penalty of death.

Mohair is a wonderful fiber that is luxurious and lustrous, soft and strong. It can range from very fine and very soft to coarse (on older animals). In 1954, Congress passed the National Wool Act, which provided incentive payments to wool and mohair producers. As a result, the mohair industry became well established, particularly in Texas, but when the incentive payments were phased out in 1995, a number of producers got out of mohair production. Today, the industry has stabilized, with about 2,400 farms producing mohair in the United States, and a handful in Canada. Most mohair is exported for processing.

Angoras tend to be fairly mellow animals that are a little easier to contain than most goats, but they are prone to more health problems than other breeds and are quite susceptible to internal parasites. They produce 7 to 16 pounds (3.18 to 7.26 kg) of fleece per year. Higher production requires excellent nutrition and management, as well as shearing twice a year. Angoras are not highly prolific; does tend to have a single kid, though twins are not unheard of.

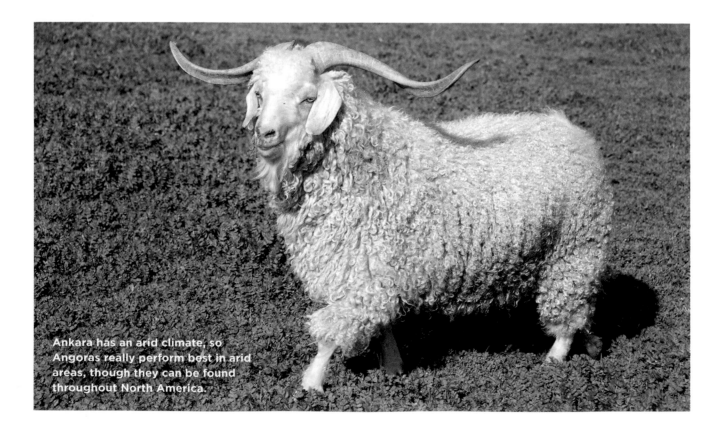

Ankara has an arid climate, so Angoras really perform best in arid areas, though they can be found throughout North America.

ANGORA

FUNCTIONAL TYPE Fiber.

APPEARANCE White dominates, though other colors are possible. Medium-size, droopy ears. In full fleece, easily identified by long, wavy tresses.

SIZE Medium.

HORNS Male horns have a distinctive open curl and continue to grow, reaching 2 feet or more. Does have fairly short horns.

CONSERVATION STATUS Not applicable.

PLACE OF ORIGIN Turkey.

BEST KNOWN FOR Mohair production.

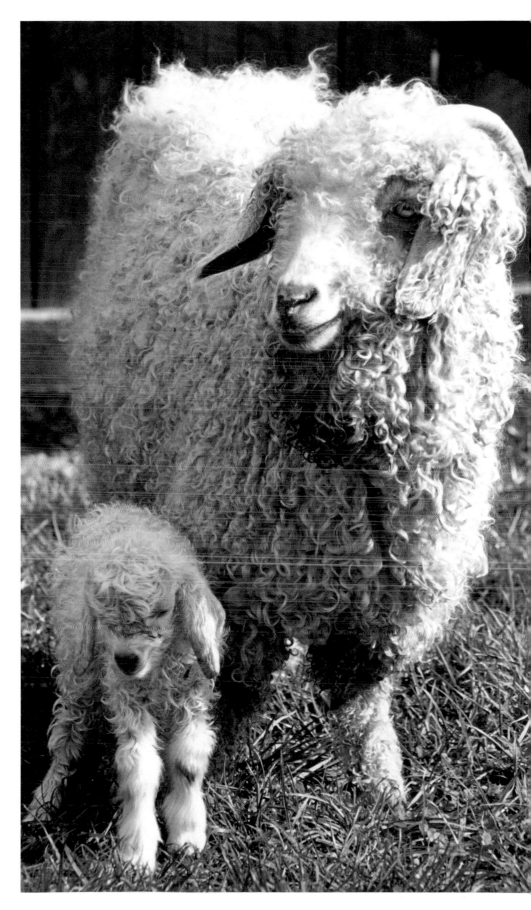

The price of Angora fiber varies widely from year to year, based on the fickle tastes of the fashion industry. The best and most steady returns for small-scale producers come from direct marketing fiber to hand spinners or from marketing top-quality custom processed yarn to knitters.

Arapawa

THE ARAPAWA GOAT is a feral breed from Arapawa Island, off the coast of New Zealand. No one is sure exactly how, or when, the goats got to the island, but the New Zealand Rare Breeds Conservation Society speculates they may have been brought there in the 1830s when a small whaling station was established on the island.

The island is also home to feral sheep and pigs. They all thrived on the island for well over a century, but in the 1970s, the government of New Zealand planned to eliminate them because they were doing too much damage to the ecosystem. All the feral animals were to be shot. But in 1972, Betty and Walt Rowe, American expatriats, moved to Arapawa Island and immediately fell in love with the island's wildlife, including the goats, pigs, and sheep. They acquired 300 acres on the island and established a sanctuary for some of the animals.

In 1993, staff at the Plimoth Plantation, a living history museum in southeastern Massachusetts that has long been committed to preserving historic breeds of livestock at its Nye Barn, imported six Arapawa Island goats. There are now a number of breeders across the country helping to protect the Arapawa Island goats. Some breeders are interested in the breed's dairy potential.

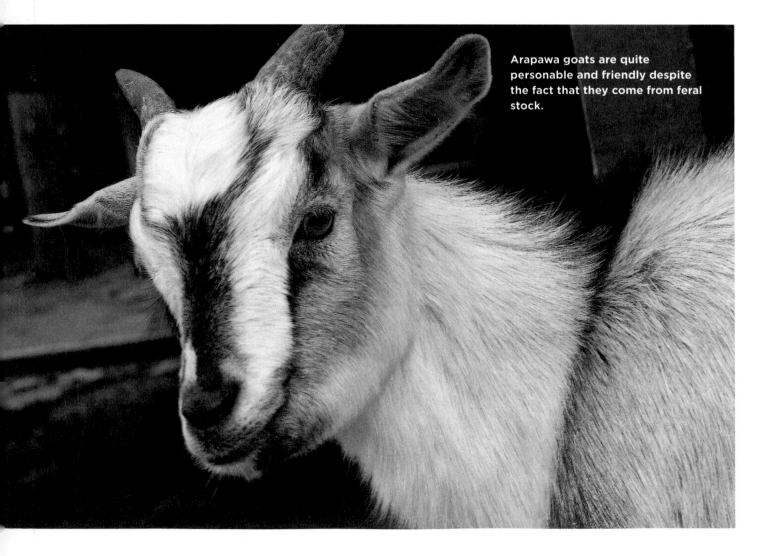

Arapawa goats are quite personable and friendly despite the fact that they come from feral stock.

Recent DNA research fron the University of Córdoba in Spain shows that the Arapawa is a genetically distinct breed, possibly descended from now-extinct Old English goats dropped on the island by Captain Cook in 1773.

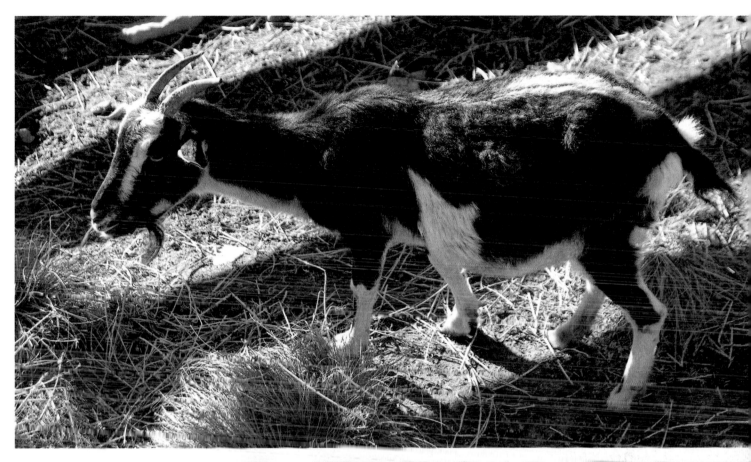

ARAPAWA

FUNCTIONAL TYPE Feral, but with dairy potential.

APPEARANCE Wide variety of colors and patterns. Males have a prominent beard; females may have a small beard. Medium-size ears tend toward a horizontal cant from the head.

SIZE Small.

HORNS Males have prominent horns; shape varies. Females have smaller horns.

CONSERVATION STATUS Critical.

PLACE OF ORIGIN New Zealand.

BEST KNOWN FOR Uniqueness as a feral goat from New Zealand.

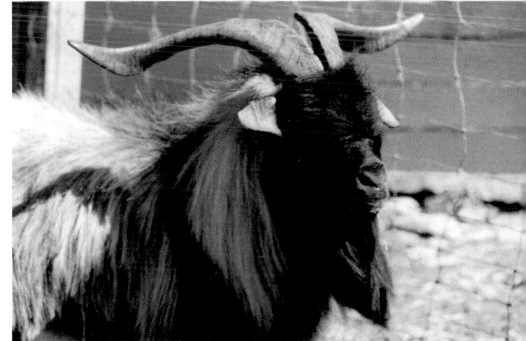

Boer

BOER GOATS WERE DEVELOPED in South Africa during the late nineteenth and early twentieth centuries by breeding native goats to imported European goats. Farmers and African tribes selected goats for a meaty carcass and hardiness in Africa's harsh, hot climate. South Africa was a Dutch colony at that time, and the word *boer* means "farmer" in the Dutch language.

By the 1950s, the Boers were very successful across large areas of southern Africa, and they were quite distinct from other goats. Breeders joined together to form a breed society in 1959 and began promoting Boer goats outside of South Africa. Beginning in the early 1970s, South African breeders participated in progeny and performance testing, which drastically improved meat characteristics across the breed. The breed was first imported to North America in early 1993, via New Zealand. There were more importations from New Zealand, as well as from Australia beginning in 1995. Since their introduction in the early 1990s, Boer goats have found wide acceptance with North American producers and their numbers have skyrocketed.

Boer goats are brawny and prolific. They will breed throughout the year. Does often have twins, triplets, or quadruplets. The Boers produce a meaty yet lean carcass and grow quickly. They are adaptable to a variety of climates but perform best in more arid areas of the West.

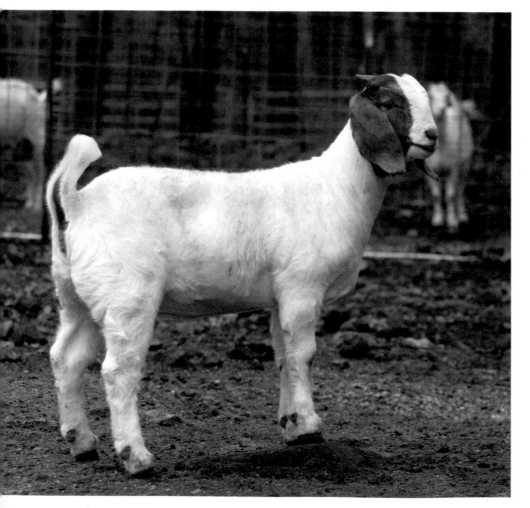

BOER

FUNCTIONAL TYPE Meat.

APPEARANCE White body with reddish brown (or occasionally black) head that can be solid or marked with white. Color may extend into shoulder area.

SIZE Large.

HORNS Medium horns that sweep back and down from the top of head (both sexes).

CONSERVATION STATUS Not applicable.

PLACE OF ORIGIN South Africa.

BEST KNOWN FOR Excellent carcass production. Breeds any time of year.

When you look at the stocky and firm build of a Boer goat it is quite easy to understand why they are a popular breed for meat production. Bucks are often used as terminal sires.

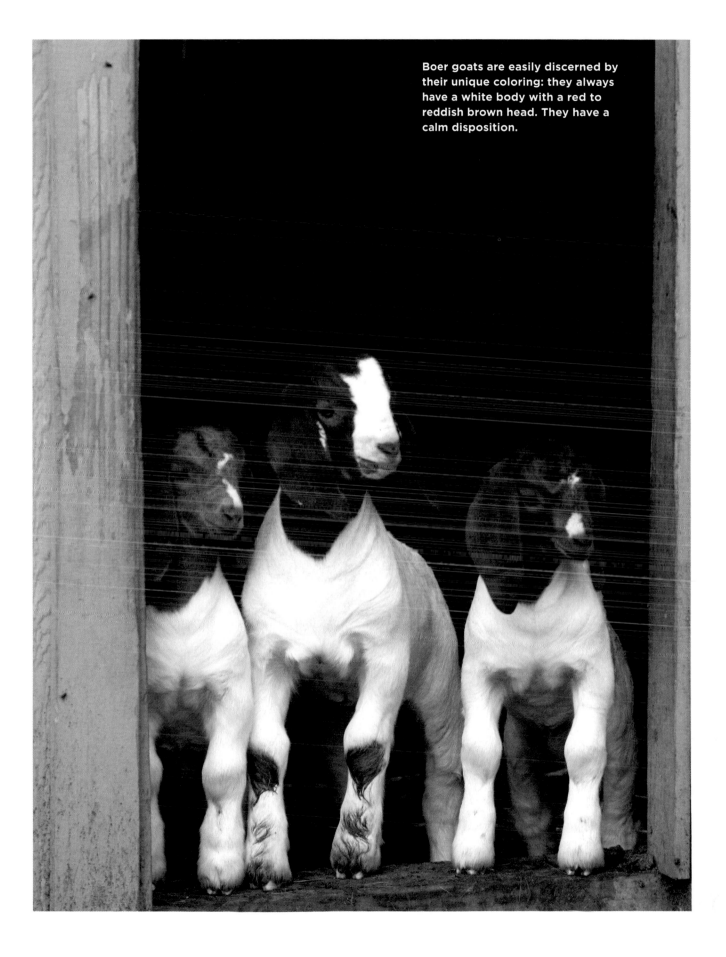

Boer goats are easily discerned by their unique coloring: they always have a white body with a red to reddish brown head. They have a calm disposition.

Golden Guernsey

HAILING FROM THE ISLE OF GUERNSEY in the English Channel, the Golden Guernsey goat is renowned for its lovely coat. The history of the breed is fairly obscure. It was mentioned in a book about the island of 1826, but no one is quite sure how the breed developed. Some breed historians believe that it was developed from native goats bred up following introductions of various bloodlines, possibly including Nubian, Maltese, Syrian, British Alpine, and Swiss Gemsfarbige Gebirgsziege (Chamois-colored Swiss Alpine goats) breeds. Islanders started a registry for the Golden Guernsey in 1922.

The breed was almost lost during World War II, when Germans occupied the island and ordered that all small livestock be butchered to feed their troops. Local farmers hid some Guernseys in caves on the island, thus keeping the breed alive. They were first exported to England in 1965. In 1996, Allen and Connie Skolnick imported embryos and semen to the United States and Canada, and the first Golden Guernseys in North America were born in 1998. There still aren't very many Golden Guernsey goats on this continent, but due to their rarity in Britain, the American Livestock Breeds Conservancy added the breed to its conservation list for study.

Golden Guernsey goats produce a respectable quantity of milk relative to their size, and the milk has high butterfat and protein content. In fact, Golden Guernsey/Alpine does have been milked in the Dairy Herd Improvement program and performed comparably well to the Alpines in terms of volume, but with higher butterfat and protein. The animals are quite docile and friendly, making them a good choice for pets or homestead milkers, though their numbers are still quite limited on this side of the Atlantic.

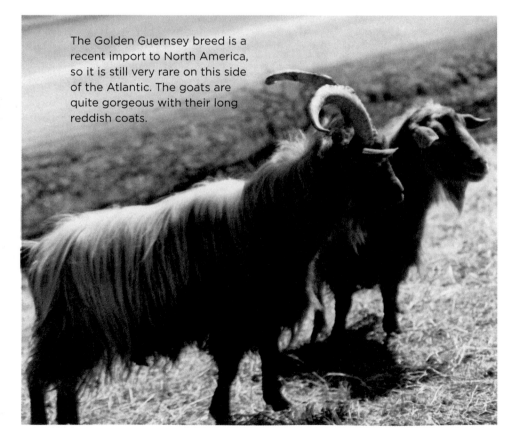

The Golden Guernsey breed is a recent import to North America, so it is still very rare on this side of the Atlantic. The goats are quite gorgeous with their long reddish coats.

GOLDEN GUERNSEY

FUNCTIONAL TYPE Dairy.

APPEARANCE Color varies from light tan to golden red. Skin is golden as well. May have small white markings on head. Long hair is common.

SIZE Small to medium.

HORNS Mostly polled, but occasionally horns show up as a recessive trait.

CONSERVATION STATUS Study.

PLACE OF ORIGIN Channel Island of Guernsey.

BEST KNOWN FOR Beautiful coat. Excellent disposition.

Kiko

A MODERN BREED, the Kiko was developed by a consortium of farmers in New Zealand starting in 1978. New Zealand never had a native wild goat, but when European settlers arrived there in the 1770s, goats came with them. Today, the islands have a significant population of feral goats, and it was from these feral herds that farmers began selecting the foundation animals of the Kiko breed.

Through the introduction of Nubian, Toggenburg, and Saanen bloodlines, followed by careful selection, the farmers soon improved performance for commercial goat meat production. Once the traits were solidified, in 1986, the herdbook was closed, meaning that animals could only be registered if their parents were already recorded in the herdbook. The farmers named the breed Kiko, from the Maori word for meat. The first Kiko goats arrived in the United States in 1993.

The Kiko breed performs particularly well in the humid areas of the Southeast, in part thanks to its naturally good resistance to internal parasites and hoof rot. It is a little smaller than the Boer, but it has good weight gain (and, according to research done in the Southeast, it outperformed the Boer in that climate). Does are fertile, typically having twins, and have good mothering traits. The breed is said to be a bit standoffish, so it isn't the best choice for a pet goat, but it will perform well for commercial production.

KIKO

FUNCTIONAL TYPE Meat.

APPEARANCE Usually white, but color and pattern can vary widely. Medium to large ears that flop forward. Males have significant beards, females have either no beard or a very slight one.

SIZE Medium to large.

HORNS Have an outward sweep to the horizontal. Mature males display a distinctive shallow spiral in horn conformation.

CONSERVATION STATUS Not applicable.

PLACE OF ORIGIN New Zealand.

BEST KNOWN FOR Excellent commercial meat production, particularly in the Southeast. Good parasite and foot rot resistance.

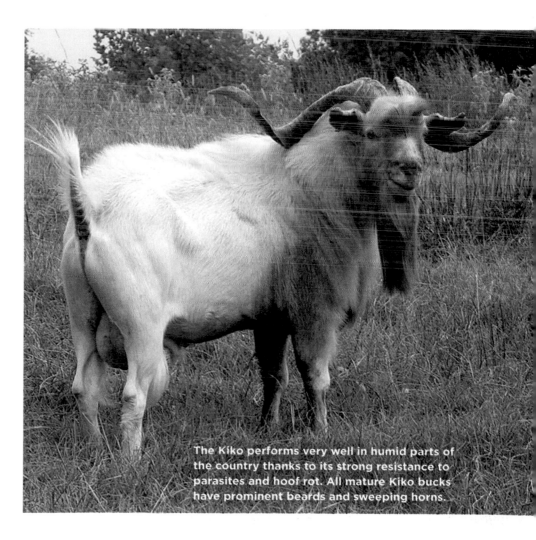

The Kiko performs very well in humid parts of the country thanks to its strong resistance to parasites and hoof rot. All mature Kiko bucks have prominent beards and sweeping horns.

Kinder

THIS BREED WAS DEVELOPED BY ACCIDENT by a farmer in Washington State. Pat Showalter had a Nubian buck, a Pygmy buck, and two Nubian does on her Snohomish, Washington, farm. In 1985, her old Nubian buck died. Unable to find another Nubian buck, she let her Pygmy buck service the does. In the spring of 1986, she had three Nubian-Pygmy kids, and the foundation of the Kinder breed had been born.

Showalter kept one of the doe kids and two neighbors took the other two. When those does came of age, Showalter and the others were impressed with their dairy output relative to their size and feed consumption, and the flavor and quality of their milk. They became interested in further developing the cross as a practical, dual-purpose animal. According to Showalter, they were having trouble coming up with a name for their new synthetic breed when one of the early breeders saw a new child-care business opening in the community called KinderCare. Showalter says, "Everyone liked the sound of the word *kinder* [from the German word for child and pronounced with a soft "i," as in kindergarten] and these goats are small, playful, and smart, so we thought the name really fit." They formed the Kinder Goat Breeder's Association in 1988 to maintain the herdbook and promote the breed.

There are only a few Kinder herds currently participating in the official USDA Dairy Herd Improvement Program testing, but for the small number of animals on record, they are averaging more than 1,400 pounds (635 kg) per 305-day lactation, with an average of 6.5 percent buttermilk and 4 percent protein (the highest of any dairy goat). Animals raised for butcher produce excellent carcasses quickly. Does will breed throughout the year.

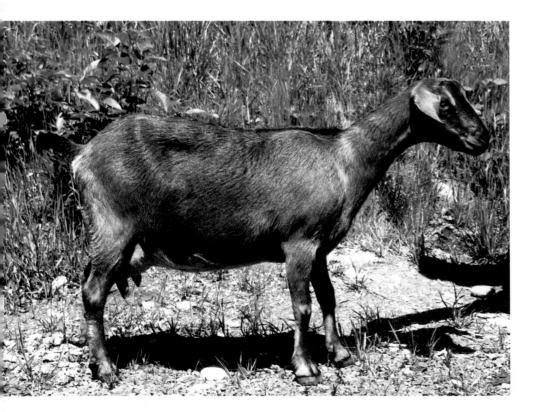

KINDER

FUNCTIONAL TYPE Dual-purpose, dairy and meat.

APPEARANCE No color standards; color and patterns vary. Pendulous to semipendulous ears. Compact body, yet with heavy bone.

SIZE Medium.

HORNS Upright, small (female) to medium (male) in size.

CONSERVATION STATUS Not applicable.

PLACE OF ORIGIN Washington State.

BEST KNOWN FOR Highest butterfat and protein of any dairy goat. High feed efficiency.

For its small size, the Kinder produces abundant milk, making it an excellent choice for homestead production. Animals are friendly and have long, productive lives.

LaMancha

LAMANCHA GOATS are unique-looking animals. Their development is credited to Eula Fay Frey, who, along with her husband, bought a 130-goat dairy farm in California in 1937. Two of the goats were a small doe and her kid (named Tommy) that had very short, odd-looking ears.

Frey wrote in a 1960 *Dairy Goat Journal* article that she and her husband "were not favorably impressed by them" due to their looks, but she did use Tommy to breed a couple of Nubian–French Alpine does. One of the kids from these matings was a short-eared little doe that Frey liked right away and kept. Other breeders in California also had occasional short-eared goats, and most suspected the trait came from a line of goats brought here by the early Spanish explorers and settlers. The old-time goat farmers said the breed that was brought over was called LaMancha, so Frey called her breed American LaMancha. By 1957, she had quit using any other breeds, and in 1958 she helped form the first American LaMancha registry.

(continued)

With their short or nonexistent ears, LaManchas are funny looking, but the lack of external ear tissue doesn't impact their hearing one bit. Bucks are required to have the nonexistent, gopher-type ear so that their offspring will have either a gopher or an elf ear, depending on the doe's genetic contribution.

LaMancha (continued)

LaManchas are distinguished by two types of ears. Those with "gopher ear" preferably have no ears, though some may have an approximate maximum length of 1 inch, with very little or no cartilage. The end of the ear must be turned up or down. Bucks must have a gopher ear to be registered. "Elf ears" have an approximate maximum length of 2 inches. The end of the ear must be turned up or turned down and cartilage shaping the small ear is allowed.

The LaManchas being tested in the USDA Dairy Herd Improvement Program produced 1,799 pounds (816 kg) of milk in 2005, with 3.6 percent butterfat and 3.1 percent protein.

LAMANCHA

FUNCTIONAL TYPE Dairy.

APPEARANCE May come in any color. The most important physical feature is their ears, defined by two types: gopher or elf.

SIZE Medium to large.

HORNS Males have medium, upright horns with slight curl to back; females have smaller, similarly shaped horns.

CONSERVATION STATUS Not applicable.

PLACE OF ORIGIN California.

BEST KNOWN FOR Short ears. Very good dairy production.

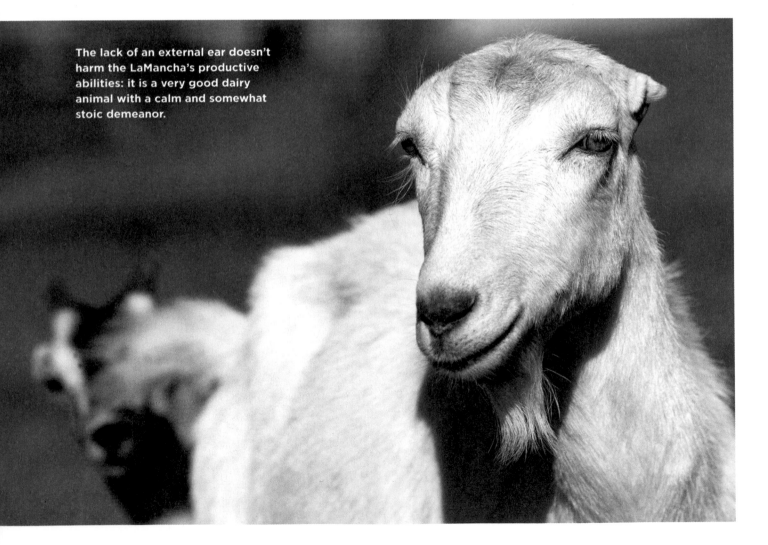

The lack of an external ear doesn't harm the LaMancha's productive abilities: it is a very good dairy animal with a calm and somewhat stoic demeanor.

Myotonic

MYOTONIC GOATS share an unusual inherited condition called "congenital myotonia." Goats that exhibit the condition are known informally by a number of names, including Tennessee fainting goats, wooden-leg goats, nervous goats, stiff-leg goats, scare goats, or epileptic goats, but the agreed-upon formal name is Myotonic. Goats with this condition, which is caused by a set of recessive alleles, stiffen up when they are startled or frightened. Some goats will fall to the ground and lie stiff as a board. Goats remain conscious and recover quickly (usually in about 10 seconds).

Myotonia is also seen in other animals and humans. It isn't painful, and the degree of stiffness varies markedly from one animal to the next. Myotonic animals generally have heavier muscling than other animals, which could have been what led early breeders in the area of Tennessee and surrounding states to begin selecting for the trait when it first appeared during the latter years of the 1880s. The breed was developed and spread throughout several southern states by the 1930s.

Some Myotonic goats have extended breeding seasons. They are particularly resistant to internal parasites, but there doesn't seem to be a correlation between the myotonia and resistance, so it was likely just a good genetic coincidence. The original Myotonic goats were medium-size meat animals, but some modern strains, which may have Pygmy bloodlines, have been selected for smaller size and are kept primarily as pets. Some strains produce particularly abundant and high-quality cashmere fibers during the winter. There are also strains of Myotonic goats that frequently produce polled offspring. Breeders who maintain polled strains are careful to never breed polled animals to each other, so as to reduce the chances of hermaphroditism.

(continued)

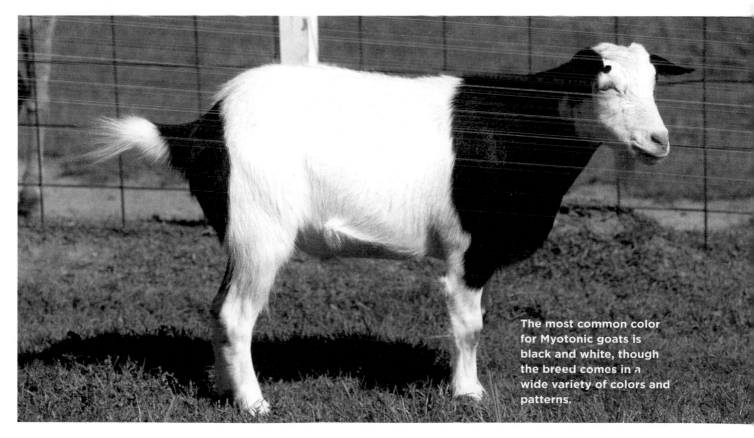

The most common color for Myotonic goats is black and white, though the breed comes in a wide variety of colors and patterns.

Myotonic (continued)

A number of breeders are finding that purebred Myotonic goats and Myotonic-Boer crosses are excellent goats for meat production in humid parts of the South. One breeder in Texas has started developing an improved strain, the Tennessee Meat Goat, for meat production. Only time will tell whether the strain will become unique and merit recognition as a new breed, but for now, improved production traits can help protect against the loss of the threatened Myotonic goat. Myotonic goat have been added to Slow Food USA's Ark of Taste (page 38).

MYOTONIC

FUNCTIONAL TYPE Meat or pet.
APPEARANCE Various colors. Coat length can be either short or long. Full, wide body. May have a beard.
SIZE Small to medium.
HORNS Either horned, sweeping up and out to the sides, or polled.
CONSERVATION STATUS Threatened.
PLACE OF ORIGIN Tennessee.
BEST KNOWN FOR Stiffening and possibly falling over when scared.

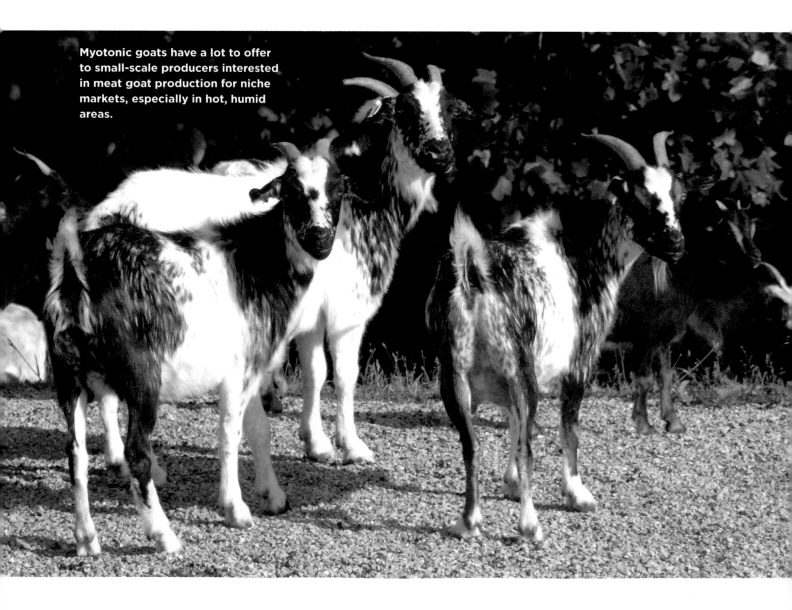

Myotonic goats have a lot to offer to small-scale producers interested in meat goat production for niche markets, especially in hot, humid areas.

Nigerian Dwarf

GOATS PLAY A VITAL PART in African subsistence agriculture. More than 140 million animals representing more than 100 unique breeds are raised throughout the continent, including several dwarf breeds. Agricultural historians think that some of these dwarf goats first came to the United States on slave ships as a food source, but once here were likely lost in crossbreeding with other breeds. Later, from the 1930s through 1950s, zoos acquired some for their collections, often in their petting zoos, though no one is sure how they came to be in the collections.

At first, all of these dwarf goats were lumped under the title of "pygmy" goats. Only later did breeders notice that there were two distinct types. The one with a more angular dairy frame gave significantly higher quantities of milk and was named the Nigerian Dwarf. The other, an animal that was sometimes described as a beer keg on legs for its stocky build, was eventually named the Pygmy goat.

In the 1970s, interest in these small breeds grew, particularly for pets, and breeders formed the first breed association for all Pygmy goats. In the 1980s, breeders split the association in two, forming one association for the Nigerian Dwarf dairy type and another for the Pygmy meat type. There are currently multiple breed associations for the Nigerian Dwarf, which creates some confusion for potential breeders. Some associations are more dedicated to show and companion animals that are bred a bit smaller, while others are more geared to animals used for dairy production.

Nigerian Dwarf goats being tested by the USDA's Dairy Herd Improvement Program are averaging about 750 pounds (340 kg) of milk, with 6.5 percent butterfat (though some animals exceed 10 percent butterfat) and 3.9 percent protein. Considering their small size and high feed efficiency, this is stellar production. Nigerian Dwarf goats are also known for a docile temperament, good hardiness, and longevity (often being productive well into their teens). They breed throughout the year, and does typically have twins, though triplets and quadruplets are not unusual.

NIGERIAN DWARF

FUNCTIONAL TYPE Dairy or pet.

APPEARANCE Wide variety of colors; males may have a beard.

SIZE Small.

HORNS Either horned, which stand upright from the head, or polled.

CONSERVATION STATUS Recovering.

PLACE OF ORIGIN West Africa.

BEST KNOWN FOR Excellent milk production for small size. Pleasant disposition.

A Nigerian Dwarf buck poses for the camera in front of a flock of sheep. Bucks stand 19 to 23 inches tall at the withers.

Nubian

THE NUBIA REGION is located in northern Sudan and southern Egypt. Though the goats found there are somewhat similar to the ones we know as Nubians, agricultural historians don't believe they were the goats used to develop the modern Nubian breed. So why the name? For some reason, in the early nineteenth century, the British and French both apparently dubbed any goats from Africa or India that had a Roman nose as Nubians. So, when breeders in Britain and France developed a new breed beginning in the mid-nineteenth century by mixing bloodlines of their local goats with "exotic" Roman-nosed bucks from several areas of Africa and India, they simply used the common moniker, Nubian, for their new breed.

The English, or Anglo-Nubians, which are the forebears of North American Nubians, also benefited from being crossbred with other European dairy breeds, such as the Swiss Alpine. By the 1890s, the Anglo-Nubian was a recognizable breed with a breed organization. The breed first arrived on this side of the Atlantic in 1896, but these animals were apparently lost before leaving a legacy. Another importation in 1913 was the foundation for today's North American Nubian herd. They are now the most common registered goats in North America.

Nubians will breed all year. Records in 2005 from the USDA's Dairy Herd Improvement Program show a herd average of 1,459 pounds (663 kg), at 4.5 percent butterfat and 3.6 percent protein. They generally have a mellow temperament, but due to their size, bucks can be dangerous during the breeding season. The breed is highly adaptable to a wide variety of climate conditions. Nubians do have an inherited recessive disorder that results in tremors, inability to stand, and often death in young kids, but testing is available to identify carriers.

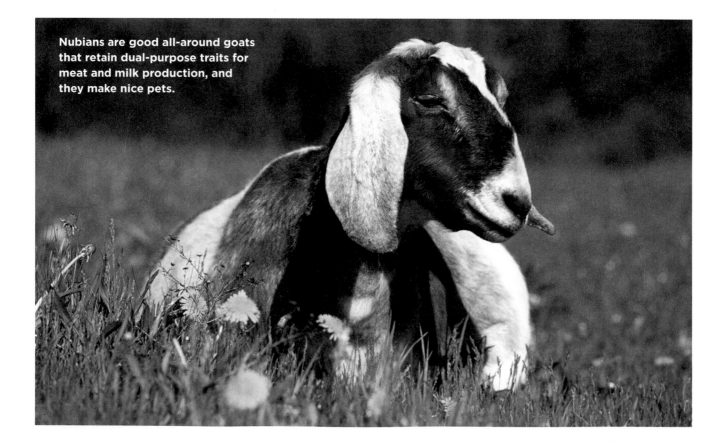

Nubians are good all-around goats that retain dual-purpose traits for meat and milk production, and they make nice pets.

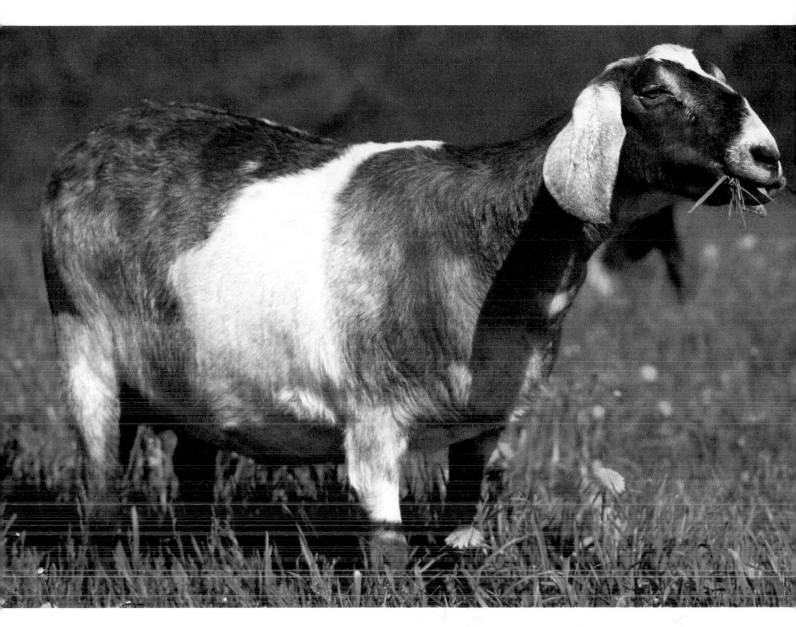

NUBIAN

FUNCTIONAL TYPE Dual-purpose, dairy but with good carcass traits.

APPEARANCE Any color, solid or patterned. Long, floppy ears fall to the front and extend at least 1 inch below the muzzle.

SIZE Large.

HORNS Either horned, with horns that rise up and curl to the back or slightly to the side, or polled.

CONSERVATION STATUS Not applicable.

PLACE OF ORIGIN England.

BEST KNOWN FOR Consistently high production as a dairy breed. Good meat characteristics.

Nubians are large (bucks are about 35 inches tall at the withers; does, 30 inches), friendly goats. Due to their pendulous ears, they are nicknamed lop-eared goats.

Oberhasli

PEOPLE OFTEN SAY that the Oberhasli, a Swiss Alpine breed, looks more like a deer than a goat. The breed was improved as a dairy goat around Berne, Switzerland, in the early 1900s, from the area's ancient, native, chamois-colored goats. They were first imported to the United States in 1906, but animals from the earliest imports were lost to crossbreeding. In 1936, a Kansas City goat dairyman, Dr. H. O. Pence, imported one buck and four does. These animals are the foundation for all Oberhasli in North America today.

The Oberhasli breed is known as a hardy and active breed, yet it has a very friendly disposition. It is fairly meaty for a dairy breed. Its 2005 records from the USDA's Dairy Herd Improvement Program show that, on average, the breed produces 1,830 pounds (830 kg) of milk, with 3.5 percent butterfat and 2.8 percent protein.

Many people who use goats as pack animals particularly like the Oberhasli because of its athletic and strong nature. Although not as common as other breeds in North America, the Oberhasli's numbers have been increasing steadily over the past decade or so as breeders become familiar with this beautiful and productive breed.

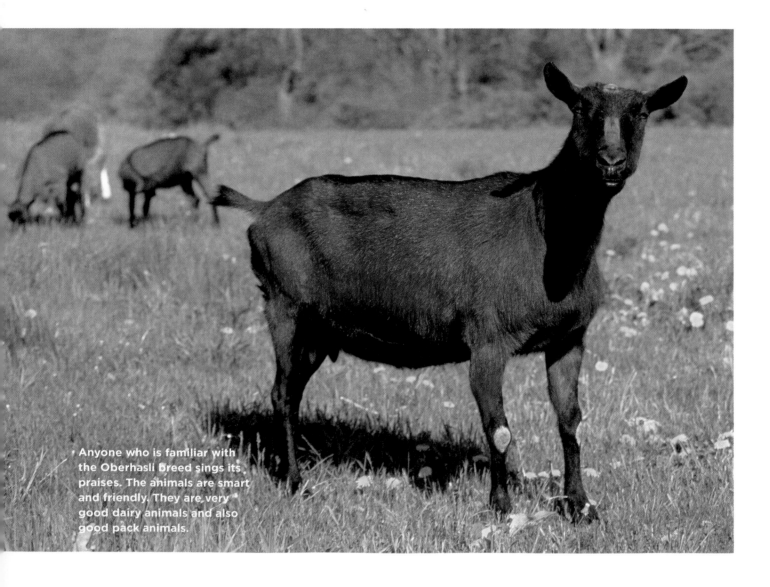

Anyone who is familiar with the Oberhasli breed sings its praises. The animals are smart and friendly. They are very good dairy animals and also good pack animals.

OBERHASLI

FUNCTIONAL TYPE Dairy.

APPEARANCE Preferred color is chamoisee (deep brown to brownish red) with black markings along the face, back, and underbelly, and with some white hairs allowed around the ears, or a few distributed in the coat. Occasionally solid black or a very light brown bordering on cream. Medium, upright ears rise from side of head. Males have a beard and wattles.

SIZE Medium.

HORNS Either horned, with medium to long horns that lift upward and sweep to the back, or polled.

CONSERVATION STATUS Recovering.

PLACE OF ORIGIN Switzerland.

BEST KNOWN FOR Hardy, active animals. Good milkers and good as pack animals.

The name Oberhasli comes from the name of one of the 26 districts (similar to counties in the United States) within the Swiss canton (state) of Berne.

Pygmy

ALTHOUGH DWARF GOATS are found through a large swath of western and central Africa, the Pygmies are thought to come primarily from the area around Cameroon. Some made their way to zoos in the early part of the twentieth century, but the first importation for the specific purpose of developing a Pygmy goat breed in North America is thought to have happened in 1959. The Rhue family, who ran a petting zoo in Thousand Oaks, California, and a game farm in the Catskills of New York, shipped some here from Sweden. The first breed registry in the United States was formed in 1972.

Pygmy goats have several distinct patterns of coat color. Agouti patterns have solid stockings that are darker than the main body color; muzzle, forehead, eyes, and ears are accented in tones lighter than the dark portion of the body. Caramel patterns have light vertical stripes on the front side of darker stockings; muzzle, forehead, eyes, and ears are accented in tones lighter than the dark portion of the body.

Pygmy goats are still favored by petting zoos, but they are now a popular pet goat for all kinds of people. They are playful, truly sweet little critters. Some owners do milk them for personal use. Their milk is very rich, and, during the early part of a lactation, they produce almost as much milk as the Nigerian Dwarf, though they taper off more quickly. They are able to breed all year and multiple births are the norm. The breed also is used for meat production.

Pygmy goats are like little bundles of joy, sure to capture the heart of anyone who is around them. They are very sociable and best kept with at least one other goat.

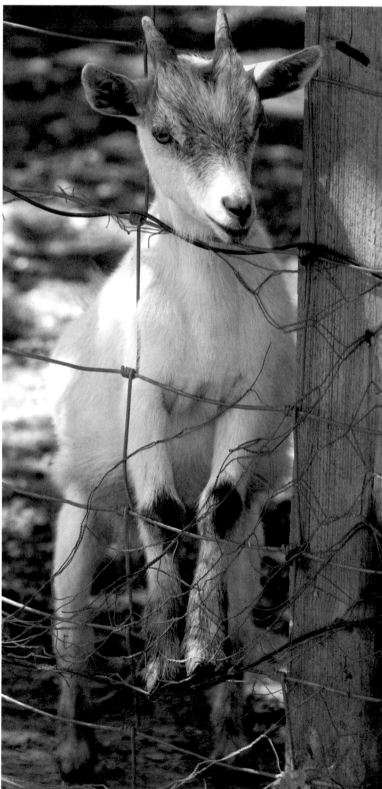

PYGMY

FUNCTIONAL TYPE Pets. Meat.

APPEARANCE Short (less than 23 inches at withers) but very stocky. Full coat of straight, medium-length hair. Perky ears stand upright or just above horizontal. May have a beard. Recognized color patterns include:

Agouti, black Mainly black, occasionally with intermingled white hairs.

Agouti, brown Mainly brown, occasionally with intermingled white hairs.

Agouti, dark brown Brown hairs intermingle with fewer white hairs, but there is still a pronounced dark brown salt and pepper appearance.

Agouti, dark gray Dark gray appearance with few white hairs but a pronounced salt and pepper appearance.

Agouti, light brown Light or silver-gray hairs intermingle with white; brownish tips on main body hairs make the top coat appear a burnt-silver or pewter shade.

Agouti, light gray Black and white hairs intermingle with slightly more white hairs, making the top coat appear to be silver or pewter.

Agouti, medium brown Brown and white hairs intermingle in equal amounts, giving the top coat a brownish salt and pepper appearance.

Agouti, medium gray Black and white hairs intermingle in equal amounts, giving the top coat a slightly blacker appearance, close to an equal amount of salt and pepper.

Black Solid black except for muzzle, forehead, eyes, and ears, which are accented in tones lighter than the dark portion of the body.

Black, solid All black with no white seen anywhere.

Caramel, brown Mainly brown, occasionally with intermingled white hairs in the undercoat, making the top coat a pronounced darker brown.

Caramel, dark White hairs intermingle with darker caramel/buff or brown hairs in the undercoat, making the top coat appear to be similar in color to a grocery shopping bag.

Caramel, light White or caramel hairs intermingle with white in the undercoat to make the top coat appear to be a shade of pure white to cream.

Caramel, medium Caramel and white hairs intermingle in the undercoat to make the top coat appear to be a shade of apricot to orange.

SIZE Small.

HORNS Small, upright horns that are straight or sweeping slightly to back.

CONSERVATION STATUS Not applicable.

PLACE OF ORIGIN Africa.

BEST KNOWN FOR Being the favored breed for pet goats. Affectionate and loving.

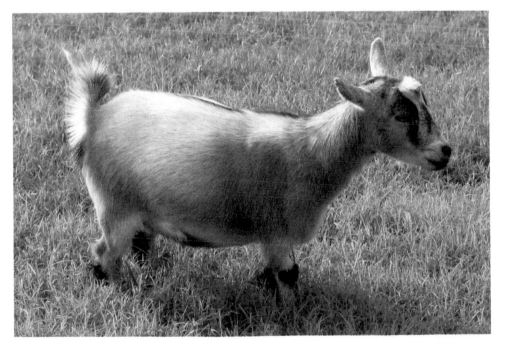

Pygmy goats are not very cold hardy, so in deep-freeze areas they need very good housing. Some people raise them as house pets, housebreaking them much as dogs are housebroken.

Pygora

ANOTHER SYNTHETIC BREED, the Pygora was developed in the late 1970s by Katherine Jorgensen, who crossed Pygmies with Angoras. Jorgensen, an avid fiber artist, had some registered Pygmy goats but their cashmere was too short to work with easily. She enjoyed working with Angora's mohair but was interested in getting a naturally colored mohair, so she experimented with breeding an Angora doe to a Pygmy buck. She bred the crosses back to each other and found they bred true.

Pygoras produce three types of fiber: Type A, Type B, and Type C. Type A is a long fiber, averaging 6 inches in length. It drapes in long, lustrous ringlets. It may be a single coat, but a silky guard hair is usually present. The fiber is very fine, mohairlike, and is usually less than 28 microns.

Type B is a fiber with characteristics of both mohair-type and cashmere-type fleece. It's usually curly and should average 3 to 6 inches in length. There is an obvious guard hair. A second silky guard hair is also usually present. There should be a luster and it should feel soft and airy. The fiber should test, on average, below 24 microns.

Type C is a very fine fiber, usually below 18.5 microns and can be acceptable as commercial cashmere. It must be a least 1 inch long and is usually between 1 and 3 inches. It has a matte finish and feels warm and creamy. It must show crimp. There is good separation between a coarse guard hair and fleece.

By the mid-1980s, a number of other breeders and fiber artists in Oregon were also breeding the cross. A group of breeders formed the Pygora Breeder's Association in 1987. Pygoras not only provide great fiber, but they also make excellent pets. Many owners will milk them for family dairy use. They are docile, yet curious and playful.

PYGORA

FUNCTIONAL TYPE Fiber. Pets.

APPEARANCE Muscular but not blocky. White, black, or have the color patterns seen in the Pygmies (see page 169). Ears tend to be horizontal but may be erect or drop down slightly along side of head.

SIZE Small.

HORNS Small, upright horns that are straight or sweep slightly to back.

CONSERVATION STATUS Not applicable.

PLACE OF ORIGIN United States.

BEST KNOWN FOR Fleece quality, including ability to produce colored mohair.

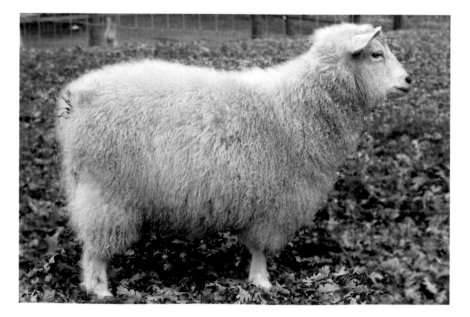

Pygora goats are largely raised for their fine fiber, which is a favorite with hand spinners and other fiber enthusiasts. Unlike their Pygmy ancestors, they are quite cold-hardy.

Saanen and Sable

NAMED FOR THE SAANEN VALLEY, which is south of Berne, Switzerland, the Saanen is one of the improved breeds of dairy goats developed in the Swiss Alps. Farmers selected for color (they are primarily white, though recessive color genes are found throughout the Saanen herd) and milk production. The breed was first imported to North America in 1904 and about 150 head arrived during the next 35 years.

The first breed club formed in 1937, though it folded several years later. Soon after, a new club, the National Saanen Breeders Association, formed, but they discriminated against colored Saanens, even if they were the offspring of purebred, registered parents. In 1974, a group of breeders established the first Sable Breeders Association, which did register colored Saanens. The Sables were basically any Saanens that, due to recessive color genes, weren't pure white. Today, the International Sable Breeders Association, which developed from the first Sable Breeders Association, registers Sables.

Saanens (and Sables) are quite adaptable to a variety of climate conditions. The does are feminine with excellent dairy capabilities. Their 2005 records from the USDA's Dairy Herd Improvement Program show a herd average of 1,986 pounds (901 kg) of milk, at 3.6 percent butterfat and 2.9 percent protein. They are calm, mellow animals by nature.

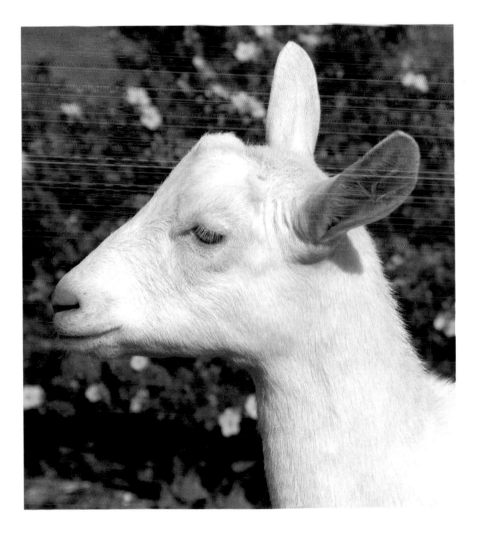

SAANEN AND SABLE

FUNCTIONAL TYPE Dairy.

APPEARANCE Short, fine hair, in two major color groups: the solid white and the "Sable." Ears are moderately long, erect, and face forward. Bucks have a substantial beard and may have wattles; does may have a small beard.

SIZE Large and big-boned. They are the tallest domestic goats in North America.

HORNS Medium to large horns that grow upright and curve slightly to the back.

CONSERVATION STATUS Not applicable.

PLACE OF ORIGIN Switzerland.

BEST KNOWN FOR Highly adaptable. Calm milkers.

All goats registered as Saanens are white, but the breed has recessive color genes, so those born with colored coats are registered as Sables.

Saanen and Sable (continued)

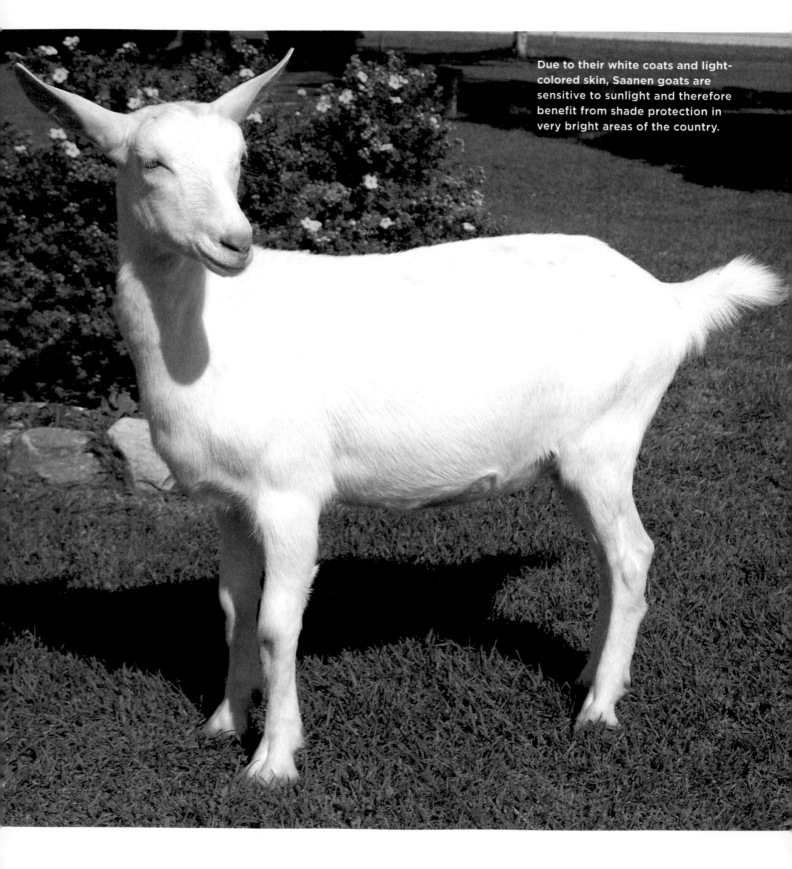

Due to their white coats and light-colored skin, Saanen goats are sensitive to sunlight and therefore benefit from shade protection in very bright areas of the country.

San Clemente

SAN CLEMENTE ISLAND, located 68 miles off the coast of San Diego, California, in the Channel Island chain, has long been the home of a group of feral goats. No one can say with absolute confidence how, or when, the goats arrived. Until recently, some people attributed them to Spanish explorers, but there is better evidence that they were left on the island around 1875 by a resident of one of the neighboring islands in the chain. In fact, recent DNA analysis clearly shows that the San Clemente goats are not of Spanish origin. The DNA tests also show that it is clearly a unique breed, but as of yet, the data isn't sufficient to determine what breed or breeds did serve as the San Clemente's foundation.

Regardless of how the herd became established, the U.S. military, which controls the island and uses it for a training ground, decided in the mid-1980s that the goats had to go — purportedly because they were destroying endangered plants on the island. At that time, there were about 15,000 goats living on the 57-square-mile island. The military's first solution was to simply exterminate the herd. Thousands were killed, but the Fund for Animals, an animal welfare

(continued)

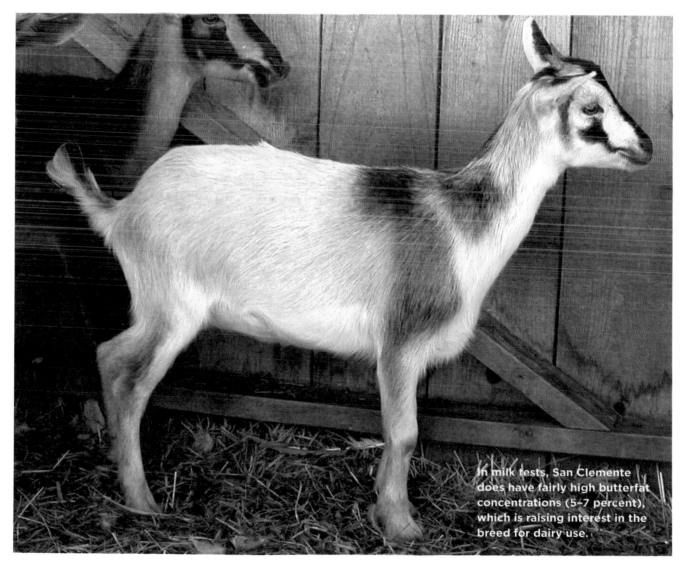

In milk tests, San Clemente does have fairly high butterfat concentrations (5–7 percent), which is raising interest in the breed for dairy use.

San Clemente (continued)

organization, successfully litigated for live removal of the remaining animals (about 6,000). Most were simply adopted as pets, but the American Livestock Breeds Conservancy and a small number of breeders worked to save some breeding populations. There are about 300 of these cute, small goats left with conservation breeders. The goats are considered critically endangered by American Livestock Breeds Conservancy.

The couple of dozen breeders around the country who have been helping to save the San Clementes say they are personable and friendly when raised with human contact. They are small, so they are easy to keep as pets, but some breeders are also looking into their potential as dairy animals or for meat production. The International Dairy Goat Registry has worked with the breeders to provide registration services.

SAN CLEMENTE

FUNCTIONAL TYPE Feral.
APPEARANCE Typically colored brown to reddish brown or tan, with black markings. Fine-boned and agile. Ears are perpendicular to head.
SIZE Small.
HORNS Medium horns sweep to the back and sides.
CONSERVATION STATUS Critical.
PLACE OF ORIGIN San Clemente Island, California.
BEST KNOWN FOR Status as a critically endangered feral breed.

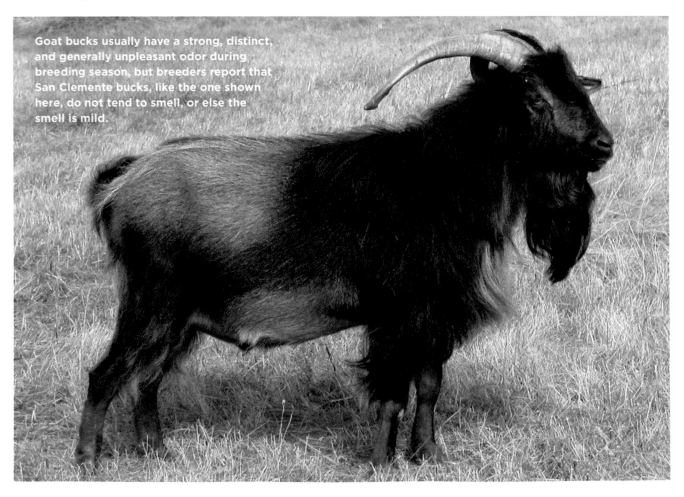

Goat bucks usually have a strong, distinct, and generally unpleasant odor during breeding season, but breeders report that San Clemente bucks, like the one shown here, do not tend to smell, or else the smell is mild.

Spanish

A CRIOLLO GOAT, the Spanish goat was developed across the American South, from Florida to California, from goats brought to the New World by early Spanish explorers. In the intervening centuries, some other breeds, including dairy, meat, and fiber breeds, have been introduced to its bloodlines, yet the Spanish goats retain significant similarities to the goats the explorers brought with them.

The American Livestock Breeds Conservancy points out that because the forebears of our Spanish goats have become extinct in Spain, it is critical to save the bloodlines here. Slow Food USA has recognized the Spanish goat on its Ark of Taste (see page 38), and breeders are becoming involved in protecting the breed. As well as using the breed for typical commercial meat production, a number of Texan and New Mexican ranchers are also developing hunting preserves, where big-game hunters pay to hunt the goats.

Spanish goats look rugged and have a bit more of a wild-goat look than many breeds. Some strains are known for high-quality cashmere, and a number of strains are known for very good carcass traits. They are all quite hardy and adaptable and can thrive in places that would be difficult for more refined breeds. Does are long-lived and quite prolific. A newly formed breed association should help preserve the Spanish goat's unique genetics for future generations.

Spanish goats perform extremely well in hot climates, whether humid or arid. They have high resistance to parasites, so in hot, humid climes they wean more pounds of kid per pound of doe than Boers or Kikos.

SPANISH

FUNCTIONAL TYPE Meat

APPEARANCE Color varies very widely, even within individual herds, from light to dark and solid to patterned. Medium to large ears held horizontally forward from the head. Straight to concave face.

SIZE Medium to large.

HORNS Impressive curling horns in males; smaller curling horns in the females.

CONSERVATION STATUS Watch.

PLACE OF ORIGIN United States.

BEST KNOWN FOR Hardiness. Ruggedness.

Toggenburg

THE OLDEST distinguishable breed of goat, the Toggenburg is named after a valley in the northeast corner of the Swiss Alps. Swiss documentation suggests that as early as the 1600s, when the first (and earliest known for any breed of livestock) herdbook was started, it was already recognized for the breed characteristics we see today, including color. William Schafer, an Ohio farmer, imported four Toggenburgs, via England, in 1893, and that importation was quickly followed by many more. By 1904 the breed was well established, and Schafer helped form the American Milk Goat Record Association as a vehicle for registering Toggenburgs.

Their 2005 records with the USDA's Dairy Herd Improvement Program show that they averaged 1,665 pounds (755 kg) of milk, with 3.4 percent butterfat and 2.8 percent protein. The does have particularly nicely formed udders and teats, which helps explain their longevity as milkers. They are active and hardy, doing best in cooler climates, but they also perform fairly well in hotter areas. The breed is known for being independent minded, which means training them to stand for milking can take a little time, but they are also quite affectionate.

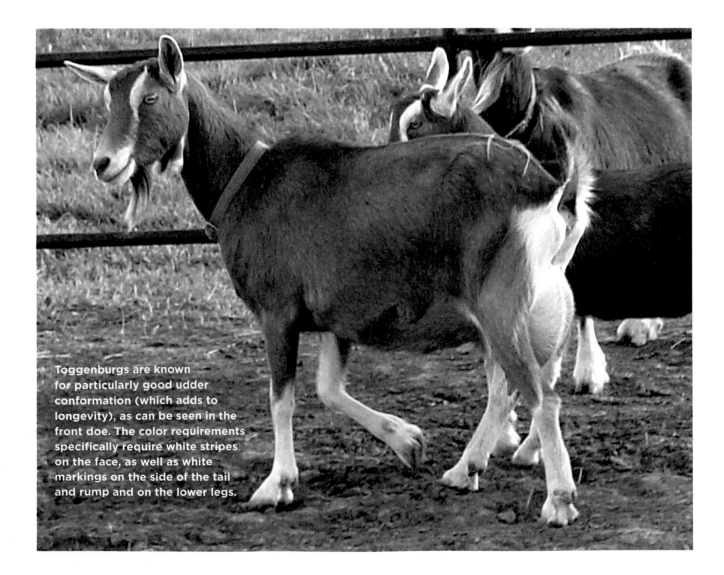

Toggenburgs are known for particularly good udder conformation (which adds to longevity), as can be seen in the front doe. The color requirements specifically require white stripes on the face, as well as white markings on the side of the tail and rump and on the lower legs.

TOGGENBURG

FUNCTIONAL TYPE Dairy.

APPEARANCE Grayish brown with distinct white markings on face, legs, and around tail. Coat may grow fairly long during winter. Ears are pert and erect.

SIZE Medium to large.

HORNS Upright with slight curl to back.

CONSERVATION STATUS Not applicable.

PLACE OF ORIGIN Switzerland.

BEST KNOWN FOR Consistently good milk production. Well-formed udders and teats.

Toggenburgs will grow a fairly heavy coat in cold climates (as seen on this buck) but shed out to a slick coat in warm weather, making them highly adaptable to a variety of climates. The coat includes both cashmere fibers and outer guard hairs.

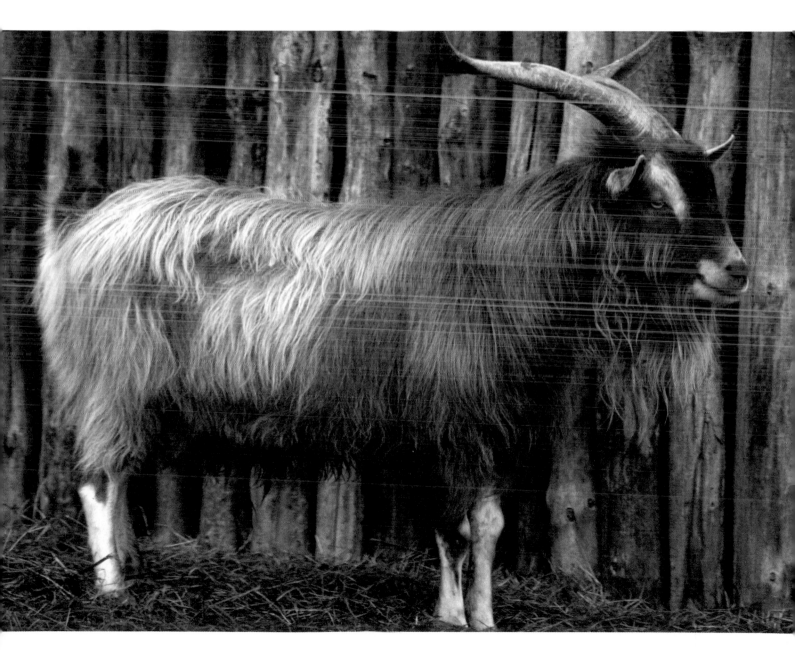

PIGS

WORLDWIDE, PORK IS THE MOST HIGHLY CONSUMED MEAT (even in spite of religious restrictions among practitioners of Islam, Judaism, and certain Christian sects), and North America is both a major consumer and producer of pork. Currently, more than 60 million hogs live in the United States according to the United States Department of Agriculture, 10 percent of which are breeding sows and boars. Factoring in Canada's hogs, North America is the third-highest pork-producing region in the world, behind China and the European Union. The Chinese consume the most pork overall, but residents of Eastern European countries, such as the Czech Republic, Poland, and Hungary, consume the highest amount of pork per person, with the Czechs topping the list.

Traditionally, pigs had a place on every farm and were even in many backyards. They were referred to as "the mortgage lifter" because they could bring some cash to hardscrabble farmers from the by-products of farming and living. Crops that wouldn't sell, garden waste, dairy by-products, and kitchen scraps could all be recycled through the family's hogs. But today the overwhelming majority of the hogs in North America are raised in industrial operations. Even into the 1980s, small-farm production was still viable, but as the packing industry has consolidated, markets have dried up for small farmers. During the 1990s, the corporate sector monopolized pig production and megafarms sprang up in many midwestern states and rural states in other regions, as well as the Canadian provinces of Quebec, Ontario, Alberta, and Manitoba.

The scale is almost incomprehensible. A farrowing barn may contain thousands of sows under one roof, each confined in a crate so small that it prevents her from even turning around. There are terrible environmental and social stresses caused by the new pork economy, and as a result, consumers are beginning to seek local food produced by family farmers, which offers hope for both the farmers and the breeds of hogs that have traditionally provided our bacon, ham, and lard.

There is no comparison in taste and flavor between hogs raised in industrial confinement and those raised on small farms, where the animals have some access to the outdoors. Consumers will seek the flavor of the hogs raised on small farms, giving pigs the chance to again become mortgage lifters for farmers and homesteaders who get into direct marketing. Pigs are highly intelligent, gregarious animals, and they can be great fun to raise.

A Brief History

PIGS BELONG TO THE SUIDAE FAMILY, which evolved from prehistoric species that date back more than 40 million years to the mid-Eocene period. At that time, the first group of piglike animals were clustered in the Entelodontidae family, including the "terrible pig" (*Dinohyus hollandi*), a bison-sized, pig-type animal that roamed over much of North America, and which, like today's pigs, was omnivorous though thought to be more a scavenger than predator. By the end of the Eocene (about 33 million years ago), the forebears of the domestic pig (*Sus domesticus*), the wild boar (*Sus scrofa*), were also roaming the planet.

The wild boars were quite adaptable, living in a very wide range of climatic conditions, and also quite able to be domesticated. There are at least seven independent sites of domestication, and scientists studying porcine domestication now think they will find additional sites. Not surprisingly, there are domestication sites, or clades, in the Middle East and Asia, but there are also sites in Europe. Current archaeological evidence suggests that Turkey was the first place where pigs were domesticated, about nine thousand years ago, though further research may uncover older domestication sites in Europe, Africa, or Asia. Pigs were abundant in temperate-to-hot regions within their range, including a number of Old World island chains.

Wild boars can reach weights above 750 pounds (340 kg), though most are far smaller than this. The sows drop a number of eggs into their fallopian tube during each estrus, so multiple births are the norm for both the wild sows and their domesticated progeny. The typical litter size in the wild is 4 to 8 baby pigs, though wild sows may wean as many as 12 in ideal circumstances. In temperate regions they are limited to farrowing 1 litter in the spring, but in tropical climates they can farrow multiple litters throughout the year if food supply (which corresponds to rainfall) is sufficient. Domestic pigs have one major advantage over their wild brethren, a consistent feed supply. This results in increased fertility and fecundity, with domestic sows producing 2.35 litters per year, from which they typically wean 9 baby pigs.

Long-living animals, wild pigs are known to regularly live into their teens or 20s if they survive to adulthood, though death loss of young pigs in the wild is very high. Females and young pigs live in herds (also known as sounders) of 20 to 100 animals or more, but mature males live apart from the group, fighting violently for breeding

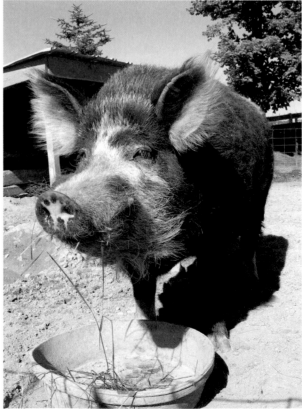

Pigs are omnivores, eating all kinds of vegetable matter, as well as meat. If humans like it, then there's a good chance the pigs will like it too.

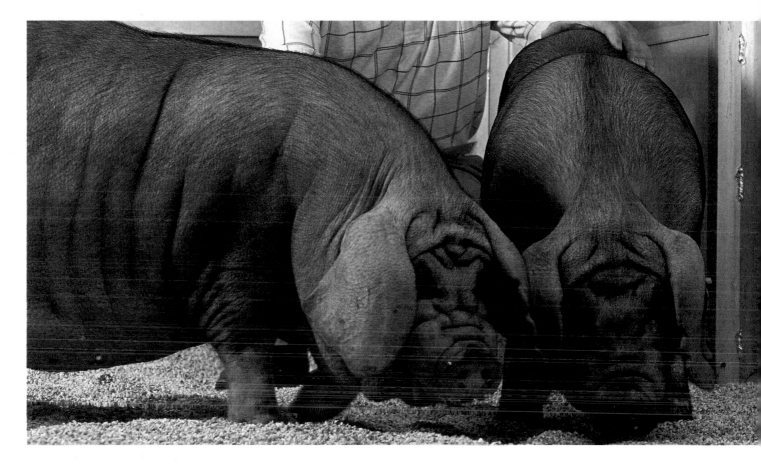

CHINESE PIGS

With the importance of pork to China's diet and economy, it isn't a surprise that that country has more than 75 breeds of swine. In recent years, researchers in the United States at universities and government research centers have imported hogs from China to see if these animals' genetics may be of value to producers here.

The imports, such as the Meishan, Fengjing, and Minzhu breeds, mature early and are highly prolific, but their growth rate is low and their carcass quality is a bit low. The flavor of their meat is said to be excellent. Chinese breeds don't seem to be destined for a significant place in North American agriculture, and most of the research populations have been abandoned.

With its folds of pendulous skin, the Meishan pig looks a bit like a shar-pei dog. Chinese breeds such as the Meishan have interesting genetics, but don't expect to see them on farms near you.

females during estrus. Each sounder has a large home range, and it routinely travels throughout it. The pigs live in moist forests (oak forests are the favored habitat) and shrubland. Like domestic pigs, wild pigs have a bristly hair coat and a very tough hide. Males have tusks (long front teeth that grow up from the bottom jaw and on the outside of the upper jaw), which are used in fighting, though farmers cut these off baby pigs to reduce injuries as the pigs grow.

Form and Function

PIGS TRADITIONALLY came in two essential types, the lard type and the bacon type. As the name suggests, lard pigs produced high concentrations of fat that was rendered for cooking and the production of lubricants, soap, lamp oil, cosmetics, explosives, and myriad other industrial products. These pigs were compact and thick, with short legs and deep bodies. They fattened quickly, particularly on a diet rich in corn. Historically, breeds such as the Poland China and the Berkshire were lard types. Lard types were also known for having particularly flavorful meat thanks to intramuscular fat.

The bacon pigs were distinguished by long, lean, and muscular frames, and they grew more slowly than their lard counterparts but yielded high-quality, fine-grained meat from a diet of legumes, small grains, turnips, and garden and dairy by-products, feeds that are high in protein and roughage and low in energy. The Yorkshire and the Tamworth represent bacon-type breeds.

By the end of World War II, synthetic lubricants and plant-based fats for cooking became widely available, and lard production, as well as the lard breeds, began a steep decline. The downward sliding market for lard quickly caused demand for lard pigs to collapse in the 1950s and 1960s, so breeders began selecting for leaner hogs. In the 1970s, breeders began concentrating on breeding hogs that not only produced leaner meat but could do so in a confinement system. Breeds that have been selected for leaner genetics, such as the Berkshire, are listed as "modern meat" in the functional type descriptions that follow. Those that didn't undergo intensive selection for leaner bodies during this period are still listed as "lard" or "bacon" in the functional type descriptions.

The Gloucestershire Old Spot and her baby pigs (professional swine people don't use the term *piglet* and may even take offense to it) represent old-type lard animals. The lard types have marvelously flavored meat.

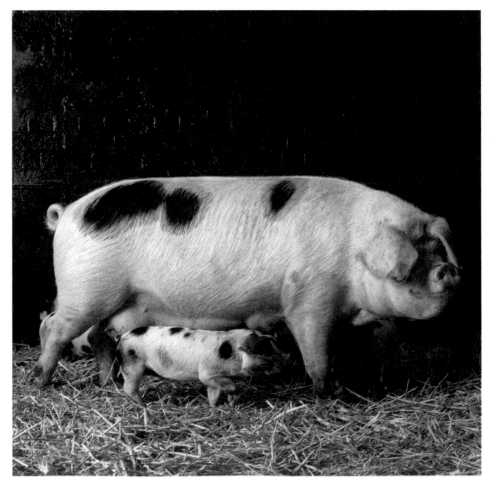

Swine have another function in modern times: they are widely used for biomedical research because of the similarities between their physiology and ours. Like humans, pigs are omnivores, eating a varied diet that includes both meat and vegetable matter. They also have a similar heart and cardiovascular system. Swine used in biomedical research are mainly from strains of miniature pigs, such as the Yucatan and the Chinese Meishan. These strains are not common outside of research-based breeding facilities.

Most hogs are intended for the butcher, so the majority of hogs produced are crossbred to take advantage of heterosis, or hybrid vigor. Breeds considered as "maternal lines" for crossbreeding include the Yorkshire, the Landrace, and the Chester White, while boars used as terminal sires are primarily selected from Duroc, Hampshire, and Berkshire breeds. I have designated breeds in the functional type description as "maternal" or "terminal sire" based on which use the breed is best known for in crossbreeding operations. Commercial producers may also purchase synthetic strains for breeding from corporations such as Monsanto and Babcock Swine, or use three-way crosses from Duroc, Hampshire, and Yorkshire bloodlines.

MATING METHODS

Natural pen mating, where a boar is placed in a pen with a group of females, is still the most commonly used method of swine breeding. However, artificial insemination is quickly catching up with natural mating. Purebred animals that are being mated for the purpose of producing potential breeding stock are often "hand mated," which means a single boar is placed with a single sow, with the farmer observing them until mating occurs.

The Tamworth represents the traditional bacon-type hog, with leaner and more muscular lines. It produces a fine-grained meat that provides an excellent eating experience — good flavor and exceptional texture.

American Landrace

THE NAME "AMERICAN LANDRACE" is a misnomer of sorts because it is not a landrace breed from America. It was developed, starting in 1934, by researchers from the United States Department of Agriculture and Iowa State University from a foundation of 24 Danish Landrace hogs. The Danish Landrace was an exceptionally successful bacon breed developed by breeding native Danish swine with Yorkshire (English Large White) hogs in the late 1800s.

With the success of the Danish Landrace breed, the Danes had cornered the European bacon and pork market. They refused to export breeding stock until 1934, when they agreed to send 24 head to Iowa State University to be used exclusively for research purposes. In 1949, they lifted the restriction on producing breeding stock from the Danish Landrace. The American Landrace is primarily the Danish Landrace, with small additions of Poland China, Norway Landrace, and Swedish Landrace bloodlines.

Landrace sows are very prolific; litters of 10 to 12 baby pigs are common, and some litters exceed 15 pigs. Sows produce abundant milk, so weaning weights are good. The breed is considered to be generally docile.

AMERICAN LANDRACE

FUNCTIONAL TYPE Bacon. Maternal.
APPEARANCE White. Muscular. Fine-boned with a long, straight back. Thin, floppy ears.
SIZE Large.
CONSERVATION STATUS Not applicable.
PLACE OF ORIGIN United States.
BEST KNOWN FOR Commonness as a maternal breed. High prolificacy. Good milk production.

Landrace sows are excellent mothers and the breed is gentle, but due to their floppy ears (which interfere with their vision) the pigs are easily startled.

American Yorkshire

NOT SURPRISINGLY, the original Yorkshire was developed in the shire (county) of York, England, where today the breed is known as the English Large White. During the late eighteenth century, Yorkshire farmers began crossing the white native hogs of York with Leicester hogs developed by Robert Bakewell. Through selection, they improved the breed.

The breed was first imported to North America in 1830, though Yorkshire bloodlines from this and other early importations were apparently lost to crossbreeding. Most of today's Yorkshires come from imports beginning in 1893. The American Yorkshire Club formed the same year in Minneapolis. The breed's numbers remained low until the 1940s, when farmers began looking for better meat-producing pigs. Today it has the greatest number of registrations of any North American breed.

Yorkshire sows are known for their mothering ability. They produce large litters (10 or more pigs) with lots of milk. Finished pigs from Yorkshire and Yorkshire-crossed breeding have a lean carcass with a small amount of back fat. They are fairly hardy animals with good longevity.

AMERICAN YORKSHIRE

FUNCTIONAL TYPE Bacon. Maternal.
APPEARANCE White. Long, straight back. Small, upright ears. Long, dished face. Small black spots on the skin don't prohibit eligibility for registration, but they are undesirable.
SIZE Large.
CONSERVATION STATUS Not applicable.
PLACE OF ORIGIN England.
BEST KNOWN FOR Mothering ability. Good carcass traits.

Although Yorkshires are common in industrial settings because they can stand up to confinement, sows also do very well in small-scale production systems and in pasture-pork operations.

Berkshire

ONE OF THE OLDEST identifiable breeds, the Berkshire, a black hog with white points, was documented in the English shire (county) of Berks more than 350 years ago, when Oliver Cromwell's army wintered in the area. They were originally sandy-colored animals that were large for that time and had good-tasting meat. The breed was improved during the eighteenth and nineteenth centuries through selection and the introduction of some Chinese and Siamese bloodlines, which were responsible for the breed's easily distinguishable coloring.

Thanks to the breed's excellent meat qualities, it was raised by Queen Victoria's husband, Prince Albert, both on the grounds of Windsor Castle and at the prince's farm on the Isle of Wight. Berkshires made their way to the United States in 1823, and in 1875 breeders formed the first American Berkshire Association, which was the first swine breeders' group and registry in the world.

Berkshires are hardy, with good mothering capabilities, and they perform very well outdoors, especially when grazing on pasture. Their meat is redder and far more flavorful than commercial pork. Thanks to its excellent flavor, chefs and discriminating consumers are asking for Berkshire pork, and it is a major export to the Japanese market. Berkshire breeders have taken the course of marketing flavor as the most important characteristic for eating, which may benefit other traditional swine breeds.

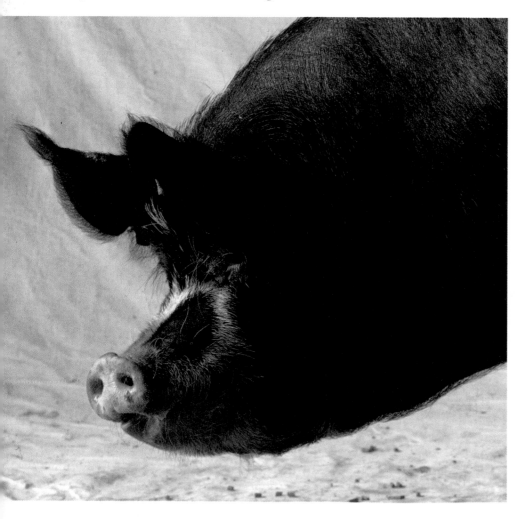

BERKSHIRE

FUNCTIONAL TYPE Modern meat. Terminal sire.

APPEARANCE Black with six white points on the tip of the tail, the snout, and four white-stockinged feet. Short snout. Short, erect ears.

SIZE Medium.

CONSERVATION STATUS Not applicable.

PLACE OF ORIGIN England.

BEST KNOWN FOR Very flavorful meat. Hardiness. Good production on pasture.

The infusion of Chinese and Siamese bloodlines is responsible for the Berkshire's distinctive coloring.

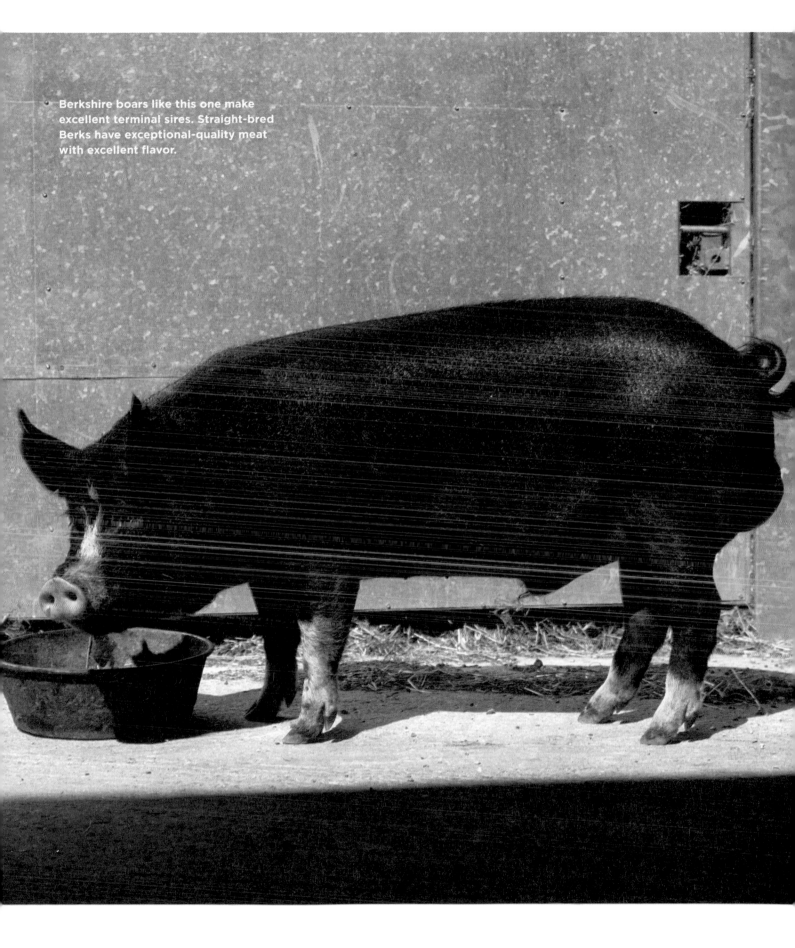

Berkshire boars like this one make excellent terminal sires. Straight-bred Berks have exceptional-quality meat with excellent flavor.

Chester White

NAMED FOR CHESTER COUNTY in southeast Pennsylvania, the Chester White was developed there during the early years of the nineteenth century. Large, coarse, bony, slow-maturing white strains of unimproved swine were common in Pennsylvania around 1818, when Captain James Jeffries imported a Bedfordshire boar from England. When mated to the native swine, this boar produced superior offspring, and the Chester White breed was developed from its progeny. Some livestock historians also believe that some white Chinese pigs were imported to the county about the same time and may have also influenced the Chester's development.

The first Chester White breed association started in 1884, and several more associations formed as the breed moved from Pennsylvania to other areas of the country. In 1930, all of the breed organizations came together as the Chester White Swine Record Association, and with the consolidation, the breed's influence expanded.

The Chester White has traditionally been considered a dual-purpose breed that has less lard than the typical lard breeds and that is not as long and lean as the typical bacon breeds. Chester sows are prolific (typically more than 11 pigs are weaned per litter), with excellent mothering ability and abundant milk, so their young tend to be a bit heavier than those of other breeds. Meat from the Chester is flavorful, and the breed has outperformed other major breeds for overall meat quality traits (such as yield; pH, which affects keeping quality; and intramuscular fat) in the National Barrow Show Sire Progeny Test. The breed is hardy and will perform well in a pasture-based operation.

CHESTER WHITE

FUNCTIONAL TYPE Modern meat. Both sows and boars are actively used for crossbreeding.

APPEARANCE White, though some small black spots on the skin don't prohibit eligibility for registration. Medium-size floppy ears. Medium-length, slightly rounded back.

SIZE Medium.

CONSERVATION STATUS Not applicable.

PLACE OF ORIGIN United States.

BEST KNOWN FOR Good-quality meat. Good production under a variety of management systems.

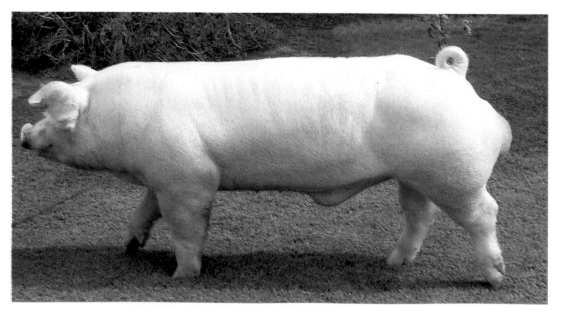

For overall characteristics and adaptability to a variety of production systems and environments, the Chester White is hard to beat. It is a truly versatile breed.

Choctaw

A CRIOLLO BREED, the Choctaw descended from the pigs Spanish explorers brought to the New World. It was common in Mississippi and Alabama, where it was kept by the Native American tribe for which it was named. When the Choctaw tribe was moved to a reservation in Oklahoma during the Trail of Tears, some members managed to take their hogs with them. The breed has an unusual single toe, known to scientists as a syndactylism. Syndactylism in hogs is a mutant trait that can show up occasionally in any breed, but it is common in the Choctaw hog, and in the Mulefoot hog, which lived farther north along the Mississippi.

The Choctaw breed is critically rare according to the American Livestock Breeds Conservancy. It is raised in a few counties in Oklahoma, where the traditional approach to rearing, allowing the hogs to reproduce under range conditions and forage for their own food, is still practiced. Because of this, the animals are extremely hardy. When raised in a more controlled environment, such as a barnyard operation, they tame down quite nicely. Although their carcass isn't marketable in the commodity system, it does produce flavorful meat for homestead production.

CHOCTAW

FUNCTIONAL TYPE Lard.

APPEARANCE Black, though they may have white markings. Medium-size ears that are usually upright but may droop a bit. May have fleshy wattles on the side of their neck. Toes are fused, forming a single, mulelike hoof. Relatively long legs for their size.

SIZE Small.

CONSERVATION STATUS Critical.

PLACE OF ORIGIN United States.

BEST KNOWN FOR Historical importance as a breed from the earliest American pigs of Spanish descent.

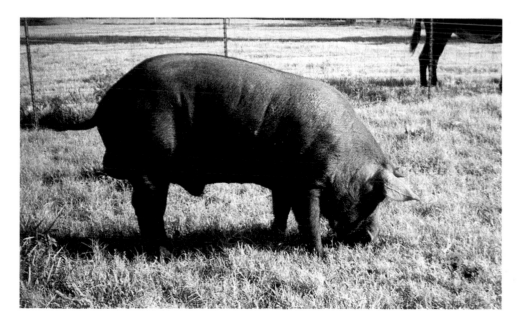

Choctaws are excellent hogs for range and pasture production in southern-tier states, yielding very flavorful meat for direct-market, pasture-pork producers.

Duroc

DURING THE EARLY DECADES of the nineteenth century, red hogs were fairly common in the mid-Atlantic states. In 1823, Harry Kelsey, a New York State farmer, owned pigs and a famous trotting stallion named Duroc. When Isaac Frink, a sheriff and farmer from Saratoga County, came to see the famous horse, he also saw an impressive litter of 10 baby pigs. Frink left with some pigs from the large red litter. He named one, a superior boar that produced offspring that showed his smoothness, carcass quality, cherry-red color, quick growth, early maturity, deep body, and quiet disposition, after the celebrated horse.

Though Frink's Duroc strain was a bit smaller than other hogs of the time, it became popular around Saratoga and the surrounding counties, and by the 1860s it was well known throughout New York State. Farmers wanted to add some size, so they crossed Durocs with the larger (now extinct) Jersey Red. The Duroc-Jersey breed was born, and by the time of the 1893 Chicago World's Fair, where the first Duroc–Jersey show was held, the breed was highly regarded and had spread throughout the mid-Atlantic states and the Midwest.

The first breed organization formed in 1883, and, just as with the Chester White, several other breed organizations also formed as the breed's influence spread to new regions. The groups united in 1934 and dropped Jersey from the breed's name.

Durocs are known for their high feed efficiency and fast growth, with the best conversion of feed to meat of any breed raised today. Duroc boars are common terminal sires in commercial operations; sows are prolific and long-lived. The breed is also known for flavorful meat, a strong frame, and hardiness. Commercial packers discount purebred Durocs because of the deep-rooted, colored hair, which requires them to skin the animal prior to processing.

Duroc boars are one of the most common terminal sires in today's swine industry. They pass along a number of very valuable traits to their offspring, but purebred animals are discounted by commercial packers due to their deep-rooted red hair.

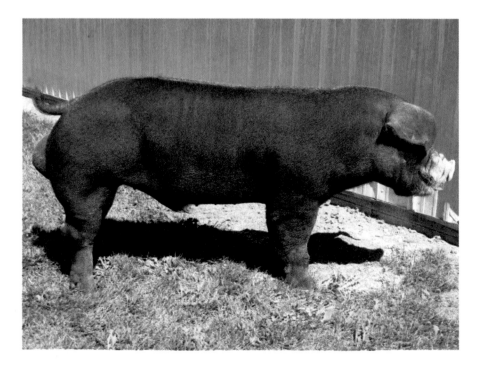

DUROC

FUNCTIONAL TYPE Modern meat. Terminal sire.

APPEARANCE Red-skinned pigs with red (or sometimes black) hair. Overall color ranges from a light golden red to a deep cherry-red. Relatively short yet floppy ears. Long, slightly rounded back. Athletic build.

SIZE Large.

CONSERVATION STATUS Not applicable.

PLACE OF ORIGIN United States.

BEST KNOWN FOR Excellent conversion of feed. Good-tasting meat.

Gloucestershire Old Spot

SPOTTED PIGS have been shown in English art for more than three centuries, but when breeders started a registry in the shire (county) of Gloucester in 1912, the Gloucestershire Old Spot became the first spotted pig to have pedigree records maintained. Gloucestershire is a traditional dairy and orchard region of southern England, near the Welsh border along the Severn River. As long as residents of the area could recall, the spotted pigs were used to clean up orchard waste and excess dairy whey.

The breed fell out of favor after World War II as pig farming intensified. By the 1950s it was almost extinct, but one British farmer, George Styles, made a commitment to save the breed. Styles sought out and acquired the remaining breeding animals (fewer than 60 sows and about a dozen boars) and continued to raise them on his family's farm. He promoted the breed among other small farmers, and thanks to his efforts,

today the breed's numbers are up in Britain, where organic consumers have become big fans of Gloucestershire Old Spot pork. With between 500 and 1,000 breeding sows, the breed is now considered a "minority" breed by the Rare Breeds Survival Trust (similar to the American Livestock Breeds Conservancy's threatened category).

A few Old Spots were imported to the United States in the nineteenth century and used in developing other breeds in North America, including the

(continued)

Gloucestershire Old Spots are exceptionally hardy, so they do very well in outdoor production. Sows are known to farrow and wean healthy litters outdoors, even in midwinter in northern states, provided they have some type of well-bedded hut in which to snuggle.

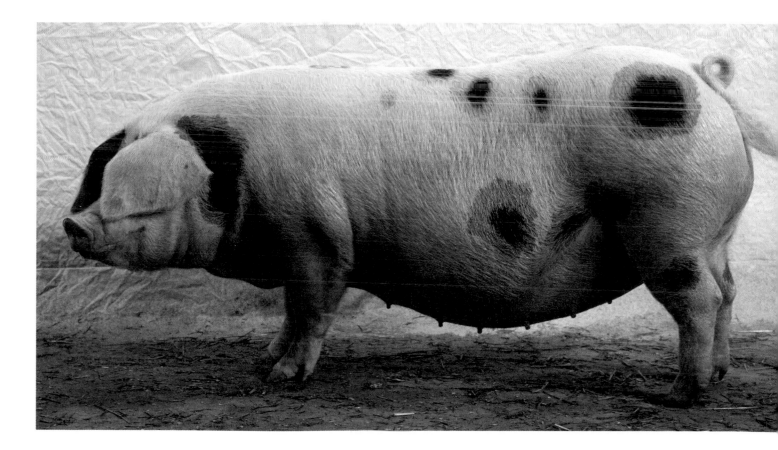

Gloucestershire Old Spot (continued)

Spotted Poland China and the Minnesota No. 3, a now-extinct breed developed by researchers at the University of Minnesota. Old Spots never became common on this side of the Atlantic, however, and nearly died out by the 1990s. In 1995, the Kelmscott Farm Foundation of Maine imported 20 Old Spots. Today there are a couple of dozen breeders helping to increase the breed's numbers and chances for survival.

Old Spots are remarkably hardy animals with great foraging ability. The sows are excellent mothers. When crossed with white pigs, the spots disappear, so boars can be used in crossbreeding to add hardiness and foraging capability for pasture-pork operators who are starting with sows that come from a confinement system. The meat of the Old Spot and its crossbred offspring is renowned for having excellent flavor. The breed is friendly and docile.

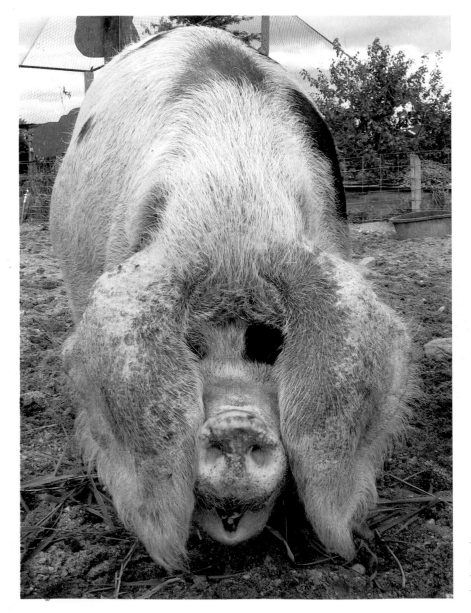

GLOUCESTERSHIRE OLD SPOT

FUNCTIONAL TYPE Lard.
APPEARANCE White with distinctive black spots. Floppy ears. Long, slightly curved back.
SIZE Medium to large.
CONSERVATION STATUS Critical.
PLACE OF ORIGIN England.
BEST KNOWN FOR Exceptional hardiness for pasture production.

Which way did they go? Those crazy floppy ears can interfere with the Old Spot's vision, but its hearing is very acute.

Guinea Hog

THE GUINEA HOG'S ANCESTRY has been traced back to Africa, and it came to North America aboard slave ships that sailed from the African west coast. It was once widely distributed throughout the southern states, where it was kept as a homestead hog and allowed to forage in yards and adjacent woods. Selection, and possibly crossbreeding with the Essex, an English breed that was imported in the 1820s, changed the breed enough that it was no longer recognized in the African nation of Guinea. Like many landrace breeds from the South, it was occasionally referred to as the Pineywoods Guinea hog (an even less common name was Guinea Forest hog). Also like other southern landraces, it is endangered today. An association was formed in 2005 to help conserve the Guinea Hog.

As foragers, Guinea Hogs truly excel. They eat not only roots, grass, nuts, and fallen fruit, but they are also aggressive varmint controllers, relishing snakes, rats, and other small critters that can be dangerous or a nuisance in the South. They are easy to keep and quite friendly, making them excellent pet pigs. Their meat is flavorful, and they were successfully nominated to Slow Food USA's Ark of Taste (see page 38) by the American Livestock Breeds Conservancy.

All of the Guinea Hog's attributes make it a perfect homestead hog for southern-tier states. Although individual animals don't produce a large quantity of meat, the quality is excellent, with a delicate flavor.

GUINEA HOG

FUNCTIONAL TYPE Lard, Pet.

APPEARANCE Predominantly black, though occasionally a red hog (the color of the African hogs from which they were developed) is born. Large, upright ears. May be big-boned or medium-boned, have a short or a long snout, and have short legs or long legs (depending on strain). Hair is long, dense, and somewhat curly in some strains.

SIZE Small.

CONSERVATION STATUS Critical.

PLACE OF ORIGIN United States.

BEST KNOWN FOR Suitability for the South as a homestead hog.

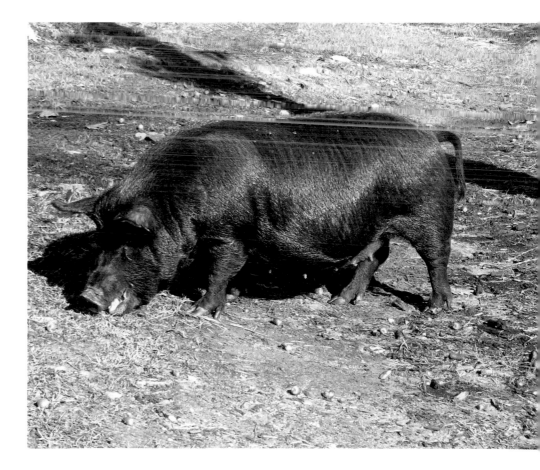

Hampshire

HAMPSHIRE HOGS were actually developed in Kentucky from Old English pigs that were imported from southern Scotland and northern England via the southern English port of Hampshire in the early nineteenth century. The foundation animals went from Britain to New England, then to Pittsburgh, and finally, in 1835, to Boone County, Kentucky, where breeders quickly became enamored of the animal. At first these hogs were frequently called Thin Rind hogs due to their thin skin, but they also went by a variety of other names, including Belted hogs, Saddleback hogs, McKee hogs, and McKay hogs, the latter being the names of some of the earliest importers.

When the first association formed in 1893, it was organized under the name American Thin Rind Association, but in 1904 the breeders reorganized and called their breed the Hampshire in recognition of the area in England from which the breed's ancestors were thought to have arrived. In the early decades of the twentieth century, the Hampshire spread throughout the Midwest, the Northeast, and the mid-Atlantic states.

Hampshires are hardy and vigorous hogs that will forage well if given the chance, but they have also performed admirably in confinement production. The boars are used as terminal sires, and thanks to their overall performance, they are the second-most commonly registered pig in North America, just behind the Yorkshire. Hampshires produce lean meat with low back fat and large loin eyes, and they have a good meat-to-bone ratio and high cutability.

HAMPSHIRE

FUNCTIONAL TYPE Modern meat. Terminal sire.
APPEARANCE Easily distinguished by their coloring: black with a white band around the front quarters. Upright ears. Straight to slightly curved back.
SIZE Large.
CONSERVATION STATUS Not applicable.
PLACE OF ORIGIN United States.
BEST KNOWN FOR Good production in confinement or on pasture. Good carcass quality.

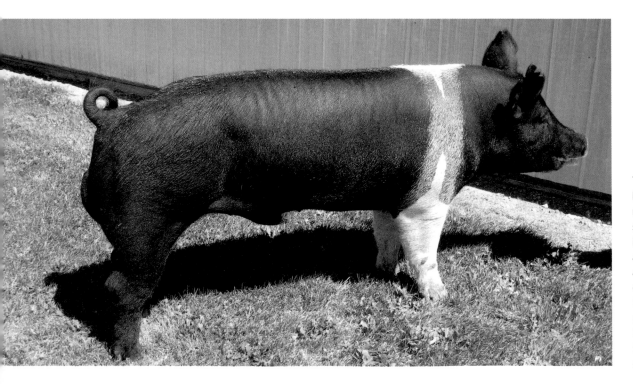

The Hampshire boar is a top-notch terminal sire. Although the breed is common as a confinement animal, it also does quite well in small-scale production and has exceptionally high feed-conversion rates.

Hereford

NAMED AFTER THE HEREFORD CATTLE BREED, to which it bears a resemblance in terms of color, the Hereford was developed in Iowa and Nebraska beginning in 1920. Swine breeders used Duroc, Poland China, and possibly some Chester White blood in developing the Hereford, selecting for both color and performance traits, including early maturity and high feed efficiency on pasture or in confinement. The breed became popular in the Midwest and the Plains States, but by 1960 its numbers had tumbled to near extinction. Its status has improved from critical to watch, according to the American Livestock Breeds Conservancy, and there are Hereford breeders spread throughout the country.

The Hereford is a very adaptable breed, doing well from Georgia and Texas to Washington and Montana, as well as in the Plains and the Midwest, where it got its start. It does quite well for pasture-pork producers. The Hereford has a gentle disposition and is an excellent breed for 4-H or Future Farmers of America projects. The breed is known for its high feed efficiency. The sows are dutiful mothers, raising 10 or more baby pigs per litter.

HEREFORD

FUNCTIONAL TYPE Modern meat.
APPEARANCE A red hog with white points (snout, feet, ears). Slight dish to the face. Pouchy jowls. Long neck. Floppy ears that aren't too long.
SIZE Medium.
CONSERVATION STATUS Watch.
PLACE OF ORIGIN United States.
BEST KNOWN FOR Coloring. Good disposition. Suitability for pasture or homestead production of tasty meat.

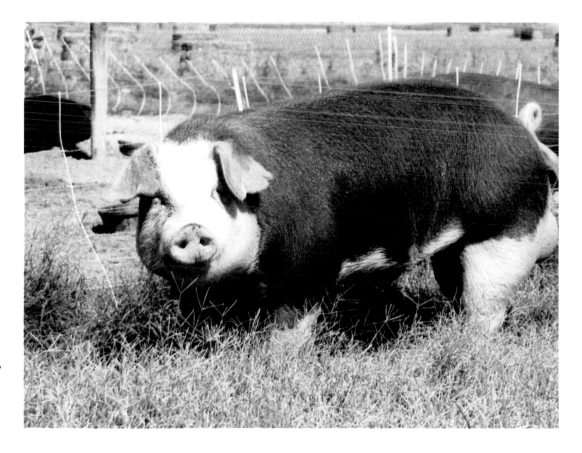

Herefords, such as this boar, have high feed efficiency. Hereford sows are great mothers, weaning large and healthy litters of hogs that mature early.

Lacombe

A CANADIAN BREED, the Lacombe is named for the Lacombe Research Centre in Alberta, where it was developed starting in 1947. Dr. Jack Stothart and Dr. Howard Fredeen began breeding Berkshire sows to Danish Landrace–Chester White cross boars. Their goal was to develop a terminal sire breed for crossing with Yorkshires, the predominant breed in Canada. From their new sire breed they wanted animals that would be productive under Canada's harsh conditions, produce vigorous offspring, and have good carcass characteristics.

Stothart and Fredeen worked for a decade before the breed was released to pork producers in Canada in 1957. For the first several decades of its existence the Lacombe was quite popular, but, like other breeds, it is suffering today. Registrations have fallen to dangerously low numbers as the remaining Lacombe hogs are held in proprietary strains by private corporations and are not available to farmers as breeding stock.

Lacombes are especially renowned for hardiness, fertility, and docility. They have excellent feed efficiency and are fast-growing animals that perform well in confinement but also do well in less-intensive operations.

LACOMBE

FUNCTIONAL TYPE Modern meat. Terminal sire.
APPEARANCE White. Medium-length, slightly floppy ears. Rounded back. Muscular build on strong legs.
SIZE Medium.
CONSERVATION STATUS Critical (Rare Breeds Canada).
PLACE OF ORIGIN Canada.
BEST KNOWN FOR Canadian origins. Good production traits. Docility.

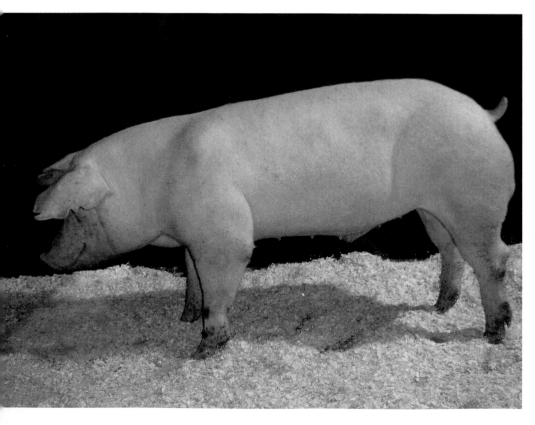

Critically rare in Canada, the Lacombe has ideal production traits and exceptional hardiness for northern areas. Boars make good terminal sires, passing along high feed-conversion rates to the baby pigs.

Large Black

THE LARGE BLACK is sometimes called the Devon or the Cornwall Black for the areas of southwestern England from which it came. It was developed in that area from crosses of native hogs with pigs of Chinese descent that were dropped off by traders at the docks of Plymouth.

The breed fared well throughout southern England for centuries. Its influence peaked in the 1920s, when it was exported around the world, but as pork production went indoors, the Large Black's popularity fell. Now listed as vulnerable in England by the Rare Breeds Survival Trust and as critical here by the American Livestock Breeds Conservancy, the breed is struggling to maintain viable breeding numbers. It was first imported to North America in the 1920s, and a subsequent importation in 1985 provided additional bloodlines for the breed.

The Large Black is an outdoor hog with excellent foraging ability and good mothering ability in a low-intensity production system. Sows have high fertility, and one sow is listed in the *Guinness Book of World Records* for having produced 26 litters in 12 years. The Large Black is docile and produces flavorful, juicy meat, without an excess of back fat, so the breed's meat is finding a following among some high-end chefs.

LARGE BLACK

FUNCTIONAL TYPE Bacon.
APPEARANCE Grayish skin (light- to steel-colored) with black hair. Large, floppy ears. Long snout.
SIZE Large.
CONSERVATION STATUS Critical.
PLACE OF ORIGIN England.
BEST KNOWN FOR Excellent foraging and maternal qualities for outdoor production. Very flavorful meat.

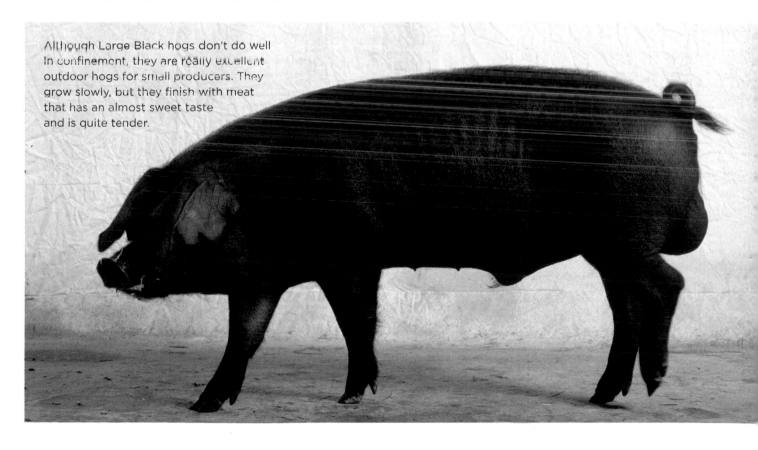

Although Large Black hogs don't do well in confinement, they are really excellent outdoor hogs for small producers. They grow slowly, but they finish with meat that has an almost sweet taste and is quite tender.

Mulefoot

NAMED FOR ITS SINGLE HOOF, the Mulefoot was developed in the nineteenth century along the Mississippi River in Missouri and Illinois, and from there it had spread throughout the Corn Belt by the early years of the twentieth century. During the summer months, farmers near the Mississippi and Missouri rivers would often put Mulefoot hogs on islands in the great rivers, retrieving them and their offspring in the fall. The Mulefoot did not do well in confinement production, and so as a result, it is critically endangered.

Like the Choctaw, which shares the syndactyl-hoof trait, livestock historians speculate that the Mulefoot developed from Spanish hogs. Some people hypothesize that the single hoof on both of these breeds was a good adaptation for the swampy life of the Mississippi River valley and islands, and that people therefore selected for the trait.

The Mulefoot is easy to raise, with a good disposition, though it grows slower than the modern production breeds. It produces well in outdoor systems off forage and less-intensive husbandry. Its meat is flavorful (it is on the Slow Food USA's Ark of Taste [see page 38]) and its hams are excellent.

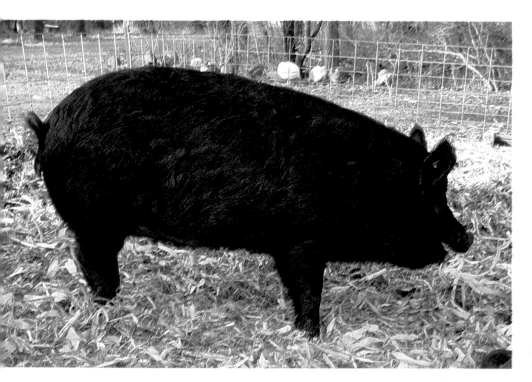

MULEFOOT

FUNCTIONAL TYPE Lard.

APPEARANCE Solid black, though occasionally one is born with white points. Ears are upright but lean forward. May have wattles.

SIZE Medium.

CONSERVATION STATUS Critical.

PLACE OF ORIGIN United States.

BEST KNOWN FOR The single, solid hoof that gives them their name. Hardiness. Ruggedness for outdoor production.

Above left: Mulefoot hogs are another breed that simply won't cut it in confinement, but they will produce excellent-quality meat on pasture. They are personable and calm animals, making them a great choice for homestead production.

Left: The single hoof is a unique trait found in Mulefoot hogs and Choctaw hogs. Some people speculate that the trait was selected for because it seemed to work well in wet environments.

Ossabaw Island

OSSABAW ISLAND IS A BARRIER ISLAND about 10 miles off the coast of Georgia. Spanish explorers in the 1500s left pigs on the island, and the pigs became feral. The island has never been highly populated. A Native American tribe lived there at the time of the Spanish explorers, and later, four English farmers owned the island.

In 1926, the island was sold to a wealthy couple from Michigan who used it as a vacation spot, and in 1978, their daughter, Eleanor Torrey West, donated the island to the State of Georgia as a heritage preserve, overseen by the State's Department of Natural Resources (DNR). The future of the Ossabaw Island hogs has become far more uncertain in recent years, as the DNR has decided to eliminate the island's hog population, as well as other nonnative species of plants and animals (though there are some mainland breeders of the hogs).

The Ossabaw Island hogs are quite small (less than 200 pounds [91 kg] at maturity), but they have adapted to island life. They are able to tolerate a high level of salt in their diet, a mechanism that allowed them to survive drought periods when freshwater disappeared, and they have a "thrifty gene," which enables them to add fat when food is abundant and live off their own fat in lean times. These traits are of interest to medical researchers, particularly the thrifty gene, which is essentially a genetic predisposition to obesity. Relative to their size, they have up to five times greater fat content than most other pigs, and, like humans, when they become inactive they also become too rotund and develop metabolic syndrome (prediabetes).

Ossabaws are friendly and intelligent, and, obviously, they are well adapted to the Southeast. They are excellent foragers and grow somewhat slowly, but they produce flavorful meat of good quality for the handful of farmers who are raising them on the mainland in Georgia and the Carolinas. They have been listed on Slow Food USA's Ark of Taste (see page 38).

(continued)

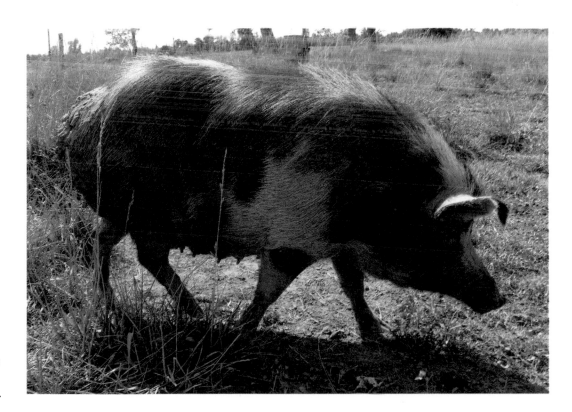

Though the animal is small, the Ossabaw Island's meat is exceptionally well flavored. Most are black, but spots, as seen on this hog, are not uncommon.

Ossabaw Island (continued)

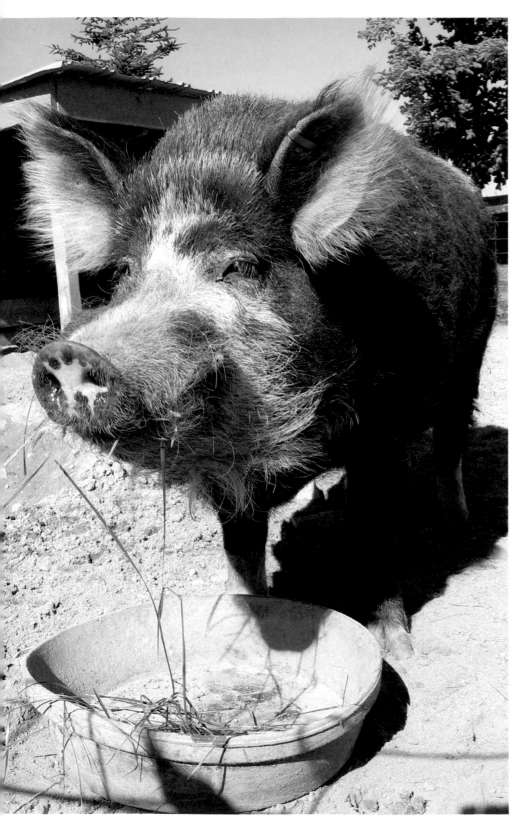

OSSABAW ISLAND

FUNCTIONAL TYPE Feral.

APPEARANCE Black or black and white spotted. Hair is denser than that of most pigs. Small, upright ears. Relatively long snout. Heavy shoulders. Light rear quarters.

SIZE Small.

CONSERVATION STATUS Critical.

PLACE OF ORIGIN United States.

BEST KNOWN FOR Being an important genetic resource. Being feral pigs that are excellent foragers. Fleetness of foot. Tasty meat.

Ossabaw Island hogs may be the perfect choice for homestead producers in the Southeast, as they thrive in heat and humidity.

Pietrain

THE PIETRAIN IS NAMED AFTER A VILLAGE of the same name in central Belgium where the breed has been raised since the 1920s. Belgian farmers developed the breed by crossing Berkshire boars to native sows. It remained a local breed until the 1950s, when its unique meat traits, including double muscling similar to that found in cattle, brought the breed international attention. It was imported to the United States in 1992 via Ireland. There are not many purebred Pietrain breeders on this side of the Atlantic, but semen is available commercially.

Pietrain sows aren't the most prolific; they average 8 to 10 pigs per litter, which is less than some other breeds. Also, they tend to have a slightly longer interval between weaning and conception, but the breed is known for producing exceptional carcasses. Not only are they double muscled, but they are the world's leanest hogs.

One of the factors that has prevented the breed from becoming more common is a genetic problem.

Ninety-eight percent of Pietrains have a halothane-recessive gene allele, which, incidentally, plays a role in their double muscling and leaness. Pigs that have this recessive allele suffer from PSS, or Porcine Stress Syndrome, and are susceptible to sudden death due to stress. Pigs that suffer from PSS also have a higher incidence of other health problems, and slaughtered PSS pigs frequently have pale, soft pork, which is highly discounted by packers. Scientists from all over the world have worked on crossbreeding and mapping Pietrain lines to develop a new Pietrain strain that doesn't suffer from PSS. It appears the development of this new strain may expand interest in raising Pietrains.

Although Pietrains are rare on this side of the Atlantic (this one lives in Belgium), their semen is being used frequently for crossbreeding purposes. As new strains that don't suffer from Porcine Stress Syndrome are identified, the breed's influence will increase.

PIETRAIN

FUNCTIONAL TYPE Modern meat. Terminal sire.

APPEARANCE Spotted (black or gray spots on white). Broad back. Bodybuilder type muscling, particularly in the rump. Upright ears. Long snout.

SIZE Medium to large.

CONSERVATION STATUS Not applicable.

PLACE OF ORIGIN Belgium.

BEST KNOWN FOR Extremely lean meat. Double muscling.

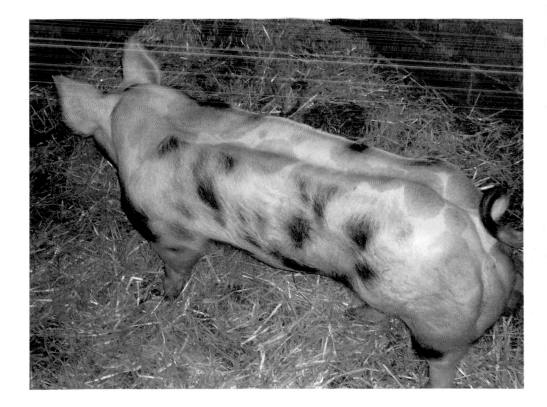

Poland China

HAILING FROM NEITHER POLAND NOR CHINA, the Poland China comes from the Miami Valley of Ohio. The breed's development took place during the first half of the nineteenth century. The Miami Valley was the center of the early Corn Belt, and Cincinnati was the most important pork-packing city at that time (in fact, it was sometimes called Porkopolis). Due to their proximity to the Cincinnati packers, farmers in Ohio, Indiana, and Kentucky were among the most progressive hog producers.

The farmers used a number of different breeds to develop the Poland China, including native hogs, Russian pigs, Chinese pigs, Irish Grazers, and Berkshires. The origin of the name is somewhat of a mystery, since no Polish pigs were involved in developing the breed, but the name was established by the 1860s, when the breed's first record book was established.

The modern Poland China is known for quick growth and excellent carcass quality, with intramuscular marbling but little back fat. It has a strong frame, so its legs and feet are good, giving it longevity and ruggedness. Sows are gentle and quiet, and they produce lots of milk, so their babies grow quickly. In spite of this, the breed has suffered in recent decades because it doesn't tolerate tight confinement well, but it will produce admirably on pasture.

POLAND CHINA

FUNCTIONAL TYPE Modern meat. Terminal sire.
APPEARANCE Black with six white points (feet, tail, snout). Long, lean, and rugged looking. Erect to slightly drooping ears. Short snout.
SIZE Medium to large.
CONSERVATION STATUS Not applicable.
PLACE OF ORIGIN United States.
BEST KNOWN FOR Top production per sow. Good carcass quality, particularly in outdoor production.

Although Poland Chinas can't stand up to industrial confinement, they are excellent hogs for larger-scale pasture producers or producers doing pork in hoop houses.

Red Wattle

THE RED WATTLE is named for its phenotype. It is a red hog (though some have black spots or hair) with wattles (little fatty, hair-covered skin flaps emerging from the sides of its neck). The wattles, which don't appear to have any biological function or advantage, are associated with a single gene, and though they can show up from time to time in other breeds, they are standard in the Red Wattle.

The Red Wattle as it is known today is a traditional "woods hog" that ran in semiferal packs in the eastern woods of Texas and northwest Louisiana. Its exact origin is unclear, but it probably has some criollo blood and possibly some blood from breeds that were introduced to Louisiana in the 1700s by French settlers coming from their New Caledonian colony off the coast of Australia. By the 1960s, timber companies in Louisiana and Texas were paying a bounty on the pigs, and the breed's numbers plummeted, though a few breeders in the region worked to save the breed from extinction.

Whatever the origin of the Red Wattle's genetics, one thing is for sure: pork connoisseurs routinely say they produce some of the best-tasting pork available. The breed was successfully nominated by the American Livestock Breeds Conservancy to Slow Food USA's Ark of Taste (see page 38).

A resurgence of interest in the breed in the 1980s produced three breed registries, yet none of these were particularly active, and once again the breed's numbers fell into decline. In 2001, the American Livestock Breeds Conservancy sponsored a meeting of breeders, developed a registry system, and helped to organize the Red Wattle Hog Association. The number of Red Wattle pigs and the market for Red Wattle pork is on a slow but steady rise. The pigs are very hardy outdoors, being adaptable to a wide range of climatic areas. Sows commonly wean 8 to 10 baby pigs that convert feed efficiently.

RED WATTLE

FUNCTIONAL TYPE Bacon.

APPEARANCE Always has wattles. Usually red, but may have black spots or black hair. Short back is humped toward the rear. Ears are upright to slightly droopy. Snout is long.

SIZE Medium to large.

CONSERVATION STATUS Critical.

PLACE OF ORIGIN United States.

BEST KNOWN FOR Exceptionally tasty pork. Hardiness for pasture production.

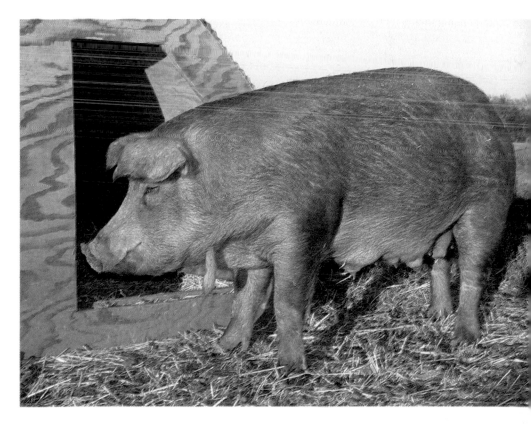

If you look closely, you can see the wattle hanging just behind this sow's jaw. The breed produces truly delicious meat.

Spotted

ALSO KNOWN AS SPOTS, the Spotted swine was developed in Indiana from the breeding of local stock with Poland China hogs and a few Gloucestershire Old Spot hogs. The Poland China breed does occasionally throw this pattern, and historically it was common for Poland Chinas to be spotted. The Poland China's spots are thought to trace back to crosses with the Big China breed, a white animal with small black spots.

During the 1880s, the Indiana farmers selected strongly for the spotted pattern, because they felt the animals were hardier and thriftier producers than even other strains of Poland China. They started a Spotted Poland China registry in 1914 that required the animals to have at least 20 percent white and no more than 80 percent white on the body. Initially, they accepted any animals that met this color requirement and were "largely of Poland China origin," but after 1915 the animals had to be from registered Spotted or registered Poland China stock. In 1960, the registry's breeders dropped Poland China from the breed's name.

The Spots are strong and hardy animals. They have a high rate of gain and a high feed efficiency, producing lean meat and an excellent carcass. They were a farmer's pig, and, like the Poland China, they have not made an easy switch to industrial confinement, but they will perform well in outdoor production.

SPOTTED

FUNCTIONAL TYPE Modern meat. Terminal sire.
APPEARANCE Black and white spots over their bodies with an ideal ratio of 50 percent black/50 percent white. Long back. Muscular build with a strong frame. Forward-leaning ears (not upright, but not really floppy, either). Dished face with a medium-to-short snout.
SIZE Medium to large.
CONSERVATION STATUS Not applicable.
PLACE OF ORIGIN United States.
BEST KNOWN FOR Black and white spotted coloring. Good production of meat outdoors.

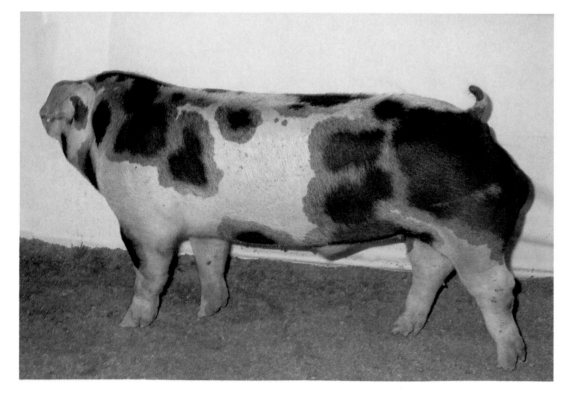

Like the Poland China from which they were selected, Spotted swine don't hold up to industrial confinement. However, they are excellent animals for farm-scale production on pasture or in hoop houses, efficiently producing high-quality carcasses and tasty meat.

Tamworth

THE TAMWORTH is considered an ancient British hog, and some people speculate that it was developed directly from wild boar, though that supposition has yet to be proven in the scientific community. It was widely recognized among central England's native hogs by the Middle Ages. Improvement of the breed seems to have taken place simultaneously in several areas of the United Kingdom, including Ireland, where it was sometimes called the Irish Grazier, during the late eighteenth and early nineteenth centuries. Most improvement methods were probably based on selection, but outside bloodlines, including Yorkshire and Berkshire, may also have been introduced.

Tamworths were first imported to North America in 1877, to Canada, and in 1882 to the United States. Even though bacon-type animals never enjoyed prominence in North America's agricultural landscape, by the 1930s the Tamworth was more common than the Yorkshire. It never did well in confinement, so in the 1960s its numbers began falling.

Tamworths are quite social and intelligent, though their intelligence sometimes proves problematic. They are Houdini-like and harder to contain than most pigs. In fact, in 1998, a pair of Tamworths escaped from an English slaughterhouse and their week on the lam became big news. They were dubbed Butch Cassidy and the Sundance Pig, and a British newspaper bought them and sent them to live out their lives at an animal sanctuary. The BBC even made a movie about them, *The Legend of the Tamworth Two.*

Tamworths are extremely hardy, excellent foragers, and they seem to have some resistance to diseases. Sows are excellent mothers (8 to 10 baby pigs are common), though baby pigs grow a bit more slowly than those of many of the modern breeds. Tamworth pork is lean, yet moist and well flavored. They perform well on pasture (though make sure the fences are good!), but they don't take to confinement.

(continued)

TAMWORTH

FUNCTIONAL TYPE Bacon.
APPEARANCE Ginger red to dark red. Arched back. Upright ears. Long snout. Long legs.
SIZE Medium.
CONSERVATION STATUS Threatened.
PLACE OF ORIGIN England.
BEST KNOWN FOR Historical importance as an ancient breed. Good production traits for pasture operators.

Tamworths do quite well in extensive operations (on pasture or in hoop-house production), or as homestead hogs, but fencing does need to be top-notch. They are extremely hardy even into northern Canada.

Tamworth (continued)

Tams, as they are known for short, have a distinctively long snout. Their color ranges from light ginger to dark mahogany. They are thought by many people to have the best-quality bacon of any breed.

Vietnamese Potbelly

IN VIETNAM, this pig is simply called Í. There are said to be several million Potbelly pigs in the Red River delta of Vietnam. They are raised within the household as an important source of protein and income. They consume kitchen and garden scraps, rice bran, and aquatic plants, as well as rodents and other small creatures. From this diet they produce a fatty carcass, which is an important component of the Vietnamese's rice-dominated diet. The Í was first imported to North America in the 1960s as a research animal. From research labs it made its way to petting zoos, and from there it went to the open market, where it was sold as a pet pig sometime in the late 1980s.

Vietnamese Potbelly sows mature early and are highly fertile and prolific (10 to 12 baby pigs are common), though they tend to not wean a full litter, and the baby pigs have a slow rate of growth. In spite of their slow growth rate, many pet pigs become obese and suffer from related health problems. When kept as pets they're usually spayed or neutered to avoid moodiness in females or unpleasant odors in males.

VIETNAMESE POTBELLY

FUNCTIONAL TYPE Pet.
APPEARANCE In Vietnam, these pigs are predominantly black; in North America many are black and white. Fine bones. Short legs. Upright ears. Long snout.
SIZE Small.
CONSERVATION STATUS Not applicable.
PLACE OF ORIGIN Vietnam.
BEST KNOWN FOR Status as pets.

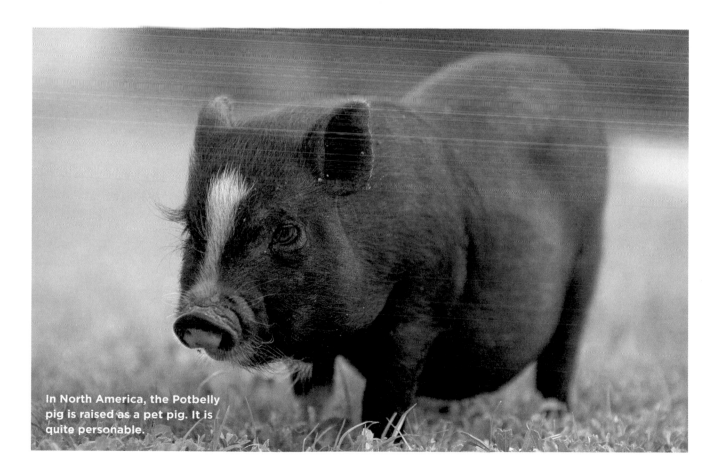

In North America, the Potbelly pig is raised as a pet pig. It is quite personable.

SHEEP

SHEEP ARE THE MOST COMMON farm animal in the world. More than one billion head provide meat, fiber, and milk. China, with more than 143 million head, is the leading nation in sheep production, followed by Australia, with more than 98 million head. Compared to these two countries, Canada and the United States produce a small number of sheep. There are just over 7.7 million head in the United States and just less than 1 million in Canada, yet sheep are found in every corner of North America, and more than 70,000 families benefit from keeping sheep.

Like goats, sheep are relatively small and thus provide an opportunity for people with a smaller land base to raise livestock. A piece of land that can typically carry one cow and her calf will serve five ewes and their offspring well. Or you can mix cattle and sheep to carry more total animals than either type alone. For example, you could carry one cow and three or four ewes on the same piece of land that supported just one cow. How? The answer relates to eating habits. Sheep eat a wider variety of feed types (including some brush and some coarse, woody weeds) than cattle, so the cattle eat their preferred plants, and the sheep eat theirs, and there is only limited crossover.

Sheep are quite gregarious, and though most animals do best when raised with their own kind, it is critical to have a flock when raising sheep. The flock, which provides both safety and companionship, should include at least four or five members. A flock has its own personality and usually moves as a unit, in much the same way as a school of fish seems to move as one. Learning to understand flock dynamics makes handling sheep much easier!

Sheep are underappreciated animals in the United States. They are versatile and able to fill niches anywhere in the country. They are also wonderful animals for small-scale producers and homesteaders, with the potential for both meat and fiber production.

A Brief History

DOMESTIC SHEEP (*Ovis aries*) are in the same family, *Bovidae*, as cattle, goats, and other, wild ruminants, such as antelope and gazelles. Our domestic sheep are descended from the Asiatic mouflon (*Ovis orientalis*), one of six wild species of sheep found throughout the world. From the earliest domestication of sheep, which scientists currently think occurred about 9,000 years ago, more than one thousand recognizable breeds, representing an amazing range of variation in coat type and color, horns, size, and adaptability, have been developed. The first domestication site is thought to be in northeastern Iraq, near the Iranian border, though some evidence supports at least one other domestication site in northwest China.

The Asiatic mouflon is a dark reddish brown sheep with a black throat ruff and white underparts and rump. Its coat consists of a hair layer and a natural woolly undercoat that is shed in the spring. It isn't a large animal (a big ram may be 100 pounds [45 kg], but most are around 70 pounds [32 kg]), but it has relatively long legs and impressive curling horns that show an annual ringed-growth pattern. The curling horns of a mature ram can measure 3 feet in length from the base of the skull to the tip of the horn. Ewes have one or two lambs.

The Asiatic mouflon is thought to have originated in the southern Himalayan Mountains between India and Tibet. Although it is still found in the wild throughout the mountainous areas of Afghanistan, Armenia, Azerbaijan, India, Iran, Pakistan, Tajikistan, Turkey, and Turkmenistan, the World Conservation Union considers the Asiatic mouflon vulnerable to extinction.

A subspecies, called the European mouflon, is found on the Mediterranean islands of Corsica and Sardinia and is critically endangered in the wild. Interestingly, this subspecies most likely developed from some of the earliest domestic sheep that were transported to the islands by Neolithic farmers about seven thousand years ago and were allowed to go feral.

The Soay is an ancient breed that still retains many characteristics of the earliest domestic sheep.

Form and Function

IN NORTH AMERICA, sheep are best known for two functions, producing fiber and meat. But today there is growing interest in sheep dairying, particularly for preparing traditional sheep's milk cheeses, such as those commonly found in the mountainous and the very arid areas of Europe. For example, Greek feta, Spanish Manchego, and Italian pecorino and ricotta are all traditionally sheep's milk cheeses in Europe.

Although sheep produce less milk than cattle and goats, their milk is very high in solids (butterfat and protein), so it yields about twice as much cheese per volume as cow's milk, and about 1.4 times the amount of cheese per volume as goat's milk. Sheep milk is nutritious, with more vitamins A, B, and E, calcium, phosphorus, potassium, and magnesium than cow's milk. It contains a higher proportion of short- and medium-chain fatty acids, which have recognized health benefits, including easier digestibility,

Shearers are clipping the fleece from these Debouillet sheep. Wool is a wonderful natural fiber that has great insulating qualities.

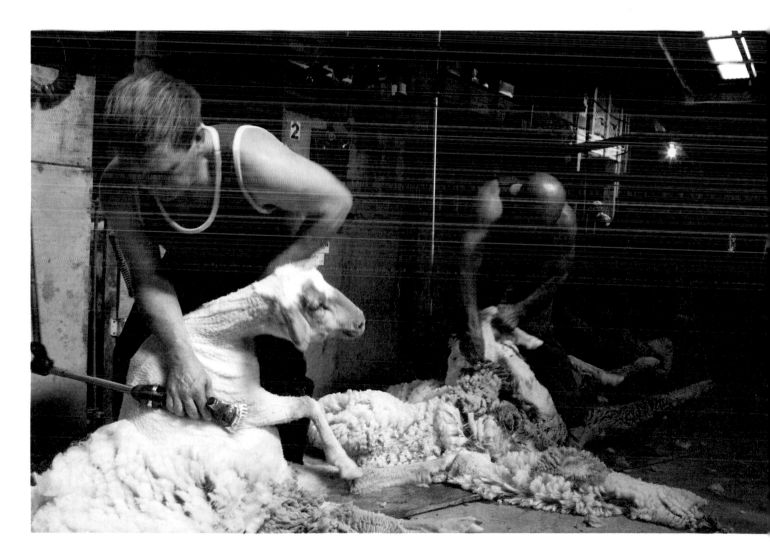

and it has more conjugated lino-leic acid, which has been shown to have cancer-fighting qualities, than the milk from goats, cattle, or humans.

When you hear the word *fiber* in relation to sheep, your mind probably jumps immediately to wool, yet not all sheep produce wool. Hair sheep, like their mou-flon relatives, have an outer hair coat, and during cold periods they

Here, shepherd Bill Hardman of Delta, Colorado, moves his flock of Polypay sheep. Sheep have excellent potential for small-scale producers looking to capitalize on direct marketing opportunities of meat and/or fiber.

may develop a wool-like undercoat that sheds out during the spring. In the past, commercial shearers could be found in most sheep-producing areas, but today there are very few shearers. For shepherds primarily interested in meat production, hair sheep significantly reduce their labor costs and direct the energy and protein of their feed to the development of flesh rather than wool. As for the commercial value of wool, the world has had a glut for several decades, so prices have remained pitifully low for all but the finest-quality fleeces. The highest revenue from wool goes to those shepherds who sell top-quality fleece directly to hand spinners and fiber artisans.

Much of the lamb sold in supermarket meat cases is imported from New Zealand and Australia. Shepherds selling to the commodity meat market have had a hard time competing with the down under producers. As an alternative, many producers are direct-marketing their lamb to ethnic communities and buyers who are interested in niche-produced meat, such as organic or grassfed meat.

Overall, sheep breeds still maintain a great deal of multipurpose func-tion. In other words, most breeds do provide both fiber and meat, and several breeds are being used for dairy purposes or in crossing for dairy. Under "Functional Type" in the breed descriptions that follow, I categorize the functions in order of importance, so if the listing reads "Fiber, meat," then fiber production is the more important function for that breed. These "rankings" represent my opinion.

Most sheep are prolific, meaning ewes typically give birth to multiple young. In the breed descriptions, you will see references to lambing per-centage, which relates to how many young a ewe for that breed typically has. If the lambing percentage is reported as 150 percent, then in the average flock of that breed, a shepherd can expect that for every two ewes he or she has, there will be three lambs. (These are averages; actual numbers of lambs depend on good husbandry.) Some breeds, such as the Finnsheep, have so many young that shepherds will refer to them as litters.

Blackbelly

THE BLACKBELLY IS A HAIR SHEEP, and there are actually two breeds, the Barbados Blackbelly and the American Blackbelly, which was developed from the Barbados. The island of Barbados is the easternmost island in the Caribbean chain. The first sheep to come to the island were thought to be an African hair type, brought to the New World aboard slave-trade ships. Later, European wool breeds were also imported, and by 1680 descriptions of the island's sheep were recognizable as the Barbados Blackbelly.

The first Barbados Blackbellys were imported to the United States by the Department of Agriculture in 1904, and there may have been a few subsequent importations from South America or Mexico during the early years of the twentieth century. In 1970, Dr. Lemuel Goode at North Carolina State University

(continued)

BARBADOS BLACKBELLY

FUNCTIONAL TYPE Hair. Meat. Dairy.

APPEARANCE Almost deerlike, with long legs for their size. Coloring is brown, tan, or yellow, highlighted with contrasting black underparts and points on the nose, forehead, and inside of the ears.

SIZE Small.

HORNS Naturally polled; may have small scurs or diminutive horns.

CONSERVATION STATUS Recovering in the United States, and secure in its country of origin, Barbados.

PLACE OF ORIGIN Barbados.

BEST KNOWN FOR Prolificacy. Very good performance in the South. Widely used to train herding dogs because of its athleticism.

Barbados Blackbelly sheep are finding a niche beyond producing meat efficiently in the hot and humid South: they are being used as exterminators of cedar trees in areas of the country where cedar is a noxious weed plant.

Blackbelly (continued)

imported additional animals. At some time, probably during the 1970s (documentation is scant), ranchers in Texas and Oklahoma who ran hunting preserves began crossing Barbados Blackbellys with mouflon sheep and some other breeds, such as Dorsets and Merinos, in order to produce a large-horned sheep that hunters would pay to bag. They dubbed these crosses Corsican sheep, or Barbados sheep. Now these horned crosses are called American Blackbelly. The Barbados Blackbelly Sheep Association registers both the true Barbados Blackbelly and the American Blackbelly.

The Barbados Blackbelly is prolific, regularly having twins or triplets, and occasionally far larger litters; the record on the island is eight lambs to one ewe. It will breed throughout the year and is often bred on a cycle of three lambings per two-year period. It has high resistance to internal parasites and great heat resistance.

AMERICAN BLACKBELLY

FUNCTIONAL TYPE Hair. Meat.

APPEARANCE Very muscular. Gray to brown coloring and black highlights on underparts and points on nose, forehead, and ears.

SIZE Medium.

HORNS Large curling horns, reminiscent of the mouflon.

CONSERVATION STATUS Not applicable.

PLACE OF ORIGIN United States.

BEST KNOWN FOR Being a domesticated "game" animal in the South and Southwest.

The American Blackbelly was developed as a game animal, but the meat has good eating qualities off pasture.

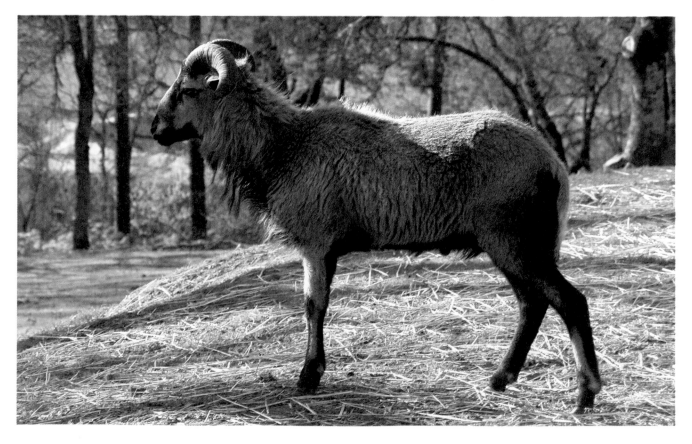

Black Welsh Mountain

WALES IS A MOUNTAINOUS COUNTRY with a long history of sheep raising. Even today, Wales is a major sheep producer within the European Union, producing about 15 percent of all sheep in Europe. Several breeds of Welsh Mountain sheep have been developed, and documentation shows that they date back at least to the thirteenth century.

The Black Welsh Mountain sheep, which comes from the southern mountains of Wales, is the only breed of Welsh Mountain sheep found in any significant numbers in North America, and the only one to have a breed association on this side of the Atlantic (though there are also a few North American breeders of Sennybrook Welsh Mountain sheep, which come in white and tan, as well as black). The sheep came to North America in 1972, from an importation of 3 rams and 13 ewes. Subsequent importations of semen added genetic diversity to the North American flock.

Black Welsh Mountain sheep are quite hardy and rugged. They have good feet and legs, making them ideal in rough country, and they have high resistance to foot rot. Their meat is flavorful, and they have a high meat-to-bone ratio. The fleece has little commercial value, but hand spinners enjoy working with it. Fibers are 3 to 4 inches long, fine, soft, and densely stapled. A typical animal will produce 3 to 4 pounds (1.36 to 1.81 kg) of wool per year. Ewes make excellent mothers, with good milk production and an average lambing percentage of 175 percent.

Most Black Welsh Mountain sheep are true, dark black, but some are reddish black, a color known as "cuchddu."

BLACK WELSH MOUNTAIN

FUNCTIONAL TYPE Fiber. Meat.

APPEARANCE No wool on face or legs below the knee, and a fairly thin layer of very fine wool on underbelly and tail (long tails must be left undocked for registration). Solid black to dark brownish black; they do not gray with age, unlike other dark-fleeced sheep.

SIZE Small.

HORNS Males have medium horns that curl; females are polled.

CONSERVATION STATUS Recovering.

PLACE OF ORIGIN Wales.

BEST KNOWN FOR Small size. Hardiness. Low maintenance. True black wool.

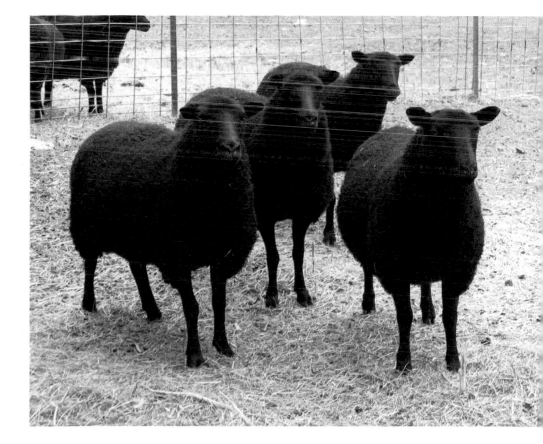

Bluefaced Leicester

THE BLUEFACED LEICESTER (pronounced "lester") was developed in the early twentieth century through selection for both the blue face (an effect seen in animals that have black skin under white hair) and for fine fleece. The Border Leicester provided the foundation breed from which Bluefaced Leicesters were selected. In northern England, Bluefaced Leicester rams are commonly used as a terminal sire breed on Blackfaced Hill ewes to produce a highly productive crossbred ewe, traditionally called the "mule." The Bluefaced Leicester was first imported to Canada in the 1970s, and then to the United States from Canada. Breeders have imported semen in recent years.

The fleece is classified as long wool, but it is fine and semilustrous to lustrous, making it popular with fiber artists, who like working with the fleece because it makes a strong yarn that wears well and takes dye nicely. The average fleece weighs between 2 and 4.5 pounds (1 to 2 kg), and the average staple length is 3 to 6 inches (7.6 to 15.2 cm). The wool qualities appear to be inherited by crossbred rate. Ewes have roughly a 250 percent lambing rate. Lambs grow quickly and mature early. The breed is quite hardy and has a genetic resistance to scrapie.

BLUEFACED LEICESTER

FUNCTIONAL TYPE Fiber. Meat.

APPEARANCE Long-bodied. Roman nose. No wool on head, neck, belly, legs, scrotum, vulval area, and udder. The "blue face" is the result of thin white hair on the face over black skin. Fleece is normally white, though there are recessive color genes.

SIZE Medium to large.

HORNS Naturally polled.

CONSERVATION STATUS Not applicable.

PLACE OF ORIGIN England.

BEST KNOWN FOR Strong, lustrous fiber that takes dye well. Hardiness. Scrapie resistance.

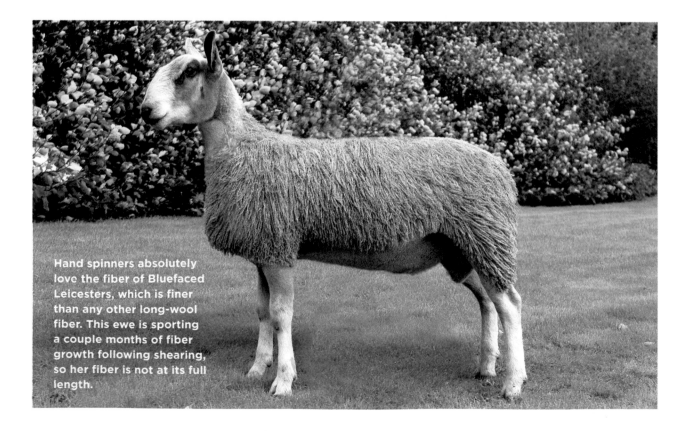

Hand spinners absolutely love the fiber of Bluefaced Leicesters, which is finer than any other long-wool fiber. This ewe is sporting a couple months of fiber growth following shearing, so her fiber is not at its full length.

Border Cheviot

NAMED FOR THE CHEVIOT HILLS that skirt the border between England and Scotland, the Border Cheviot (also known as Southern Cheviot) is said to have a heritage that dates back to the wreckage of a Spanish ship on the English coast in the later years of the fourteenth century. Spanish sheep of the time were renowned for their hardiness, and those escaped sheep are said to have quickly established a large population that adapted to the rugged hill country of northeastern England and southeastern Scotland.

During the ensuing centuries, shepherds improved the breed primarily through selection, though some Merino bloodlines were likely introduced in the fifteenth and sixteenth centuries, and some Lincoln bloodlines were likely introduced in the seventeenth century. Whatever bloodlines and selection pressures contributed to its development, the breed was well distributed and easily recognized throughout the Northumberland region of England by the eighteenth century. It was exported to other areas of Britain during the nineteenth century, contributing to the development of the Brecknock Hill Cheviots and North Country Cheviots. It was first imported to New York in 1838 from Scotland, followed by numerous importations to the United States and Canada.

Border Cheviots are very hardy and can handle harsh winter weather. They are active sheep and do well at grazing, but they don't herd well in open-range operations. Because of their active nature, breeders of working dogs (Border Collies and other herding dogs) like them for training their dogs.

The ewes are good mothers and have a high percentage of twins and few lambing problems. Their fleece is dense, with medium-fine fibers that are long-stapled (4 to 5 inches [10.1 to 12.7 cm]) and have a distinctive helical crimp that gives it strength and resilience. Lambs produce a good carcass.

The Border Cheviot's fleece, which was the principal fiber in Scotland's famous tweeds, is a great one for hand spinning. The breed also produces excellent meat off pasture.

BORDER CHEVIOT

FUNCTIONAL TYPE Meat. Fiber.

APPEARANCE Perky, upright ears. Bright white, wool-free face with a smudge of dark skin around their eyes and nostrils. Stout and blocky, but not particularly tall.

SIZE Medium.

HORNS Naturally polled.

CONSERVATION STATUS Not applicable.

PLACE OF ORIGIN Britain.

BEST KNOWN FOR Hardiness. Good general-purpose sheep.

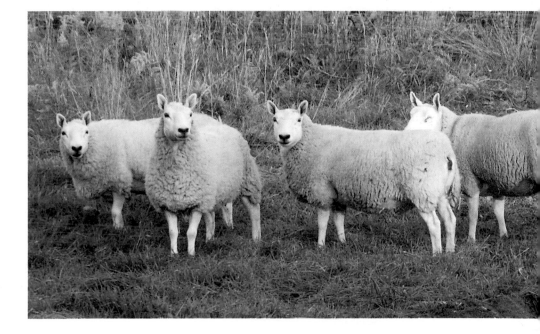

Border Leicester

THE BORDER LEICESTER was developed in 1767 by George and Mathew Cully in Northumberland, England, along the border with Scotland. The brothers were friendly with Robert Bakewell and used his Dishley New Leicester rams. Agricultural historians debate which breed of ewes were used. Some sources think that the brothers used Teeswater ewes, others think they used Cheviot ewes, and some think there was a mix of Teeswater and Cheviot lines.

Regardless of which foundation ewes were used, the Border Leicester was an easily recognizable breed in the northern hill country of England by the mid-nineteenth century. It is uncertain when the breed was first brought to North America, but a 1920 agricultural census documented 727 purebred animals. The first North American breed association was formed in 1973.

Border Leicester ewes are quite prolific and have good milk production, so lambs grow quickly. Their

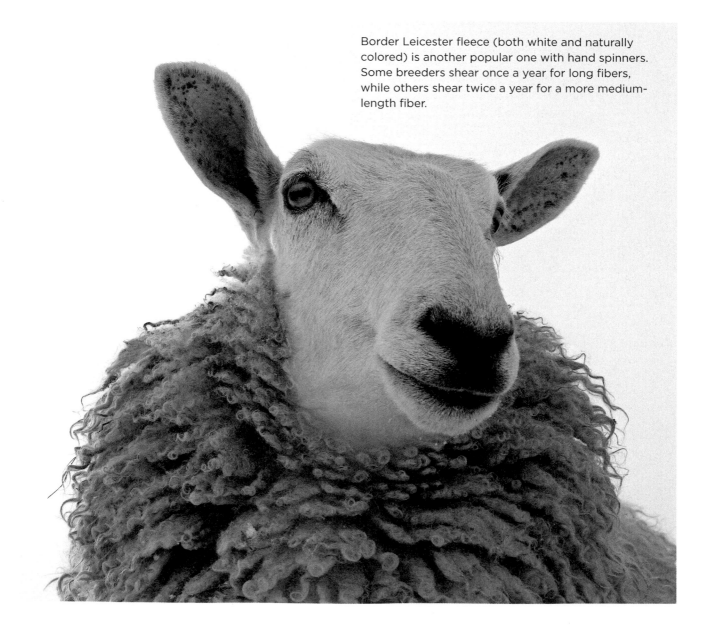

Border Leicester fleece (both white and naturally colored) is another popular one with hand spinners. Some breeders shear once a year for long fibers, while others shear twice a year for a more medium-length fiber.

fleece is beautiful; it is curly and lustrous yet coarse and has a long staple (5 to 10 inches [12.7 to 25.4 cm]). Hand spinners are extremely fond of working with it. Ewes will produce up to 12 pounds (5.44 kg) of wool per year and yield as much as 8.5 pounds (3.86 kg) after cleaning. The breed is also known for intelligence and an excellent disposition, even the rams are relatively low-key.

Border Leicester ewes have a high lambing percentage (160 to 175 percent) and finished lambs have excellent carcasses. Rams pass these characteristics on to crossbred ewes, so they are popular for developing crossbred strains for meat production.

BORDER LEICESTER

FUNCTIONAL TYPE Fiber. Meat.

APPEARANCE Roman nose. Perky, upright ears. Head and legs are wool-free. White or naturally colored (silver, black) fleece.

SIZE Large.

HORNS Naturally polled.

CONSERVATION STATUS Not applicable.

PLACE OF ORIGIN England.

BEST KNOWN FOR Wonderful fleece for hand spinning and fiber arts. Good disposition.

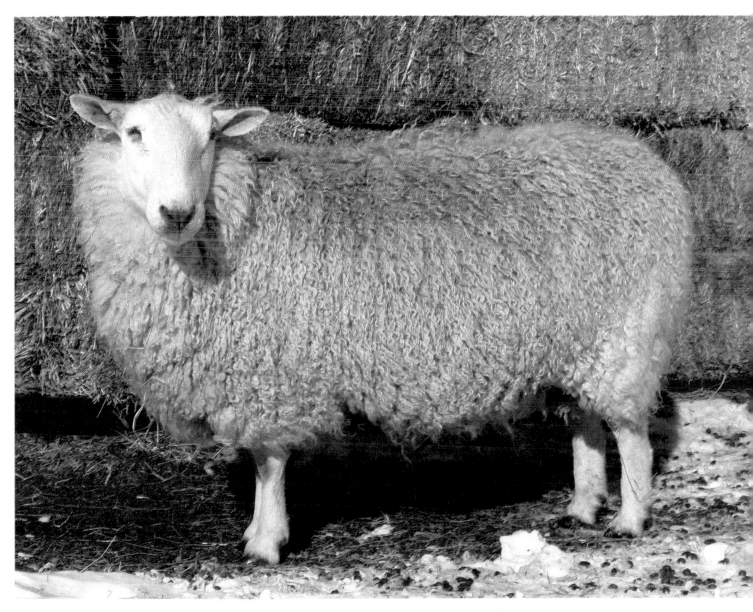

Brecknock Hill Cheviot

THE BRECKNOCK HILL CHEVIOTS (also known as Brecon Cheviots in their homeland) were developed in Wales by crossing the Border Cheviot with native landraces and through some additions of Leicester Longwool bloodlines in the 1800s. The first Brecknock Hill sheep in the United States were imported to Washington State in 1833 by the Hudson Bay Company. I couldn't determine whether the Brecknock Hill Cheviots in North America today date back to that importation or stem from later importations.

Brecknock Hill Cheviots are small sheep and have been selectively bred in recent years to be mini-Cheviots for the pet market. The full-sized Brecknock is less than 23 inches (58.5 cm) at the withers, and the minis are as small as 17 inches (43.2 cm) at the withers. The breed is docile and hardy. Ewes make good mothers.

The Brecknock Hill has medium-fine fiber in staple lengths up to 7 inches (17.8 cm). Fiber historians believe that the fiber characteristics of the Brecknock Hill are more representative of historic sheep from the Middle Ages than other breeds found today, and they favor using their fiber in garments and textiles for historical uses, such as costumes at living history museums.

Like their Border Cheviot cousins, Brecknock Hill Cheviots have marvelous fleece for spinning. Their small size makes them ideal for homestead sheep production.

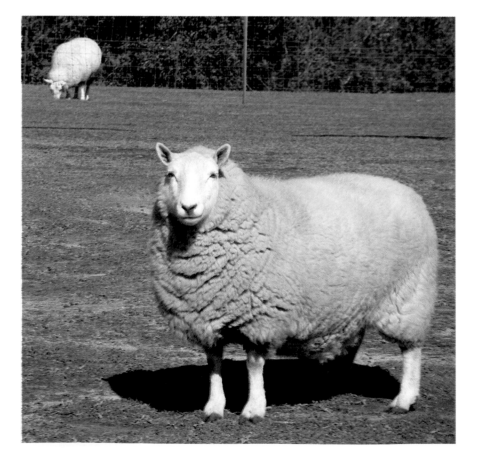

BRECKNOCK HILL CHEVIOT

FUNCTIONAL TYPE Fiber. Pet. Meat.

APPEARANCE Perky, upright ears. Wool-free face with a smudge of dark skin around the eyes and nostrils. Very short but well proportioned. White is common, but some colored strains, including black, tan, and gray.

SIZE Small.

HORNS Rams may be polled or have curling horns close to the head; ewes are normally polled.

CONSERVATION STATUS Not applicable.

PLACE OF ORIGIN Wales.

BEST KNOWN FOR Small size for fiber production and pets.

British Milk Sheep

THE BRITISH MILK SHEEP was developed in the 1970s in Britain by Lawrence Alderson. Although it is a relatively new breed, it seems that Alderson did not keep good records of what breeds were used in its development, so different sources mention different foundation breeds. Most sources cite Friesian as the dominant breed, but Bluefaced Leicester, Polled Dorset, Lleyn (a Welsh breed not found in North America), and possibly a composite breed that he kept on his farm, may have also contributed to the British Milk Sheep.

Whatever its origin, the British Milk Sheep is the most prolific breed in the United Kingdom. The average lambing rate exceeds 220 percent, and ewes have few lambing problems. Their milk is abundant and high in milk solids, with up to 7.5 percent protein and 9 percent butterfat. Fattened lambs produce a heavy, lean carcass. The fleece weighs up to 14 pounds (6.35 kg), and the wool is lustrous, with a staple that is up to 7 inches (17.8 cm) long.

In 1999, Eric and Elisabeth Bzikot imported embryos to Ontario to establish the breed in North America.

BRITISH MILK SHEEP

FUNCTIONAL TYPE Dairy. Meat. Fiber.
APPEARANCE White with a wool-free face. Ears stick out on the horizontal.
SIZE Medium to large.
HORNS Naturally polled.
CONSERVATION STATUS Not applicable.
PLACE OF ORIGIN Britain.
BEST KNOWN FOR Development in Britain specifically for dairy production and recently imported.

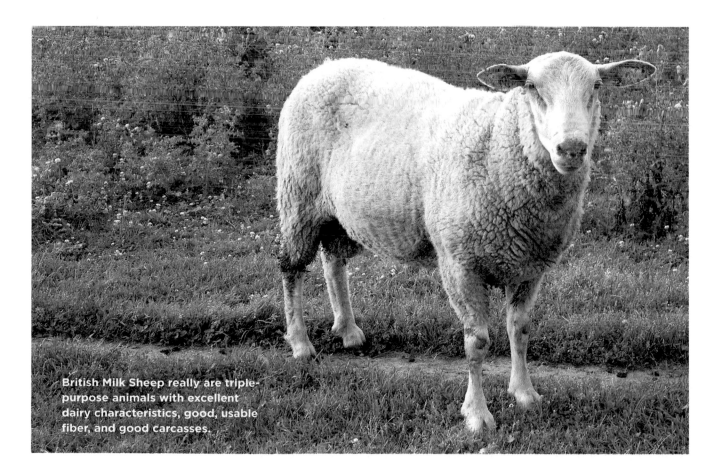

British Milk Sheep really are triple-purpose animals with excellent dairy characteristics, good, usable fiber, and good carcasses.

California Red

THE CALIFORNIA RED got its start in the 1970s when Dr. Glenn Spurlock, a sheep extension specialist with the University of California, Davis, began crossing Tunis sheep with Barbados Blackbelly sheep in his home flock. He was trying to come up with a larger wool-less breed. He failed; the Tunis/Blackbelly cross had wool and hair. But the cross exhibited some really interesting traits, so he continued the breeding program. When Spurlock was ready to retire his flock, he sold them to Aime and Paulette Soulier of Winters, California, who helped spread them to other breeders in California.

The breed is known for its lovely reddish tan fleece, which has a very silky feel and is used in preparing felt. The staple length runs from 3 to 6 inches (7.6 to 15.2 cm). The fleece weighs up to 8 pounds (3.63 kg) and yields about half that amount after washing.

Ewes are prolific and will breed year-round. They produce plenty of milk and lambing problems are rare. The carcass is lean, and the meat has a mild flavor. The breed is quite hardy and does well in both hot and cold climates. The breed is active, yet it has a very gentle demeanor.

CALIFORNIA RED

FUNCTIONAL TYPE Meat. Fiber.

APPEARANCE Red, ranging from dark cinnamon-red at birth to a light reddish oatmeal in mature animals. Clean face and legs (wool-free). Large ears that hang slightly below horizontal.

SIZE Medium to large.

HORNS Naturally polled (rams may have scurs or diminutive horns).

CONSERVATION STATUS Not applicable.

PLACE OF ORIGIN California.

BEST KNOWN FOR Low maintenance. Good production on pasture for tasty meat and silky wool.

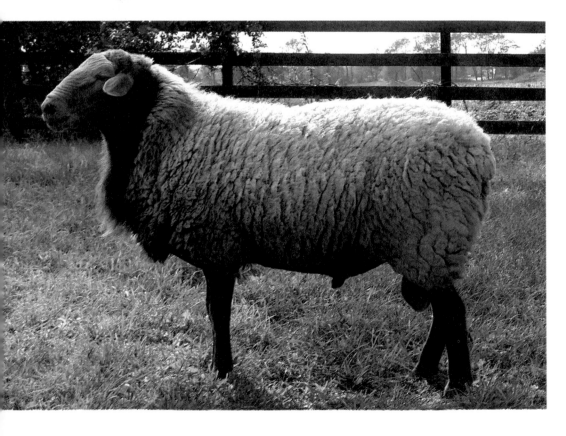

The California Red is a good all-purpose breed for small-scale producers. The fiber is quite lovely, making it popular with hand spinners.

California Variegated Mutant/Romeldale

IN 1960, California shepherd Glen Eidman found a ewe lamb with rather unique "badger-faced" coloring in his flock of Romeldale sheep. He kept that ewe, and a few years later he found a ram lamb with similar coloring. When the ram was old enough to use for breeding, he bred it to the ewe with the badger face, and the trait was retained. Eidman began selecting for badger-faced coloring, improved fiber quality, and good carcass quality. Over the next 15 years, he developed an easily identifiable flock of California Variegated Mutants (CVM). In 1982, Eidman sold his flock, and his 75 CVM sheep (which are actually recognized as a color variety of the Romeldale breed and not a unique breed) were dispersed among a number of shepherds in California.

The Romeldale, a composite from Romney and Rambouillet (also called Romnelet in Canada), did not have the support of a breed organization or registry. By 1990 there were only a few purebred flocks left. The American Livestock Breeds Conservancy added the breed to its list of endangered livestock, in part because colored fine-wool sheep are unusual. Breeders formed a joint registry for CVMs and Romeldales.

The breed's staple length runs from 3 to 6 inches (7.6 to 15.3 cm), and its wool is soft, thanks to fine fibers with a tight crimp. The fleece weighs as much as 12 pounds (5.44 kg) and yields about 60 percent of that weight when clean. Ewes are good mothers and lamb easily. Twins are common.

CALIFORNIA VARIEGATED MUTANT/ ROMELDALE

FUNCTIONAL TYPE Fiber. Meat.

APPEARANCE Well-boned, strongly muscled animal. Wool-free face and legs.

COLORING Ranges from dark grays, blacks, and browns to spotted, with a badger face. Color darkens from birth through the first year and doesn't tend to fade with age. Other Romeldales are white.

SIZE Medium to large.

HORNS Naturally polled.

CONSERVATION STATUS Critical.

PLACE OF ORIGIN California.

BEST KNOWN FOR Badger-faced coloring. Fine fleece. Excellent carcass.

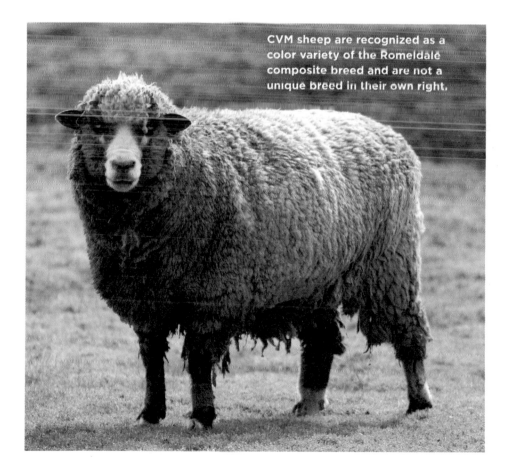

CVM sheep are recognized as a color variety of the Romeldale composite breed and are not a unique breed in their own right.

Canadian Arcott

THE CANADIAN GOVERNMENT developed three breeds of sheep in the 1970s and 1980s, each with the acronym Arcott (for the Agricultural Research Centre of Ottawa) in its name. The Canadian Arcott is a synthetic breed developed primarily from Ile de France and Suffolk parents, though some Cheviot, Leicester, and Romnelet (Romney crossbred with Rambouillet) blood was added to the mix. In the late 1980s, the Canadian government opted to eliminate the sheep-breeding program. Three of the most successful strains were named as breeds (the Canadian Arcott, the Rideau Arcott, and the Outaouais Arcott) and dispersed to Canadian shepherds in 1988.

Canadian Arcotts are hardy, performing well on pasture or in confinement operations. The ewes mature early, frequently have twins, and rarely require assistance during lambing. Lambs grow very fast and produce an excellent carcass. The breed produces a medium-diameter, medium-length wool that mainly enters the commodity pool. Canadian Arcott rams are popular as terminal sires in crossbred sheep production.

CANADIAN ARCOTT

FUNCTIONAL TYPE Meat. Fiber.
APPEARANCE White, but may have some mottling on face. Short, heavy muscling. Slight Roman nose.
SIZE Medium to large.
HORNS Naturally polled.
CONSERVATION STATUS Not applicable.
PLACE OF ORIGIN Canada.
BEST KNOWN FOR Fast growth. Meaty carcass with good meat-to-bone ratio.

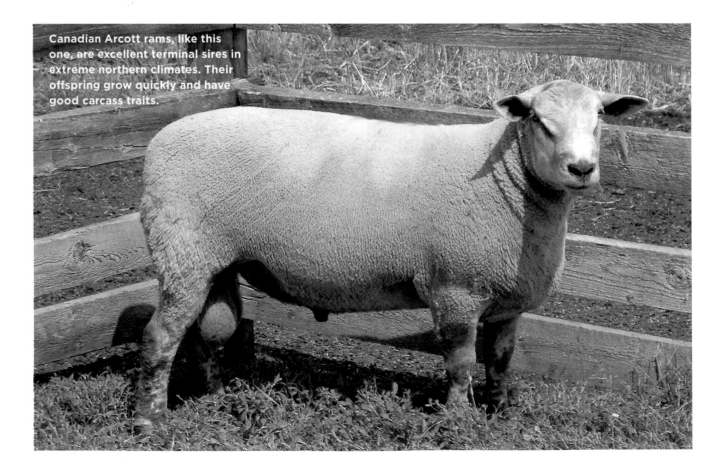

Canadian Arcott rams, like this one, are excellent terminal sires in extreme northern climates. Their offspring grow quickly and have good carcass traits.

Charollais

LIKE THE CHAROLAIS CATTLE, the Charollais sheep were developed in Charolles County in the Burgandy region of east-central France during the nineteenth century. French shepherds bred imported British Leicester Longwool sheep to native landraces, resulting in a fast-growing, muscular breed. The French government officially recognized and began promoting the breed in 1974, and the first animals were exported from France to Britain in 1976. The first imports came to Canada from Britain in 1994.

The Charollais is being used in Canada primarily as a terminal-sire breed for crossbred lamb production. These crossbred lambs grow fast and have excellent carcass characteristics, producing a large quantity of lean meat. Charollais ewes mature early and are prolific, twins are common, and triplets are not unusual. Ewes are good mothers and tend to be docile.

They produce an abundant supply of milk, so some sheep dairymen are beginning to milk them. The fleece is short and fine.

CHAROLLAIS

FUNCTIONAL TYPE Meat. Dairy.
APPEARANCE Long-bodied, with a very muscular frame. Wool-free face and legs. White fleece.
SIZE Large.
HORNS Naturally polled.
CONSERVATION STATUS Not applicable.
PLACE OF ORIGIN France.
BEST KNOWN FOR Prolificacy. Fast-growing lambs.

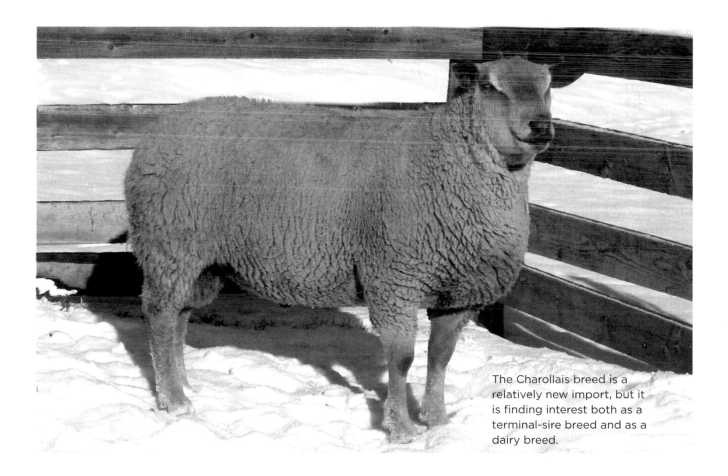

The Charollais breed is a relatively new import, but it is finding interest both as a terminal-sire breed and as a dairy breed.

Clun Forest

THE BREED TAKES ITS NAME from the Clun Forest, an area of open pastures and wooded hills on England's western coast near the ancient market town of Clun. The area has been the home to shepherds for many centuries, and the sheep they kept were hardy and self-sufficient, eking out their living from the rough grasses that were available in the region while still producing lambs and fleece. The Clun Forest breed was developed from these native sheep through crossbreeding with Hill Radnor, Shropshire, and Kerry Hill sheep in the 1860s.

The first Clun Forest sheep were imported from Ireland in 1959, but these disappeared. In 1970, Nova Scotia shepherd Tony Turner, who had recently emigrated from Wales, imported 40 ewes and 2 rams. Several additional importations were brought to North America during the 1970s, providing the foundation for the North American Clun flock.

Clun Forest sheep are still hardy and highly adaptable. The ewes are long-lived, excellent mothers, producing lots of twins, and lots of milk, so they are attracting interest from sheep dairy producers. The lambs grow quickly and produce a lean but meaty carcass. Their wool is semilustrous and short to medium in staple length (2 to 4 inches [5.1 to 10.2 cm]) but very sturdy with high elasticity. The breed association, which formed in 1970, has always emphasized production qualities over show qualities and continually strives for a sheep that does well on pasture production. To this end, the breed association prohibits competitive showing of Clun Forest sheep.

CLUN FOREST

FUNCTIONAL TYPE Meat. Fiber.

APPEARANCE Upright ears. Dark (black or brown), wool-free face. Long body. Dark, wool-free legs.

SIZE Medium.

HORNS Naturally polled.

CONSERVATION STATUS Recovering.

PLACE OF ORIGIN England.

BEST KNOWN FOR Hardiness. General-purpose characteristics. Good performance on pasture.

Clun Forest sheep are excellent multipurpose sheep that would make an excellent choice for grass-fed lamb production.

Columbia

THE COLUMBIA was developed by the United States Department of Agriculture in 1912 as an improved sheep for western range operations. Lincoln rams were crossed with high-quality Rambouillet ewes to produce large ewes that yield more pounds of wool and meat. Researchers at USDA research facilities in Laramie, Wyoming, and Dubois, Idaho, selected among those offspring to produce a true breeding strain with characteristics of the superior crossbred lines. Although the researchers were originally selecting animals to produce under range conditions in the West, the Columbia also performed well under farm flock management in the Midwest, the Northeast, and the South.

Columbias have very good flocking instincts, yet they are docile. The ewes frequently have twins and are good mothers. Lambs grow reasonably fast, producing a good carcass. They have a heavy wool clip (up to 16 pounds [7.26 kg] for a ewe) of 4- to 6-inch (10.2 to 15.3 cm) fiber that yields about 50 percent of its original amount after cleaning.

COLUMBIA

FUNCTIONAL TYPE Meat. Fiber.

APPEARANCE Tall, solidly built. White. Wool-free face. Semipendulous ears that hang to the side.

SIZE Large.

HORNS Naturally polled.

CONSERVATION STATUS Not applicable.

PLACE OF ORIGIN United States.

BEST KNOWN FOR Excellent production on the range or in farm flocks.

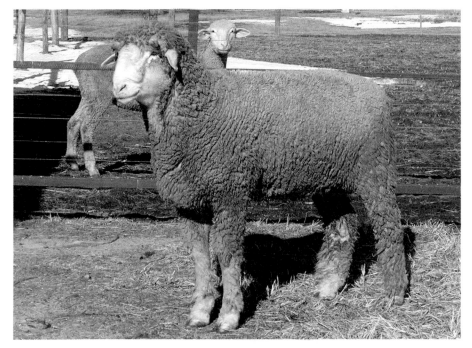

Columbias are one of the largest white-faced meat breeds, with mature rams (in front) weighing as much as 300 pounds, and ewes (behind) going as high as 225 pounds. They require good feed to fulfill their potential, but they do quite well on healthy rangeland in the West.

Coopworth

THE COOPWORTH was developed in the 1950s in New Zealand by Lincoln College researcher Dr. Ian Coop. Coop crossed Border Leicesters with Romneys and made selections based strictly on production traits. In fact, from the start, registration of breeding animals was predicated on their production traits, not their parentage. Traits evaluated for registration include frame and carcass attributes, fertility and lamb survival, growth rate to weaning stage, growth rate to yearling stage, leanness, and finally, fleece growth and quality. Coopworths were brought to North America in several large importations in the 1970s and 1980s.

Coopworths adapt to a variety of climate conditions and do well in pasture-based production systems. The ewes are good mothers and make lots of milk. They usually produce twins, though triplets are fairly common. Any ewe that fails to conceive or has problems raising her lambs will have her registration revoked, and only the top 70 percent of ewes in any flock may be registered. The breed has long-staple fleece (5 to 8 inches [12.7 to 20.3 cm]) and yields up to 12 pounds (5.44 kg) of clean, lustrous wool. Competitive showing is prohibited by the breed association.

COOPWORTH

FUNCTIONAL TYPE Meat. Fiber. Dairy.

APPEARANCE Long frame with muscular hindquarters. Roman nose. Wool-free face, though some sport a topknot of wool. White is the dominant color, but some strains are colored.

SIZE Medium to large.

HORNS Naturally polled.

CONSERVATION STATUS Not applicable.

PLACE OF ORIGIN New Zealand.

BEST KNOWN FOR Excellent economic production traits under variable conditions.

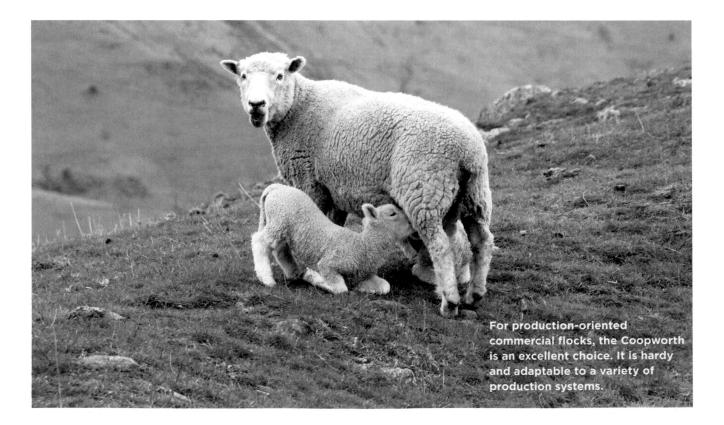

For production-oriented commercial flocks, the Coopworth is an excellent choice. It is hardy and adaptable to a variety of production systems.

Cormo

THE CORMO is another breed from the Southern Hemisphere whose registration is based on performance. Ian Downie, a shepherd who ran superfine Saxon Merinos, developed the breed in Tasmania, Australia. Downie called on researchers at the Australian Commonwealth Scientific and Industrial Research Organization, including Dr. Helen Newton Turner, one of the world's leading sheep geneticists, to help him improve his flock's performance.

Downie wanted to increase fertility, frame size, and fleece yield. He used Corriedale rams to breed his Merino ewes. The breed's name is a contraction of the parent names, Corriedale and Merino. Downie kept back the very best animals for breeding stock and used computer databases to analyze production traits at a time when computers were not commonly employed in agriculture. Twelve Cormo ewes and 2 rams were first imported to the United States in 1976, followed by a large importation of 500 ewes and 25 rams in 1979.

Ewes typically have twins and require little or no assistance during lambing. The animals perform well in a variety of climates and are excellent foragers. They produce medium- to long-stapled wool that is dense, fine, and has exceptional uniformity throughout the fleece. Lambs grow fast and have a high meat-to-bone ratio. Computer records are still kept on all registered animals, and selections for registration are strictly based on performance criteria.

CORMO

FUNCTIONAL TYPE Fiber. Meat.
APPEARANCE Long body and a broad build. White Wool-free face.
SIZE Medium to large.
HORNS Naturally polled.
CONSERVATION STATUS Not applicable.
PLACE OF ORIGIN Australia.
BEST KNOWN FOR Excellent production characteristics for meat and fiber.

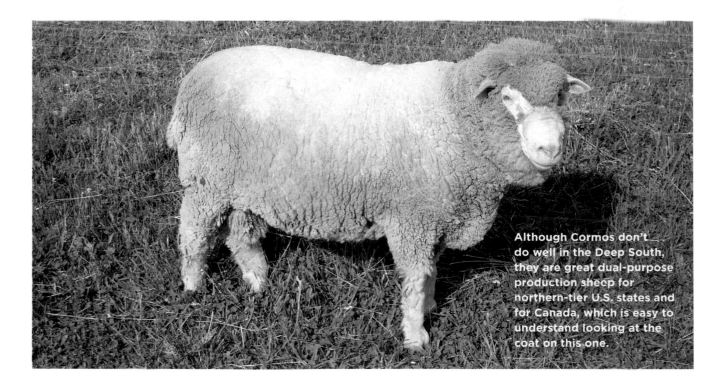

Although Cormos don't do well in the Deep South, they are great dual-purpose production sheep for northern-tier U.S. states and for Canada, which is easy to understand looking at the coat on this one.

Corriedale

DEVELOPMENT OF THE CORRIEDALE began in New Zealand in the 1880s, though similar breeding programs began shortly after in Australia. At the time, the Merino, a breed better suited to more arid grasslands, and the Romney, which is adapted for very lush, rich pastures, were the dominant breeds in both New Zealand and Australia. But both countries had large swaths of intermediate grasslands (similar to Kansas or Nebraska in the United States), so breeders were seeking a dual-purpose sheep that would perform well in these transition areas.

James Little, the manager of a ranch called Corriedale, is credited as being instrumental in the breed's development. Little crossed Lincolns with Merinos. The New Zealand Sheep Breeders Association recognized the breed in 1911. It was first imported by the United States Department of Agriculture to its research station in Laramie, Wyoming, in 1914.

Corriedale sheep will produce well over a wide geographic and climatic range. In fact, due to its adaptability, it is one of the most common breeds worldwide.

The ewes are prolific and can breed throughout the year. Lambs grow quickly and will produce a high-quality carcass off pasture. The fleece is uniform, fine to medium, relatively long (3.5 to 6 inches [8.9 to 15.3 cm]), and has an even crimp. The fiber is also soft and lustrous and is considered to be an excellent choice for novice hand spinners.

CORRIEDALE

FUNCTIONAL TYPE Meat. Fiber.

APPEARANCE Wool-free below the eyes. Semipendulous ears hang slightly below horizontal. Both white and naturally colored strains are accepted.

SIZE Medium to large.

HORNS Naturally polled.

CONSERVATION STATUS Not applicable.

PLACE OF ORIGIN New Zealand.

BEST KNOWN FOR Excellent dual-purpose traits and performance in a wide variety of climates.

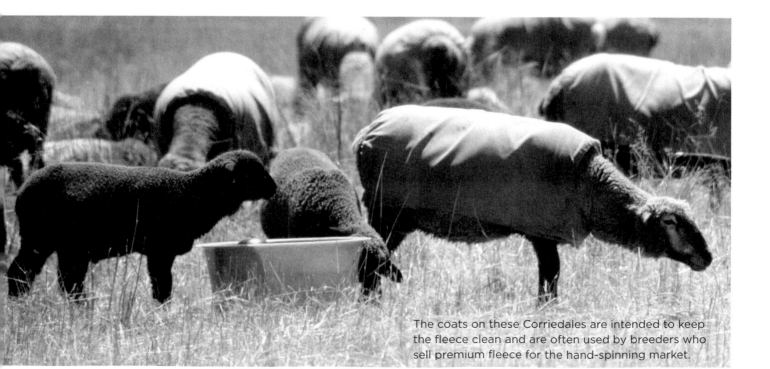

The coats on these Corriedales are intended to keep the fleece clean and are often used by breeders who sell premium fleece for the hand-spinning market.

Cotswold

THE COTSWOLD HILLS are wide, open limestone hills in the south-central area of England and the home of the Cotswold sheep. Romans introduced the sheep to the area, and the region was well known for wool production during the Middle Ages. However, the breed as we know it today developed during the late eighteenth and early nineteenth centuries, when shepherds introduced Leicester Longwool genetics to native sheep.

No one is sure exactly when these sheep were introduced to North America. The first documented importation was in 1832, though sheep that had Cotswold characteristics were already found around the country

(continued)

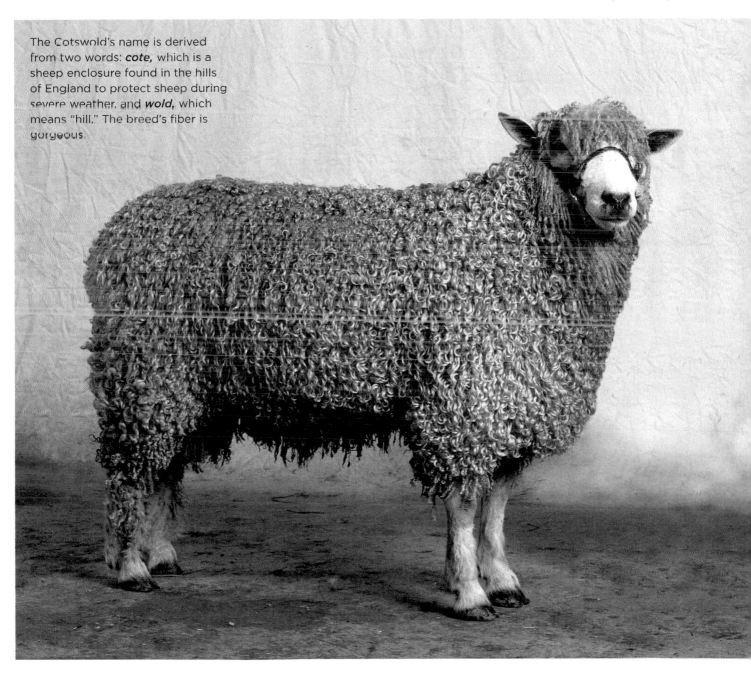

The Cotswold's name is derived from two words: *cote,* which is a sheep enclosure found in the hills of England to protect sheep during severe weather, and *wold,* which means "hill." The breed's fiber is gorgeous.

Cotswold (continued)

when these sheep arrived. They were very popular, and the American Cotswold Record Association was formed in 1878 as the first U.S. sheep breed association. By 1914, the breed association had registered more than 760,000 animals. By the 1980s, however, they were critically endangered, with fewer than 600 animals in Britain and North America.

Cotswold sheep have very long and coarse but lustrous wool with a staple length that can reach up to 15 inches (38.1 cm). Hand spinners and fiber artists fell in love with the wool, helping to bring the breed back from the brink of extinction. Cotswold meat is lean and mildly flavored. The animals do well on pasture or in open range, though maintaining high-quality fleece on the range is challenging. The ewes are good mothers, and the breed is friendly and docile.

COTSWOLD

FUNCTIONAL TYPE Fiber. Meat.
APPEARANCE Large, long-bodied. Distinct tuft of wool on the forehead, but a wool-free face. Ears are horizontal with dark pigment inside, and dark pigment around eyes and nose. White to grayish white, though some strains may throw an occasional black.
SIZE Large.
HORNS Naturally polled.
CONSERVATION STATUS Threatened.
PLACE OF ORIGIN England.
BEST KNOWN FOR Long, lustrous fiber that hand spinners love.

Debouillet

AMOS DEE JONES OF NEW MEXICO developed the Debouillet in the 1920s as a range sheep suited to the arid Southwest. Jones crossed Delaine Merino rams with his flock of Rambouillet sheep, and by 1927 he began linebreeding within the flock. A breed registry formed in 1954, but the breed never really took off outside the Southwest. Registration is based on bloodlines and an inspection by an association inspector.

Debouillet ewes produce desirable, heavy market lambs under the harsh conditions of Southwest range operations, where temperatures can vary from extremely high during the day to below freezing at night. The ewes routinely lamb unassisted on pasture. Ewes will breed throughout the year. The breed has a very strong flocking instinct, and flock members are gregarious and active. They produce a heavy and uniform fleece of fine fiber with a staple length between 3 and 5 inches (7.6 to 12.7 cm). Their wool has a close crimp.

DEBOUILLET

FUNCTIONAL TYPE Fiber. Meat.
APPEARANCE Open face (wool-free) below the eyes. Ears lay horizontal. Most are white, but some strains may occasionally throw a colored animal.
SIZE Medium to large.
HORNS Rams can be horned or polled; ewes are polled.
CONSERVATION STATUS Not applicable.
PLACE OF ORIGIN United States.
BEST KNOWN FOR Strong production under Southwest range conditions.

(continued)

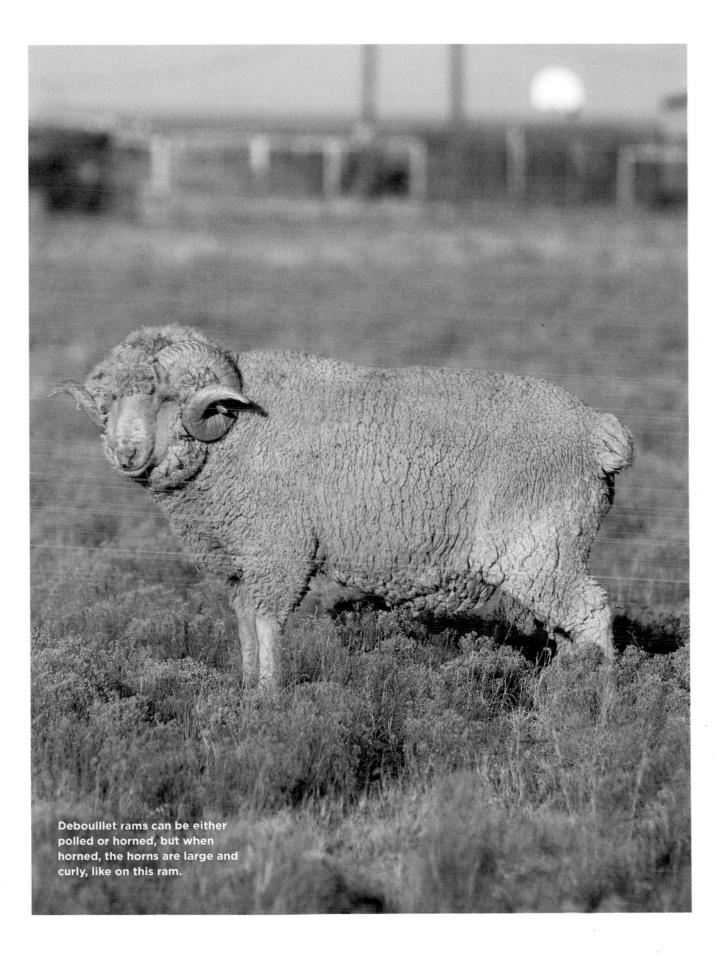

Debouillet rams can be either polled or horned, but when horned, the horns are large and curly, like on this ram.

Debouillet (continued)

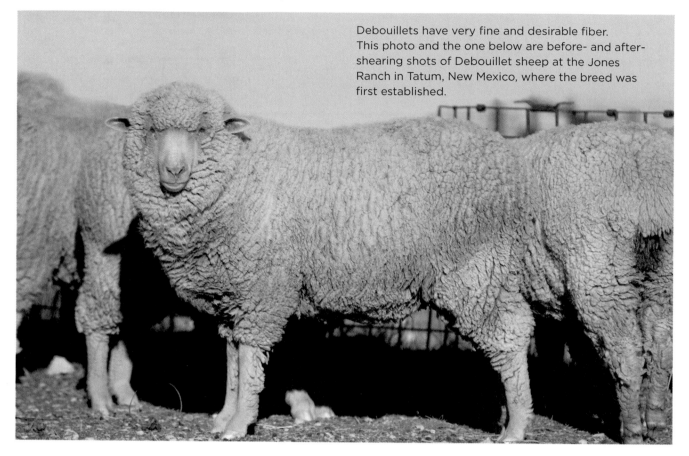

Debouillets have very fine and desirable fiber. This photo and the one below are before- and after-shearing shots of Debouillet sheep at the Jones Ranch in Tatum, New Mexico, where the breed was first established.

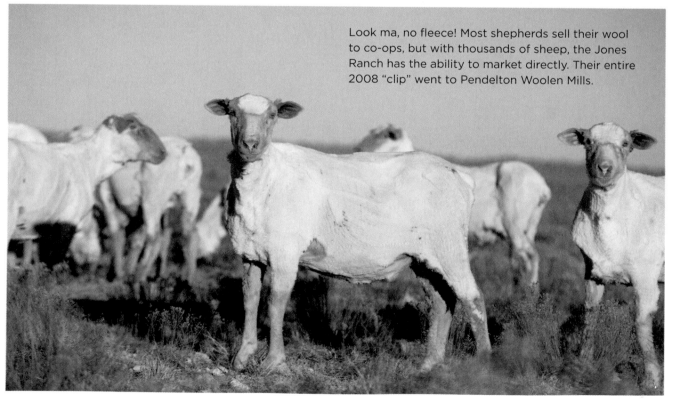

Look ma, no fleece! Most shepherds sell their wool to co-ops, but with thousands of sheep, the Jones Ranch has the ability to market directly. Their entire 2008 "clip" went to Pendelton Woolen Mills.

Dorper

DORPERS ARE LONG, MUSCULAR SHEEP bred for meat production in South Africa. In an effort to gain foreign market acceptance of its lamb, the South African Meat Board started a scientific breeding program in the 1930s. By 1946, the Dorper was recognized as the meat breed of choice for South African shepherds.

The Dorper originated from a cross between a fat-tailed hair sheep from Africa called the Blackhead Persian and Dorset Horn rams. The new breed indeed found acceptance in the international marketplace for its very high-quality carcass. The first imports came to Canada in the mid-1990s, and embryos and semen were quickly imported from Canada to start the U.S. flock.

Dorpers are large sheep that are highly fertile (twins are common) and can breed throughout the year, making it possible to lamb three times in two years. Lambs grow and finish quickly and will do so exclusively on pasture. They are adaptable to a very wide variety of climates, putting on an undercoat of wool when it is cold but shedding the coat during warm seasons. They also have a high-quality hide used for premium leather production.

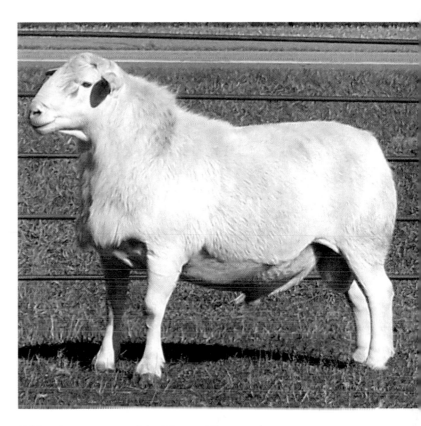

White dorpers are solid white and Dorpers have a distinctive black head. These rams will shed to a short, slick coat in summer.

DORPER

FUNCTIONAL TYPE Meat. Hair.

APPEARANCE Tall and very muscular. Slight Roman nose. Horizontal ears. Two color varieties: black-headed (called simply Dorper), and all white (called White Dorper).

SIZE Large.

HORNS Normally polled.

CONSERVATION STATUS Not applicable.

PLACE OF ORIGIN South Africa.

BEST KNOWN FOR Good meat production, particularly directly off pasture.

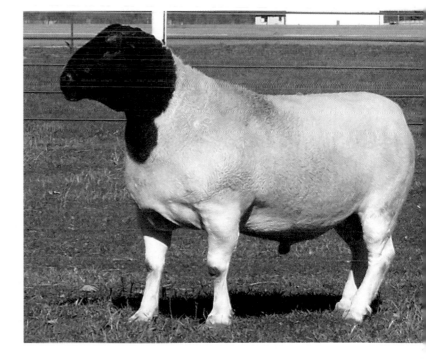

Dorset

THE DORSET is an extremely old English breed that has been found over a large area of southwest England since the Middle Ages. Its origins are shrouded in mystery. Some livestock historians speculate that Spanish Merino sheep were bred to native English and Welsh sheep, but most breeders and historians think the breed as we know it today was developed more through selection than crossing. The earliest Dorset sheep arrived in Oregon in the 1860s in a shipment brought there by the Hudson Bay Company. More importations followed, and by 1891 there was an established flock book (the term shepherds commonly used for a herdbook) for Dorsets.

Today there are two types, the Dorset Horn and the Polled Dorset. The horned type is unique in that the ewes are always horned (in most breeds, only rams have horns). The Aussies were the first to develop Polled Dorsets, starting in the 1940s. Polled Dorsets in North America come from a breeding project at North Carolina State College in 1956 and are now far more common than the horned type.

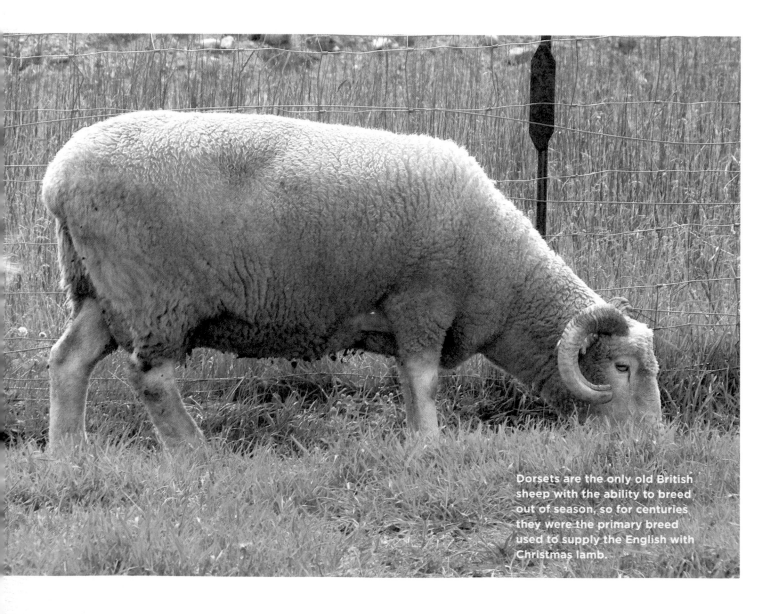

Dorsets are the only old British sheep with the ability to breed out of season, so for centuries they were the primary breed used to supply the English with Christmas lamb.

The Dorset is primarily a meat breed, though sheep dairy producers are using the ewes for milk production and hand spinners like working with its fleece, though it doesn't produce large quantities of wool. Ewes are very prolific (multiple births are the norm) and will breed in any season. The breed is known for its longevity, with ewes producing into their teens.

A new genetic mutation showed up in a Dorset ram in Oklahoma in 1983 that caused a significant increase in muscling in the buttocks. Sheep with this mutation are called Callipyge, from the Greek word for "beautiful butt." Only lambs that inherit the callipyge mutation from their father, not their mother, develop the trait.

DORSET

FUNCTIONAL TYPE Meat. Fiber. Dairy.

APPEARANCE Well-conformed bodies. Horizontal ears. Wool-free face. Legs and belly have little wool. Fleece is very white.

SIZE Large.

HORNS Dorset Horns have impressive curling horns in both sexes. Polled Dorsets are naturally polled.

CONSERVATION STATUS Dorset Horn: Watch; Polled Dorset: Not applicable.

PLACE OF ORIGIN England.

BEST KNOWN FOR Prolific meat production. Used as a foundation for crossbreeding for dairy production.

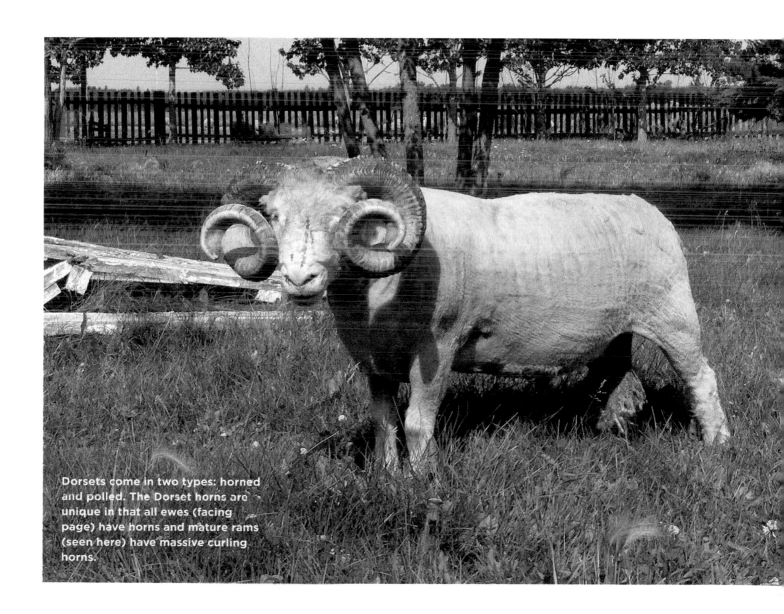

Dorsets come in two types: horned and polled. The Dorset horns are unique in that all ewes (facing page) have horns and mature rams (seen here) have massive curling horns.

East Friesian

A GERMAN DAIRY SHEEP, the East Friesian is sometimes referred to as "the Holstein of the sheep world" because of its extremely high milk production. There are actually several types of Friesians from the area where Germany, Belgium, and the Netherlands come together. The German type was recognized as the East Friesian breed in 1936. The breed was first imported to Canada in 1992, and then from Canada to the United States in 1993 for sheep dairying.

East Friesian ewes are very prolific (225 percent lamb crops are common) and breed any season. They produce an abundant supply of milk, with some ewes making 1,500 pounds (680 kg) during their lactation. Because of their high capacity for milk production, they need high-quality feed and excellent management. They perform poorly under large, extensive flock husbandry conditions, and they perform poorly in extremely hot climates. As a breed that has been milked for centuries, it is very docile and accustomed to interacting with humans.

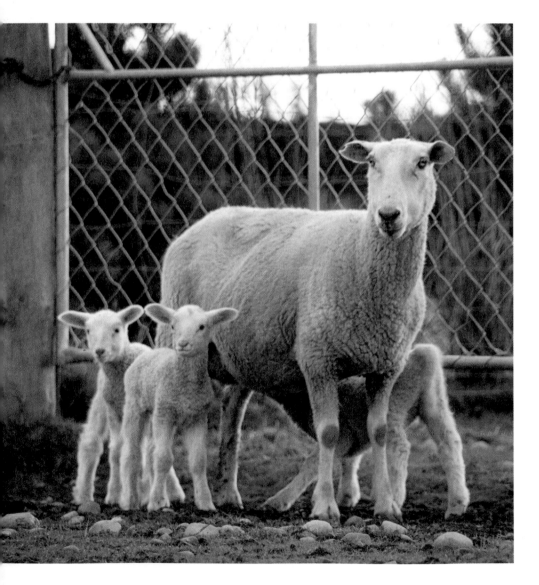

EAST FRIESIAN

FUNCTIONAL TYPE Dairy. Meat. Fiber.

APPEARANCE Long, narrow, wool-free face. Long, forward-leaning ears on the horizontal. A "rat tail" that is long and hairless. Most are white, but there are some colored varieties.

SIZE Large.

HORNS Naturally polled.

CONSERVATION STATUS Not applicable.

PLACE OF ORIGIN Germany.

BEST KNOWN FOR Excellent milk production (the top-producing dairy sheep).

East Friesians (sometimes just called Friesian sheep) are a very important part of the developing North American sheep dairy industry, but they are high-input animals, so they are not a good choice for general-purpose producers.

Finnsheep

ALSO KNOWN AS THE FINNISH LANDRACE, the Finnsheep is an ancient Scandinavian breed, though there is little knowledge of its early ancestry. It was first brought to Canada by researchers from the University of Manitoba in 1966, and progeny from this importation were brought to the United States in 1968.

Finnsheep are considered to be the most prolific sheep in the world. Lambs come in "litters" of two to eight lambs per lambing period, and three or four lambs are the most common. Finn rams are often used as terminal sires with other meat breeds in crossbreeding programs, resulting in an increase in lamb production. Finn ewes mature early and make good mothers, but due to the large size of their litters, shepherds often have to bottle-feed lambs. In spite of the large number of lambs typically born to ewes, they tend to have few lambing problems.

The fleece of Finnsheep is soft and lustrous and has a 3- to 6-inch (7.6 to 15.3 cm) staple. Though their fleece is light, generally yielding less than 5 pounds (2.25 kg) of clean wool per year, hand spinners enjoy working with it. Although they aren't particularly large sheep, their carcass is good, and the meat is lean and flavorful. The breed is most commonly used in crossbreeding systems; relatively few are maintained as purebred.

FINNSHEEP

FUNCTIONAL TYPE Meat. Fiber. Dairy.

APPEARANCE Commonly white, also black, pied (black and white spots), brown, gray, or tan.

SIZE Medium.

HORNS Naturally polled.

CONSERVATION STATUS Not applicable.

PLACE OF ORIGIN Finland.

BEST KNOWN FOR Lambing in litters; three to four lambs are common, but eight lambs per lambing is known to happen.

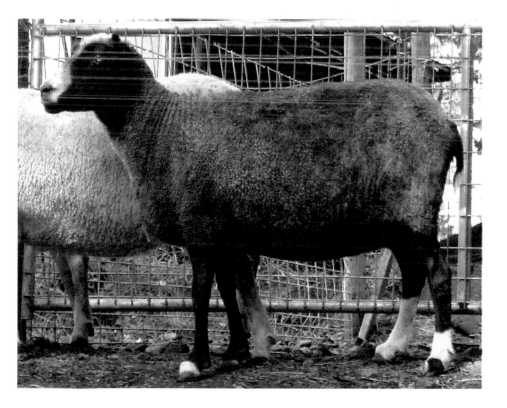

Raising purebred Finnsheep requires a serious commitment. Breeders can count on having a fair number of bottle babies during each lambing season due to the large litters that ewes are capable of producing.

Gulf Coast Native

THE GULF COAST NATIVE (also simply called Gulf Coast) evolved from criollo sheep brought to North America by early Spanish explorers. Criollos were crossed, in no particular fashion, with various sheep breeds brought to the South by later settlers. Through natural selection in an extremely unfavorable climate, the Gulf Coast Native became the dominant sheep in Florida, Georgia, Mississippi, Alabama, Louisiana, and Texas. Each area was known for its own strain, such as the Florida Native, the Louisiana Scrub, and the Pineywoods Native.

Hundreds of thousands of these sheep ranged throughout the Gulf Coast area, lambing on pasture and receiving little attention from people. Only the strongest and best suited to the region survived. But their numbers plummeted after World War II as "improved breeds," which were finally able to survive the heat and parasites thanks in large part to the development of modern worming medications, were brought into the area. Today, the Gulf Coast Native is listed as one of the Ten Most Endangered Foods by RAFT ("Renewing America's Food Traditions"), a collaboration of the American Livestock Breeds Conservancy, Slow Food USA, and other organizations, and is on Slow Food's Ark of Taste list (see page 38).

Gulf Coast sheep are small and ideally suited to the heat and humidity of the Gulf Coast region. They are excellent foragers and will consume many of the noxious plants that tend to overtake the South, such as kudzu and honeysuckle. Their lambs are small but hardy, and they have more lambs survive to finish than other breeds in the South. Ewes will breed year-round, and most often have a single lamb, but twins are not uncommon. The fleece is light, but the medium fibers are soft and liked by hand spinners. The staple is 2.5 to 4 inches (6.4 to 10.2 cm) long.

The Gulf Coast Native's best trait is critically important for southern shepherds: it has outstanding resistance to internal parasites and diseases, such as foot rot, that still plague sheep in the South.

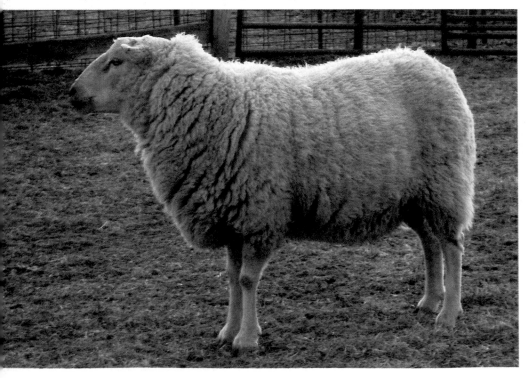

GULF COAST NATIVE

FUNCTIONAL TYPE Meat. Fiber.

APPEARANCE Lean frame with fine bone structure. Wool-free face, belly, and legs. Most are white, but there are also colored strains.

SIZE Small.

HORNS Either horned or polled.

CONSERVATION STATUS Critical.

PLACE OF ORIGIN United States.

BEST KNOWN FOR Exceptionally high resistance to parasites and disease that affect sheep in the South. High tolerance of heat and humidity.

Hampshire

THIS BREED ORIGINATED in Hampshire county, southern England, where it has been known for at least several centuries. Although no one is sure of the Hampshire's heritage, most breeders and livestock historians speculate that it was bred up from the native landrace (Old Hampshires), with additions of Berkshire Knot, Wiltshire Horn, Southdown, and later Cotswold sheep. Hampshires were documented in the United States in the 1840s, but those animals are thought to have died out; the Hampshires here today are from post–Civil War importations. In 1889, breeders in both Hampshire County and the United States formed breed associations.

Due to their large size, Hampshires do not perform well on range operations or on poor-quality pastures, but they will do very well on high-quality pastures. The ewes are good milkers and tend to have twins or triplets, but the lambs are large, so Hampshire ewes may require more birthing assistance than other breeds. The lambs grow very quickly and have good carcasses. The breed association encourages selection based on production traits rather than looks. Hampshires tend to have an easy-going disposition and are favored as "club lambs" for kids participating in 4-H and FFA (Future Farmers of America). The fleece is medium weight and has a medium-length staple.

HAMPSHIRE

FUNCTIONAL TYPE Meat. Fiber.

APPEARANCE Dark, wool-free face and dark, wool-free legs. Slight Roman nose. Long, horizontal ears. Fleece is usually white, but some strains do occasionally throw colored lambs.

SIZE Large.

HORNS Naturally polled.

CONSERVATION STATUS Not applicable.

PLACE OF ORIGIN England.

BEST KNOWN FOR Production of commodity lambs and club lambs.

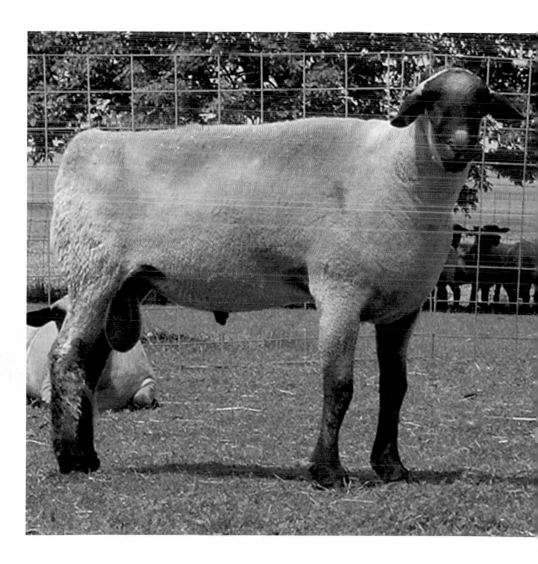

Hampshire rams, like this one, are often used for crossbreeding, passing good growth traits to crossbred ewes.

Hog Island

HOG ISLAND IS A BARRIER ISLAND off the coast of Virginia, near the mouth of the James River. The island was settled more than three hundred years ago, and sheep were raised extensively there since there was no need for fences. The exact breeds and origins of the sheep first brought to the island are unknown, though some historians believe they were British breeds.

What is known is that the sheep went feral after the settlers abandoned the island in 1933 following a devastating hurricane. Sheep rarely go feral because of their vulnerability to predators, so those that do go feral tend to do so on islands and those that survive as feral animals become very hardy. In 1970, The Nature Conservancy acquired the island and removed the sheep in order to improve survivability of the native grasses and forbs. Most of the sheep found new homes at historic sites in Virginia, including Gunston Hall Plantation and Mount Vernon, though some individual shepherds in the Southeast have also helped preserve the Hog Island.

Not surprisingly, the ewes don't need any help at lambing. They typically have single lambs or twins, and occasionally triplets. They are low-maintenance sheep that will obtain all of their feed off pasture. They have a very strong flocking instinct. Their fleece weighs up to 5 pounds (2.25 kg), has medium heft, but spins easily and dyes well.

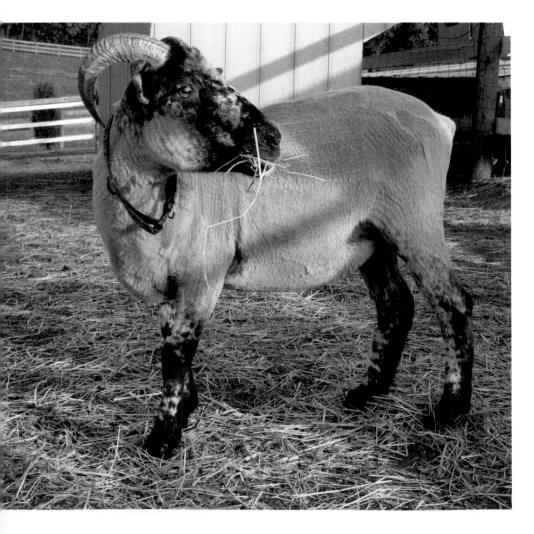

HOG ISLAND

FUNCTIONAL TYPE Feral. Meat. Fiber.

APPEARANCE Primitive-looking animals. Pendulous ears, hanging below the horizontal. Most are white but may have colored faces. About 10 percent are fully colored in black or dark brown.

SIZE Small.

HORNS Both sexes can have horns or be polled.

CONSERVATION STATUS Critical.

PLACE OF ORIGIN United States.

BEST KNOWN FOR Hardiness. Origins as feral sheep from an Atlantic barrier island.

Like other feral breeds, the Hog Island is quite independent, thus it would be a good choice for a small homestead flock. The breed still desperately needs to have more breeders involved in its preservation.

Icelandic

SHEEP ARRIVED IN ICELAND with Viking settlers between 870 and 930. After the period of Viking settlement ended, few additional animals were imported (and it has been illegal to do so for centuries), so the sheep of Iceland developed in isolation, making them one of the purest breeds in the world. They are also a critical source of income for the island nation, accounting for 25 percent of their agricultural revenue.

The first Icelandic sheep arrived in Canada in 1985 thanks to the efforts of Stefania Dignum, an Icelander who relocated to Ontario and missed the sheep of her native home. The first U.S. importation came from her flock in 1992.

Icelandic sheep are renowned for having a wonderful fleece, which is marketed as Lopi yarn. The animals have an inner coat, called *thel*, which is springy, lustrous, and soft and has a staple as long as 3 inches (7.6 cm). The outer coat, called *tog*, is corkscrewed rather than crimped, is up to 18 inches long (45.8 cm), and is excellent for worsted spinning. In spite of the quality of their wool, Icelandic sheep produce more income in Iceland from meat production than from wool production.

Ewes are good mothers with lots of milk, and they frequently produce twins and triplets, which they generally raise without assistance. Some ewes will have as many as six lambs, but these larger litters will definitely need to be bottle-fed. Ewe lambs mature early, often having their own lambs at less than one year of age. Interestingly, ewes have seasonal estrus cycles but rams can breed efficiently year-round. The breed has a high feed efficiency. Obviously, it is extremely hardy in cold climates, but it does well in temperate areas also. In the southeastern United States, it may suffer from parasite loads, so management will need to be very good in those areas.

This Icelandic ewe is about ready for spring shearing. Her lambs will grow quickly on green grass.

ICELANDIC

FUNCTIONAL TYPE Meat. Fiber. Dairy.

APPEARANCE Short but very stocky. A variety of colors, including snow-white, black, gray, and moorit (a true brown) to brownish black. Some individuals will also show mouflon-type badger-face patterns. Bicolored individuals are also fairly common.

SIZE Medium.

HORNS Both sexes can be either horned or polled.

CONSERVATION STATUS Not applicable.

PLACE OF ORIGIN Iceland.

BEST KNOWN FOR Highly valued fleece for hand spinners and fiber artists. Good-quality meat. Abundant milk.

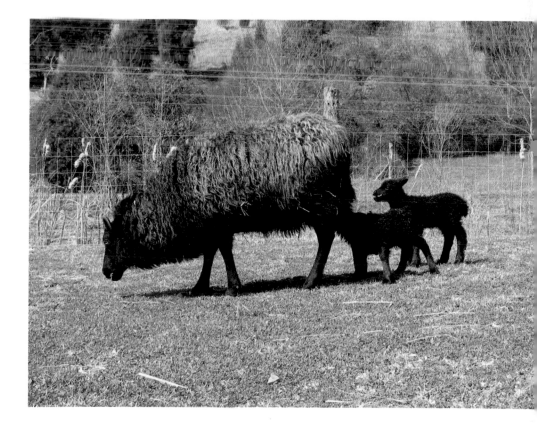

Ile de France

THE ILE DE FRANCE was developed in France, beginning in 1832, under the supervision of a professor at a French veterinary college. Dishley Leicester bloodlines were introduced to French Rambouillet Merinos with the goal of improving meat production because wool prices of the day had plummeted.

Beginning early in the breed's development, testing for specific traits became the norm. In fact, in 1933, when the breed association formed, it developed a testing station where all animals had to be evaluated for performance prior to being registered. The breed was imported via embryo transplant to Ian and Deb Clark's Medicine Ridge Farm in Alberta, Canada, and from there expanded into the United States.

In France, the breed is a meat and fiber breed, but on this side of the Atlantic it is also used for dairy. Ewes are prolific and breed year-round. Twins and triplets are common, and ewes have enough milk to feed three lambs without problem. They do well on pasture and efficiently convert their feed. The fleece is heavy (up to about 13 pounds [5.9 kg]) and medium diameter, with a staple about 3 inches (7.62 cm) long.

Ile de France sheep are still rare on this side of the Atlantic, but look for this breed to expand its influence in the future, both as a meat animal and as a dairy animal. The animals are thickly muscled with good conformation.

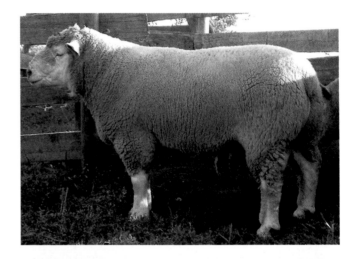

ILE DE FRANCE

FUNCTIONAL TYPE Meat. Fiber. Dairy.

APPEARANCE Heavily muscled. Broad, wool-free face with a pinkish nose and lips. Horizontal and forward-facing ears. Wool-free lower legs. Fleece is white.

SIZE Large.

HORNS Naturally polled.

CONSERVATION STATUS Not applicable.

PLACE OF ORIGIN France.

BEST KNOWN FOR Good meat production, though in North America they are being incorporated in the dairy sheep sector.

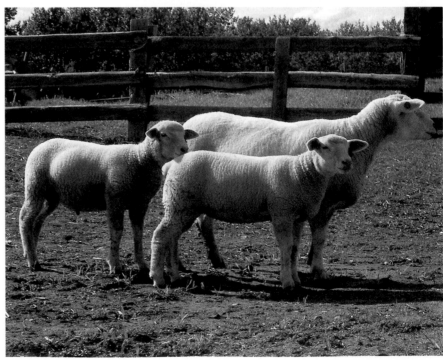

Jacob

JACOB SHEEP ARE NAMED FOR JACOB, the son-in-law of Laban in the book of Genesis. In the Genesis story, Jacob asked his father-in-law if he could keep all of the spotted sheep as payment for working for him. His father-in-law said yes, and in a dream, God told Jacob to only use spotted rams for breeding, thus yielding all spotted sheep. In spite of their name, there is no evidence linking the modern-day Jacob sheep, which have been bred in England for several centuries, to the biblical flock.

These spotted sheep, with their odd horns, have never had great commercial value. They were kept as ornamental animals by the landed gentry. The Winnipeg Zoo first imported Jacobs to Canada, and Chicago's Brookfield Zoo first imported them to the United States in 1954 as exotic ornamental animals. Additional importations were made in the 1970s.

Ewes are easy to keep and lamb without problems; singles and twins are common, but triplets do occur.

(continued)

JACOB

FUNCTIONAL TYPE Fiber. Meat. Ornamental.
APPEARANCE Almost goatlike appearance. Face is badger-colored. Spots on their body in either black and white, or "lavender" and white (the lavender is actually a bluish gray to brownish gray color).
SIZE Small.
HORNS Being polycerate (multihorned) is the norm for both rams and ewes.
CONSERVATION STATUS Threatened.
PLACE OF ORIGIN England.
BEST KNOWN FOR Multiple horns. Unusual colors.

Jacobs are one of the few breeds that show multiple horns, a characteristic known as polycerate. Rams usually have two to four horns, but they may have five or six. Ewes (shown here) are always horned, but they have just two.

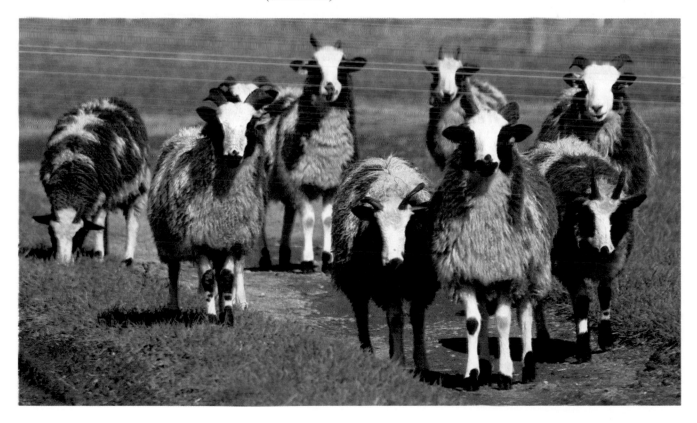

Jacob (continued)

The breed is hardy, and lambs can be butchered off grass, providing lean but flavorful meat at a low cost. The Jacob's fleece is medium in texture and quite lustrous, with a 4- to 7-inch (10.2 to 17.8 cm) staple. It doesn't put on a heavy fleece, but it has little grease, so the yield is good, usually around 3 to 4 pounds (1.3 to 1.8 kg). Hand spinners can separate a fleece into black and white, blend it for gray, or mix it to produce a tweedy-type yarn.

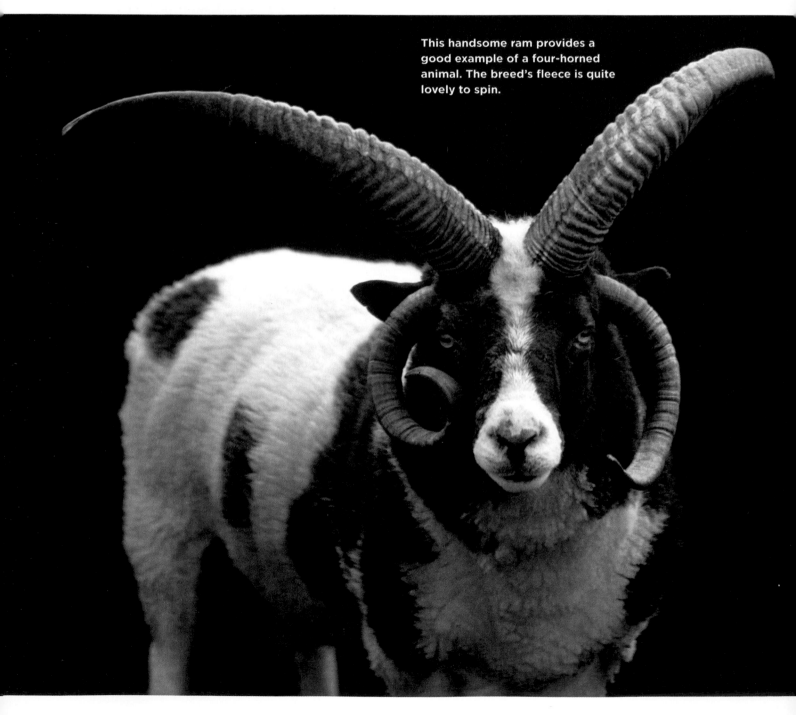

This handsome ram provides a good example of a four-horned animal. The breed's fleece is quite lovely to spin.

Karakul

THE KARAKUL IS AN ANCIENT, fat-tailed sheep from the desert steppes of Central Asia that was named for the town of Karakul in current-day Uzbekistan. Archaeological evidence suggests that these fur-type, fat-tailed sheep covered a large area of the world during the Bronze Age (3000 to 1200 BC) and Iron Age (1200 to 550 BC), from Egypt and Persia to Central Asia.

Karakuls were imported to the United States for fur production, specifically for the pelt of curly and lustrous fiber of newborn lambs. The enterprise failed when the market for Persian lamb fur went out of fashion. Most Karakul lines were lost to crossbreeding, though a handful of breeders kept the breed from dying out in North America. Today, their numbers have increased, but the American Karakuls are still listed as threatened by the American Livestock Breeds Conservancy.

Because Karakuls have always lived in harsh places, they are very hardy sheep, adapting to a very wide range of conditions. Ewes are good mothers, usually having single lambs, though twins aren't unusual. Occasionally they will have triplets, and the ewes can usually feed all three. The breed exhibits strong flocking instincts. Lambs don't grow very fast, but they produce lean and very flavorful meat that has excellent eating qualities.

The fleece of an adult is long (up to 12 inches [30.5 cm]) and somewhat coarse. Traditionally, it was used in carpet production, but hand spinners work with it today. Karakuls have a soft undercoat that sheds in the summer. Most animals have colored fleece; black is most common, but red is frequently seen. As animals mature, the color lightens, so older animals with the black gene produce a dark-gray fiber, while older animals with the red gene produce a reddish tan fiber.

KARAKUL

FUNCTIONAL TYPE Fiber. Meat.

APPEARANCE Fine bones. Long, pendulous ears. Lambs are curly coated, though fleece straightens with age and comes in a wide variety of colors.

SIZE Medium.

HORNS Either horned or polled.

CONSERVATION STATUS Threatened.

PLACE OF ORIGIN Central Asia.

BEST KNOWN FOR Karakul or Persian lamb fur, which is made from the pelts of lambs.

Karakul ewes are quite independent and rarely require assistance at lambing time. Their fiber is somewhat coarse but fun to spin.

Katahdin

IN 1957, Michael Piel, a Maine sheep farmer and amateur geneticist, read a *National Geographic* article about West African hair sheep, and his interest in the breed was piqued. Piel's main product was lamb, and he had a ready market for as much high-quality lamb as he could produce, but his sheep required shearing. He calculated that he actually took a loss on the wool when he factored in the cost of shearing, so he was interested in a meat sheep that would shed wool naturally.

Hair sheep put on a two-layer coat, an inner layer of fine wool that sheds out naturally in the summer and an outer hair coat that remains slick during the heat of summer. He thought those genetics could save him a lot of money by eliminating shearing costs, so he imported three Virgin Island White hair sheep from St. Croix, a ram and two ewes. Piel experimented with crossing the sheep with a number of breeds, including Tunis, Southdown, Hampshire, Suffolk, Cheviot, and Wiltshire Horn sheep, and by the late 1970s he had stabilized a hair sheep breed that met his goals of excellent meat production without the need for shearing. He named it Katahdin for Mt. Katahdin, the highest peak in Maine.

Katahdins are hardy, highly adaptable, and very low-maintenance sheep. Both sexes mature early, and ewes usually have twins or triplets. They can breed any time of year. They are docile and easy to handle.

KATAHDIN

FUNCTIONAL TYPE Hair. Meat. Dairy.

APPEARANCE Slight Roman nose. Droopy ears. Hair coat varies in color, though white is most common.

SIZE Medium to large.

HORNS Polled animals are preferred, but horns occur occasionally.

CONSERVATION STATUS Recovering.

PLACE OF ORIGIN United States.

BEST KNOWN FOR Economical meat production without the expense of shearing.

Katahdin sheep numbers are on the upswing as more lamb producers recognize the value of their hair trait in bottom-line economics. For producers who don't plan to market fleece as a premium product to hand spinners, wool is often a costly by-product in modern market circumstances.

Lacaune

CHANCES ARE you haven't heard of this breed from southern France, but you probably have heard of the product for which it is most famous, Roquefort cheese. In France, these sheep nurse their young for about a month, then the lambs are weaned and the ewes join the milk line, producing for about six months more. Though they produce less milk than the East Friesian dairy sheep, their milk has a higher amount of milk solids and excellent milk flavor. The first Lacaunes in North America were born on the Canadian farm of Josef and Barbara Regli, who imported 22 embryos in 1996.

For centuries Lacaune ewes have been selected for milk production and udder health, and over the past several decades selection has also been made for use in machine milking. The ewes are also hardy and very healthy in a dairy operation, with low incidence of mastitis (an infection of the udder) and respiratory problems. They have a calm demeanor. The breed has a short, double-coated fleece, and they shed out the undercoat during the summer. Dairy sheep operators are using Lacaune rams for crossbreeding to heavier milking breeds, such as Dorsets and Katahdins.

LACAUNE

FUNCTIONAL TYPE Dairy. Meat.
APPEARANCE White. Slightly angular build. Pendulous ears that flop down. Face and legs are wool-free. Light wool in winter and sheds out in summer.
SIZE Medium.
HORNS Naturally polled.
CONSERVATION STATUS Not applicable.
PLACE OF ORIGIN France.
BEST KNOWN FOR Milk production.

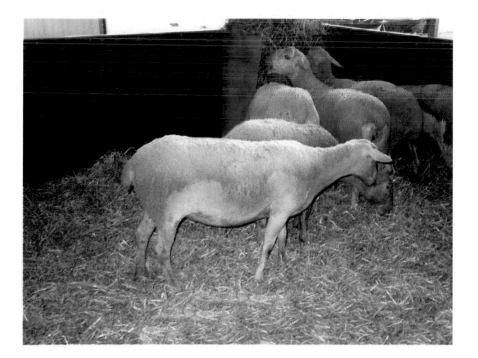

Although Lacaune sheep are rare on this side of the Atlantic, they are excellent sheep for dairy production, so look for them to become more common as time goes on.

Leicester Longwool

THE LEICESTER LONGWOOL (also called the English Leicester) is a descendant of Robert Bakewell's Dishley Farm breeding program in the 1700s, making it one of the oldest "modern" breeds. Leicester Longwool sheep have been in North America since the arrival of some of the earliest English settlers. Both George Washington and Thomas Jefferson maintained them at Mount Vernon and Monticello, respectively.

By the 1980s, the breed was almost extinct, both in the United States and in England, because the commodity wool market discounted it. The Colonial Williamsburg Foundation helped save the breed in the United States by importing some new bloodlines from Australia in 1986, about the same time that interest in fiber arts and spinning was expanding. The hand spinners loved the fleece, with its extraordinarily long, curly, silky locks, which can reach 14 inches (35.6 cm) in length. Fibers have an even crimp throughout the length of the lock.

Leicester Longwool sheep are large but quite personable and docile. They are adaptable to a variety of climatic conditions and are efficient foragers but do require good pasture to perform well. Ewes are good mothers with plenty of milk for their lambs. Typically they have singles and twins, with a lambing rate between 120 percent and 150 percent.

LEICESTER LONGWOOL

FUNCTIONAL TYPE Fiber. Meat.

APPEARANCE In full fleece, sheep look like big, shaggy dogs with a mop of wool over the top of their head. Wool-free face. Usually white, though semen from color strains has been imported from Australia.

SIZE Large.

HORNS Naturally polled.

CONSERVATION STATUS Threatened.

PLACE OF ORIGIN England.

BEST KNOWN FOR Fabulous fleece of long, lustrous locks.

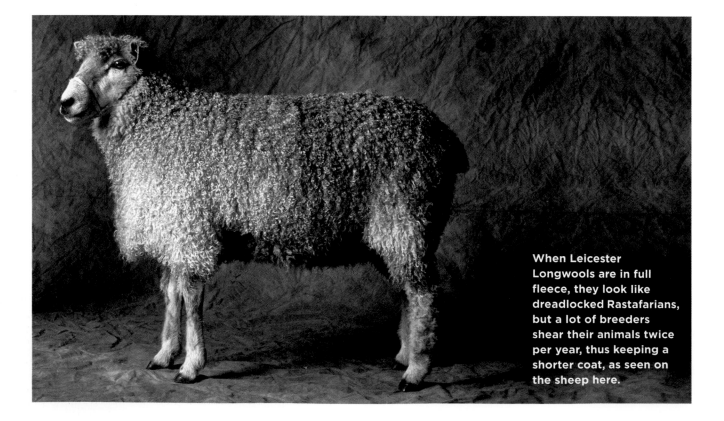

When Leicester Longwools are in full fleece, they look like dreadlocked Rastafarians, but a lot of breeders shear their animals twice per year, thus keeping a shorter coat, as seen on the sheep here.

Who says the mop top is dead? Leicester Longwools typically sport this little fringe of curly bangs. In this close-up, it's easy to see the strong and tight crimp of their lustrous fiber.

Lincoln Longwool

THE NATIVE SHEEP of Lincolnshire were around when the Roman Empire extended its reach to the east coast of England. These native Lincoln sheep were tall sheep with long, coarse fleeces, but they were also rangy animals that didn't provide good meat. Robert Bakewell used some of the native Lincolnshire sheep to develop the Leicester Longwool, and shepherds of Lincolnshire later bred some of Bakewell's improved Leicester rams with the native ewes in order to improve carcass quality. Through continued selection, the Lincoln Longwool was a recognizable dual-purpose breed by the late 1700s.

The breed was first imported to the United States and Canada at the end of the eighteenth century. It didn't gain much popularity outside the West and Pacific Northwest, where it was crossbred with range flocks to increase wool production and hardiness, but it did have a strong following in Canada. It has also played a part in the genetic development of many other breeds over the ensuing years.

The Lincoln Longwool is one of the largest breeds of sheep, and mature rams weigh up to 350 pounds (159 kg). Luckily, it is a rather docile breed. Ewes produce large, well-muscled lambs, though the lambs' growth rate is a bit slow. Ewes are good mothers. They usually have single lambs, though twins aren't rare. The Lincoln's fleece is heavy, yielding up to 11 pounds (5 kg) of usable wool. The fibers are coarse, heavily crimped, and quite lustrous.

Not only are Lincoln Longwool sheep large, but they are known as "easy keepers," meaning that they can gain too much weight if fed a rich diet. But they have an easygoing disposition too, so they are a nice breed for someone looking for a small hand spinner's flock.

LINCOLN LONGWOOL

FUNCTIONAL TYPE Fiber. Meat.

APPEARANCE Bluish tinted faces. Forward-tilting ears on the horizontal. Distinctive topknot of wool on their forehead, but a wool-free face. Most are white, but some strains produce colored wool, ranging from silver to black.

SIZE Large.

HORNS Naturally polled.

CONSERVATION STATUS Watch.

PLACE OF ORIGIN England.

BEST KNOWN FOR Large size (the largest sheep breed). Long, curly wool.

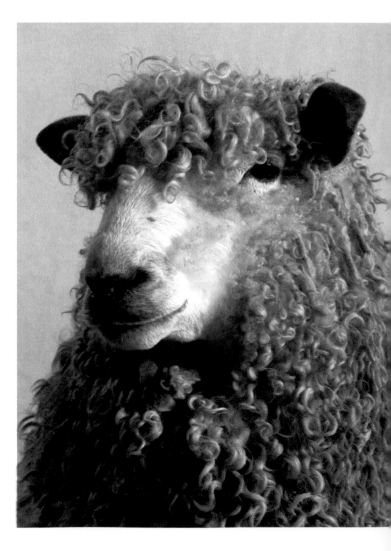

Like their Leicester Longwool ancestors, the Lincolns can grow fleece that almost touches the ground, so many breeders shear their animals twice per year.

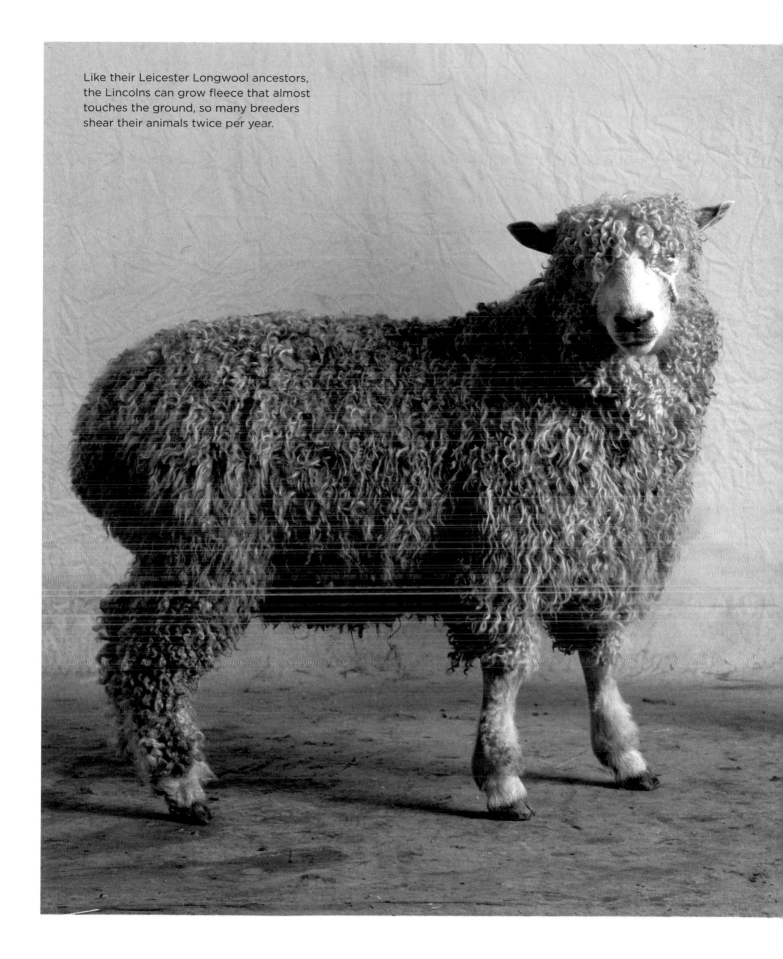

Merino

DURING THE MIDDLE AGES, the Spanish were renowned for the quality of the wool they produced for export to Flanders and England. The sheep that supplied their fine wool were the forebears of our modern Merinos. The export of those sheep was forbidden by law until the later years of the eighteenth century. Today there are at least 10 sub-breeds of Merinos, and they are the most common sheep in the world.

Merinos were imported to North America from Spain in several small lots starting in 1793, but in 1809, William Jarvis, a Vermont native and then American consul to Portugal, brought over a ship full of Portuguese Merinos (more than 3,500 animals), providing the real foundation for Merinos in America.

The most common Merino in North America is the Rambouillet, or French Merino (this breed is written about in detail on page 267). The next most common Merino in North America is the Delaine Merino, which is what people are generally referring to when they simply say Merino. The Delaine was developed in the United States from early imports of Spanish Merinos and is a fiber breed, producing a very fine fleece. Ewes will breed year-round but most only have a single lamb, and triplets are very rare. Lambs are small at birth and mature slowly, but they're quite long-lived.

The other Merino found in North America, the Booroola, was developed in Australia in the 1960s from a flock of Merino sheep that seemed to have more twins and triplets than most Merinos. It turns out that those sheep had a naturally occurring mutation that doubled their lambing rate from 120 percent for most Merinos to 240 percent, and some ewes have up to six lambs per lambing.

Both Delaines and Booroolas have heavy fleeces of very fine wool with a staple between 2.5 and 4 inches (6.4 to 10.2 cm) long. Clean fleece yields up to 8 pounds (3.6 kg). Both breeds have good flocking instincts, will travel great distances for food and water, and can get along on rough and thin pasture, making them good choices for range operations. Merinos tend to have long, productive lives, and many still produce into their teens. Ewes will breed any time of year, and rams are often used as terminal sires in crossbreeding programs.

DELAINE MERINO

FUNCTIONAL TYPE Fiber. Meat.

APPEARANCE Wool-free face with a topknot of wool on the forehead. Ears that grow down and forward a bit below the horizontal. May have some skin folds on the chest, but the rest of the body is smooth. Color is always white.

SIZE Medium to large.

HORNS Rams can be horned (impressive, curling horns) or polled; ewes are polled.

CONSERVATION STATUS Not applicable.

PLACE OF ORIGIN United States.

BEST KNOWN FOR Excellent wool quality and good production on range.

BOOROOLA MERINO

FUNCTIONAL TYPE Fiber. Meat.

APPEARANCE Wool-free face with a topknot of wool on the forehead. Ears that grow down and forward a bit below the horizontal. May have some skin folds on the chest, but the rest of the body is smooth. Color is always white.

SIZE Medium to large.

HORNS Rams are horned with substantial, curling horns; ewes can be horned or polled.

CONSERVATION STATUS Not applicable.

PLACE OF ORIGIN Australia.

BEST KNOWN FOR Excellent wool quality and multiple births.

Some Merino breeds have deeply folded skin (think of a Shar-Pei dog and you get the picture), which makes shearing difficult for both shearer and sheep, but the Delaines (seen here) were selected for smoother skin, and thus easier shearing.

Montadale

IN 1932, E. H. Mattingly, a lamb buyer from the Kansas City area, bought a Columbia ram in Kalispell, Montana. Mattingly crossed him with Cheviot ewes with the goal of increasing fertility, hardiness, and fleece quality while maintaining meat production and quality. The result was not quite what he sought, so he reversed the mix, using a Cheviot ram on Columbia ewes. This was what he was looking for, and it provided the breed's foundation.

In 1945, Mattingly and four other breeders formed a breed association and began promoting the breed. In 1996, the breed association began a "regeneration" project, again crossing approved Cheviot rams with approved Columbia ewes in order to expand the genetic base of the breed.

Montadale ewes are prolific, and thanks to the breed's small head, they very rarely have lambing problems. The lambs grow quickly and have excellent carcass traits with lean and flavorful meat. Fleeces will typically weigh from 8 to 12 pounds (3.6 to 5.4 kg) and have a 3.25- to 4.5-inch (8.25 to 11.43 cm) staple. Montadale rams are often used as a terminal sire in crossbreeding programs, and the lambs are frequently used as club lambs for 4-H and Future Farmers of America.

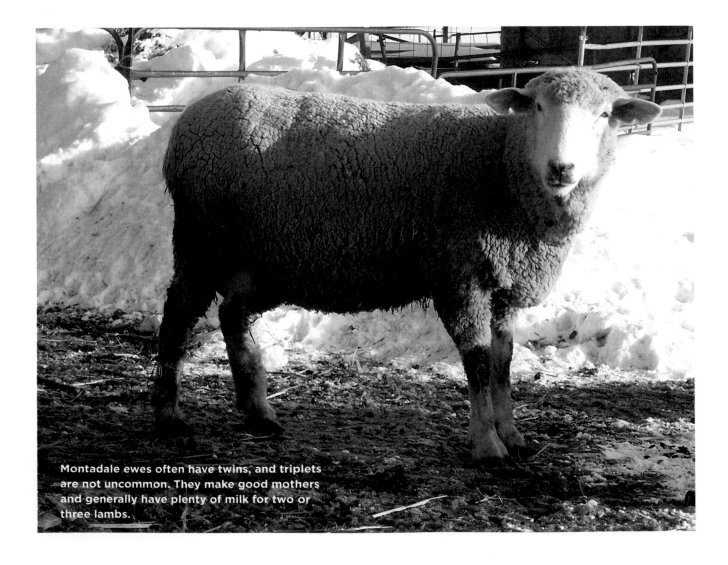

Montadale ewes often have twins, and triplets are not uncommon. They make good mothers and generally have plenty of milk for two or three lambs.

MONTADALE

FUNCTIONAL TYPE Meat. Fiber.

APPEARANCE Tall, well-conformed, long-backed, muscular. Slightly small head. Wool-free face with a black nose. Wool-free legs. Fleece is usually snowy white, though there are some black strains.

SIZE Large.

HORNS Naturally polled.

CONSERVATION STATUS Not applicable.

PLACE OF ORIGIN United States.

BEST KNOWN FOR Excellent dual-purpose qualities with adaptability to various climates.

We had some Montadales for a while, and I liked them. They were energetic, and the ram hopped around exuberantly most of the time. Rams are often used as terminal sires.

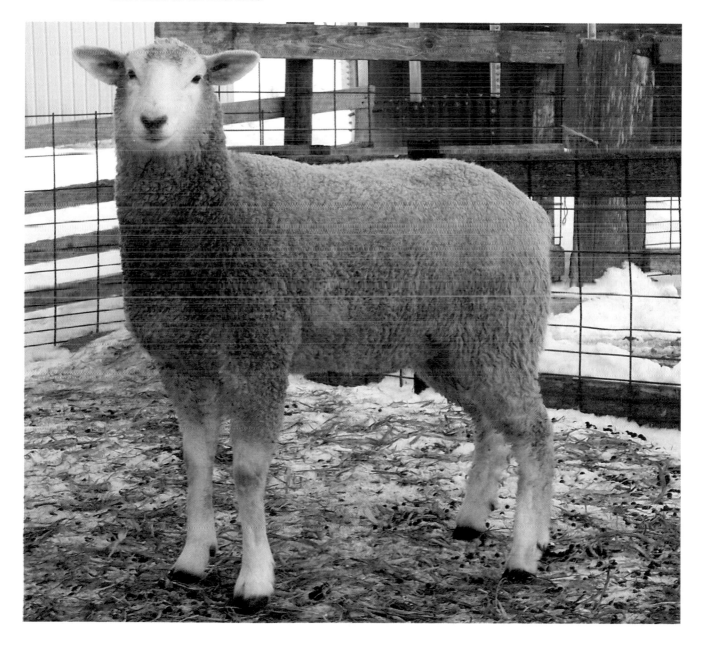

Navajo-Churro

THE NAVAJO-CHURRO is the oldest breed of sheep in North America. A criollo breed, it was developed in the Southwest from the Churra sheep that Spanish explorers brought from the Iberian Peninsula to the New World during the sixteenth and seventeenth centuries. Native Americans in the Southwest acquired animals through raids, trade, or luck when the Spanish lost animals.

The Navajo tribe in particular took to shepherding and soon relied on the Churra sheep for meat, milk, and wool, which was used in their renowned weaving. The sheep provided the basis of their subsistence economy, and to this day, the Navajo honor their relationship with their sheep in an annual Sheep Is Life celebration. As later movements of European settlers entered the Southwest, the name was changed from Churra to Navajo-Churro.

In the late 1800s, the U.S. Army killed tens of thousands of Churro sheep in an attempt to control the Navajo tribe, and later federal agencies pushed for crossbreeding Churros with other breeds in an attempt to "improve" the sheep. Despite these efforts, small pockets of original Churros remained in valleys and isolated areas of the Navajo Reservation, and these animals provided the nucleus for conservation efforts beginning in the 1970s.

With leadership from the Navajo Sheep Project, instituted by Dr. Lyle McNeal of Utah State University, and the American Livestock Breeds Conservancy, the breed was brought back from the brink of extinction. Breeders formed a breed association in 1986 and officially adopted the name Navajo-Churro. Working with Diné be' iiná, Inc., a Navajo nonprofit organization, hundreds of Navajo-Churro sheep have been returned

NAVAJO-CHURRO

FUNCTIONAL TYPE Fiber. Meat.

APPEARANCE Clean face and legs (wool-free). A variety of colors and patterns.

SIZE Medium.

HORNS Both sexes may be horned or polled; rams can have four horns.

CONSERVATION STATUS Threatened.

PLACE OF ORIGIN United States.

BEST KNOWN FOR Historical and cultural importance. Unique fiber. Tasty meat.

Like the Jacob sheep, the Navajo-Churro is polycerate, though some strains are naturally polled.

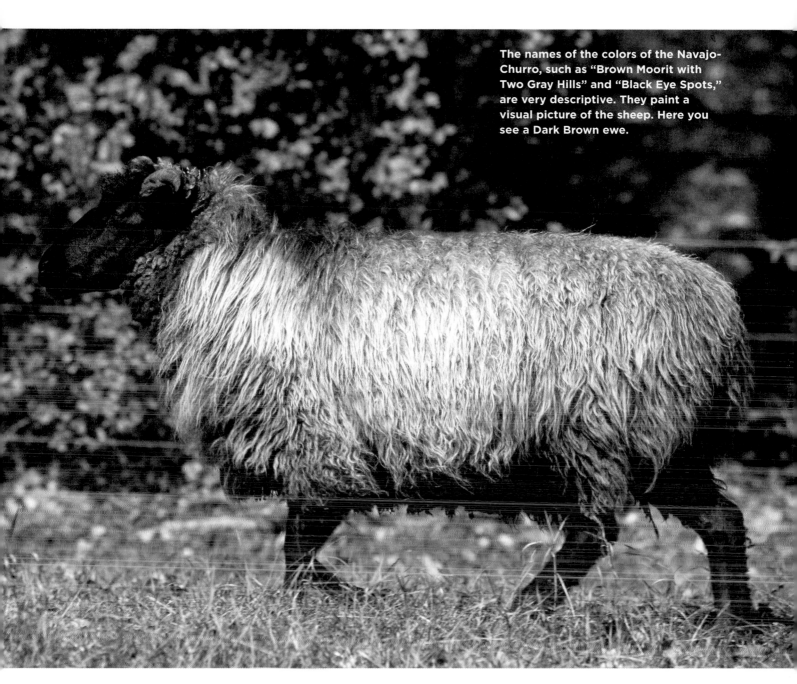

The names of the colors of the Navajo-Churro, such as "Brown Moorit with Two Gray Hills" and "Black Eye Spots," are very descriptive. They paint a visual picture of the sheep. Here you see a Dark Brown ewe.

to the Navajo and Hopi reservations. There, they are again in the hands of the sheepherders who developed the breed, and they are contributing to the resurgence of interest in Native American weaving culture.

Churros are a primitive type, having an undercoat of soft, downy wool and an outer coat of coarse wool and hair. The undercoat fibers are 5 to 6 inches (12.7 to 15.3 cm) long, while the outer fibers are 8 to 14 inches (20.3 to 35.6 cm) long. The fleece isn't especially heavy (8 pounds [3.63 kg] is a good clip), but it is wonderful wool that is low in grease (a good adaptation in the dusty, dry desert environment of the Southwest). Also, the low grease content means it yields well in spite of the somewhat light clip. It is excellent for hand spinning and the fiber arts. Since the sheep have been selected for a wide range of colors, many weavings feature natural colors. Ewes can breed throughout the year, lamb easily, often have twins and triplets, and are great mothers that are very protective of their lambs. The Churros have excellent-flavored meat and have been successfully nominated to Slow Food USA's Ark of Taste (see page 38) by the American Livestock Breeds Conservancy.

Newfoundland

THE NEWFOUNDLAND SHEEP is a landrace that has evolved on some of the islands of Newfoundland, Canada, over the five centuries that shepherds have kept sheep on the islands. Researchers postulate that the primary foundation breed was probably a Border Cheviot or Border Cheviot–precursor breed, but a mixture of other breeds has been introduced over the centuries. The Newfoundland sheep was not historically recognized as a breed, but shepherds on the islands, researchers in academia and the government, and advocates for maintaining agricultural biodiversity are suggesting that it be recognized as a breed to help protect this genetic resource. In recent decades, many shepherds have retired, and Newfoundland sheep numbers have dropped precipitously.

The Newfoundland sheep are small but very hardy and self-sufficient, living in an extremely harsh climate and feeding off native grasses that are scant and not particularly nutritious. Ewes will breed year-round, typically produce twins, and are excellent mothers. Although the lambs are small, they produce a marketable carcass. The fleece is dense, fine, and has a distinct crimp. Fibers reach 6 inches (15.3 cm) in length.

NEWFOUNDLAND

FUNCTIONAL TYPE Fiber. Meat.

APPEARANCE Primitive looking. Slight frame and short legs. Upright ears. Wool-free face and legs. Various colors.

SIZE Small.

HORNS Rams can either be horned or polled; less than 5 percent of ewes have horns.

CONSERVATION STATUS Critical.

PLACE OF ORIGIN Canada.

BEST KNOWN FOR Hardiness. Status as a landrace threatened with extinction.

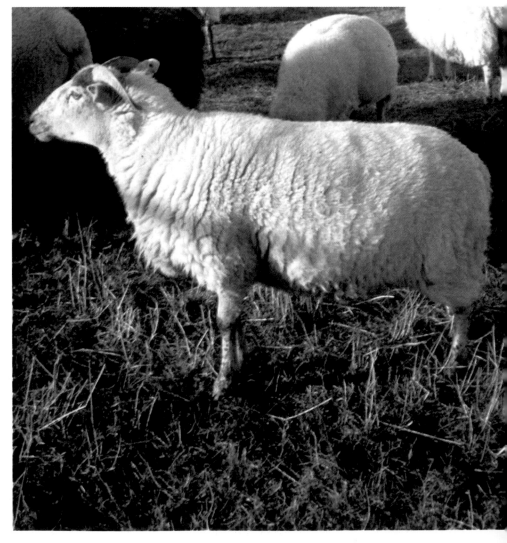

Hardiness and an ability to survive in an inhospitable environment are the hallmarks of the Newfoundland landrace.

North Country Cheviot

THIS BREED WAS DEVELOPED in northern Scotland by Sir John Sinclair beginning in 1791, when he brought five hundred Border Cheviots up from the southern part of the country. He crossed the breed with some Leicester bloodlines (Longwool and Border). The crosses performed well, and more Border Cheviots were brought north, where over the next couple of centuries the breed was fully developed through selection (both human and natural) to become the North Country breed.

North Country Cheviots came to North America in 1944, when 10 ewes and 2 rams were imported to MacDonald College in Quebec. The lambs from this small flock were so impressive that in 1949 the Canadian Department of Agriculture imported 51 ewes and 5 rams, and in 1953 several more shipments, totaling 120 head, arrived. The sheep quickly became popular with Canadian shepherds and made their way across the border to the United States in the early 1950s.

The breed is hardy, independent, and especially long-lived, with many animals producing into their teens. Ewes are good mothers and lambs are born with great vigor and vitality, making them less vulnerable to predation than those of other breeds. The fleece can be as heavy as 10 pounds (4.54 kg), and the fibers are dense, uniform, medium-diameter, and up to 6 inches (15.3 cm) long. The fleece is used extensively in producing Scottish tweeds, and hand spinners enjoy working with it.

(continued)

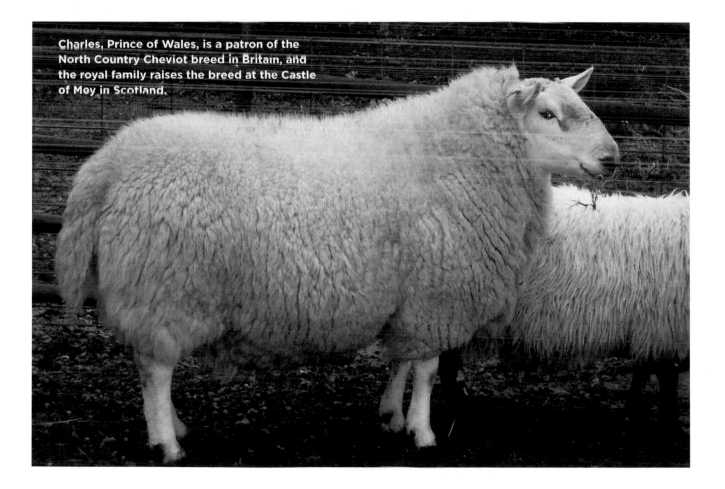

Charles, Prince of Wales, is a patron of the North Country Cheviot breed in Britain, and the royal family raises the breed at the Castle of Mey in Scotland.

North Country Cheviot (continued)

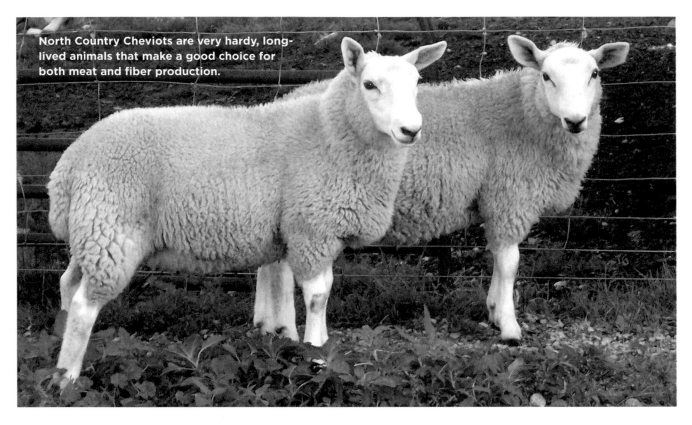

North Country Cheviots are very hardy, long-lived animals that make a good choice for both meat and fiber production.

NORTH COUNTRY CHEVIOT

FUNCTIONAL TYPE Meat. Fiber.

APPEARANCE Muscular animal with wide-set legs and a long back. Face and legs are free of wool. Ears extend at an angle of about 45 degrees from the horizontal. Straight or slightly Roman profile. The nose is dark. Fleece is white.

SIZE Large.

HORNS Rams are either horned or polled; ewes are polled.

CONSERVATION STATUS Not applicable.

PLACE OF ORIGIN Scotland.

BEST KNOWN FOR Longevity. Production of very vigorous lambs.

Oxford

HAILING FROM OXFORD COUNTY, England, this breed was developed by combining native sheep with Hampshire, Southdown, and Cotswold sheep. Oxford County is an extremely fertile agricultural area, so the shepherds who began developing the breed in 1830 were seeking a large animal that could put on exceptional muscle on the available forage and crops while also producing a high-quality fleece. It was officially recognized as a breed at the Royal Agricultural Society Show in 1862.

Oxfords were imported to the United States in a number of shipments, beginning in 1846, and the American Oxford Down Record Association formed in 1862. In the 1970s and early 1980s, some Canadian breeders imported additional animals from Scotland and England to add more diversity to the breed's bloodlines. Rams from these importations quickly influenced the breeding lines across North America.

Oxfords are very large sheep. When well fed, they produce both excellent carcasses and excellent fleece. Ewes have a 150 percent lambing rate and are good mothers. It is a docile breed and does very well in farm flocks where there is plenty of high-quality feed, but don't expect good performance from animals on rough forage. The fleece is medium-weight and 3 to 5 inches (7.6 to 12.7 cm) long. Rams are often used in crossbreeding, and lambs are used as club lambs.

OXFORD

FUNCTIONAL TYPE Meat. Fiber.

APPEARANCE Tall, muscular animal with a long, straight back. Ears (which face forward on the horizontal), face, and legs are colored (steel gray, dark brown, or black); the remaining wool should all be pure white.

SIZE Large.

HORNS Naturally polled.

CONSERVATION STATUS Watch.

PLACE OF ORIGIN England.

BEST KNOWN FOR Large size. Good production in farm-flock situations. Breed of choice for 4-H and Future Farmers of America projects.

Oxfords are well-muscled sheep with good fiber and meat production traits when raised with high-quality feed. Rams are frequently used as terminal sires.

Panama

JAMES LAIDLAW, a Scottish immigrant to Idaho, began developing the Panama in 1912 as a larger range sheep than the Merinos that dominated the area. He started by crossing 50 Rambouillet rams with 1,600 Lincoln Longwool ewes in order to increase the size and ruggedness of the animals. After three years, he began using rams from the cross, and after five years, he sold the last of his Lincoln Longwool ewes and bred only Panamas.

A registry began in 1951, but the registry has not been active in promoting the breed, so it isn't well known outside of Idaho and Montana. For practical purposes, the registry can probably be considered as abandoned at this point in time. The Laidlaw family did endow the sheep program at the University of Idaho with a flock of Panama sheep, along with the funds to maintain it. They also provided the funds for other sheep research activities geared toward producers in the northern Rockies.

Because the registry for the breed was never active, today the Panama is a bit of an enigma. The University of Idaho still maintains a small flock of foundation animals, but most other animals in this area are classified as Panama-type animals because no one really knows whether they are still purebred. Whatever you call them, shepherds who still have them in this region say they do perform very well under range conditions, including summering in the high mountains. The ewes are good mothers and produce plenty of milk. The breed also produces a heavy fleece (up to 8 pounds [3.63 kg] of clean wool) with medium-length fiber that is up to 5 inches (12.7 cm) long.

PANAMA

FUNCTIONAL TYPE Meat. Fiber.

APPEARANCE Clean-faced sheep. White fleece. Ears face forward on the horizontal.

SIZE Large.

HORNS Naturally polled.

CONSERVATION STATUS Not applicable.

PLACE OF ORIGIN United States.

BEST KNOWN FOR Hardiness and ruggedness on the northern Rocky ranges.

This Panama ewe and her winter-born lambs will be happy to get out on range once the snow begins to melt. The breed's ruggedness is ideal for the northern Plains and the Rockies.

Perendale

PERENDALE SHEEP were developed at New Zealand's Massey University by Professor Geoffrey Peren in the 1950s. Professor Peren crossed Cheviot rams with Romney ewes. They were first imported to the United States in 1977, though they are still rather rare here. The breed was developed as a dual-purpose sheep that was well adapted to the rugged hill country of New Zealand, which is known for cold and wet weather and abundant but rough-quality forage.

Perendale ewes have a good lambing rate (around 150 percent), and they are self-sufficient, rarely needing assistance during lambing. The breed is a bit nervous but responds nicely to quiet and easy handling. The Perendale's fleece is prized by hand spinners, particularly those who dye their own wool, as it takes dyes wonderfully. The fibers are strong and elastic and have a 4- to 6-inch (10.2 to 15.3 cm) staple. They produce up to 5.5 pounds (2.49 kg) of clean medium- to fine-weight wool per clipping.

PERENDALE

FUNCTIONAL TYPE Meat. Fiber.

APPEARANCE Sprightly, upright ears. Dark nose. An open face like their Cheviot forebears. Fleece can be white or colored.

SIZE Large.

HORNS Naturally polled.

CONSERVATION STATUS Not applicable.

PLACE OF ORIGIN New Zealand.

BEST KNOWN FOR Having dual-purpose traits. Good production in wet and cold climates.

A little snow won't bother this Perendale ewe. The breed is quite hardy.

Polypay

REED HULET, an Idaho shepherd, and his brother, Dr. Charles Hulet, a sheep researcher at the USDA's Sheep Experiment Station in Dubois, Idaho, developed the breed in the early 1970s. They wanted to develop a prolific sheep breed that could do equally well on range and farm pasture. They created the Polypay by crossing Targhee to Dorsets, and Rambouillets to Finnsheep. The crossbred offspring were recrossed, yielding an animal that was one-quarter of each parent breed.

The Finnsheep contributed high prolificacy, early puberty, and short gestation. The Rambouillet contributed hardiness and adaptability to range and improved pasture. The Targhee contributed superior fleece quality, large body size, and a long breeding season. The Dorset contributed superior mothering ability, good carcass quality, early puberty, and a long breeding season. The four-way cross really did perform exceptionally well, and Dr. Hulet coined the name "Polypay" in 1975, from "poly," which means many, and "pay," which indicates the potential for the breed to increase a shepherd's return on investment and labor.

Polypays are quite prolific; 200 percent lamb crops are common, and many breeders use accelerated lambing to have three lambings every two years. The ewes produce an abundant supply of milk and are being used by some sheep dairymen. Rams are often used in crossbreeding programs, and lambs are used as club lambs. The fleece is very uniform and dense. The staple is 3 to 5 inches (7.6 to 12.7 cm) long, and the fibers are medium diameter.

POLYPAY

FUNCTIONAL TYPE Meat. Fiber. Dairy.

APPEARANCE Muscular with legs squarely under the body. All white. Some wool on the forehead, but a wool-free face below the eyes. Ears are on the horizontal and forward.

SIZE Medium to large.

HORNS Naturally polled.

CONSERVATION STATUS Not applicable.

PLACE OF ORIGIN United States.

BEST KNOWN FOR Prolificacy and having excellent dual-purpose qualities.

This group of Polypay ewes and lambs seem to think that the photographer should have something for them. They have a good balance of production traits, giving them overall strong performance.

Rambouillet

IN 1786, when the Spanish began allowing some Merinos to be exported, King Louis XVI of France imported 359 of them to his estate at Rambouillet. Those Merinos, with the possible addition of some native French bloodlines, were improved mainly by selection, yet they remained pretty true to the original Spanish Merinos, whose quality was largely lost to crossbreeding when the Spanish monarchy failed. The breed was first imported to the United States in 1840 and quickly spread throughout North America, particularly leaving its mark on western range operations, where it was valued for its hardiness and ability to thrive on somewhat sparse native grasslands.

Rambouillets (also called French Merinos) do so well on open range in part because they have a very strong flocking instinct. They will spread out somewhat during the day while they graze but will bunch up tightly to sleep at night. They adapt fairly well to a variety of climates, but they don't do well in the humid Southeast, in part because they (like other fine-wooled breeds) are more vulnerable to fly strike (maggots living in their fleece). Although they are more vulnerable to fly strike than other breeds, they are more resistant to internal parasites.

The ewes make lots of milk, frequently having twins and triplets. They will breed throughout the year and can be used for accelerated lambing. Ewes often breed until they are 10 or 12 years old. Lambs grow quickly and produce a good carcass. The fleece is fine, and fibers are 2.5 to 4 inches (6.4 to 10.2 cm) long. The breed produces a heavy clip (up to 15 pounds [6.8 kg] per year) that will yield up to 8 pounds (3.63 kg) of clean wool.

RAMBOUILLET

FUNCTIONAL TYPE Fiber. Meal. Dairy.

APPEARANCE Strong-bodied animals. Some wrinkling on the brisket. Face is wool-free below the eyes. Forward-facing ears have a downward tilt. Fleece may be white or colored, depending on the strain.

SIZE Large.

HORNS Rams are either horned or polled; ewes are generally polled.

CONSERVATION STATUS Not applicable.

PLACE OF ORIGIN France.

BEST KNOWN FOR Excellent fiber production. Good performance in range operations.

The fleece on these Rambouillet sheep is still relatively short after shearing. At full growth, it will weigh up to 15 pounds.

Rideau Arcott

THE RIDEAU ARCOTT has become a very successful breed in Canada since its distribution to shepherds in 1988. Researchers at the Agricultural Research Centre in Ottawa used Finnish, Suffolk, Shropshire, Dorset, and East Friesian sheep to create the breed. In 1974, the researchers closed the flock to new genetic lines and expanded it through selection within the existing crosses.

Rideau Arcott ewes mature early and are highly fertile. Twins and triplets are the norm, and quadruplets are actually more common than single lambs. They can breed any time of the year and are often used in accelerated lambing programs. According to Canadian Sheep Flock Improvement Program performance data, the Rideau, with a 210 percent weaning rate, weans more pounds of lamb per ewe than any other breed participating in the program. When Rideau rams are used in crossbreeding, the lambing rate consistently goes up to 180 percent or more. And of course, coming out of Canada, they are hardy in cold regions.

RIDEAU ARCOTT

FUNCTIONAL TYPE Meat. Fiber. Dairy.

APPEARANCE Feminine looking. Clean, narrow face. Ears are slightly above the horizontal. Generally white, although the legs and face may show some color and spotting.

SIZE Medium.

HORNS Naturally polled, though rams may have scurs (short, horny protuberances).

CONSERVATION STATUS Not applicable.

PLACE OF ORIGIN Canada.

BEST KNOWN FOR Prolificacy and cold hardiness.

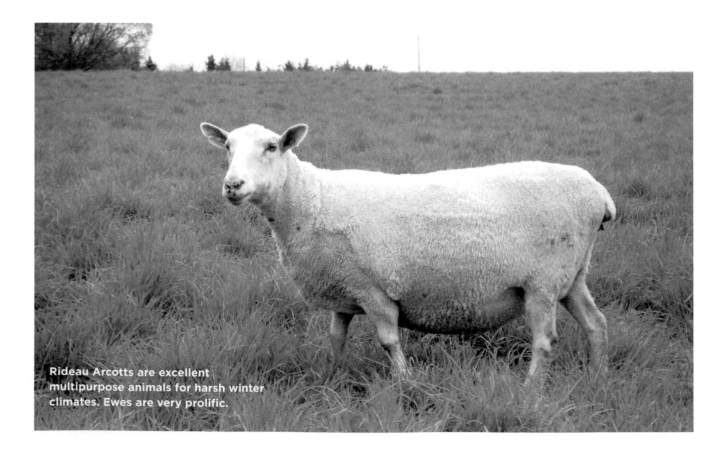

Rideau Arcotts are excellent multipurpose animals for harsh winter climates. Ewes are very prolific.

Romanov

THE ROMANOV is an ancient Russian landrace from the Volga Valley, located northwest of Moscow. It was given the family name of the last czars of Russia. In 1980, researchers from Canada imported 14 ewes and 4 rams from France, and after they completed a five-year quarantine, they were imported to the United States from Canada.

The Romanov is a short-tailed breed, similar to the Finnsheep, and, like the Finnsheep, is highly prolific and matures early. The record litter size for a Romanov ewe is eight lambs, but triplets and quadruplets are more common. Ewe lambs mature early and will have their first lambs before they are one year old. They breed throughout the year and can produce lambs every eight months. The breed's fleece is coarse, moderately long, and double-coated, and it can yield up to 10 pounds (4.54 kg) of clean wool per year. Romanovs are always colored, but when crossed to a white breed, the color doesn't pass to its offspring. The breed is hardy and independent.

Romanovs are not common here, but there is growing interest in the breed.

This Romanov ewe has crossbred lambs. Romanovs shed out their winter coat in warm weather, and this ewe is close to finishing her shed.

ROMANOV

FUNCTIONAL TYPE Meat. Fiber. Dairy.

APPEARANCE Primitive looking. Head is small. Ears are above the horizontal. Lambs are born with black, silky hair, but as they age the hair is shed and replaced by primarily gray wool, with darker wool on legs and face. Face may have white or tan badger markings.

SIZE Medium.

HORNS Mostly polled, but some have horns.

CONSERVATION STATUS Not applicable.

PLACE OF ORIGIN Russia.

BEST KNOWN FOR High prolificacy and early maturity.

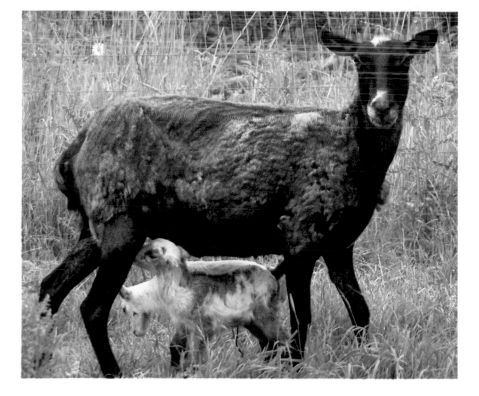

Romney

IN ITS NATIVE ENGLAND, the Romney is called the Romney Marsh, after the cold, wet, marshy area of southeast England where it developed from Leicesters bred with the old native sheep. Romney Marsh, a hundred-square-mile coastal plain, is below sea level and only kept habitable by a centuries-old system of drainage ditches and seawalls. The earliest inhabitants of the marsh brought in the sheep during the Roman Empire, but in the wet conditions most animals yielded poor-quality fleece and suffered from myriad health problems. However, as the centuries passed, the sheep adapted to these conditions.

In the mid-nineteenth century, shepherds in the Marsh improved the adapted native sheep through a combination of intensive selection and the introduction of Dishley Leicester bloodlines. This led to the modern Romney breed, which produces high-quality fleece even under wet conditions.

William Riddell, a Scottish immigrant farmer who also raised Lincoln Longwool and Cotswold sheep, imported the first Romneys to Oregon in 1904. A breed association was established in the United States in 1912.

With their swampy heritage, the Romneys developed resistance to foot rot, liver flukes, and other problems that plague sheep in wet areas, yet they also do fine in drier areas of the country. They are docile, though they don't have a strong flocking instinct, so they are not well suited for open-range operations. Romneys do well in farm flocks and can have an excellent carcass with nicely flavored meat from grass if forage quality is good.

The ewes frequently produce twins; triplets aren't rare. On decent feed, the ewe has enough milk for all three. The Romney's fleece is heavy and especially nice. A ewe can yield up to 12 pounds (5.44 kg) of clean wool with a staple as long as 8 inches (20.3 cm). The wool is coarse but highly spinnable.

This naturally colored Romney ewe yields fleece that spinners love to work with. Romneys produce wool that ranges from moderately coarse to fairly fine, with well-defined crimp that hangs in separate locks.

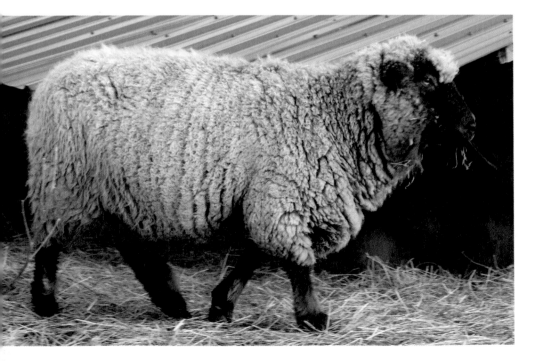

ROMNEY

FUNCTIONAL TYPE Fiber. Meat.

APPEARANCE Tall, well proportioned. Face is clean below the eyes. Ears are horizontal and forward facing. Most are white, though there are colored strains.

SIZE Large.

HORNS Naturally polled.

CONSERVATION STATUS Not applicable.

PLACE OF ORIGIN England.

BEST KNOWN FOR Excellent dual-purpose traits for farm flocks.

Royal White

IN THE EARLY 1990S, Bill Hoag, then a Utah realtor, leased a piece of land near his home to a sheep rancher. As those sheep, mainly Rambouillets, grazed the land, they fascinated Hoag. He started researching sheep production and decided that developing a new breed would fuel his creativity. After doing research and talking to as many old-time shepherds as he could, he decided his new breed would be a hair sheep, because an improved hair sheep seemed like it would offer shepherds many advantages. He acquired a large flock of St. Croix and bred it to the best Dorper rams he could find. More than 10,000 lambs later, the Royal White is an established breed that is gaining attention in the sheep industry.

Hoag designed the breed to be a maternal line, so ewes are tall and have a build that allows them to carry lots of lambs (they often have triplets and quadruplets, and sometimes larger litters) without problems. The ewes will breed throughout the year and make lots of milk, for high lamb survivability. The breed is intelligent and parasite and disease resistant. The meat is lean and flavorful.

ROYAL WHITE

FUNCTIONAL TYPE Hair. Meat.
APPEARANCE Tall. White. Hair sheep.
SIZE Large.
HORNS Naturally polled.
CONSERVATION STATUS Not applicable.
PLACE OF ORIGIN United States.
BEST KNOWN FOR Being a true hair sheep with excellent production characteristics.

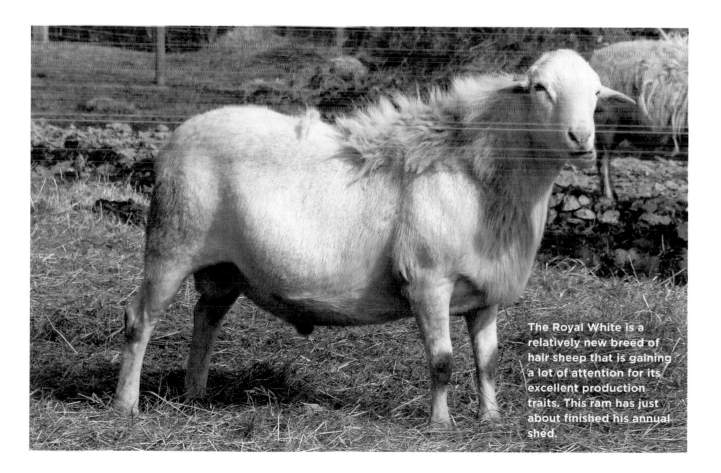

The Royal White is a relatively new breed of hair sheep that is gaining a lot of attention for its excellent production traits. This ram has just about finished his annual shed.

Santa Cruz

LIKE THE SAN CLEMENTE GOATS, the Santa Cruz sheep, a feral population, are named for the California Channel Island on which they lived. Santa Cruz Island is the largest in the Channel Island chain. No one is sure exactly what breeds were first on the island (though Merino or Rambouillet are suspected), nor is anyone sure when the sheep first came to the island, but they have been well documented there for more than 70 years and may actually have been there for a couple of hundred years.

The Nature Conservancy (TNC) and the National Park Service currently own Santa Cruz Island. When TNC acquired the lion's share of the island in 1978, it began a program to eradicate the sheep, but the American Livestock Breeds Conservancy intervened, and with the help of five California shepherds, it managed to bring some of the animals off the island. Dedicated conservation breeders have maintained the breed, but it is still critically endangered.

The Santa Cruz sheep are very hardy, self-sufficient, and able to get along on relatively poor-quality forage. The ewes have no trouble lambing and are good mothers. The breed's fleece is medium-diameter and soft.

SANTA CRUZ

FUNCTIONAL TYPE Feral. Meat. Fiber.

APPEARANCE Small, light-boned. Little or no wool on their bellies, faces, and legs. Many have short, woolless "rat" tails. May be white or naturally colored.

SIZE Small.

HORNS Either horned or polled.

CONSERVATION STATUS Critical.

PLACE OF ORIGIN United States.

BEST KNOWN FOR Historical importance as a feral breed with good survivability under less-than-ideal conditions.

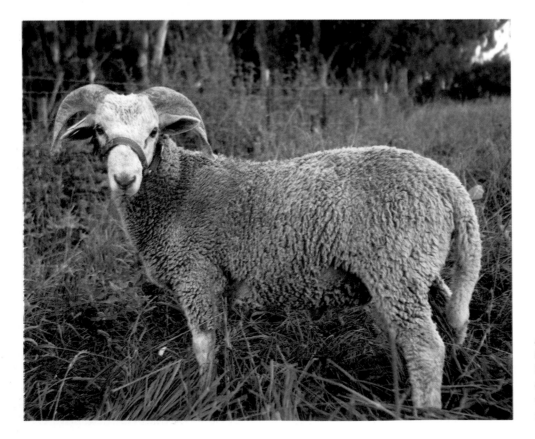

As with other feral breeds, the Santa Cruz is desperately in need of conservation breeders who will help preserve its unique genetics.

Scottish Blackface

THE SCOTTISH BLACKFACE, also known as the Black-Faced Highland, is an old breed first raised in the hills of Scotland. Monastery records from the twelfth century mention sheep very similar to the modern Scottish Blackface. Today the breed has spread throughout Britain and is the most common registered breed in the United Kingdom. It was first imported to the United States in the mid-nineteenth century, yet the breed has not enjoyed the same popularity here as in Britain; just a small number of North American shepherds keep Scottish Blackface flocks.

The Scottish Blackface is very well adapted to cool, damp conditions and produces admirably on sparse forage, but it does exceedingly well on improved pasture. Ewes are easy lambers (singles are prevalent but twins are not uncommon) and very good mothers who actively protect their young from predators. The breed's meat is lean and flavorful. They produce

(continued)

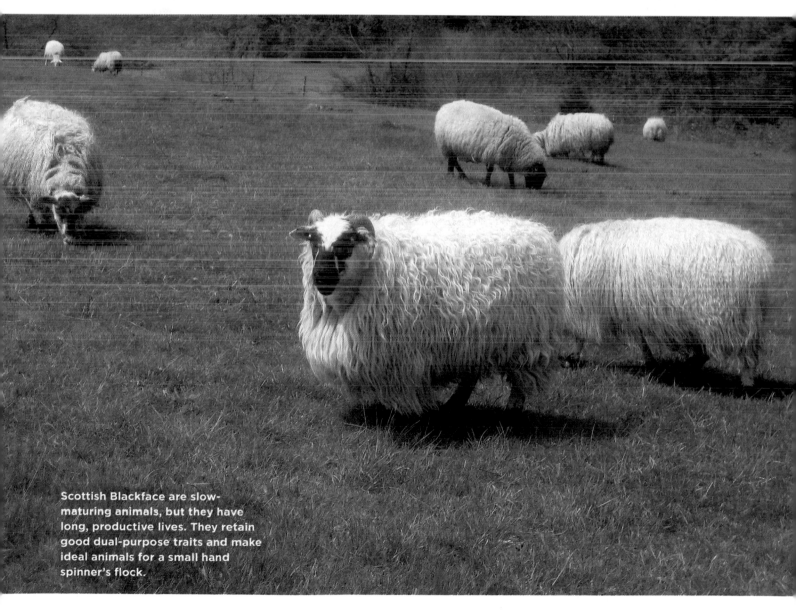

Scottish Blackface are slow-maturing animals, but they have long, productive lives. They retain good dual-purpose traits and make ideal animals for a small hand spinner's flock.

Scottish Blackface (continued)

approximately 6 pounds (2.72 kg) of fleece with a staple as long as 14 inches (35.6 cm). The wool is somewhat coarse, straight, and is generally considered a carpet wool, thanks to its strength and durability. The wool is also used in the renowned Harris tweeds, as well as in Scotland's famous tartans. Hand spinners on this side of the Atlantic appreciate its strength and springiness without excessive crimp.

Both sexes of Scottish Blackface have horns, with the horns of mature rams growing into large, full-curl horns.

SCOTTISH BLACKFACE

FUNCTIONAL TYPE Meat. Fiber.

APPEARANCE Long back and relatively short legs for their length. Wool-free face. Roman nose (prominent in the ram; slight in the ewe). Unique black and white markings. Ears are fairly large but are held horizontally. Legs are also wool-free and may have black spotting.

SIZE Small to medium.

HORNS Rams have large, curling horns; ewes have slightly smaller horns.

CONSERVATION STATUS Not applicable.

PLACE OF ORIGIN Scotland.

BEST KNOWN FOR Strong, long fleece that is used in carpets, Harris tweeds, Scottish tartans, and by hand spinners.

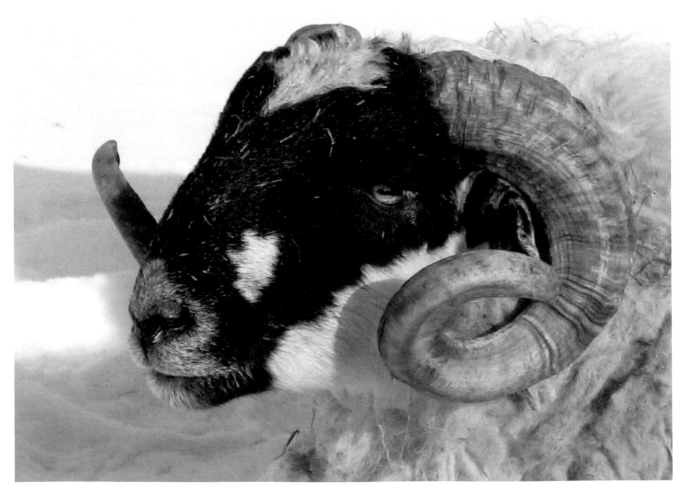

Shetland

SHETLANDS COME FROM the northernmost British islands of the same name, which are located on a latitude about equal to Fairbanks, Alaska. The breed has evolved in this harsh island climate for more than one thousand years, probably from animals brought there by the Vikings. They were imported to Canada in the 1980s, and then to the United States from Canada.

Like other island sheep, the Shetlands are quite hardy and are able to do well on poor-quality forage. They are small and primitive, with a fleece that is loved by hand spinners and fiber artists. At one time the breed was considered highly endangered by Britain's Rare Breeds Survival Trust, but today, thanks to its popularity among hand spinners, it is recovering.

Shetlands are quite docile and easy for even neophyte shepherds to handle. The ewes are attentive mothers, and twins are fairly common. Although lambs are small, the meat is lean and quite flavorful. Their fleece is fine, though there is sometimes great variability through individual fleeces and among animals, so you can find coarser fibers too. Some Shetlands have a double coat (coarse outer layer and fine inner layer) and others have a single coat of fine fiber. They come in a really wide range of colors, with distinctinve Viking names, including light to dark gray; white; "emsket," which is a dusky bluish gray; "musket," a grayish brown; black; fawn; "mioget," a yellowish brown; "moorit," a dark reddish brown; and dark brown.

(continued)

SHETLAND

FUNCTIONAL TYPE Fiber. Meat.

APPEARANCE Primitive looking with a short tail. Wool-free face and lower legs. Upright ears. Variety of colors and marking patterns.

SIZE Small.

HORNS Rams usually have impressive, curling horns; ewes are usually polled.

CONSERVATION STATUS Recovering.

PLACE OF ORIGIN Shetland Islands.

BEST KNOWN FOR Fleece that is a favorite among hand spinners. Ease of production for beginners.

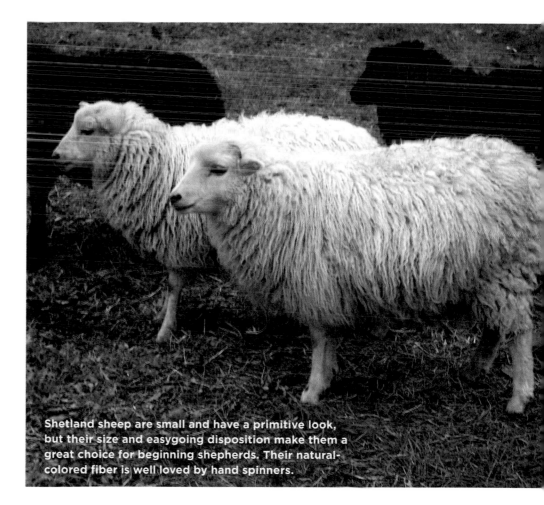

Shetland sheep are small and have a primitive look, but their size and easygoing disposition make them a great choice for beginning shepherds. Their natural-colored fiber is well loved by hand spinners.

Shetland (continued)

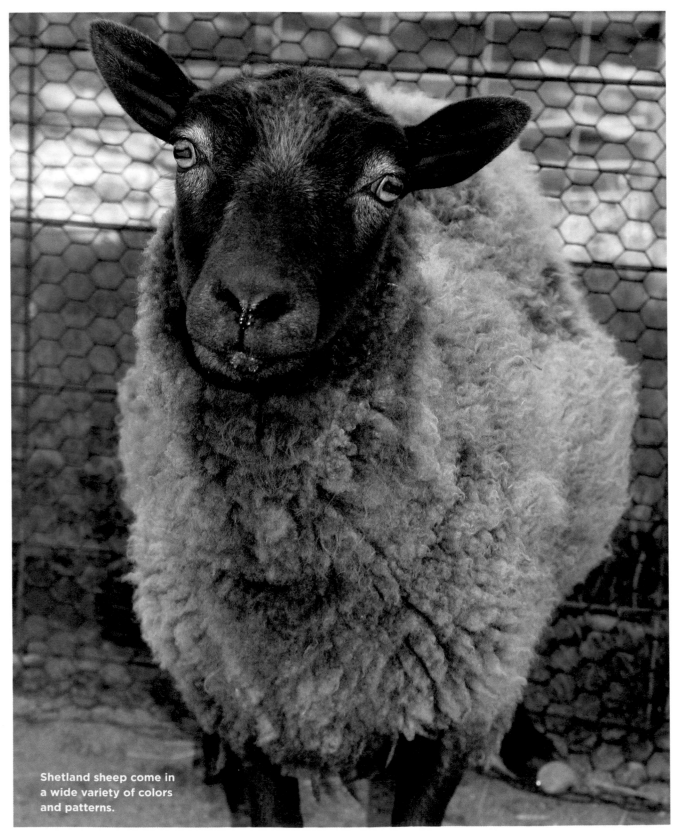

Shetland sheep come in
a wide variety of colors
and patterns.

Shropshire

SHROPSHIRE COUNTY in southwestern England, along the border with Wales, is known for its hills, or Downs, which is why this breed is sometimes also called Shropshire Down. In the nineteenth century, shepherds in the county began improving the native sheep both through selection and through introduction of new bloodlines from Southdown, Leicester, and Cotswold sheep. By 1853, the Shropshire was recognizable as a breed and began finding favor with shepherds throughout England.

The breed was first imported to North America in 1855, when it arrived in Virginia. By the 1880s, thousands of Shrophires had been imported, and the breed was widely distributed. By the 1930s, the Shropshire was the most common breed in North America. Though not as common today as it once was, it is still quite popular.

Ewes commonly have twins and triplets, so lambing rates regularly run from 180 percent to 200 per-cent, and on good feed they easily have enough milk to raise them. They are also long-lived, often producing lambs into their teens. The lambs grow quickly and produce a lean but well-muscled carcass. Rams are often used as terminal sires in crossbreeding. Their medium-weight fleece is dense and uniform, and they yield about 6 pounds (2.7 kg) of clean wool. The breed is very cold hardy.

SHROPSHIRE

FUNCTIONAL TYPE Meat. Fiber. Dairy.

APPEARANCE Black face and legs. White fleece on the body. Tall with a straight back.

SIZE Large.

HORNS Naturally polled.

CONSERVATION STATUS Recovering.

PLACE OF ORIGIN England.

BEST KNOWN FOR Good dual-purpose production for farm flocks.

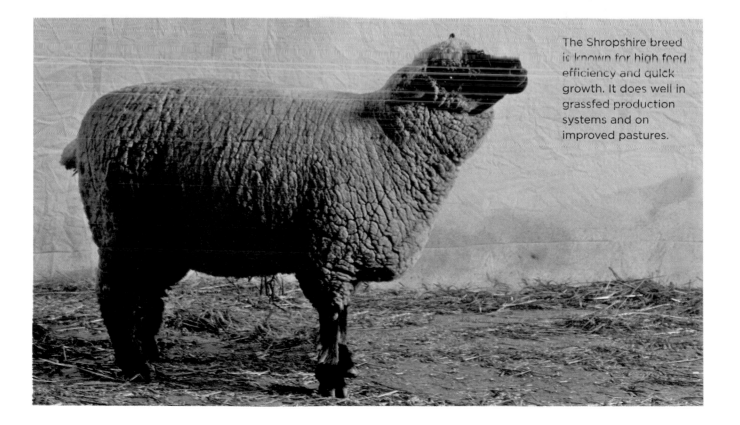

The Shropshire breed is known for high feed efficiency and quick growth. It does well in grassfed production systems and on improved pastures.

Soay

THE SOAY is a very ancient breed, and livestock historians believe it is representative of the earliest domestic sheep brought to Britain about two thousand years before the birth of Christ. The modern Soay is still rare in Britain. Soays are found on a couple of islands (one named Soay Island, for which the breed is named) off the coast of Scotland, where they have lived in a feral state for decades. There are also a number of flocks kept on the mainland of Britain.

In 1974, four Soay sheep were imported to the Winnipeg Zoo, and in 1990 six more sheep were imported.

Today several conservation breeders maintain Soay sheep in Canada and the United States, and there is also an upgraded population in North America known as the American Soay, whose foundation breed is the Soay but which has been crossed with other breeds.

Soays are hardy and intelligent, though a bit wary. Like antelope, they will jump straight up off all four feet when excited. The ewes are excellent mothers and rarely require any assistance during lambing. They shed, but hand spinners will collect the wool for spinning.

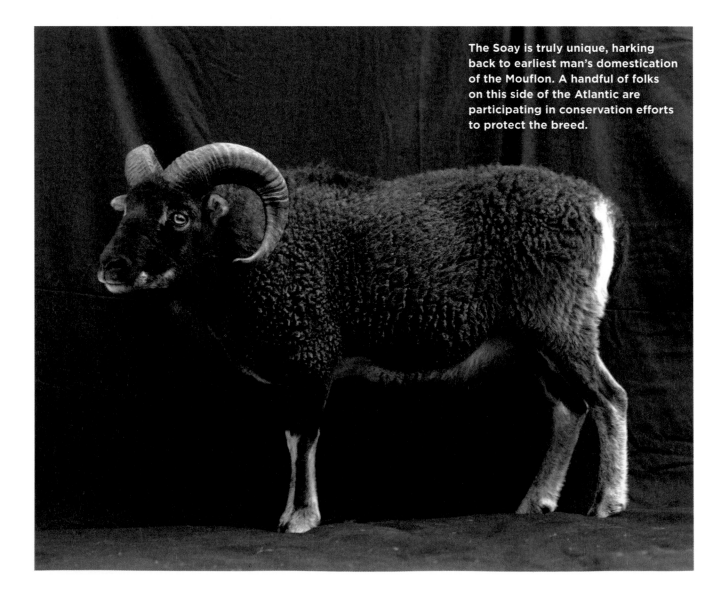

The Soay is truly unique, harking back to earliest man's domestication of the Mouflon. A handful of folks on this side of the Atlantic are participating in conservation efforts to protect the breed.

SOAY

FUNCTIONAL TYPE Feral.

APPEARANCE Antelope-like frame, unlike other domestic sheep. Face is marked with various colors and patterns. Fairly large ears for their size, which come out of their head at about a 45-degree angle. Rams may have a mane. Colored fleece with a double coat that sheds out in summer.

SIZE Small.

HORNS Rams have full-curling horns; ewes have small upright horns.

CONSERVATION STATUS Vulnerable (according to Britain's Rare Breeds Survival Trust).

PLACE OF ORIGIN Britain.

BEST KNOWN FOR Historical importance as oldest domesticated sheep.

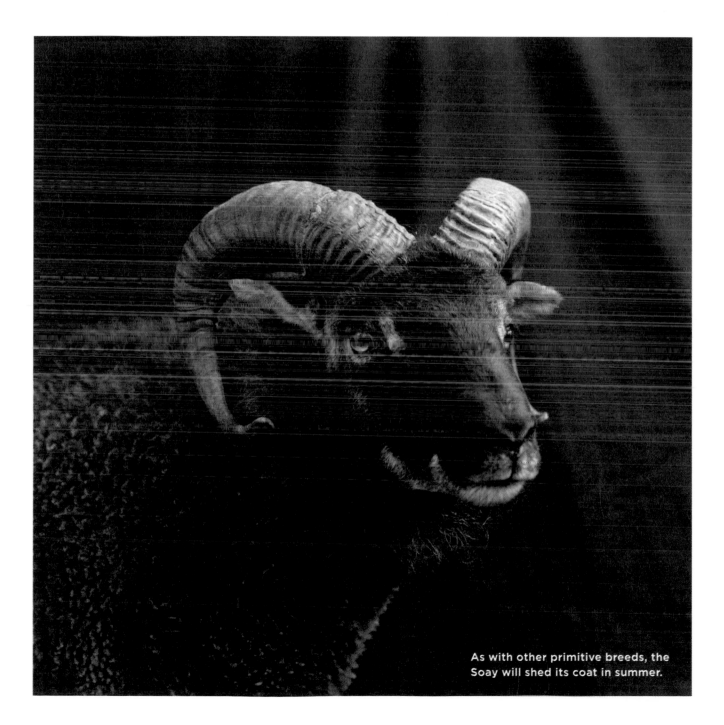

As with other primitive breeds, the Soay will shed its coat in summer.

Southdown

SUSSEX COUNTY, on the southeastern coast of England, is the original home of the Southdown breed. The Southdown was a native sheep to the Downs of Sussex, an area about 60 miles long by 6 miles wide.

As with other old English sheep breeds, the Southdown went through a period of improvement in the late 1700s and early 1800s. John Ellman, a master breeder in the Downs, is credited with modernizing and improving the sheep through selection as a meat breed. Although some early importations of old Southdown came across the Atlantic, the breed in North America today comes from imports of modern Southdown sheep, beginning in 1803. During the 1960s and the 1970s, Southdown breeders imported additional bloodlines from New Zealand.

The traditional Southdown was a small- to medium-size breed, but American breeders have selected for increased stature, so the North American Southdown is considerably larger than the traditional British Southdown. Today there are a few types of Southdowns, each with its own breed association. One association represents breeders of the medium-size Standard Southdown; one for the much smaller Baby Doll Southdown; and still a third for the Miniature and Toy Southdown, a recent type that was developed by breeders who selected for small size to get a sheep that was less than 24 inches tall at the withers.

All types are docile and easy to handle, with rather affectionate dispositions. The Baby Doll and Miniature/Toy Southdowns are largely raised as pets and for fleece, but the Standard Southdown of today is first and foremost a meat breed, producing a lean yet tender carcass with good taste, and doing so with high feed efficiency. Thanks to its easy-going disposition and its strong performance in the show ring, the Standard type is very popular as a club lamb. Twins are quite common, triplets are not out of the ordinary. Southdown ewes can breed throughout the year. The fiber length is short (less than 3 inches [7.6 cm]), but the fleece is soft and fine- to medium-diameter.

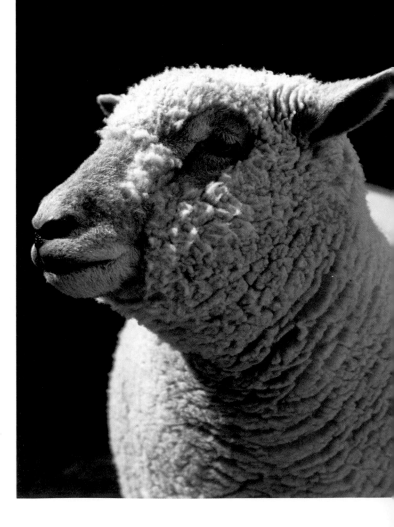

The breed has been used in the development of a number of other breeds, such as the Hampshire, the Shropshire, and the Suffolk.

SOUTHDOWN

FUNCTIONAL TYPE Meat. Fiber. Pet.

APPEARANCE White fleece is most common, but colored strains exist. Additional characteristics distinguish the three types.

Standard Tall relative to their weight with a long, straight back. Head is upright. Light wool, which has a brownish tint, on the face. Ears slightly above the horizontal. Dark nostrils.

Baby Doll, Miniature/Toy Small, boxy animal, but proportioned to its size.

SIZE Standard is medium; Baby Doll is small; Miniature/Toy is very small.

HORNS Naturally polled.

CONSERVATION STATUS Recovering (applies to standard-sized animals).

PLACE OF ORIGIN England.

BEST KNOWN FOR Standard Southdown is an efficient meat breed. Baby Doll and Miniature/Toy Southdowns are mainly pet sheep.

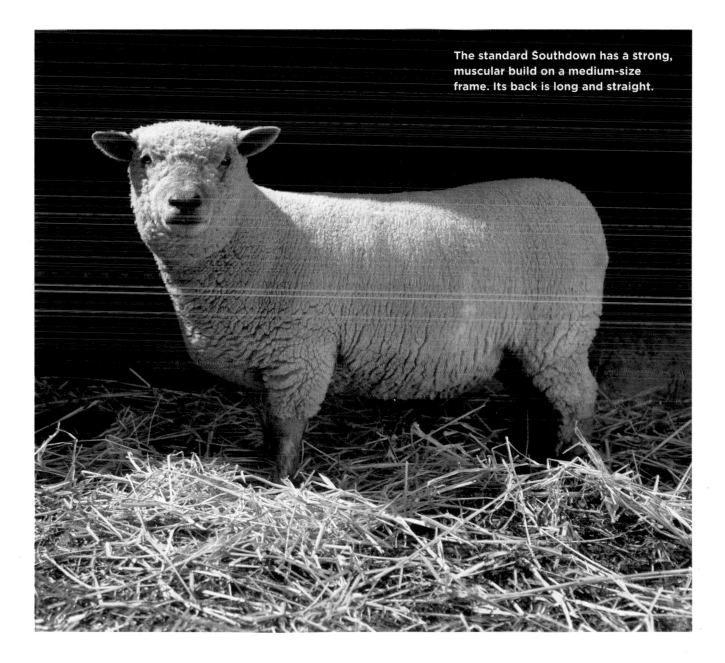

The standard Southdown has a strong, muscular build on a medium-size frame. Its back is long and straight.

St. Croix

LIKE THE BARBADOS BLACKBELLY, the St. Croix is a Caribbean island hair-sheep breed with West African roots that date to the time of the slave trade. There is some evidence that Wiltshire Horn and criollo sheep were crossed with West African sheep, and then the sheep continued to adapt naturally on the island of St. Croix over the next several centuries. The breed is also known as the Virgin Island White for its dominant color, though some animals are colored. Michael Piel, developer of the Katahdin, was the first to import one ram and two ewes in the 1960s, but the breed was established in the United States from an importation of 22 ewes and 3 rams by Dr. Warren Foote, a Utah State sheep researcher, in 1975.

The St. Croix can adapt to a fairly wide range of conditions. In hot regions it maintains the hair coat year-round, and in cold regions it puts on a heavy undercoat of fine wool that sheds out naturally in summer. The breed is active and has good flocking instincts yet is easy to handle. It has high resistance to internal parasites. The sheep mature early, breed any time of the year, and ewes regularly produce twins and triplets, with plenty of milk to feed them. The meat is lean with a mild flavor.

ST. CROIX

FUNCTIONAL TYPE Hair. Meat. Dairy.

APPEARANCE Fine-boned. Mature rams have a long beard and throat ruff that can reach their knees. Ears are held on the horizontal. Most are white, but some are colored.

SIZE Medium.

HORNS Naturally polled.

CONSERVATION STATUS Threatened.

PLACE OF ORIGIN St. Croix, Virgin Islands.

BEST KNOWN FOR Adaptability for meat and dairy production with good parasite resistance.

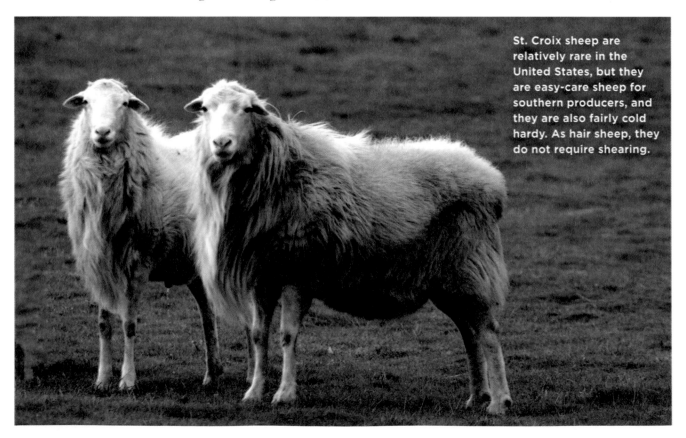

St. Croix sheep are relatively rare in the United States, but they are easy-care sheep for southern producers, and they are also fairly cold hardy. As hair sheep, they do not require shearing.

Suffolk

THE SUFFOLK was developed in England in the eighteenth century by crossing Southdown rams with old Norfolk Horned ewes. The breed was recognized in 1810. The first documented importation was to New York in 1888 by G. B. Streeter, who acquired some prize-winning animals to begin a flock. The first year he had a 200 percent lamb crop, spurring lots of interest in the breed. It remained primarily an eastern farm flock breed until 1919, when the English Suffolk Sheep Society donated three ewes and two rams to the University of Idaho. The breed quickly captured the attention of western range operators, just as it had earlier done with eastern farmers, and its numbers rapidly grew throughout the West. In fact, today the Suffolk is the most common purebred sheep breed in North America.

Why were shepherds so taken with the Suffolk? Because they are superior converters of feed into meat.

They are the largest meat breed, with mature rams topping out at about 350 pounds [159 kg]). Carcasses have high cutability; they have a good meat-to-bone ratio and produce abundant lean muscle. And they produce a respectable medium-grade fleece under a variety of conditions.

The ewes typically produce twins and triplets, and occasionally more. Rams are used as terminal sires, and lambs are popular for club lambs. Suffolk sheep (and to a much lesser extent, Hampshire sheep) sometimes suffer from a genetic disorder known as Spider Lamb Syndrome. Afflicted lambs may be indistinguishable or only slightly different from their flock mates at birth, but as they grow a number of symptoms become obvious, including angular limb deformities and degenerative changes in the joints. Scientists have developed a test for the syndrome, and producers are using it to eliminate the syndrome from their flocks.

(continued)

SUFFOLK

FUNCTIONAL TYPE Meat. Fiber.

APPEARANCE Black head. Roman nose. Large, slightly droopy ears. A white-headed variety in Australia and New Zealand hasn't been imported here yet.

SIZE Large.

HORNS Naturally polled.

CONSERVATION STATUS Not applicable.

PLACE OF ORIGIN England.

BEST KNOWN FOR Status as the most common purebred sheep in North America for commercial production of meat and fiber and a common club lamb for 4-H and Future Farmers of America.

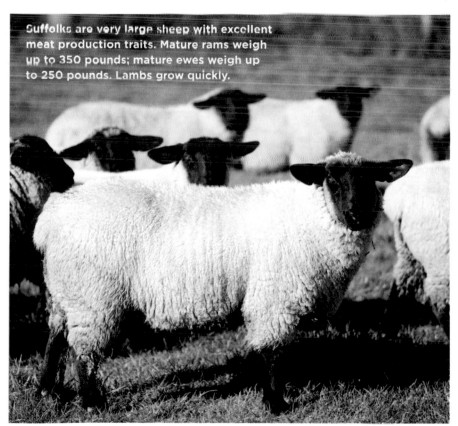

Suffolks are very large sheep with excellent meat production traits. Mature rams weigh up to 350 pounds; mature ewes weigh up to 250 pounds. Lambs grow quickly.

Suffolk (continued)

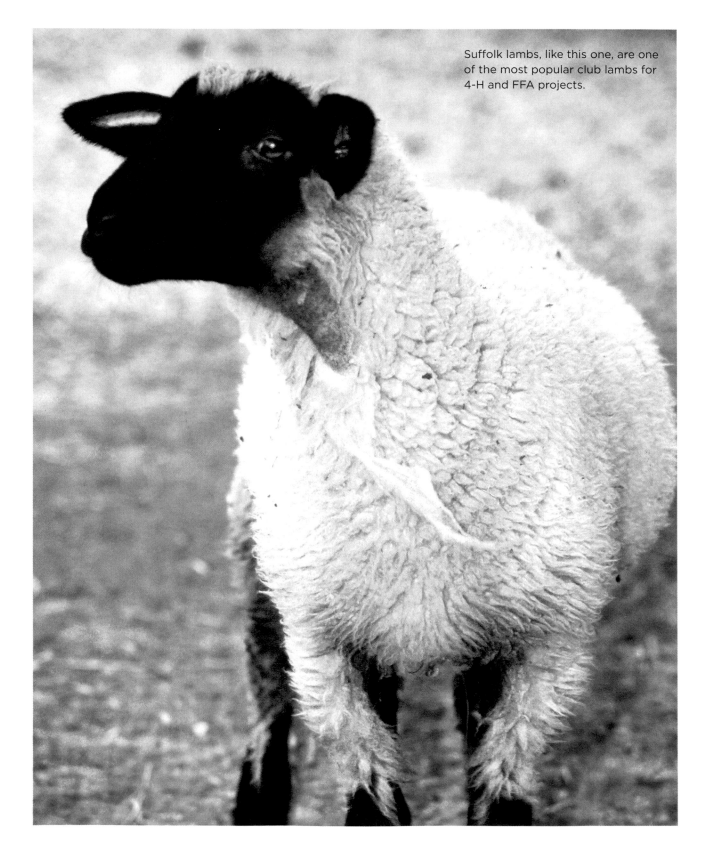

Suffolk lambs, like this one, are one of the most popular club lambs for 4-H and FFA projects.

Targhee

IN 1926, researchers at the Sheep Experiment Station in Dubois, Idaho, began breeding Rambouillet rams to Corriedale and Lincoln/Rambouillet ewes, and then bred the crosses together. Their goal was to produce an all-around, dual-purpose sheep that would do very well on range and farm operations in the West and High Plains states. They named their new breed Targhee after the Targhee National Forest, where the station's sheep flock would graze in the summer.

The Targhee is a large-framed animal with excellent production traits for meat and fleece. It produces up to 14 pounds (6.35 kg) of fine- to medium-diameter wool that can have a 5-inch (12.7 cm) staple. Their clean-wool yield runs around 7 to 8 pounds (3.2 to 3.6 kg). The breed is cold hardy, has a strong flocking instinct, and has high feed efficiency on less-than-ideal forage. Ewes typically have single lambs or twins, though sometimes a ewe will have triplets. Under range conditions they have been shown to wean more lambs than those of other range breeds. Rams are sometimes used as terminal sires in the northern Plains, with lower weaning weights than Suffolk- and Columbia-sired lambs but much higher fleece weight and quality.

TARGHEE

FUNCTIONAL TYPE Meat. Fiber.
APPEARANCE Large. White. Squarely built. Wool-free face. Ears slightly below the horizontal.
SIZE Large.
HORNS Naturally polled.
CONSERVATION STATUS Not applicable.
PLACE OF ORIGIN United States.
BEST KNOWN FOR Excellent production of both meat and wool on the range and in northern farm flocks.

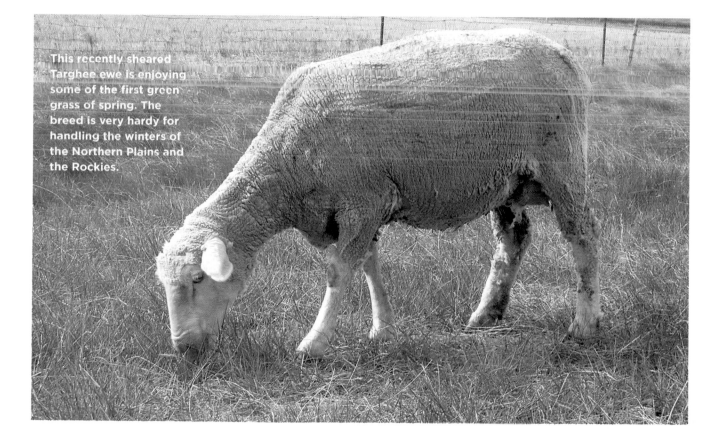

This recently sheared Targhee ewe is enjoying some of the first green grass of spring. The breed is very hardy for handling the winters of the Northern Plains and the Rockies.

Teeswater

THE TEESWATER is an old breed that comes from northeastern England, around the Teesdale area in County Durham. It is a long-wool breed that may have been derived from the Lincoln Longwool, or from the sheep brought to Britain by the Romans. It was rare outside the Teesdale area until the 1920s, when rams started being used in more areas of Britain, and by 1949 it was popular enough throughout Britain that breeders formed the first breed association.

Unfortunately, the breed's numbers began declining again shortly after the breed association formed, and today it is endangered in Britain. There are no purebred Teeswater in North America, though a handful of breeders have recently begun importing semen and some breeders are using an upgrading program to develop an American strain of Teeswater.

The breed is well built and hardy. Ewes are prolific, with a lambing rate in the 180 percent to 220 percent range. Lambing problems are rare, and the lambs grow quickly, producing a good carcass. The fleece is long and lustrous, with no dark fibers and no kemp.

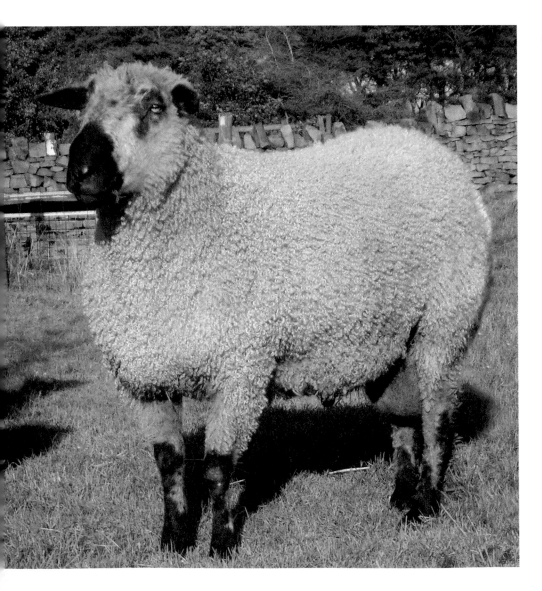

TEESWATER

FUNCTIONAL TYPE Fiber. Meat.

APPEARANCE Shaggy white to off-white fleece with lots of crimp. Head color varies from off-white to gray-blue with dark brown or black markings around the nose, ears, and eyes. Wool-free face below the eyes, but a forelock of wool falls over the face. Ears are horizontal to slightly upright. Legs are wool-free below the knees.

SIZE Medium to large.

HORNS Naturally polled.

CONSERVATION STATUS Not applicable in North America. Endangered in Britain according to the Rare Breeds Survival Trust.

PLACE OF ORIGIN Britain.

BEST KNOWN For high-quality, long, lustrous fleece. Prolificacy among ewes.

A small number of Teeswater sheep are being developed in North America through up breeding, mainly by a handful of dedicated fiber enthusiasts who are looking to acquire the lustrous long-wool fleece the breed is known for.

Texel

THE TEXEL SHEEP is named for the Isle of Texel, an island off the coast of the Netherlands. The native sheep of the island were crossed with Lincoln and Leicester Longwools in the mid-1800s to develop a lean-meat breed with high cutability. First imported to the United States in 1985 by the USDA's Meat Animal Research Center (MARC), some Texels were released to breeders after a five-year quarantine period. Private breeders have since arranged for additional importations of live animals, embryos, and semen.

Texels are docile and quiet sheep, but they are quite hardy and adaptable to a wide range of conditions. They produce an extremely meaty carcass. Testing at the MARC showed that Texel-sired lambs have less fat and a larger loin eye than other breeds. In fact, breeders use scanning of the loin eye as a selection tool. Ewes are prolific mothers, with a normal lambing rate of 175 percent, and they have a long breeding season. Texel rams are used as terminal sires.

TEXEL

FUNCTIONAL TYPE Meat. Fiber.

APPEARANCE White. Well muscled. Clean, short face. Black nose. Slightly upright ears. Rams may have a slightly Roman nose. Wool-free legs.

SIZE Medium to large.

HORNS Naturally polled (rams may have scurs or a small growth of horn tissue attached to the skin where the horn would be in horned animals).

CONSERVATION STATUS Not applicable.

PLACE OF ORIGIN The Netherlands.

BEST KNOWN FOR Excellent production of meat under a wide variety of conditions.

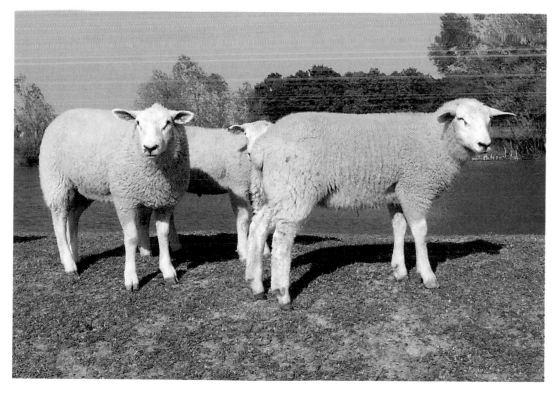

The Texel is a relatively new addition in North America, and the only Dutch breed of sheep on this side of the Atlantic. It is an excellent meat animal.

Tunis

THE TUNIS is a unique, reddish tan sheep that was developed in the United States from Tunisian Barbary sheep (an ancient breed that dates back to biblical times). These Tunisian Barbary sheep were given as a gift to the U.S. government from His Highness the Bey of Tunis in 1799. George Washington is said to have used a Tunis ram to rebuild his Mount Vernon flock after retiring from the presidency.

The Tunis is particularly well adapted to hot and humid climates, so early on it spread throughout the Southeast and mid-Atlantic states and was popular with other presidents, including John Adams and Thomas Jefferson. Unfortunately, large numbers of Tunis flocks were destroyed during the Civil War, and the breed never really came back to its prewar numbers.

The original Tunisian Barbary was a fat-tailed sheep, and the breed retains some of this fat-tail tendency, so it has very tender, tasty meat. The American Livestock Breeds Conservancy successfully nominated the breed to the Slow Food Ark of Taste (see page 38).

The breed is docile, hardy, and though it is usually associated with hot climates, it adapts well to colder areas. The ewes are good mothers and can breed year-round. Single lambs and twins are most common, but some ewes have triplets. Tunis fleece is medium diameter, with a roughly 4-inch (10.2 cm) staple. Each sheep yields up to 7.5 pounds (3.4 kg) of clean wool.

TUNIS

FUNCTIONAL TYPE Meat. Fiber.
APPEARANCE Pendulous ears. Face is red, with lighter coloring around the nose. Fleece is white to creamy tan (lambs are born all red).
SIZE Medium to large.
HORNS Naturally polled.
CONSERVATION STATUS Watch.
PLACE OF ORIGIN United States.
BEST KNOWN FOR Unique color. Heat tolerance. Cold hardiness. Excellent-flavored meat.

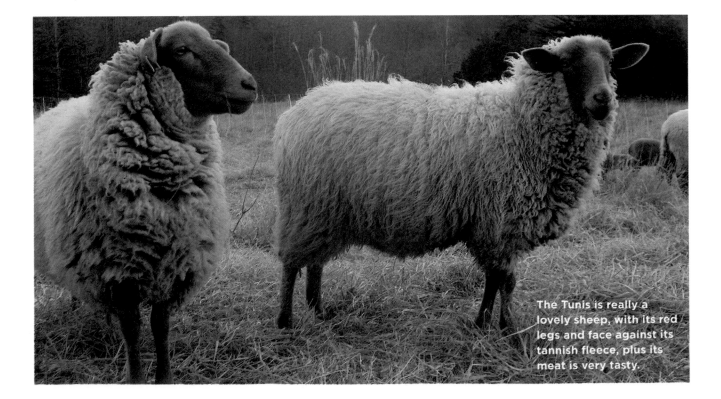

The Tunis is really a lovely sheep, with its red legs and face against its tannish fleece, plus its meat is very tasty.

Wensleydale

WENSLEYDALE SHEEP were developed in the early years of the nineteenth century by crossing a now-extinct long-wool breed from Yorkshire, England, with a Dishley Leicester ram by the name of Bluecap, so named for his unusual blue-tinged face. All Wensleydale sheep trace their lineage to this one ram. The breed has remained somewhat rare in England and live animals were never imported to North America, but in 1999 breeders in the United States began importing semen and up breeding Lincolns, Cotswolds, and Leicester Longwools to develop a separate, upgraded Wensleydale population on this side of the Atlantic.

Whereas other long-wool breeds have fairly coarse fiber, the Wensleydale boasts a medium-diameter fiber that is very lustrous and up to 12 inches (30.5 cm) long. It also has the heaviest fleece of any North American breed, weighing up to 20 pounds (9.1 kg). Ewes typically produce twins, and triplets are not uncommon among mature ewes. Lambing problems are rare, and the ewes produce enough milk to feed triplets if the forage is of reasonable quality. Rams are often used in England as terminal sires to increase fleece production and size, so as the North American population increases we may see breeders here move that way also.

(continued)

WENSLEYDALE

FUNCTIONAL TYPE Fiber. Meat.

APPEARANCE Long, fine, curly locks, including a long set of bangs over their blue-tinged, wool-free face. Ears are fairly large, forward facing, and a bit above the horizontal. Fleece comes in white and black, though black may bleach out from the sun to gray or brown.

SIZE Large.

HORNS Naturally polled.

CONSERVATION STATUS Not applicable.

PLACE OF ORIGIN England.

BEST KNOWN FOR The finest wool of any long-wool breed.

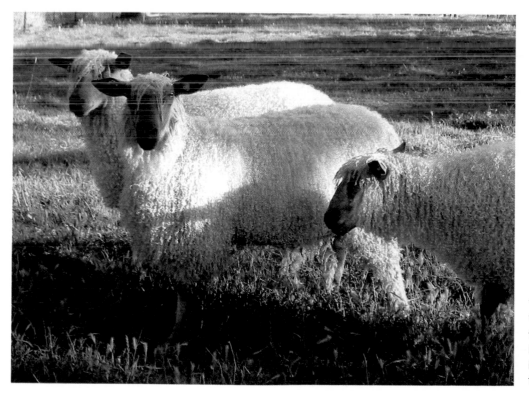

The upgraded Wensleydales have finer fiber than other longwool breeds, which is what has attracted fiber enthusiasts.

Wensleydale (continued)

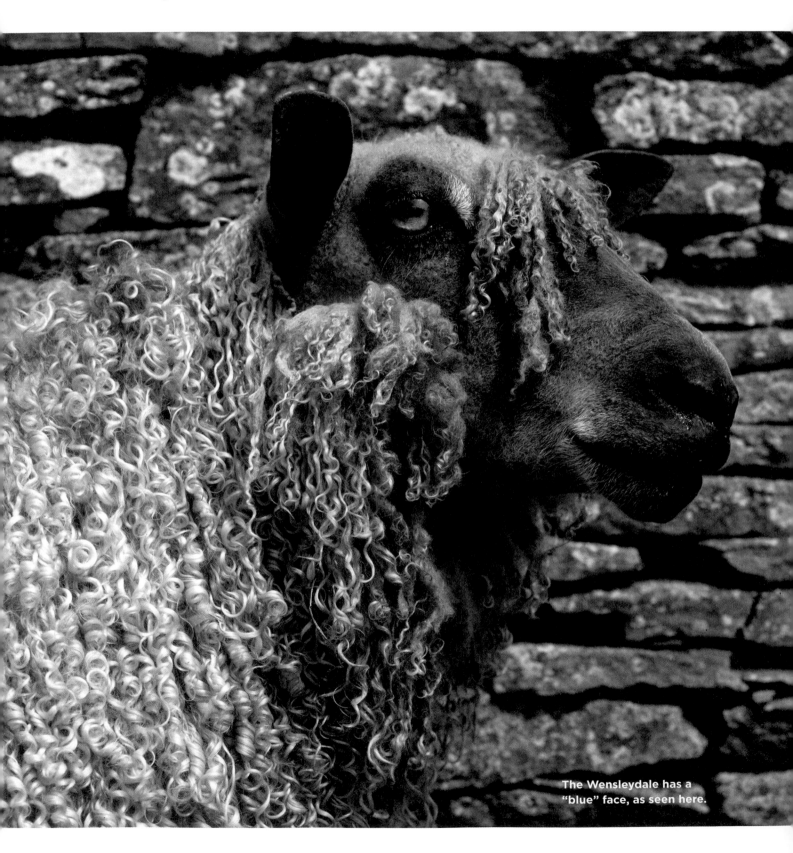

The Wensleydale has a "blue" face, as seen here.

Wiltshire Horn

THE WILTSHIRE HORN is an ancient, and ancient-looking, breed, thanks in part to its horns, which are large and curling on the rams, and short and back curling on the ewes. There is archaeological evidence of Wiltshire Horn–type sheep in the southern "chalk downs" of Wiltshire County, dating to the Roman occupation. At the end of the eighteenth century about 500,000 Wiltshire Horns were recorded on summer pasture in the area, but by the end of the nineteenth century, the number had plummeted as Southdowns and Merinos replaced the Wiltshire Horns.

A handful of producers, however, did maintain original strains of Wiltshire Horn sheep. Michael Piel imported some of these via Canada in the 1970s for use in developing the Katahdin. After Piel no longer needed the animals, he donated them to the Plimoth Plantation, and as Plimoth's flock of Wiltshire Horns grew, it gave some of its sheep to additional conservation breeders. Semen has since been imported from Australia and the United Kingdom to increase the genetic diversity. A polled variety of the Wiltshire Horn has been developed in Australia that is known as the Wiltipol breed, though it has yet to make its way to North America.

In part, what makes the Wiltshire unusual is that it is a hair-breed with no connection to the hair breeds of Africa, the place that, logically due to the heat, was the center of hair breed development. Wiltshire Horns are generally docile and easy to keep. Ewes twin frequently and are excellent mothers who rarely need assistance. The lambs grow a little bit slower than those of some other breeds but put on an excellent carcass.

WILTSHIRE HORN

FUNCTIONAL TYPE Hair. Meat.

APPEARANCE White. Athletic looking. Off-white Roman nose. Horizontal ears.

SIZE Medium.

HORNS Rams have large horns with a full curl; ewes have short, back-curling horns.

CONSERVATION STATUS Recovering.

PLACE OF ORIGIN England.

BEST KNOWN FOR Docility. Easy keeping. Being hair sheep with an interesting heritage.

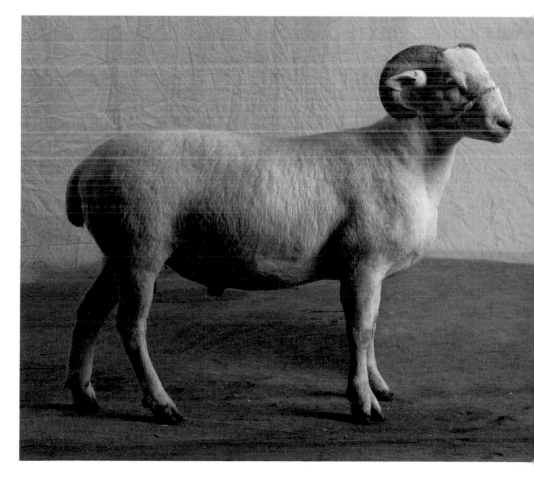

Wiltshire Horn lambs are born with a coat that sheds out soon after birth if the weather is warm. They grow a bit slowly but reach sexual maturity early.

GLOSSARY

Adaptability. The ability of an animal to adapt to changes in the environment in which it lives.

Barrow (Swine). A castrated male; a castrated boar pig.

Birth Weight. The weight of an animal at birth. Heavy birth weights are associated with calving problems in beef cattle, lambing problems in sheep, and farrowing problems in swine. But heavier weights are also usually associated with greater survival rates.

Boar (Swine). An intact male; a male that is not castrated; a male capable of breeding females.

Breed. A group of animals of common descent and possessing distinctive characteristics (physical or production traits) that distinguish them from other groups within the same species.

Breed Character. Particular characteristics of separate breeds (such as color, horns, ear set, and wool type) that distinguish animals among the various breeds.

Breed Class. Any set of categories that classifies breeds according to appearance or function.

Breeding Animal. An animal kept for the purpose of breeding, as opposed to a market animal.

Brindle. A color (often fawn or brownish) created by an intermixing black hairs with a brown or reddish base coat color. In some animals it may create a stripped effect, while in others it gives a spotty effect to the coat.

Bull (Beef Cattle). An intact male; a male that is not castrated; a male capable of breeding females.

Calf (Beef Cattle). A bovine that is younger than 1 year of age.

Calving Ease. The ability of a heifer, or cow, to deliver a calf without difficulty.

Carcass. The dressed body of an animal after slaughter (muscle, bone, and fat after removal of the head, hide, and internal organs).

Carcass Quality. The observed properties of a carcass that may directly or indirectly influence the palatability characteristics of the edible lean meat.

Conformation. The overall composition or appearance of an animal or a carcass.

Composite Breed. A breed that has been formed by crossing two or more breeds.

Cow. A female that has had a calf.

Crossbreeding. Mating animals from different breeds. Utilized to take advantage of hybrid vigor (heterosis) and complementary traits.

Cutability. The percentage of boneless, closely trimmed retail cuts of a carcass.

Dam. The female parent of an animal.

Double-muscling. Also known as muscular hypertrophy, this is an autosomal recessive genetic trait associated with the myostatin gene that results in the enlargement of muscle cells. The trait is characterized by a 20 percent increase in muscle mass, and can be seen in various species. Certain breeds, such as the Belgian Blue and Piedmontese cattle or the Texel sheep, have been selected for the trait. The trait does yield larger animals that produce more meat, but double-muscled animals tend to have some more birthing problems than their lesser-muscled counterparts.

Dressing Percent. The proportion of carcass weight to live weight of an animal; carcass weight divided by live weight.

Early Maturing. An animal or breed that typically reaches puberty and the ability to reproduce at an earlier age than other animals of that breed or species.

Ewe (Sheep). A female sheep of any age.

Expected Progeny Difference. An Expected Progeny Difference (EPD) takes into account the relationships in a pedigree and predicts how progeny or offspring of a particular animal should perform relative to animals from an average parent.

Fat Thickness (Sheep, Beef Cattle). The typical linear measurement of fat taken over the rib eye.

Feed Efficiency. The calculated measurement of conversion of feed to body weight gain; pounds of feed divided by pounds of body weight gain.

Feral. Wild, but of domestic origin.

Fertility. The associated characteristics of reproduction.

Fleece (Sheep). The coat of wool covering a sheep.

Fleece Clean Weight (Sheep). The weight, in pounds, of a fleece that has been washed appropriately.

Fleece Grade (Sheep). The classification system used to describe grease wool. Three systems are used: the blood, or American, system; the numerical, or English, system; and the metric system.

Fleece Grease Weight (Sheep). The weight, in pounds, of a freshly shorn fleece that has not been washed or scoured.

Fleece Staple Length (Sheep). The length, in inches, of a lock of shorn wool.

Fleece Type (Sheep). A classification system to group sheep according to wool quality. Fleece type or wool type is considered as either fine, medium, long, or crossbred and describes the type of wool fiber characteristic of the breed.

Flock EPD (Sheep). These EPDs are similar to those used by the beef cattle industry to predict progeny performance of the animal. The EPDs can be listed as such, or they may take the form of Flock Expected Progeny Differences (FEPD) for sheep; presently, they can be used only within a flock.

Fullblood. A purebred that possesses only the genes of a recognized breed.

Gilt (Swine). A female that has not had a litter of pigs.

Gregariousness (Sheep). The characteristic of a group of sheep to remain in close proximity to one another; flocking instinct.

Growth Rate. Typically, the pounds of body weight gained during a specified period of time (average daily gain).

Hardiness. The ability of an animal to withstand the environment.

Heifer. A female that has not had a calf.

Hybrid vigor. Increased growth rate and improved health traits seen offspring resulting from first-cross matings. It is believed that desirable traits in parents are dominant over undesirable traits.

Lamb (Sheep). Any sheep younger than 1 year of age.

Late Maturing. An animal or breed that typically reaches puberty late; the ability to reproduce at a later age than other animals of that breed or species.

Line Breeding. The purposeful breeding of closely related individuals.

Longevity. Life span of an animal; usually refers to the number of years an animal remains productive.

Marbling. Flecks of intramuscular fat distributed in muscle tissue. Marbling is usually evaluated in the rib eye between the twelfth and thirteenth ribs.

Market Animal. Any young animal intended for slaughter.

Maternal. The dam or the dam's side of the pedigree.

Paternal. The sire or the sire's side of the pedigree.

Pedigree. A diagram of the sire, the dam, and the grandparents of an animal (similar to a family tree).

Performance Data and Records. Objective numerical indexes of economically important traits associated with livestock production.

Polled. Natural trait of not having horns nor the genetic ability to develop horns.

Progeny. All offspring from a particular parent animal.

Prolificacy. The ability to reproduce in quantity.

Puberty. The age at which an animal is capable of reproducing.

Purebred. An animal that is eligible for registry with a recognized breed association.

Ram (Sheep). An intact male; a male that is not castrated; a male capable of breeding females.

Rib-eye Area. The surface area of the Longissimus dorsi muscle between the twelfth and thirteenth ribs of a beef or lamb carcass.

Sire. The male parent of an animal.

Sow (Swine). A female that has had a litter of pigs.

Steer. A castrated male; a castrated bull.

Terminal Sire. A breeding male that is used for generating market animals; it typically has a high growth rate and desirable carcass characteristics.

Weaning. The time when young animals are removed from their mothers and are forced to give up their dam's milk as a source of nutrients.

Weaning Weight. The weight of an animal at weaning or at a standard weaning age. Adjusted weaning weight is calculated for one of the standard weaning ages listed, and the standard age is listed also. The weight of a calf taken from 160 to 250 days of age and then adjusted to a constant age of 205 days. Standard weaning ages for lambs are 45, 60, 90, and 120 days. The standard weaning age for swine is 21 days.

Wether (Sheep). A castrated male sheep; a castrated ram.

Yield. The percentage of boneless, closely trimmed, retail cuts obtained from a carcass.

RESOURCES

EVERY EFFORT WAS MADE to confirm the accuracy of these listings. You may send any corrections or updates to the Editorial Department, Storey Publishing, 210 MASS MoCA Way, North Adams, MA 01247. To check for updated information, go to *www.agbreeds.com*.

Some of these organizations are run by individual farmers and ranchers and may be challenging to get a hold of during business hours.

BREED ORGANIZATIONS

Cattle

AMERICAN
Sam Marks
36425 EW 1210 RD
Wewoka, Oklahoma 74884
405-257-3251

**AMERICAN WHITE PARK
(BRITISH WHITE)**
American-British White Park
Association
Harrison, Arkansas
877-900-2333
www.whitecattle.org

British White Cattle Association
of America
Bells, Texas
800-826-4038
www.britishwhite.org

AMERIFAX
Amerifax Cattle Association
Hastings, Nebraska
402-463-5289

ANCIENT WHITE PARK
Ancient White Park Cattle
Society of North America
1273 Otter Creek Road
Big Timber, Montana 59011

ANGUS & RED ANGUS
American Angus Association
St. Joseph, Missouri
816-383-5100
www.angus.org

Red Angus Association of
America
Denton, Texas
940-387-3502
www.redangus.org

Canadian Angus Association
Calgary, Alberta
888-571-3580
www.cdnangus.ca

Canadian Red Angus Promotion
Society
Pincher Creek, Alberta
403-627-2790
www.redangus.ca

ANKOLE-WATUSI
Ankole Watusi International
Registry
Spring Hill, Kansas
913-592-4050
www.awir.org

World Watusi Association
Crawford, Nebraska
308-665-1919
www.watusicattle.com

AUBRAC
Aubrac International
Oak Creek, Colorado
970-736-1049
www.aubracusa.com

AYRSHIRE
Ayrshire Breeders' Association
Columbus, Ohio
614-335-0020
www.usayrshire.com

Ayrshire Breeders' Association
of Canada
Saint Hyacinthe, Quebec
450-778-3535
www.ayrshire-canada.com

BARZONA
Barzona Breeds Association of
America
Fort Collins, Colorado
970-498-9306
www.barzona.com

BEEFALO
American Beefalo International
Somerset, Kentucky
800-233-3256
www.ababeefalo.org

BEEFMASTER
Beefmaster Breeders United
San Antonio, Texas
210-732-3132
www.beefmasters.org

BELGIAN BLUE
American Belgian Blue Breeders
Hedrick, Iowa
641-661-2332
www.belgianblue.org

Canadian Belgian Blue
Association
Lefaivre, Ontario
613-679-4133
www.belgianblue.ca

BLONDE D'AQUITAINE
American Blonde d'Aquitaine
Association
Grand Saline, Texas
903-570-0568
www.blondecattle.org

Canadian Blonde d'Aquitaine
Association
Ottawa, Ontario
613-731-7110
*www.canadianblonde
association.ca*

BRAFORD
United Braford Breeders
Nacogdoches, Texas
936-569-8200
www.brafords.org

BRAHMAN
American Brahman Breeders
Association
Houston, Texas
713-349-0854
www.brahman.org

BRAHMOUSIN
American Brahmousin Council,
Inc.
Wallis, Texas
979-478-6690
www.brahmousin.org

BRALERS
American Bralers Association
P.O. Box 75
Burton, Texas 77835

BRANGUS & RED BRANGUS
International Brangus Breed
Association
San Antonio, Texas
210-696-4343
www.int-brangus.org

American Red Brangus
Association
Drippings Springs, Texas
512-858-7285
www.americanredbrangus.org

International Red Brangus
Breeders Association
San Antonio, Texas
713-943-5107
www.redbrangus.org

BRAUNVIEH & BROWN SWISS
Braunvieh Association of
America
Lincoln, Nebraska
402-466-3292
www.braunvieh.org

Canadian Brown Swiss &
Braunvieh Association
Guelph, Ontario
519-821-2811
www.browncow.ca

BROWN SWISS

Brown Swiss Association
Beloit, Wisconsin
608-365-4474
www.brownswissusa.com

Canadian Brown Swiss &
Braunvieh Association
Guelph, Ontario
519-821-2811
www.browncow.ca

BUELINGO

BueLingo Beef Cattle Society
Warren, Illinois
815-745-2147
www.buelingo.com

CANADIAN SPECKLE PARK

Canadian Speckle Park
Association
Spruce Grove, Alberta
780-934-6682
www.specklepark.ca

CANADIENNE

Rare Breeds Canada
*Listed under Other
Organizations*

CHAROLAIS & CHARBRAY

American-International Charolais
Association
Kansas City, Missouri
816-464-5977
www.charolaisusa.com

Canadian Charolais Association
Calgary, Alberta
403-250-9242
www.charolais.com

CHIANINA & CHINAMPO

American Chianina Association
Platte City, Missouri
816-431-2808
www.chicattle.org

Canadian Chianina Association
Meskanaw, Saskatchewan
306-864-3644
www.clrc.ca/chianina.shtml

CORRIENTE

North American Corriente
Association
North Kansas City, Missouri
816-421-1992
www.corrientecattle.org

DEVON/MILKING DEVON

American Devon Cattle
Association
Canton, North Carolina
828-235-8269
www.americandevon.com

American Milking Devon Cattle
Association
New Durham, New Hampshire
603-859-6611
www.milkingdevons.org

DEXTER

American Dexter Cattle
Association
Watertown, Minnesota
952-215-2206
www.dextercattle.org

Purebred Dexter Cattle
Association of North America
Prairie Home, Missouri
660-841-9502
www.purebreddextercattle.org

Canadian Dexter Cattle
Association
Ottawa, Ontario
613-731-7110, ext. 303
www.dextercattle.ca

DUTCH BELTED (LAKENVELDER)

Dutch Belted Cattle Association
of America
Delevan, Wisconsin
608-883-6834
www.dutchbelted.com

FLORIDA CRACKER

Florida Cracker Cattle
Association
P.O. Box 110910
Gainesville, Florida 32611

GALLOWAY & BELTED GALLOWAY

American Galloway Breeders
Association
Ottawa, Ontario
www.americangalloway.com

Belted Galloway Society
Bendersville, Pennsylvania
717-677-9655
www.beltie.org

GELBRAY

Gelbray International
Ardmore, Oklahoma
580-223-5771
don_yeager@hughes.net

GELBVIEH

American Gelbvieh Association
Westminster, Colorado
303-465-2333
www.gelbvieh.org

Canadian Gelbvieh Association
Calgary, Alberta
403-250-8640
www.gelbvieh.ca

GUERNSEY
American Guernsey Association
Reynoldsburg, Ohio
614-864-2409
www.usguernsey.com

Canadian Guernsey Association
Guelph, Ontario
519-836-2141
www.guernseycanada.ca

HAYS CONVERTER
Canadian Hays Converter
Association
Calgary, Alberta
403-245-6923
www.clrc.ca/haysconverter.shtml

HEREFORD & POLLED HEREFORD
American Hereford Association
(includes Polled Hereford)
Kansas City, Missouri
816-842-3757
www.hereford.org

Canadian Hereford Association
Calgary, Alberta
888-836-7242
www.hereford.ca

HIGHLAND
American Highland Cattle
Association
Denver, Colorado
303-292-9102
www.highlandcattleusa.org

Canadian Highland Cattle
Society
Smithers, British Columbia
250-877-7783
www.chcs.ca

HOLSTEIN
Holstein Association USA
Brattleboro, Vermont
800-952-5200
www.holsteinusa.com

JERSEY
American Jersey Cattle
Association
Reynoldsburg, Ohio
614-861-3636
www.usjersey.com

Canadian Jersey Cattle
Association
Guelph, Ontario
519-821-1020
www.jerseycanada.com

KERRY
American Livestock Breeds
Conservancy
*Listed under Other
Organizations*

Rare Breeds Canada
*Listed under Other
Organizations*

LIMOUSIN
North American Limousin
Foundation
Centennial, Colorado
303-220-1693
www.nalf.org

Canadian Limousin Association
Calgary, Alberta
866-886-1605
www.limousin.com

LINCOLN RED
North American Lincoln Red
Association
Coniston, Ontario
705-694-0669

LINEBACK
Randall Cattle Registry
South Kent, Connecticut
www.randallcattleregistry.org

Randall Lineback Breed
Association
Berryville, Virginia
www.randalllineback.com

LOWLINE
American Lowline Registry
North Kansas City, Missouri
816-221-0641
www.usa-lowline.org

Canadian Lowline Cattle
Association
Edmonton, Alberta
780-486-7553
www.canadianlowline.com

MAINE-ANJOU
American Maine-Anjou
Association
Platte City, Missouri
816-431-9950
www.maine-anjou.org

Canadian Maine-Anjou
Association
Calgary, Alberta
403-291-7077
www.maine-anjou.ca

MARCHIGIANA
American International
Marchigiana Society
Walton, Kansas
620-837-3303
www.marky.willadsenfamily.org

Canadian Marchigiana
Association
Box 37
Priddis, Alberta T0L 1W0
403-931-2415
cass@davincibb.net

MASHONA
American Mashona
Causey, New Mexico
505-273-4237
www.americanmashona.com

MURRAY GREY
American Murray Grey
Association
Reno, Nevada
775-972-7526
www.murraygreybeefcattle.com

Murray Grey International
Association
Lawton, Oklahoma
580-353-1211
http://murraygrey.org

Canadian Murray Grey
Association
Stettler, Alberta
403-742-3843
www.cdnmurraygrey.ca

NORMANDE
North American Normande
Association
Rewey, Wisconsin
800-573-6254
www.normandeassociation.com

PARTHENAIS
Parthenais Cattle Breeders
Association
Chipley, Florida
850-638-8873
www.parthenaiscattle.org

PIEDMONTESE
Piedmontese Association of the
United States
Elsberry, Missouri
573-384-5685
www.pauscattle.org

Canadian Piedmontese
Association
Lacombe, Alberta
403-782-2657
www.piedmontese.ca

PINEYWOODS
Pineywoods Cattle Registry &
Breeders Association
Poplarville, Mississippi
601-795-4672
www.pcrba.org

PINZGAUER & PINZBRAH
American Pinzgauer Association
Bethany, Missouri
800-914-9883
www.pinzgauers.org

Canadian Pinzgauer Association
Olds, Alberta
403-507-2255
www.pinzgauer.ca

RED POLL
Canadian Red Poll Association
Ottawa, Ontario
613-731-7110
www.clrc.ca/redpoll.shtml

ROMAGNOLA
American Romagnola
Association
Lincoln, Nebraska
402-466-3334
www.americanromagnola.com

North American Romagnola &
RomAngus Association
LaCygne, Kansas
913-594-1080
www.romcattle.com

Canadian Romagnola
Association
Box 37
Priddis, Alberta T0L 1W0
403-931-2415

SALERS
American Salers Association
Parker, Colorado
303-770-9292
www.salersusa.org

SALORN
International Salorn Association
Elmendorf, Texas
210-635-7819
www.salorn.com

SANTA GERTRUDIS
Santa Gertrudis Breeders
International
Kingsville, Texas
361-592-9357
http://santagertrudis.com

SENEPOL
Senepol Cattle Breeders
Association
Leland, North Carolina
800-736-3765
www.senepolcattle.com

SHORTHORN & MILKING SHORTHORN

American Shorthorn Association
Omaha, Nebraska
877-272-0686
www.shorthorn.org

American Milking Shorthorn
Society
Beloit, Wisconsin
608-365-3332
www.milkingshorthorn.com

Canadian Shorthorn Association
Regina, Saskatchewan
306-757-2212
www.canadianshorthorn.com

SIMMENTAL & SIMBRAH

Canadian Simmental Association
Calgary, Alberta
866-860-6051
www.simmental.com

SOUTH DEVON

North American South Devon
Association
Parker, Colorado
303-770-3130
www.southdevon.com

Canadian South Devon
Association
Rockglen, Saskatchewan
306-476-2303
www.southdevon.ca

TARENTAISE

American Tarentaise Association
Elkhorn, Nebraska
402-639-9808
www.americantarentaise.org

Canadian Tarantaise Association
Shellbrook, Saskatchewan
800-450-4181
www.tarentaise.ca

TEXAS LONGHORN

Texas Longhorn Breeders
Association of America
Ft. Worth, Texas
817-625-6241
www.tlbaa.org

TULI

North American Tuli Association
College Station, Texas
979-774-9095
www.tuliassociation.com

WAGYU

American Wagyu Association
Pullman, Washington
509-397-1011
www.wagyu.org

Canadian Wagyu Association
Camrose, Alberta
780-672-2990
www.canadianwagyu.ca

WELSH BLACK

Canadian Welsh Black
Association
Balzac, Alberta
403-226-0416
www.clrc.ca/welshblack.shtml

ZEBU

International Miniature Zebu
Association
Crawford, Nebraska
308-665-3919
www.imza.name

Goats

ALPINE

Alpines International
7195 County Rd 315
Silt, Colorado
970-876-2738
www.alpinesinternationalclub.com

ANGORA

American Angora Goat Breeders
Association
Rocksprings, Texas
830-683-4483
www.aagba.org

Colored Angora Goat Breeders
Association
Glen Rock, Pennsylvania
717-235-5140
www.cagba.org

ARAPAWA

Arapawa Goat Breeders USA
Rehoboth, Massachusetts
508-252-9469
www.arapawagoat.org

BOER

American Boer Goat Association
San Angelo, Texas
325-486-2242
www.abga.org

International Boer Goat
Association
Whitewright, Texas
877-402-4242
www.intlboergoat.org

United States Boer Goat
Association
Spicewood, Texas
866-668-7242
www.usbga.org

Canadian Boer Goat Association
c/o Canadian Meat Goat
Association
Lancaster, Ontario
613-347-1103
www.canadianmeatgoat.com

CASHMERE
Eastern Cashmere Association
Groverport, Ohio
614-837-7635
*www.easterncashmere
association.org*

Northwest Cashmere
Association
Yakima, Washington
509-965-3708
www.nwcashmere.org

Canadian Cashmere Producers
Association
info@canadiancashmere.ca
www.canadiancashmere.ca

KIKO
American Kiko Goat Association
Trenton, Georgia
706-657-8649
www.kikogoats.com

KINDER
Kinder Goat Breeders
Association
Snohomish, Washington
360-668-4559
www.kindergoats.com

LAMANCHA
American LaMancha Club
Hawkins, Wisconsin
715-585-2307
www.lamanchas.com

**MYOTONIC
(OR WOODEN LEG, TENNESSEE
FAINTING GOAT)**
International Fainting Goat
Association
2455 Deanburg Road
Pinson, Tennessee 38366
www.faintinggoat.com

International Fainting Goat
Association
2228 N US Highway 231
Greencastle, Indiana 46135

Miniature Silky Fainting Goat
Association
Lignum, Virginia
540-423-9193
www.msfgaregistry.com

NIGERIAN DWARF
Nigerian Dwarf Goat Association
Wilhoit, Arizona
928-445-3423
www.ndga.org

NUBIAN
International Nubian Breeders
Association
Franklin, Texas
979-828-4158
www.i-n-b-a.org

OBERHASLI
Oberhasli Breeders of America
Palatka, Florida
secretary@oberhasli.net
www.oberhasli.net

PYGMY
National Pygmy Goat
Association
Snohomish, Washington
425-334-6506
www.npga-pygmy.com

PYGORA
Pygora Breeders Association
Lysander, New York
315-678-2812
www.pygoragoats.org

SAANEN
National Saanen Breeders
Association
Santa Margarita, California
805-461-5547
*www.nationalsaanen
breeders.com*

SAN CLEMENTE
San Clemente Island Goat
Association
The Plains, Virginia
540-687-8871
www.scigoats.org

SPANISH
American Meat Goat Association
Sonora, Texas
325-387-6100
www.meatgoats.com

TOGGENBURG
National Toggenburg Club
Buhl, Idaho
208-543-8824
www.nationaltoggclub.org

Pigs

AMERICAN LANDRACE
National Swine Registry
Listed under Other Organizations

AMERICAN YORKSHIRE
National Swine Registry
Listed under Other Organizations

Canadian Yorkshire Swine Club
Dunham, Quebec
450-295-3150
www.canswine.ca/york.html

BERKSHIRE
American Berkshire Association
West Lafayette, Indiana
765-497-3618
www.americanberkshire.com

CHESTER WHITE
Certified Pedigreed Swine
Listed under Other Organizations

Canadian Swine Breeders
Association
Listed under Other Organizations

DUROC
National Swine Registry
Listed under Other Organizations

Canadian Swine Breeders
Association
Listed under Other Organizations

GLOUCESTERSHIRE OLD SPOT
Gloucestershire Old Spots Pigs
of America
Lenox, Massachusetts
www.gosamerica.org

GUINEA HOG
American Guinea Hog
Association
New Boston, New Hampshire
AGHA@sullbarfarm.com
*www.americanguineahog
association.org*

HAMPSHIRE
National Swine Registry
Listed under Other Organizations

Canadian Swine Breeders
Association
Listed under Other Organizations

HEREFORD
National Hereford Hog Record
Association
Flandreau, South Dakota
605-997-2116
www.herefordhog.org

LACOMBE
Canadian Swine Breeders
Association
Listed under Other Organizations

LARGE BLACK
North American Large Black Pig
Registry
740 Lower Myrick Road
Laurel, Mississippi 39443
601-426-2264
stillmeadow@c-gate.net

MULEFOOT
American Mulefoot Hog
Association and Registry
Tekonsha, Michigan
517-767-4729
http://mulefootpigs.tripod.com

OSSABAW ISLAND
Ossabaw Island Hog Association
c/o American Livestock Breeds
Conservancy
Listed under Other Organizations

POLAND CHINA
Certified Pedigreed Swine
Listed under Other Organizations

RED WATTLE
American Livestock Breeds
Conservancy
Listed under Other Organizations

SPOTTED
Certified Pedigreed Swine
Listed under Other Organizations

TAMWORTH
Tamworth Swine Association
Greencastle, Indiana
765-653-4913
tamassoc@webtr.net

VIETNAMESE POTBELLY
North American Potbellied Pig
Association
Bradenton, Florida
941-746-7339
www.petpigs.com

Sheep

BARBADOS BLACKBELLY
Barbados Blackbelly Sheep
Association International
Cobden, Illinois
618-893-4568
www.blackbellysheep.org

North American Barbados
Blackbelly Sheep Registry
McKean, Pennsylvania
www.barbados.
sheepregistry.com
blackbellies@sheepregistry.com

Consortium of Barbados
Blackbelly Sheep Breeders
moderator@consortium.
blackbellysheep.info
www.consortium.
blackbellysheep.info

BLACK WELSH MOUNTAIN
American Black Welsh Mountain
Sheep Association
Paonia, Colorado
970-527-3573
www.blackwelsh.org

BLUEFACED LEICESTER
Bluefaced Leicester Union of
North America
Schoolcraft, Michigan
269-679-5497
www.bflsheep.com

BORDER LEICESTER
American Border Leicester
Association
Millerton, New York
518-789-6113
www.ablasheep.org

CALIFORNIA RED
California Red Sheep Registry
Merced, California
209-725-0340
www.caredsheep.com

CALIFORNIA VARIEGATED MUTANT
American Romeldale/CVM
Association
Valparaiso, Indiana
219-759-9665
www.arcainc.org

National CVM Conservancy
Seville, Ohio
330-606-3588
www.NationalCVM
Conservancy.com

CVM Registrar
Carnation, Washington
425-333-4934
www.cvmsheep.com

CANADIAN ARCOTT
Canadian Sheep Breeders'
Association
Listed under Other
Organizations

CHAROLLAIS
Canadian Sheep Breeders'
Association
Listed under Other
Organizations

CHEVIOT
American Cheviot Sheep Society
New Richland, Minnesota
507-465-8474
www.cheviots.org

American North Country
Cheviot Sheep Association
Walkerton, Indiana
574-586-3778
www.northcountrycheviot.com

Miniature Cheviot Sheep
Breeders Association
Silver Springs, Nevada
775-629-1211
www.minicheviot.com

CLUN FOREST
North American Clun Forest
Association
Houston, Minnesota
507-864-7585
www.clunforestsheep.org

COLUMBIA
Columbia Sheep Breeders
Association of America
Columbia, Missouri
573-886-9419
www.columbiasheep.org

COOPWORTH
Coopworth Sheep Society of
North America
Kingston, Washington
360-297-4485
www.coopworthsheep.org

CORMO
American Cormo Sheep
Association
Broadus, Montana
406-427-5449
www.cormosheep.com

CORRIEDALE
American Corriedale Association
Clay City, Illinois
618-676-1046
www.americancorriedale.com

COTSWOLD
Cotswold Breeders Association
Cornersville, Tennessee
931-293-4466
http://
cotswoldbreedersassociation.org

DELAINE MERINO
American Delaine & Merino
Record Association
Jacobsburg, Ohio
740-686-2172
www.admra.org

DORPER
American Dorper Sheep
Breeders' Society
Columbia, Missouri
573-442-8257
www.dorperamerica.org

International Dorper Sheep
Breeders' Association
DeLeon, Texas
254-485-1469
www.discoverdorpers.com

DORSET
Continental Dorset Club
North Scituate, Rhode Island
401-647-4676
www.dorsets.homestead.com

EAST FRIESIAN
Dairy Sheep Association of
North America
Listed under Other
Organizations

FINNSHEEP
American Finnsheep Breeders
Association
Hominy, Oklahoma
918-519-4140
www.finnsheep.org

GULF COAST NATIVE
Gulf Coast Sheep Breeders
Association
Spruce Pine, Alabama
256-332-6847
www.gulfcoastsheepbreeders.org

HAMPSHIRE
American Hampshire Sheep
Association
Milo, Iowa
641-942-6402
www.hampshires.com

HOG ISLAND
Hog Island Sheep Registry
c/o American Livestock Breeds
Conservancy
Listed under Other
Organizations

ICELANDIC
Icelandic Sheep Breeders of
North America
Haydenville, Massachusetts
413-268-3086
www.isbona.com

JACOB
American Jacob Sheep Registry
McKean, Pennsylvania
jacob@sheepregistry.com
www.jacob.sheepregistry.com

Jacob Sheep Breeders
Association
Dexter, Oregon
541-747-6149
www.jsba.org

Jacob Sheep Conservancy
Beavercreek, Oregon
snielsen@arednet.org
www.jacobsheepconservancy.org

KARAKUL
American Karakul Sheep
Registry
Boonville, Missouri
660-838-6340
www.karakulsheep.com

KATAHDIN
Katahdin Hair Sheep
International
Fayetteville, Arkansas
479-444-8441
www.khsi.org

Canadian Katahdin Sheep
Association
Ottawa, Ontario
www.katahdinsheep.com

LEICESTER (OR ENGLISH)
LONGWOOL
Leicester Longwool Sheep
Breeders Association
Albright, West Virginia
304-379-9100
www.leicesterlongwool.org

LINCOLN LONGWOOL
National Lincoln Sheep Breeders
Association
Milo, Iowa
kclaghorn@earthlink.net
www.lincolnsheep.org

MONTADALE
Montadale Sheep Breeders
Association
Fargo, North Dakota
701-297-9199
www.montadales.com

NAVAJO-CHURRO
Navajo-Churro Sheep
Association
Ojo Caliente, New Mexico
N-CSA@navajo-churro
sheep.com
www.navajo-churrosheep.com

NEWFOUNDLAND
Rare Breeds Canada
Listed under Other Organizations

OXFORD
American Oxford Sheep
Association
Stonington, Illinois
217-325-3515
www.americanoxfords.org

PERENDALE
Perendale Association of North
America
McArthur, California
www.perendale.us.org

POLYPAY
American Polypay Sheep
Association
Milo, Iowa
641-942-6402
www.polypay.org

RAMBOUILLET
American Rambouillet Sheep
Breeders Association
Levelland, Texas
806-894-3081
www.rambouilletsheep.org

RIDEAU ARCOTT
Canadian Sheep Breeders'
Association
Listed under Other Organizations

ROMANOV
North American Romanov Sheep
Association
Pataskala, Ohio
740-927-3098
*http://home.columbus.rr.com/
narsa*

ROMELDALE
American Romeldale/CVM
Association
Valparaiso, Indiana
219-759-9665
www.arcainc.org

ROMNEY
American Romney Breeders
Association
Grants Pass, Oregon
541-476-6428
www.americanromney.org

ROYAL WHITE
Royal White Sheep Association
Beallsville, Ohio
740-926-1085
www.royalwhitesheep.org

SANTA CRUZ
American Livestock Breeds
Conservancy
Listed under Other Organizations

SHETLAND
North American Shetland
Sheepbreeders Association
Milo, Iowa
secretary@shetland-sheep.org
www.shetland-sheep.org

SHROPSHIRE
American Shropshire Registry
Association
Marshfield, Missouri
417-859-4452
www.shropshires.org

SOAY
Soays of America, Inc.
Gig Harbor, Washington
www.soaysofamerica.com

SOUTHDOWN
American Southdown Breeders
Association
Fredonia, Texas
325-429-6226
www.southdownsheep.org

North American Babydoll
Southdown Sheep Association &
Registry
Wellsville, Kansas
785-883-4774
http://nabssar.org

ST. CROIX
International St. Croix Hair
Sheep Association
Milo, Iowa
641-942-6402
www.stcroixsheep.org

SUFFOLK
United Suffolk Sheep
Association
Newton, Utah
435-563-6105
www.u-s-s-a.org

TARGHEE
U. S. Targhee Sheep Association
Fort Shaw, Montana
406-467-2462
www.ustargheesheep.org

TEXEL
Texel Sheep Breeders Society
Milo, Iowa
641-942-6402
www.usatexels.org

TUNIS
National Tunis Sheep Registry
Milo, Iowa
641-942-6402
www.tunissheep.org

WENSLEYDALE
North American Wensleydale
Sheep Association
Loma Rica, California
530-743-5262
www.wensleydalesheep.org

WILTSHIRE HORN
American Livestock Breeds
Conservancy
Listed under Other Organizations

OTHER ORGANIZATIONS

**American Dairy Goat
Association**
Spindale, North Carolina
828-286-3801
www.adga.org

**American Livestock Breeds
Conservancy**
Pittsboro, North Carolina
919-542-5704
www.albc-usa.org

**American Sheep Industry
Association**
Centennial, Colorado
303-771-3500
www.sheepusa.org

Ark of Taste
Slow Food U.S.A.
Brooklyn, New York
877-756-9366
www.slowfoodusa.org

**Canadian Food Inspection
Agency**
Ottawa, Ontario
800-442-2342
www.inspection.gc.ca

Canadian Goat Society
Ottawa, Ontario
613-731-9894
www.goats.ca

Canadian Livestock Records
Ottawa, Ontario
613-731-7110
www.clrc.ca

**Canadian Sheep Breeders'
Association**
Deerville, New Brunswick
866-956-1116
www.sheepbreeders.ca

Canadian Sheep Federation
Guelph, Ontario
888-684-7739
www.cansheep.ca

**Canadian Swine Breeders
Association**
Ottawa, Ontario
613-731-5531
www.canswine.ca

Certified Pedigreed Swine
Peoria, Illinois
309-691-0151
www.cpsswine.com

**Dairy Sheep Association of
North America**
c/o Shepherd's Dairy
Anselmo, Nebraska
308-749-2349
www.dsana.org

National Swine Registry
West Lafayette, Indiana
765-463-3594
www.nationalswine.com

Rare Breeds Canada
Castleton, Ontario
905-344-7768
www.rarebreedscanada.ca

**United States Department of
Agriculture**
Washington, D.C.
www.usda.gov

Veterinary Services
National Center for Import and
Export
Riverdale, Maryland
301-734-3277
www.aphis.usda.gov/vs/ncie

MAGAZINES AND NEWSLETTERS

Acres U.S.A.
Austin, Texas
800-355-5313
www.acresusa.com

American Small Farm
Delaware, Ohio
740-363-2395
www.smallfarm.com

Black Sheep Newsletter
Scappoose, Oregon
503-621-3063
www.blacksheepnewsletter.net

Beef
Penton Media
Minneapolis, Minnesota
952-851-9329
www.beef-mag.com

Cattle Today
Fayette, Alabama
800-548-5029
www.cattletoday.com

Countryside & Small Stock Journal
Medford, Wisconsin
800-551-5691
www.countrysidemag.com

Dairy Goat Journal
Medford, Wisconsin
800-551-5691
www.dairygoatjournal.com

Hobby Farms Magazine
Mission Viejo, California
800-627-6157
www.hobbyfarmsmagazine.com

Mother Earth News
Ogden Publications
Topeka, Kansas
000 201 3368
www.motherearthnews.com

Sheep!
Jefferson, Wisconsin
800-551-5691
www.sheepmagazine.com

Sheep Canada
Deervile, New Brunswick
888-241-5124
www.sheepcanada.com

Small Farmer's Journal
Sisters, Oregon
800-876-2893
www.smallfarmersjournal.com

Small Farm Today
Clark Missouri
800-633-2535
www.smallfarmtoday.com

The Stockman Grass Farmer
Ridgeland, Mississippi
800-748-9808
www.stockmangrassfarmer.net

BIBLIOGRAPHY

Anderson, Virginia DeJohn. "Animals into the Wilderness: The Development of Livestock Husbandry in the Seventeenth-Century Chesapeake," *The William and Mary Quarterly.* 2002 April, 3rd Series, Vol. LIX, 377–408.

Baker, C.M. Ann. "The Origin of South Devon Cattle," *The Agricultural History Review.* 1984, Vol. 32.3, 145–58.

Becker, Raymond B. *Dairy Cattle Breeds: Origin and Development.* Gainesville, Florida: University of Florida Press, 1973.

Bixby, Don. "Genetic Diversity Dwindling in Swine Populations," *Countryside.* 2003 January.

Blackburn, Harvey D., Terry Stewart, Don Bixby, Paul Siegal, and Eric Bradford. *United States of America Country Report for FAO's State of the World's Animal Genetic Resources.* USDA Agricultural Research Service, 2003.

Borg, Randy C. "Developing Breeding Objectives for Targhee Sheep," Dissertation, Virginia Polytech, 2004.

Bradley, Daniel G. "Genetic Hoofprints," *Natural History Magazine.* 2003 February.

Bradley, Daniel G., David E. MacHugh, Patrick Cunningham, and Ronan T. Loftus. "Mito-chondrial Diversity and Origins of African and European Cattle." *Proceedings of the National Academy of Science.* 1996 May, Vol. 93, 5131–35.

Briggs, Hilton M. *Modern Breeds of Livestock.* New York: Macmillan, 1958.

Bruford, Michael W., Daniel G. Bradley, and Gordon Luikart. "DNA Markers Reveal the Complexity of Livestock Domestication," 2003 November, Vol. 4.

Christman, Carolyn J., D. Phillip Sponenberg, and Donald E. Bixby. *A Rare Breeds Album of American Livestock.* Pittsboro, North Carolina: American Livestock Breeds Conservancy, 1997.

Clutton-Brock, Juliet. *A Natural History of Domesticated Mammals.* Cambridge University Press, 1999.

Conroy, Drew, and Dwight Barney. *The Oxen Handbook.* Maryville, Missouri: Doug Butler, 1986.

Dohner, Janet Vorwald. *The Encyclopedia of Historic and Endangered Livestock and Poultry Breeds.* New Haven, Connecticut: Yale University Press, 2001.

Dunn, Peter. *The Goat Keepers Veterinary Book.* Alexandria Bay, New York: Farming Press Limited, 1998.

Friend, John B. *Cattle of the World.* Dorset, England: Blandford Press, 1978.

Gentry, A., Juliet Clutton-Brock, and Collin P. Groves. "The Naming of Wild Animal Species and Their Domestic Derivatives," *Journal of Archaeological Science.* 2004, Vol. 31, 645–51.

Hansen, C., J. N. B. Shrestha, R. J. Parker, G. H. Crow, P. J. McAlpine, and J. N. Derr. "Genetic Diversity Among Canadienne, Brown Swiss, Holstein and Jersey Cattle of Canada Based on 15 Bovine Microsatellite Markers," *Genome.* 2002, Vol. 45, 897–904.

Hickman, C. G., ed. *World Animal Science: Cattle Genetic Resources.* Elsevier, New York, 1991.

Hildebrandt, Dale. "Dairy Farmers Starting to Look at Crossbreeding," *Farm & Ranch Guide.* 2007 February, 5382–84.

Klug, William S., and Michael R. Cummings. *Concepts of Genetics.* 7th ed. New Jersey: Pearson Education, 2003.

MacHugh, David E., and Daniel G. Bradlye. "Livestock Genetic Origins: Goats Buck the Trends," *Proceedings of the National Academy of Sciences.* 2000 May, Vol. 98:10.

National Pork Board. "Quick Facts: The Pork Industry at a Glance." Des Moines, Iowa, 2005.

Ollivier, L., and M. Molenat. "A Global Review of the Genetic Resources of Pigs," in *The Management of Global Animal Genetic Resources.* FAO Animal Production and Health Paper; Expert Consultation on the Management of Global Animal Genetic Resources, Hodges, J., Rome, Italy: FAO, 1992: 177–87.

Otto, John Solomon. "Open Range Cattle: Ranching in the Florida Pinewoods," *Proceedings of the American Philosophical Society.* 1986, Vol. 130:3, 248–324.

Porter, Valerie, reviser of *Mason's World Dictionary of Livestock Breeds, Types and Varieties.* 5th ed. New York: CABI Publishing, 2002.
——. *Cattle: A Handbook to the Breeds of the World.* New York: Facts on File, 1991.
——. *Goats of the World.* Ipswich, England: Farming Press, 1996.
——. *Pigs: A Handbook to the Breeds of the World.* East Sussex, England: Helm Information, 1993.

Ritvo, Harriet. *The Platypus and the Mermaid, and Other Figments of the Classifying Imagination.* Harvard University Press, 1997.

Rowe, Betty. *Arapawa: Once Upon an Island.* Auckland, New Zealand: Halcyon Press, 2005.

Ryder, M. L. "The History of Sheep Breeds in Britain," *The Agricultural History Review.* 1984, Vol XII, pp.1–7 and 73–82.

Sanders, James O. "History and Development of Zebu Cattle in the United States," *Journal of Animal Science.* 1980 June, Vol. 50, 1188–1200.

Schmutz, Sheila. *Genetics of Coat Color in Cattle.* http://homepage.usask.ca/~schmutz/colors.html.

Smith, William W. *Pork Production.* New York: Macmillan, 1937.

Sponenberg, Philip, and Carolyn J. Christman. *A Conservation Breeding Handbook.* Pittsboro, North Carolina: American Livestock Breeds Conservancy, 2004.

Tapio, Miika. "Origin and Maintenance of Genetic Diversity in Northern European Sheep," Dissertation, Acta Univ. Ouluensis Oulu, Finland A 473, 2006.

"Twenty-First Annual Report of the Bureau of Animal Industry," Washington, D.C.: USDA, 1904.

PHOTO CREDITS

INTRODUCTION

2 © Robert Dowling
6 © Lynn Stone
9 © Lynn Stone
13, 14 © Lynn Stone
15 © Christine Wilson, Durbin Ridge Farm, www.
 durbinridge.com (top), © Robert Dowling (bottom)
17 © John Cleary
18 © Corbis Premium RF/Alamy (top), © Linda Davis,
 Davis' Farmland, www.davisfarmland.com (bottom)
19 © Linda Davis, Davis' Farmland,
 www.davisfarmland.com
20 © Robert Dowling
21 © John and Melody Anderson, Wayfarer
 International Ltd.
22 © Lynn Stone
23 © Robert Dowling
24 © Joe McDaniel/iStockphoto (top),
 © Robert Dowling (bottom)
25 © Lynn Stone
27 Courtesy of National Human Genome
 Research Institute
28 © Lynn Stone
29 © Lynn Stone (top), © Sheila Schmutz (bottom)
31, 32 © Lynn Stone
36 © AP Photo/Beatrice Daily Sun, Stephanie Geery-Zink
 (top), © Tom Myers/AGStockUSA (bottom)

CATTLE

41–43 © Lynn Stone
44 © M. Watson/ardea.com (top), © Lynn Stone (bottom)
46 © iStockphoto (top), © Lynn Stone (bottom)
47 © Russell Graves/AGStockUSA
48 © iStockphoto
50 © Connie Brooks, MNP Farm, www.mnpfarm.com
51 © Lynn Stone (top), © Drew Conroy (bottom)
52 edboltphoto.com
53, 54 © Lynn Stone
55 © Doug Jauer, Jauer Dependable Genetics,
 www.jauerangus.com
56 © American Livestock Breeds Conservancy,
 Jeanette Beranger
57 © Robert Dowling
58–61 © Lynn Stone
62 © Eric Grant
63, 64 © Lynn Stone
65 © Margaret Erjavec, http://BarzonaCattle.com
66 © Linda Hays, P&L Beefalo, www.beefalocattle.com

67 © Lynn Stone
68 © Connie Brooks, MNP Farm, www.mnpfarm.com
69–73 © Lynn Stone
74 © Ernie Gill
75, 76 © Lynn Stone
77 © Canadian Speckle Park Association, Julianne Sage
78 © Patric Lyster, Coyote Acres
79 © Lynn Stone
80 © Sam Wirzba/AGStockUSA
81 © Adam Mastoon
82, 83 © Lynn Stone
84 © Martha Trantham (top), © Drew Conroy, Courtesy of
 the American Milking Devon Association (bottom)
85 © Patti Adams, Wakarusa Ridge Ranch,
 www.kansasdexters.com
86–93 © Lynn Stone
94 © Browarny Photographics
95, 96 © Lynn Stone
97 © Derek Dammann/iStockphoto
98 © Maureen Blaney Flietner, Mameframe Photography
99, 100 © Lynn Stone
101 © Maureen Blaney Flietner, Mameframe Photography
102, 103 © Lynn Stone
104 © Lincoln Red Cattle Society
105 © Lynn Stone
107 © Claudia Myers (top), © J. Robert Lynch (middle),
 © Lynn Stone (bottom)
109 © Shelley Dodd
110 © Sid Greer, The Greer Farm, www.greerfarm.com
111 © Martie TenEyck, Marky Cattle Association
112–114 © Lynn Stone
115 © Elly Geverink
116 © Vincent Loiseau, French Parthenais Association
117, 118 © Lynn Stone
119 © Bonnie & Bill Fritz, Hudson River Landing Farm,
 http://PineyWoodsBeef.com
120 © Rick Mooney/AGStockUSA
121 © Lynn Stone
122 © Robert Dowling
123–126 © Lynn Stone
127 © Lynn Stone//AGStockUSA
128–131 © Lynn Stone
132 © Joe Mertz, River Creek Farms,
 www.rivercreekfarms.com
133, 134 © Lynn Stone
135, 136 © Sandy Ankenman, Ankenman Ranch,
 www.ankenmanranch.com
137–139 © Lynn Stone

140 © Browarny Photographics, courtesy of Robert Estrin, Lone Mountain Ranch

141 © Browarny Photographics, courtesy of Randy Kaiser, Canadian Welsh Black Association

GOATS

143 © Maureen Blaney Flietner, Mameframe Photography

144 © Kenneth W. Fink/ardea.com

145 © Russell Graves/AGStockUSA

146, 147 © Maureen Blaney Flietner, Mameframe Photography

148 © Heidi Greniger, Just Kidding Goat Farm, www.jkgoats.com

149 © Steve Pope Photography, LLC

150 © Paul Collis/Alamy

151 © cfgphoto.com

152 © John and Melody Anderson, Wayfarer International Ltd.

153 © John and Melody Anderson, Wayfarer International Ltd. (top), © American Livestock Breeds Conservancy, Walter and Betty Rowe (bottom)

154, 155 © Luke Vickrey

156 © Laura Burnside, Southwind Farms, www.southwindfarms.org

157 © Terry Hankins

158 © Patricia Showalter, courtesy of the Kinder Goat Breeders Association

159–161 © Lynn Stone

162 © American Livestock Breeds Conservancy, Jeanette Beranger

163 © Elise Toups, owner Pam Keaton, Divine Sheep Farm, www.divinesheep.com

164–166 © Lynn Stone

167, 168 © Maureen Blaney Flietner, Mameframe Photography

169 © Edwin Hogan, 3 H Farms, www.3HFarms.com

170 © Jill P. Gallagher, Hollyhock Hollow Pygoras, www.hhollow.com

171, 172 © Maureen Blaney Flietner, Mameframe Photography

173, 174 © American Livestock Breeds Conservancy, Maria Castro

175 © Jackson M. Dzakuma, PhD, International Goat Research Center

176 © Maureen Blaney Flietner, Mameframe Photography

177 © Robert Dowling

PIGS

179 © Robert Dowling

180 © Linda Davis, Davis' Farmland, www.davisfarmland.com

181 Courtesy of USDA

182, 183 © Robert Dowling

184 © National Swine Registry

185 © Maureen Blaney Flietner, Mameframe Photography (left), © Dusty Cain, Cain Farms, www.cainfarms.com (right)

186, 187 © Robert Dowling

188 © W-D Swine Farm

189 © American Livestock Breeds Conservancy, Jim Combs

190 © Scott Isler, Isler Genetics, www.islergenetics.com

191 © Robert Dowling

192 © Linda Davis, Davis' Farmland, www.davisfarmland.com

193 © Sullbar Farm, New Boston, New Hampshire

194 © Scott Isler, Isler Genetics, www.islergenetics.com

195 © American Livestock Breeds Conservancy, Mark Hess

196 © Alfred Wahl, Peak Swine Genetics, www.peakswine.com

197 © Robert Dowling

198 © American Livestock Breeds Conservancy, Arie McFarlen (top), © Arie McFarlen, Maveric Heritage Ranch Co., www.maveric9.com (bottom)

199 © American Livestock Breeds Conservancy, Jeanette Beranger

200 © Linda Davis, Davis' Farmland, www.davisfarmland.com

201 © Jacques Dacosse, www.dacosse.be

202 © Steven R. Mapes, courtesy of Certified Pedigreed Swine

203 © Arie McFarlen, Maveric Heritage Ranch Co., www.maveric9.com

204 © Steven R. Mapes, courtesy of Certified Pedigreed Swine

205, 206 © Robert Dowling

207 © Terry Swartz/iStockphoto

SHEEP

209, 210 © Robert Dowling

211 Scott Mann

212 © Jean G. Green, sheep owner Bill H. Hardman, Polypay Farm

213 © Maureen Blaney Flietner, Mameframe Photography (left), © Mary Swindell, Bellwether Farm, www.bellwetherfarm.com (right)

214 © Mike Walker, The Black Oak Ranch

215 © Eugenie McGuire, Desert Weyr, LLC, courtesy of American Black Welsh Mountain Sheep Association

216 © The Bluefaced Leicester Sheep Breeders Association, U.K., www.blueleicester.co.uk

217 © Richard M. Fritz, Ugly Dog's Farm, Davison, MI

218 © Grace Smith, Smith Family Farms, www.smithfamilyfarmvt.com

219 © Malcom Shaw, Creature Comforts

220 © Elise Toups, owner Pam Keaton, Divine Sheep Farm, www.divinesheep.com

EXPERT CONSULTANTS

Russ Bueling, rancher
Alfred Gardner, Ph.D., Smithsonian Institution
Wes Henthorne, rancher
Leonard Johnson, Brown Swiss Association
Robert Lynch, rancher
Carl and Jesse Nichols, farmers
Tim Olson, Ph.D., University of Florida, Department of Animal Science

Betty Rowe, breed conservationist
Sheila Schmutz, Ph.D., University of Saskatchewan, Department of Animal and Poultry Science
Pat Showalter, farmer
John Winder, Washington State Extension

INDEX

OTHER STOREY TITLES
YOU WILL ENJOY

Getting Started with Beef & Dairy Cattle, by Heather Smith Thomas.
The first-time farmer's guide to the basics of raising a small herd of cattle.
288 pages. Paper. ISBN 978-1-58017-596-8. Hardcover with jacket. ISBN 978-1-58017-604-0.

Grass-Fed Cattle, by Julius Ruechel.
The first complete manual in raising, caring for, and marketing grass-fed cattle.
384 pages. Paper. ISBN 978-1-58017-605-7.

Keeping Livestock Healthy, by N. Bruce Haynes, DVM.
A complete guide to disease prevention through good nutrition, proper housing,
and appropriate care.
352 pages. Paper. ISBN 978-1-58017-435-0.

Livestock Guardians, by Janet Vorwald Dohner.
Essential information on using dogs, donkeys, and llamas as a highly effective, low cost, and
nonlethal method to protect livestock and their owners.
240 pages. Paper. ISBN 978-1-58017-695-8. Hardcover. ISBN 978-1-58017-696-5.

Oxen: A Teamster's Guide, by Drew Conroy.
The definitive guide to selecting, training, and caring for the mighty ox.
304 pages. Paper. ISBN 978-1-58017-692-7. Hardcover. ISBN 978-1-58017-693-4.

Small-Scale Livestock Farming, by Carol Ekarius.
A natural, organic approach to livestock management to produce healthier animals, reduce feed
and health care costs, and maximize profit.
224 pages. Paper. ISBN 978-1-58017-162-5.

Storey's Barn Guide to Sheep.
Step-by-step visuals for all aspects of sheep care in a handy, hanging format.
96 pages. Paper with concealed wire-o binding. ISBN 978-1-58017-849-5.

Storey's Guide to Raising Series.
Everything you need to know to keep your livestock and your profits healthy.
Latest title is *Meat Goats.* Other titles in the series are *Rabbits, Ducks, Turkeys, Poultry,
Chickens, Dairy Goats, Llamas, Pigs, Sheep,* and *Beef Cattle.*
Paper. Learn more about each title by visiting *www.storey.com.*

Storey's Illustrated Guide to Poultry Breeds, by Carol Ekarius.
A definitive presentation of more than 120 barnyard fowl, complete with full-color photographs
and detailed descriptions.
288 pages. Paper. ISBN 978-1-58017-667-5. Hardcover with jacket. ISBN 978-1-58017-668-1.

These and other books from Storey Publishing are available
wherever quality books are sold or by calling 1-800-441-5700.
Visit us at *www.storey.com.*